Visions of Modern Art

Painting and Sculpture from The Museum of Modern Art

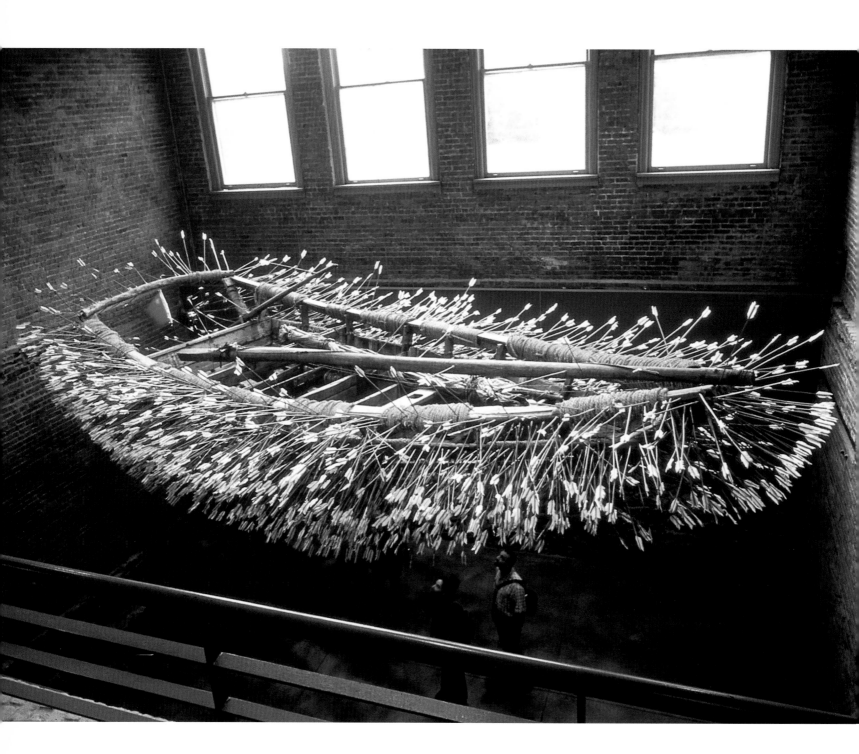

Visions of Modern Art

Painting and Sculpture from The Museum of Modern Art

Edited by **John Elderfield** **The Museum of Modern Art, New York**

Visions of Modern Art: Painting and Sculpture from The Museum of Modern Art is published on the occasion of the exhibition *The Heroic Century: The Museum of Modern Art Masterpieces, 200 Paintings and Sculptures* at the Museum of Fine Arts, Houston, September 21, 2003–January 4, 2004, organized by John Elderfield, Chief Curator, Department of Painting and Sculpture, The Museum of Modern Art, New York

This exhibition was organized by The Museum of Modern Art, New York, under the auspices of The International Council.

Produced by the Department of Publications, The Museum of Modern Art, New York

Edited by Joanne Greenspun
Designed by Steven Schoenfelder
Production by Marc Sapir
Printed and bound by Dr. Cantz'sche Druckerei, Ostfildern, Germany
Printed on 150gsm Biberist Allegro

Library of Congress Control Number: 2003109322
ISBN 0-87070-700-0 (clothbound)
ISBN 0-87070-701-9 (paperbound)

Published by The Museum of Modern Art, New York
11 West 53 Street, New York, New York, 10019
(www.moma.org)

Distributed in the United States and
Canada by D.A.P., New York

Distributed outside the United States and
Canada by Thames & Hudson, Ltd., London

Cover (clockwise from top left): details of Giorgio de Chirico. *The Evil Genius of a King.* 1914–15; Philip Guston. *Box and Shadow.* 1978; Gerhard Richter. *Confrontation 3.* 1988; Jasper Johns. *Green Target.* 1955; Meret Oppenheim. *Object.* 1936; Paul Klee. *Actor's Mask.* 1924; Kazimir Malevich. *Woman with Water Pails: Dynamic Arrangement.* 1912–13; and Claude Monet. *Water Lilies.* c. 1920

Frontispiece: Cai Guo-Qiang. Chinese, born 1957. *Borrowing Your Enemy's Arrows.* 1998. Wood boat, canvas sail, arrows, metal, rope, Chinese flag, and electric fan; boat approximately 60" x 23' 7" x 7' 6" (150 x 720 x 230 cm); arrows approximately 24" (62 cm). Gift of Patricia Phelps de Cisneros in honor of Glenn D. Lowry

Printed in Germany

Contents

Foreword

The Museum of Modern Art is extremely pleased to be able to share with the Museum of Fine Arts, Houston, two hundred works that together provide a lucid overview of modern art since 1880 as represented by the Museum's collection of painting and sculpture. The Museum of Modern Art is currently engaging in the final stage of a thorough physical and organizational transformation that will increase its overall size, diversify its sites of operation, and substantially expand and innovate its programming. The closure of the permanent collection galleries during construction of the Museum's new building has enabled the inclusion in this exhibition of a number of works that seldom travel but are nonetheless internationally known as canonical milestones in the development of modern art.

Alfred H. Barr, Jr., The Museum of Modern Art's founding director, spoke of the Museum's collection as being metabolic and self-renewing. While he meant this in terms of the Museum's acquisition processes, the idea of an institution capable of considering and reconsidering itself in response to an ongoing and continuous inquiry about modern art is central to any understanding of the Museum. This exhibition and its accompanying catalogue are the result of the most recent phase of reassessment that has looked at the museum's collection as an evolution strongly dependent on individual judgment and tastes of curators and collectors, not to mention the vagaries of historical opportunities. The works selected for this exhibition do not offer a simple teleology of movements and counter-movements, but reflect the richness of the collection distinguished by masterworks and lesser-known, yet equally pivotal examples of painting and sculpture. In like manner, the anthology of texts presented in this volume, representative of nearly seventy-five years of the museum's literature, reveals that just as its collection is strongly dependent on fluctuating preferences and the contingencies of history, so too is the explication of images and the writing of modern art's history.

An exhibition of this scale requires the skill and dedication of many people. I wish to express my particular appreciation for the extraordinary efforts of John Elderfield, Chief Curator, Department of Painting and Sculpture, who brought this large group of works together, and conceived of the publication with the assistance of Claudia Schmuckli, Assistant Curator, and Angela C. Lange, Curatorial Assistant; Jennifer Russell, Deputy Director for Exhibitions and Collections Support, and Elizabeth Peterson, Assistant to the Deputy Director for Exhibitions and Collections Support. Gratitude also goes to Joanne Greenspun, Editor, without whom the publication would not have come to fruition, and designer Steven Schoenfelder.

Additional assistance has also come from many other colleagues, including in the Department of Painting and Sculpture: Kynaston McShine, Kirk Varnedoe, Mary Chan, Lianor da Cunha, Fereshteh Daftari, Sharon Dec, Sarah Ganz, Christel Hollevoet, Mattias Herold, Iris Mickein, Avril Peck, Cora Rosevear, and Lilian Tone; in the Department of Drawings: Gary Garrels and Kathleen Curry; in the Department of Film and Media: Mary Lea Bandy and Barbara London; in the Department of Photography: Peter Galassi and Sarah Hermanson Meister; in the Department of Architecture and Design: Paola Antonelli; in the Director's Office: Diana Pulling; in the Department of Exhibitions and Collections Support: Beatrice Kernan and Maria de Marco Beardsley; in the Department of the Registrar: Ramona Bannayan, Seth Fogelman, Rob Jung, Peter Omlor, Whitney Snyder, and Terry Tegarden; in the Department of Painting and Sculpture Conservation: James Coddington, Anny Aviram, Karl Buchberg, Michael Duffy, Roger Griffith, and Lynda Zycherman; in the Department of Exhibition Design: Jerome Neuner, Hope Cullinan, David Hollely, and Peter Perez; in the Department of Publications: Michael Maegraith, Marc Sapir, Christopher Zichello, and Rebecca Zimmerman; in Museum Archives and the Library: Milan Hughston, Michelle Elligott, Michelle Harvey, and Jennifer Tobias; in the Department of Imaging Services: Mikki Carpenter and Holly Boerner; in General Counsel: Patty Lipschutz, Stephen Clark, and Jane Panetta; in the Department of Education: Deborah Schwartz, Maria-Carmen Gonzalez, and Susanna Rubin; in Development: Michael Margititch and Monika Dillon; and in the Department of Communications: Ruth Kaplan and Kim Mitchell.

— *Glenn D. Lowry*
Director, The Museum of Modern Art, New York

The Front Door of Understanding

John Elderfield

In 1929, the first published statement of the founders of The Museum of Modern Art asserted that "the ultimate purpose will be to acquire, from time to time, either by gift or by purchase the best modern works of art." Should this be consistently done, it was argued, New York "could achieve perhaps the greatest museum of modern art in the world." When these words were written, the Museum occupied a rented loft space, had no endowment, no purchase funds—and no collection. It did, however, have a group of enthusiastic and committed founder-Trustees, and its first director, a twenty-seven-year-old art historian, Alfred H. Barr, Jr.

As soon as he had been appointed, Barr proposed to the Trustees that they establish a multi-departmental museum, one devoted to all the visual arts of our time: architecture and design, photography, film, as well as painting and sculpture, drawings, and prints. One of his two greatest achievements was that he was the first thus to conceive of a comprehensive museum of modern visual arts and to bring such a museum into being. His second was that he envisioned the Museum's collection of painting and sculpture as something that should afford a comprehensive overview of modern art composed of the finest possible works, and that he brought such a collection into being. If this no longer seems a novel approach to either collecting or exhibiting the art of our time, it is because Barr's vision of the modern museum is now so widely accepted.

This present publication, and the exhibition it accompanies, offers a review of what Barr, together with his colleagues and successors, achieved in forming the Museum's collection of painting and sculpture. This introduction has two parts. In the first, I shall offer an explanation of the structure and contents of this volume. In the second will be found a brief survey of the development of the painting and sculpture collection of The Museum of Modern Art.

1. A Double Anthology

This publication is conceived to accompany an exhibition at the Museum of Fine Arts, Houston, of paintings and sculptures from the collection of The Museum of Modern Art. The exhibition coincides with—indeed, is made possible by—the greatly reduced display space of the Museum in its temporary quarters in the New York City borough of Queens during the rebuilding of its midtown Manhattan premises. Therefore, the exhibition and publication could contain a selection of exceptional paintings and sculptures over the full range of the Museum's collection, all of which are likely to be found,

at one time or another, in the newly expanded galleries of the reopened Museum. Consequently, our aim has been twofold. First, it has been to make a selection of two hundred works that not only reflects the range and strengths of the collection but also comprises, more than simply a group of masterworks, a cogent overview of modern art in the period since 1880 represented by the collection of painting and sculpture. Second, it has been to produce a publication that can serve both as a guide and a souvenir for visitors to the temporary exhibition and that will be of continuing interest to students of art history and visitors to The Museum of Modern Art.

The two hundred works of art reproduced in this publication, and the texts relating to them, are arranged in eight parts, each devoted to a broad art-historical period, with subsections for individual movements or artists. The selection concentrates on major figures and on paintings and sculptures understood to be "masterworks," yet at the same time it includes some lesser artists and less-well-known works. In this respect, it follows Barr's ecumenical stance toward the collection. While he was unswerving in his pursuit of quality—once defining his task as "the conscientious, continuous, resolute distinction of quality from mediocrity"—his approach was more that of the art historian than of the pure connoisseur, guided by his belief that the collection should serve the educational purpose of providing a balanced historical survey of modern painting and sculpture. The important works of lesser as well as greater artists are integral to the collection, as are works that are principally important for their influence or reputation. Still, Barr's ecumenicalism was more than matched by his evangelism, which led him to privilege works of critical historical importance in the development of modern art. This position was adopted by his successors and is followed in this selection of paintings and sculptures as well.

Thus, major artists have been collected in depth and throughout their careers, and are represented here by multiple works. However, in the development of the collection and in this selection, the particularly innovative moment has mattered most—and therefore the works that define an artistic reputation, movement, or significant change. The Museum's creation of an historical overview has aimed to balance such moments to tell the competing stories of invention and emulation that comprise what we still call modern art.

Here, each of the eight parts that tell these stories is introduced by a set of texts, drawn from the archives and publications of The Museum of Modern Art, on selected individual works and the artists and movements represented in that part of the volume. Each part opens with a short prefatory note that discusses the changing interpretive contexts in which these texts originally appeared. Rather than writing or commissioning yet new texts on frequently much-discussed works, we felt that it would be far more useful to offer a history of The Museum of Modern Art's critical and art-historical writing to parallel the art-historical record afforded by the works themselves. Consequently, the artists and movements presented are introduced by the words of curators who originally presented them at the Museum. The resulting double anthology offers a unique overview of how modern art was greeted and interpreted, as well as collected and exhibited, at The Museum of Modern Art.

Finally, for the convenience of readers, the Chronology on pages 334 to 347 presents in parallel: principal events in the Museum's history; a selection of the Museum's major

exhibitions of painting and sculpture; and the sequence of its acquisition of the works in this publication.

Turning now to the contents of the publication, it first needs emphasizing that a selection of some two hundred works made since 1880 is bound to comprise a highly selective account of the stories of modern art. This account concentrates upon, and offers a reasonably full account of, art from Post-Impressionism through and just beyond Minimalism. But it is neither comprehensive nor fully representative in its account: in the first place because it is substantially a selection of paintings and sculptures, with the exception of only an occasional work on paper. No such selection can be fully representative of movements like Dada in which works on paper were so important. For this reason, we represented only Dada in New York. Moreover, in the development of the Museum's collection, certain movements to which both paintings and works on paper were important were first represented through the latter—and in the case of some movements have still not gained full representation in the former. This is one of the reasons that *Die Brücke* is unrepresented here.

The overall focus, on European art before World War II and on North American art afterwards, is not entirely accurate to the composition of the Museum's collection, especially with respect to contemporary art, but that has historically been the bias of the collection, so we adopted it. Within that conception, though, the presentation in depth of important artists meant having to exclude others whom we would ideally have included; the cogency of the whole meant avoiding merely token representation. And, because this publication is designed to accompany and record a traveling exhibition, the fragility (sometimes the size and on rare occasions the restriction against loan) of certain works in the collection precluded their inclusion, which again meant, at times, that certain artists had to be excluded. All this said, though, the roster of great masterworks and their necessary complements afford more than a fair representation, in their eight parts, of an unrivalled collection and more than a century of modern art.

In titling these eight parts, we have used the names of appropriate Museum of Modern Art exhibitions. However, for the convenience of readers we have divided the parts into subsections and given them the more familiar names of art-historical movements, artists, or geographical, national, or temporal sites of production.

Part One, **Modern Starts**, takes its name from the first of the Museum's end-of-century exhibitions of 1999–2000, which reexamined, in this case, works from the collection that composed the multiple pathways that started modernism. In the present publication, four such early areas are isolated. The first, *Post-Impressionism*, contains works by the four artists who were the subject of the Museum's very first loan exhibition, in 1929, namely, Paul Cézanne, Georges Seurat, Vincent van Gogh, and Paul Gauguin. This is followed by sections devoted to *Symbolism*, including works by James Ensor and Edvard Munch, to *Fauvism*, and, finally, *Later Symbolist Currents*, which includes environmental works of 1914 and 1920 by Vasily Kandinsky and Claude Monet, respectively. In the main, this part draws on the relatively small, late-nineteenth-century section of the collection, which, as we shall see later, was where the collection in fact began.

Part Two, **Matisse Picasso**, is named for another recent exhibition, which took place at the Museum in 2003, and features works by the two artists, Henri Matisse and Pablo

Picasso, who have been the subject of more exhibitions than any other artists at the Museum, and collected as assiduously as any.

Part Three, **Cubism and Abstract Art**, is named for the first of Barr's great encyclopedic exhibitions, held in 1936, that laid out the historical framework of modernism. In this part of the publication, whose size reflects the attention paid to this area in the Museum's collection, we focus on seven of the subjects considered by Barr's exhibition. *Cubism*, with works by Picasso, Georges Braque, and five other Cubist painters, is followed by *Futurism*, then by *Brancusi*, a selection of sculptures by Constantin Brancusi. The fourth section is devoted to *Russia and the Bauhaus*, namely, Suprematist and Constructivist paintings and reliefs by Kazimir Malevich, Aleksandr Rodchenko, and others, and the fifth to *De Stijl*, paintings by Piet Mondrian and Theo van Doesburg. The sixth is titled *Four Abstract Artists*, a selection of later, abstract painting and reliefs by artists including Sophie Taeuber-Arp, George L. K. Morris, and others, and finally *Four American Modernists*, works by Stuart Davis and other artists influenced by geometric abstraction but with a descriptive content.

Part Four, **Fantastic Art, Dada, Surrealism**, takes its name from the second of Barr's historical survey exhibitions, of 1936–37. Also a large part, again reflecting its attention in the Museum's collection, it comprises five sections. The first two sections are devoted to *New York Dada* in the work of Marcel Duchamp and his colleagues and to *Two Fantasts*, as Barr named them, Giorgio de Chirico and Paul Klee. Then come three sections devoted to the three main typological branches of Surrealism: *Surrealist Dream Images*, paintings by Salvador Dali and others; *Abstract Surrealism*, works by artists including Jean Arp and Joan Miró; and *Surrealist Sculpture*, a catholic selection of works from Meret Oppenheim to Alberto Giacometti and Joseph Cornell to Louise Bourgeois.

Part Five, **New Images of Man**, is named after an exhibition of 1959, which readdressed figurative identity in a period of abstraction. This part focuses on two areas. First, *Early Figurative Sculpture* represents works from Auguste Rodin and Aristide Maillol to Gaston Lachaise and Picasso. Second, *Figurative Painting Between the Wars* includes artists as varied as Max Beckmann and Amedeo Modigliani, Pierre Bonnard, and Edward Hopper. This part thus mainly focuses on figuration made outside the avant-garde of Fauvism, Cubism, and Surrealism—either before these developments existed or outside their immediate orbits. Their separation in this part of the publication reflects the difficulty of their assimilation into a collection devoted to the innovative moment. But works of this sort—and of a perhaps surprising quality and quantity—appear in the collection, nonetheless, affording a critique of its avant-gardism.

Part Six, **The New American Painting**, is named after the Museum exhibition that toured eight countries in 1958–59 and, more than any other exhibition, introduced Abstract Expressionist and post-Abstract Expressionist American art to Europe. Here, the Abstract Expressionist works are arranged in three sections. *Gorky and de Kooning* focuses on early figurative-derived works by Arshile Gorky and Willem de Kooning. *Abstraction Expressionist Field Painting* concentrates on the classic field paintings of Jackson Pollock, Barnett Newman, and their associates. *Abstract Expressionism: Image and Gesture* includes works by artists from Franz Kline to Robert Motherwell. These

are followed by *After Abstract Expressionism*, color field paintings by Helen Frankenthaler and Morris Louis; *Proto-Pop Art*, works by Jasper Johns and Robert Rauschenberg; and *Geometric Abstraction*, compositions by Ellsworth Kelly and Alejandro Otero.

Part Seven, **The Art of the Real**, is named after another traveling exhibition, this one of 1968 and dedicated to Minimalism and related currents. The first section, *Pop Art*, contains works by six American Pop artists from Jim Dine to Andy Warhol. This is followed by *Abstract and Minimalist Painting*, works by artists from Frank Stella to Robert Ryman; *Minimalist Sculpture*, works by six sculptors including Donald Judd and Sol LeWitt; and *Post (and non)-Minimalism*, works of the 1960s by artists from Lee Bontecou to Eva Hesse.

Part Eight, **Open Ends**, takes its name from the third and final aforementioned end-of-century exhibition, whose title was meant to connote the continuing open-endedness of modern art. This section is, effectively, a coda to the exhibition. It seemed both presumptuous and unrealistic to attempt to present for recent art the same kind of synthetic overview offered for the earlier periods, and certainly impossible to do justice to recent art while holding its representation to roughly the same number of works per decade as for decades before 1970. Moreover, because the selection is essentially limited to paintings and sculptures, it could hardly offer a representative survey of a contemporary art in which these mediums are no longer privileged as they once were, but coexist with installation, video, and media art. And finally, and most importantly, since recent art is more widely disseminated than earlier art, it seemed inappropriate to offer token, nominal representation of artists whose works are to be found in many other museums and galleries. This is why we selected two important and influential groups of works in the Museum's collection, by Philip Guston and Gerhard Richter, to represent painting in the 1970s and 1980s, and, therefore, the persistence of the medium that dominates modern art since 1880 and this exhibition.

2. Making Choices: Barr and After

I said earlier that, if there was a bias in Barr's acquisitions, it was in favor of paintings and sculptures of high quality that were also of crucial historical importance in the development of modern art. Hence his determination to shift the collection from its original late-nineteenth-century emphasis, brought about by the composition of the Lillie P. Bliss Bequest of 1934 that effectively established the collection, and to acquire major examples of pioneering modern styles. In 1934, by the end of the Museum's first five years, half the collection comprised nineteenth-century works, and the twentieth-century holdings, though some were of high quality, were essentially conservative. By the end of the first decade, with the help of generous purchase funds, principally from Mrs. Simon Guggenheim and Mrs. John D. (Abby Aldrich) Rockefeller, Jr., and with the latter's gift of her own collection in 1935, the balance had substantially changed in favor of the twentieth century with most of the important modern artists and movements at least represented, some by major works. (Henri Rousseau's *Sleeping Gypsy* of 1897 and Giacometti's *Palace at 4 A.M.* of 1932–33 entered the collection in the late 1930s.) Moreover, the basis of what was to become the most complete and important Picasso

collection in any public museum had been established with the acquisition in the late 1930s of *Les Demoiselles d'Avignon* (1907), *The Studio* (1927–28; page 86), and *Girl Before a Mirror* (1932; page 87).

Barr was once described as "the most powerful tastemaker in American art today and probably in the world"; to this he replied that he was a "reluctant" tastemaker, for he did not believe that it was a museum's primary task to discover the new, but to move at a discreet distance behind developing art, not trying to create movements or reputations but putting things together as their contours begin to clarify.* These principles continue to be followed today, as are Barr's refreshingly straightforward and realistic criteria for the acquisition of recent art: that mistakes of commission are more easily remedied than mistakes of omission. In Barr's view, the exhibited collection is "the authoritative indication of what the Museum stands for." With this as its base, the temporary exhibitions the Museum organizes can be "adventurous (and adventitious) sorties" into less charted areas. In fact, Barr organized not only such adventurous exhibitions but also clearly historical ones. The latter were intended to complement the holdings of the Museum Collection and to serve the very useful purpose of discovering potential acquisitions to fill lacunae in the historical collection, just as exhibitions of the former kind led acquisitions of newer art.

More important, however, than works acquired from Museum-organized exhibitions have been the series of gifts and bequests that Barr brought to the Museum. After the initial period of expansion, the war years of 1940 to 1946 saw a decline in purchase funds. Nevertheless, certain crucial masterpieces were added as gifts to the collection in the early 1940s, including the first of Beckmann's triptychs, *Departure* (1932–33; pages 208–09), and Mondrian's last completed work, *Broadway Boogie Woogie* (1942–43), while van Gogh's *The Starry Night* (1889; page 44) was obtained through the exchange of works from the Bliss Bequest. Also, the Inter-American Fund was established for the purchase of Latin American art. It was only in the postwar period, between 1947 and 1959, that Barr saw the collection approaching the status he desired for it. The Cubist, Surrealist, and abstractionist collections continued to grow. A great Matisse collection was taking shape in the late 1940s and 1950s with the acquisition of *The Piano Lesson* (1916), *The Red Studio* (1911), and *The Back* series of reliefs, all from Mrs. Simon Guggenheim's funds, and the gift of *The Moroccans* (1915–16; page 76) from Mr. and Mrs. Samuel A. Marx in 1955. Subsequently, a gift of *The Dance* (1909; page 71) from Nelson A. Rockefeller in 1963 and life-interest gifts in 1964 of major Matisses from what had become the Schoenborn-Marx collection made the Matisse holdings equal in importance for the Museum to those by Picasso. Additionally, the Katherine Dreier Bequest in 1953 brought important Duchamps to the Museum, and a collection of Abstract Expressionist painting was established, although not without opposition from some of the Museum's Trustees.

This dramatic growth brought with it crucial problems of space. These had dogged the Museum from its beginning. Indeed, Barr had insisted that lack of space had proven a more severe handicap to the collection than lack of funds, and he had led the Museum in four different premises in its first ten years. Only in 1945–46, in its building at 11 West 53 Street, designed in 1939 by Goodwin and Stone, was the collection first

shown in depth, and then only fifteen per cent of the paintings and sculptures in the collection were exhibited, approximately the same percentage as is seen now. That exhibition, however, was but a temporary one, and not until the newly enlarged building was opened in 1964 did the collection find a permanent place on the second and third floors.

The expanded space was certainly required. Between 1958 and 1963, major new gifts had come to the Museum: the Larry Aldrich Fund for the purchase of recent art, the Kay Sage Tanguy Bequest of Surrealist works, the Mrs. David M. Levy Bequest of European master paintings, the promised gift of the James Thrall Soby Collection, the bequest of works from Philip L. Goodwin's collection, and the gift of two late Monets (*Water Lilies*, c. 1920; pages 54–55), both of mural scale, from Mrs. Simon Guggenheim, which were installed in a special gallery bearing her name. To these were added, between 1963 and 1967, among other important works, immediate and promised gifts from two Trustees—Louise Reinhardt Smith's gifts of European masterpieces and Philip Johnson's gifts of recent art, part of a succession of generous gifts from Philip Johnson, who was one of the earliest donors to the collection—and a donation from Alexander Calder of a large group of his own sculptures. In this period the Museum also received important gifts from William S. Paley and William A. M. Burden, among others.

Although Barr's role in building the Museum Collection was of the first importance, he was by no means alone in his work but benefited from the help and support of many colleagues. Chief among these were James Thrall Soby, since 1940 an active and generous participant in the Museum's development; Dorothy C. Miller, Curator from 1935 to 1969; René d'Harnoncourt, Director of the Museum from 1949 to 1968; James Johnson Sweeney, particularly important in the Museum's early years; and William S. Lieberman, Peter Selz, and William C. Seitz in the later years. In 1967, Barr retired from the Museum. The same year, James Thrall Soby left the Chairmanship of the Committee on the Museum Collections and the Committee itself was dissolved, to be divided into separate units, one for each curatorial department. In 1968, d'Harnoncourt also retired, and Miller retired the year after. With these changes of staff, The Museum of Modern Art reached its fortieth anniversary in a period of major transition.

Barr, as first Director of the Museum and then Director of its Museum Collections, had ultimate responsibility for all of the Museum's collections. After Barr's retirement and the division of the Committee on the Museum Collections, the Department of Painting and Sculpture came into its own as a distinct, separate unit. Thus began the second, still continuing period of collecting and exhibiting painting and sculpture at The Museum of Modern Art. From 1971 to 1988, William Rubin was Director of the Department of Painting and Sculpture, and from 1988 to 2001, Kirk Varnedoe. As this volume was going to press, the author of this introduction was appointed to that position.

In 1930, when Barr unsuccessfully proposed to the Trustees that a room be provided for showing the collection, it comprised only thirteen paintings and sculptures. When Rubin assumed directorship of the Department of Painting and Sculpture in 1971, the collection numbered some 2,500 works. Under Rubin's tenure, it would be refined and enlarged in numerous ways.

Between Barr's retirement in 1967 and Rubin's assumption of the directorship of the Painting and Sculpture Department in 1971, a bequest of the Sidney and Harriet Janis Collection served to strengthen and balance the Museum's survey of modern art, most notably with Umberto Boccioni's *Dynamism of a Soccer Player* (1913; page 123), Mondrian's *Composition with Color Planes, V* (1917; page 132), Klee's *Actor's Mask* (1924; page 168), and Dali's *Illumined Pleasures* (1929; page 173) to name but a few examples. The bequest also introduced Abstract Expressionism into the permanent collection with the work of Gorky, Kline, Pollock, and de Kooning.

Prior to his appointment as director, Rubin had seized the opportunity to assemble an unprecedented representation of New York School paintings with the purchase in 1968 of Pollock's *One (Number 31, 1950)* and the acquisition of Newman's *Vir Heroicus Sublimis* (1950–51) in 1969, complimented by contemporaneous gifts from Mark Rothko, Ad Reinhardt, Adolph Gottlieb, and Robert Motherwell. Also in 1969 there were acquisitions of the principal successors to Abstract Expressionism. These included Kelly's *Colors for a Large Wall* (1951; page 262), Cy Twombly's *The Italians* (1961; page 261), and Carl Andre's *144 Lead Square* (1969; page 292). Likewise, Philip Johnson's gifts of the 1970s offered pioneering representation of Minimalism and Pop art, notably Agnes Martin's *Red Bird* (1964; page 286), Rauschenberg's *First Landing Jump* (1961), and Johns's *Flag* (1954–55).

While keeping apace of contemporary developments, the Museum's stellar Picasso collection was continuing to take shape with the Janis bequest of *Painter and His Model* (1928) that complemented *Three Musicians* (1921), which had been acquired in 1949 through the Mrs. Simon Guggenheim Fund. In 1971 Picasso donated to the Museum his pivotal metal construction *Guitar* of 1912–13. The same year William S. Paley gave *The Architect's Table* (1912), and the Museum purchased Picasso's *The Charnel House* (1945)—the so-called sequel to *Guernica* that had been on loan to the Museum since 1939 (it was returned to Spain in 1981 according to the artist's wishes). The long-promised Nelson A. Rockefeller Bequest, which entered the collection in 1979, included the early Cubist works *Girl with a Mandolin (Fanny Tellier)* (1910; page 82) as well as the *papier collé Student with Pipe* (1913) complemented by Braque's collage *Still Life with Tenora* (1913; page 114).

Also in 1979, the Museum acquired superb early modern masterworks through the generosity of James Thrall Soby. His bequest of de Chirico's Metaphysical paintings included *The Enigma of a Day* (1914; page 166), a prelude to the fine Surrealist works distinguished by Dali's *Debris of an Automobile Giving Birth to a Blind Horse Biting a Telephone* (1938) and Miró's *Still Life with Old Shoe* (1937), given by Soby in 1969. Indeed, the many fine Mirós in the bequest supplemented Nelson A. Rockefeller's 1976 gift of *Hirondelle/Amour* (1933–34; page 174) and Rubin's 1972 critical purchase of the artist's *The Birth of the World* (1925). Shortly after, Lee Krasner's 1980 gift of early Pollocks and the simultaneous purchase of *Stenographic Figure* (1942) provided strong representation of the significant influence of Surrealism on the artist prior to his heroic Abstract Expressionist years.

While the bequests and gifts of the 1970s began to provide a cohesive narrative of modern art, Rubin made several important acquisitions during the decade to enrich

notable absences in the collection. Among the most critical were Munch's *The Storm* (1893; page 47), Gustav Klimt's late Symbolist painting *Hope, II* (1907–08; page 48), and Matisse's cutout *The Swimming Pool* (1952–53). While Stella's *The Marriage of Reason and Squalor, II* (1959; page 284), purchased during Barr's tenure, demonstrated the anticipation of 1960s machine-made Minimalist art, the 1978 gift of Stella's *Empress of India* (1965), along with the timely purchase of Minimalist sculptures by Tony Smith, Sol LeWitt, Anthony Caro, Eva Hesse, Robert Morris, and Richard Serra, formed an early and rather complete representation of the period. In 1979 Rubin also strengthened the Museum's holdings of Russian Constructivism with Gustav Klucis's *Maquette for Radio-Announcer* (1922) and the later acquisition of Aleksandr Rodchenko's *Oval Hanging Construction Number 12* (c. 1920)—works responsive to new technologies and intended to encourage new social forms.

Shortly after, through the mediation of John Elderfield, then Director of the Department of Drawings, the 1983 Riklis/McCrory Corporation gift of 249 works of geometric abstract art, including László Moholy-Nagy's *Q 1 Suprematistic* (1923; page 131) and Ivan Puni's *Suprematist Relief-Sculpture* (1915; page 129), not only bolstered Rubin's previous purchases but encouraged a reappraisal of the Russian avant-garde and its influences on later abstraction as demonstrated by Sophie Taeuber-Arp's *Composition of Circles and Overlapping Angles* (1930; page 136) and George L. K. Morris's *Rotary Motion* (1935; page 137), also included in the collection. This substantial acquisition of pioneering abstraction was augmented the same year by the acquisition (by exchange with the Guggenheim Museum) of the final two panels to complete Kandinsky's ensemble of four paintings created for Edwin R. Campbell's New York apartment in 1914 (pages 52–53).

In 1988, Kirk Varnedoe succeeded Rubin as Director of the Department of Painting and Sculpture. He was able to complement a now rather cohesive and nuanced representation of modern art with several significant purchases, initiated in 1989 with van Gogh's important *Portrait of Joseph Roulin* (1889). Leo Castelli's 1989 gift in Barr's honor of Rauschenberg's *Bed* (1955) was later enhanced, in 1999, toward the end of Varnedoe's tenure, by the purchase of *Factum II* (1957) and *Untitled (Ashville Citizen)* (c. 1952; page 256). The expansion of the Museum's gallery space in the late 1980s afforded the opportunity to acquire large works such as James Rosenquist's *F-111* (1964–65), Kelly's *Sculpture for a Large Wall* (1957), and Serra's monumental *Intersection II* (1992).

While the art-market boom of the 1980s and 1990s may have slowed the pace of major purchases, the 1990s were graced by a series of pivotal bequests from individuals who had played key roles in the founding and administration of the Museum. William S. Paley, who had served as trustee, president, and chairman between 1937 and 1985, presented his collection of early modernism to the Museum in 1991. It included Matisse's *Woman with a Veil* (1927; page 77) as well as important Cézannes and a Gauguin that filled lacunae in those artists' representation. Florene May Schoenborn's 1996 bequest was also distinguished by early modernist paintings, most notably Bonnard's *Nude in Bathroom* (1932; page 210). The 1998 bequest of Mrs. John Hay Whitney, who had been central to the pioneering effort of the Museum, included van Gogh's *The Olive Trees* (1889; page 44), an important companion to the Museum's *The Starry*

Night. In like manner, the bequests of Mary Sisler and Louise Reinhardt Smith—distinguished respectively by Stuart Davis's *Odol* (1924; page 138) and by Picasso's early *Bather* (1908–09; page 81), among other pivotal works—served to strengthen and in many respects seal the permanent collection of early modern art, permitting a sharpened focus to be devoted to contemporary trends.

The commitment to expanding the Museum's collection of later-twentieth-century art was aided by a series of major gifts and the redirection of acquisition funds. Supplementing the museum's strong holdings of Philip Guston's gestural work, Musa Guston's 1992 bequest ensured the largest representation of the artist's oeuvre. The UBS PaineWebber gifts of 1992 together with the 1996 donation of the Werner and Elaine Dannheisser Collection provided an international mix of late Conceptual and Minimal art that decisively improved the Museum's post-1960 representation with works by Matthew Barney, Robert Gober, Felix Gonzalez-Torres, Jeff Koons, Annette Messager, Bruce Nauman, and Sigmar Polke among others. This influx of contemporary art was augmented during Varnedoe's tenure as Chief Curator with the commitment of all available funds to the purchase of works by younger artists with the belief, as he articulated, that "new art is the ideal way constantly to reassess and understand anew the nature of the diverse potentials those earlier masterworks added to the expanding field of modern expression." This idea of the present in concert with the past was particularly realized with the Museum's important purchase of Gerhard Richter's *October 18, 1977* cycle (1988; pages 312–23), a work responding to particular episodes in German history yet equally informed by aesthetic concerns that had preoccupied early modernists.

The additions to the collection made by Rubin and then Varnedoe necessarily exacerbated the problem of showing these works. Barr's original concept of a comprehensive modern collection, always visible to the public, came closer to realization in the enlarged building of 1964 than it had previously, but even then Barr recognized that space would be inadequate for the future—especially when the many important promised gifts he had obtained eventually passed into the collection. Thus, further expansion was understood to be necessary. In 1984, a major expansion was concluded, designed by Cesar Pelli, which roughly doubled the space allocated to the painting and sculpture collection, and with it a more extensive installation, by Rubin, of that collection than any earlier one. Varnedoe would reshape that installation in 1993, but it was already then becoming obvious that growth of the collection made it necessary to expand yet again.

This initiative resulted in the about-to-be-realized building by Yoshio Tanaguchi. However, in the development of the program for this building, two important things were finally acknowledged. First, that all previous expansions had been incremental additions to an existing building—and an existing concept of installation—whereas what was now needed was a new concept of installation for a newly conceived building. And second, that if the collection were to continue to grow, there would never be a situation when all of it could be on view at one time; indeed, when all of its most valued works could be on view at one time.

From these twin acknowledgments have derived the two principles on which the new galleries are to be installed: first, to maintain a core display of the great master-

works that visitors to the Museum reasonably expect to see, as a synoptic overview of the development of modern art since 1880; second, to allow for more frequent re-installation of selected galleries in that sequence to provide opportunities to see changing arrangements of other paintings and sculptures—and, at times and in places, of works in all mediums—that complement and inflect the more fixed display. A large percentage of the two hundred works illustrated in this publication will find their way into this display; therefore, this publication, and the exhibition it accompanies, offers the core of what will be seen in the new Museum of Modern Art.

This publication surrounds these two hundred works with the words that the Museum's curators, past and present, have written about them. Adding words to objects—to make the unfamiliar familiar and the familiar unfamiliar—has been, and will continue to be, a primary curatorial function at The Museum of Modern Art. But it is worth remembering what Barr wrote in 1934, in the introduction to *Modern Works of Art: Fifth Anniversary Exhibition*. He stressed how the most profound experiential moments are fundamentally wordless occasions: "Words about art may help explain techniques, remove prejudices, clarify relationships, suggest sequences and attack habitual resentments through the back door of the intelligence. But the front door of understanding is through experience of the work itself."

* The discussion of the acquisition of works under Alfred Barr's tenure until his retirement, in the second part of this text, is adopted from the text written by the present author as Richard E. Oldenburg's foreword to *Painting and Sculpture in The Museum of Modern Art 1929–1967*, published by the Museum in 1977. The discussion of acquisitions of works under William Rubin's and Kirk Varnedoe's tenure, which follows, is indebted to Sarah Ganz.

Texts and Plates

Note to the Reader: In the texts that follow, titles of publications are given in abbreviated form. Full citations appear in the bibliography, pages 330–33. Notes to the texts are on pages 325–29. The texts appear exactly as published and have not been amended to conform to a consistent style of punctuation or capitalization.

Modern Starts

The loan exhibition *Cézanne, Gauguin, Seurat, van Gogh*, installed in the Heckscher Building at 730 Fifth Avenue, inaugurated The Museum of Modern Art in 1929. In stark contrast to European precedents and the proclivity for emulating such traditions found in most American museums at the time, the works were hung at eye level on neutral walls rather than skied against silk-lined galleries, deliberately articulating a decidedly modernist, even democratic, aesthetic to introduce these four modern masters to the American public.

The exhibition catalogue, written by Director Alfred H. Barr, Jr., demonstrated what would become his signature style, plotting works in the teleology of modernism that consisted of a series of formal achievements leading toward abstraction. Although he did not espouse the catchy 1910 label "Post-Impressionism" coined by the English critic Roger Fry, Barr similarly presented Cézanne, Gauguin, Seurat, and van Gogh as imbuing the work of the prior generation with more formal and metaphysical girth, coherent harbingers of the artistic revolutions of the twentieth century.

Barr suggests that Cézanne's innovations are "comparable in extent to that of Giotto, Roger van der Weyden, Donatello or Michelangelo." Yet, it was by challenging this very pictorial tradition, with its insistence on illusionism, that Cézanne would provide a model for Cubism—his primary significance for Barr: "Had not Cézanne remarked that the fundamental forms of nature were the sphere, the cone and the cylinder? The earliest phase of cubism is but a step beyond." Cézanne sought to make Impressionism's transient forms concrete by challenging the traditional conception of an image as a window onto another world in favor of flat planes and the immediacy of the canvas surface. In like manner, Seurat's scientific method aimed to ground Impressionism's interest in the ephemeral and fleeting. For Barr, Seurat's pointillist method had implications for Fauvism, while his strong design and Neoclassicism encouraged the Cubists.

Both Barr and the art historian John Rewald, in the latter's book *Post-Impressionism: From van Gogh to Gauguin* (1978), approach van Gogh through biography, emphasizing psychological torment as both the impetus and consequence of genius. Van Gogh, "the artist, the seer, the mystic," ultimately becomes victim to his own biography that masks the artist's rather conscious aim to create a painting of consolation and enchantment, an antidote to the ailments of modernity—alienation, disenfranchisement, urbanism. Assiduously tracing cause and effect, Barr places van Gogh's posterity in the North, admitting that although he "tried to be a French painter . . . it is the North [Holland] that has done him justice." Thus, style is fundamentally the expression of national essence, or a northern versus southern sensibility: "In Germany . . . the 'expressionists' . . . owe more to van Gogh than to any other inspiration. Van Gogh is in fact the archetype of *expressionism*, of the cult of pure uncensored spontaneity."

While van Gogh begets German Expressionism, it is the Fauves who "carried Gauguin's emancipating ideas far beyond the limits which Gauguin himself had reached," according to Barr. William Rubin's 1992 text provides a close reading of Gauguin's strategies and sources in constructing a primitive Arcadia where the inhibitions of European society are shown to be artificial creations. Rejecting naturalistic color and illusionism, Gauguin suggests a utopia of geographical and cultural distance. For Rubin this deviance bespeaks originality, the telling symptom of genius.

The scope of painting—its subjects and sensations—was dramatically expanded as the Symbolists, following the example of van Gogh and Gauguin, renounced the faithful allegiance to motif to give visible form to underlying emotion. Art historian Libby Tannenbaum, John Elderfield, and Kirk Varnedoe, in their respective texts in this section, acknowledge the French Symbolist precedent in their examinations of James Ensor, Edvard Munch, and Gustav Klimt, but suggest that the subordination of objective representation for subjective expression is not the sole impetus for these at once highly personal and extremely accessible figurative representations. The Northern Romantic tradition, with its existentialist penchant for penetrating emotion, informs these artists' poignant probing of moderism's underside—its questionable, tumultuous, often sinister repercussions. A tenuous balance between stasis and collapse is maintained as Klimt's impregnated woman is haunted by the specter of fatality (page 48), Ensor's carnival revelers double as masked allegories of death (page 46), while Munch's woman in white suggests an internalized tempest as much as the meteorological one surrounding her (page 47). In like manner, Henri Rousseau's *The Dream* is at once the materialization of the model's reverie and a projection of the artist's own desire (page 49).

Fauvism, championed as the first vanguard movement of the twentieth century, was born through exhibition. The Museum of Modern Art's 1952 exhibition *Les Fauves* was in keeping with the predilection for shows devoted to the group which consistently emphasized Fauvism as a cohesive enterprise to push painting beyond the distortion of form permitted by Symbolist theories. Yet, as John Elderfield suggests in his catalogue accompanying the 1976 exhibition *The "Wild Beasts": Fauvism and Its Affinities*, unlike later avant-garde movements, Fauvism did not pronounce theories or propagate a consistent style. The vigorous manner in which Henri Matisse and André Derain began to record the effect of light on the Mediterranean coastal town of Collioure in the summer of 1905 challenged the limits of painting with "a belief in both individual and pictorial autonomy" (see page 50).

Such hard-won "pictorial autonomy" may have suggested the liberation of painting, but with the latitude to be flat, rapidly executed, and without illusionism, a sense of distance between image and audience was introduced. The spatial control that an image beholden to perspective, modeling, and narrative had on the viewer was forfeited on behalf of unhampered expression. Independently of one another and from opposing aesthetic trajectories, Vasily Kandinsky and Claude Monet confronted this predicament of painting. Perceiving the modern dilemma as a persistent struggle between the material and the spiritual, Kandinsky's "nonobjective" painting, as author Werner Haftmann describes it in the exhibition catalogue *German Art of the Twentieth Century* (1957), suggested the least connection with material reality, offering the viewer a sense of solace or transcendence. Conversely, Monet, the quintessential Impressionist, was committed to the depiction of material reality meditatively registering the ever-changing effect of light on nature.

Monet's *Water Lilies* (pages 54, 55), like Kandinsky's *Panels for Edwin R. Campbell* (pages 52, 53), envelops the viewer, evoking the concept of *Gesamtkunstwerke* (complete work of art) as advocated by the Symbolists. Applied to painting, this concept transcends the notion of the two-dimensional canvas, which can only allude to three-dimensional space, and permits painting to physically construct an embracing halcyon environment. For Barr in 1929, Kandinsky was the "first 'abstract' expressionist" before the fact. Similarly, William Seitz described Monet in his 1960 catalogue *Claude Monet: Seasons and Moments* as "concerned with 'unknown' as well as apparent realities." His text, informed by contemporary art-historical discourse on Abstract Expressionism, suggests that Monet's most intimate communion with nature, which had "always appeared mysterious, infinite, and unpredictable," was ultimately realized through abstraction.

— *Sarah Ganz*

Post-Impressionism

Alfred H. Barr, Jr., *The Museum of Modern Art: First Loan Exhibition, New York, November 1929: Cézanne, Gauguin, Seurat, van Gogh,* **1929,** pages 11, 12, 14, 15, 16, 20, 21, 22, 23, 24, 26, 27

By the painters of the first quarter of the 20th century, four men of previous generations were especially honored as pioneers who founded new traditions and, more important perhaps, rediscovered old ones.

They are [Paul] Cézanne and [Georges-Pierre] Seurat, [Paul] Gauguin and [Vincent] van Gogh.

Cézanne and Gauguin died about 1905, Seurat and van Gogh about 1890, almost forty years ago. Yet so revolutionary are certain aspects of their work that it is still subject to misunderstanding and, for a recalcitrant few, battleground of controversy.

All four had one element in common—Impressionism as a point of departure, as a background from which their individual attitudes emerged. Since late medieval times painters had been stimulated and seduced by various problems in the "realistic" imitations of nature. Anatomy, the appearance, structure, and movement of the human body, making painted forms round by sculpturesque modeling in light and shade, giving the illusion of space by perspective, each of these scientific problems was solved by groups of research specialists. The impressionists . . . were specialists in the problem of outdoor lighting and, like that of their predecessors in science, their art was unbalanced, eccentric in relation to the great "central" tradition of European painting. For in their eager effort to represent the shimmer of sunlight they lost interest in definite convincing forms, in arrangement and composition, as well as in all dramatic and psychological values. . . .

During the early eighties Cézanne, Seurat and Gauguin and a little later van Gogh, worked in the Impressionist manner. But before 1890 all four had come out of the Impressionist blind-alley, though by very different paths. Cézanne and Seurat gradually modified Impressionism but Gauguin and van Gogh rebelled against it far more suddenly and overtly. It is not surprising therefore that their heresies, more conspicuous and more easily understood, should have become powerful influences considerably before the subtle and profound discoveries of Cézanne and Seurat. . . .

Subject matter, "human interest," was of considerable importance to Gauguin. Whoever looks at his work as mere decoration or experiment in "form" sadly misconstrues the intention of the painter. . . .

[August] Strindberg wrote of Gauguin: "Who then is he? He is Gauguin the wild man . . . the titan who, jealous of his creator, knocks together a little creation of his own at odd moments; a child who destroys his toys to make new ones of the fragments; a man who challenges ordinary opinion, who prefers to paint the sky red instead of blue." But Gauguin wrote of himself: "I have escaped from the false and have entered into Nature confident that tomorrow will be as free and as lovely as today. Peace wells up within me."

As early as 1890 Gauguin gained an important place among the progressive younger painters of the period. . . . [Maurice] Denis writes: "Gauguin freed us from all the restraints which the idea of copying nature had placed upon us. For instance, if it was permissible to use vermilion in painting a tree which seemed reddish . . . why not stress even to the point of deformation the curve of a beautiful shoulder or conventionalize the symmetry of a bough unmoved by breath of air? Now we understood everything in the Louvre, the Primitives, Rubens, Veronese."

This is of the greatest importance, for it is one of the earliest deliberate statements of an attitude which has dominated painting during the last thirty years. . . .

Vincent van Gogh had neither the intelligence nor the hardihood of his friend Gauguin. He was passionately single-minded, a fanatic whether in love, religion, or art. His pathetically tragic life is too well known to need recounting. "To what end can I be put? What purpose can I serve? There is some power within me but I know not what it is.". . .

Under the burning sun of Provence he at last discovered himself. For six months during the summer of '88 he worked continuously with the most violent energy. He painted in bold unbroken patches of scarlet, startling greens and yellow. His brush swirled and leapt in staccato rhythms as if he found joy in the very action of his hand and wrist. . . . He sees with

such intolerable intensity that painting alone can give him release from his torment. Van Gogh the evangelist is transmuted into van Gogh the artist, the seer, the mystic, apprehending, making visible the inner life of things. . . .

From 1880 till his death in 1906 Cézanne saw his path lying clear before him. It was a synthesis of his baroque and Impressionist decades. Twice he defined his program: "We must make of Impressionism something solid like the art of the museums." And, again: "What we must do is to paint Poussin over again from nature." In these pregnant sentences he insists both upon the importance of tradition and the validity of contemporary discovery. . . .

With the exception of his early work and the sporadic *baignades* and *bacchanales* which appear during the '80's and '90's, Cézanne was purely a realist, that is, he depended entirely upon the look of things which he made no conscious effort to alter. But he looked not once as might, ideally, an Impressionist but a thousand times. . . .

Such was Cézanne's dependence upon the stimulation given him by the object—whether human, landscape, or the convenient apple. "One cannot be too scrupulous or too sincere or too submissive to nature; but one should be master of one's model and certainly of one's manner of expression.". . .

What did Cézanne really see in nature? Let him answer: "An optical sensation is produced in our eyes which makes us classify [grade] by light—half tones and quarter tones—each plane represented by a sensation of color." He gives us here the key to the technical understanding of his later work. Each plane of light in nature is represented on his canvas by a plane of color. If we examine a landscape, or a still life, we find the paint broken up into a series of small planes, each one of which, especially in the landscapes, is made up of several subtly graded parallel strokes and hatchings. By this technique which Cézanne developed only after twenty years of painting he "realized" what he modestly called his "petite sensation.". . .

While we study a Cézanne we can feel . . . [color] planes shifting forward and back, taking their appointed distances until after a time the painted world into which we are drawn becomes almost more actual than the real world. The grandeur of a Poussin is perceived, is read, remains as it were at arm's length. But a great Cézanne is immanent; it grows around one and includes one. The result is at times almost as hypnotic as listening to great music in which strength and order are overwhelmingly made real. . . .

Seurat's theory of art rested upon a very simple and purely formal aesthetic. He believed that the art of painting depended upon the relations between tones (lights and darks), colors, and lines, and on the harmony of these three elements. . . . He asserted that color in painting should consist only of "red and its complementary green, orange and blue, yellow and violet." He then proceeded to apply these six primary colors systematically in little round dots of equal size, thereby eliminating, theoretically at least, all trace of the personal "touch." He even painted the frames in such a way that their colors were complementary to the adjacent colors in the picture. . . .

Seurat was the inventor of a method, the constructor of a system without parallel in the history of art for its logical completeness. What other man, artist or layman, came so near realizing the 19th century illusion of possible perfection through science? But Seurat, the artist, was greater than Seurat, the scientist. In his work, from the least drawing to the most elaborate composition, great intelligence is complemented by consummate sensibility. . . .

Gauguin whose burning color and exotic sentiment conceal somber power; van Gogh the master—and victim—of spontaneous artistic combustion; Cézanne arriving by infinitely patient trial and error at conclusions which have changed the direction of the history of art; Seurat who proves that great art can proceed from cool exquisite calculation; here are four painters!

Paul Cézanne
Pines and Rocks. 1896–99
Illustrated on page 42

Theodore Reff, "Painting and Theory in the Final Decade" in *Cézanne: The Late Work,* **1977,** pages 13, 46, 47

"Painters must devote themselves entirely to the study of nature and try to produce pictures which will be an education," Cézanne wrote shortly before his death.[1] Yet he could hardly foresee how exemplary his own pictures would become: since then almost every major painter, even if less devoted to nature than he, has found in his work a source of instruction as well as inspiration. For [Paul] Klee he was "the teacher par excellence," for [Henri] Matisse "the father of us all," for [Pablo] Picasso "a mother who protects her children."[2] As is evident from their work, each of them responded to another aspect of Cézanne's complex and constantly evolving art, and the same is true of all those modern painters who, from [Paul] Gauguin in the 1880s to Jasper Johns eighty years later, have taken it as a model or ideal.

If, nevertheless, one period in Cézanne's long

development has been of special importance, it is surely the last one, comprehending the extraordinary changes that occurred in his work after 1895 and especially after 1900 and continued without interruption until his death in 1906. It is this phase which, although little understood or appreciated at the time, has so deeply impressed later artists, regardless of their own stylistic tendencies. For the Orphic Cubist [Robert] Delaunay, there was "in the last watercolors of Cézanne a remarkable limpidity tending to become a supernatural beauty beyond anything previously seen."[3] To the Purist [Amédée] Ozenfant, it was clear that "toward the end of his life [he] conceived painting as approximate to an effort of pure creation."[4] The Surrealist Marcel Jean found "the effect of mirror-light [seen in Stéphane Mallarmé] reappearing with Cézanne, especially in the [late] watercolors . . . prismatic universes crossed by jagged rainbows."[5] And the Abstract Expressionist Hans Hofmann saw in his last pictures "an enormous sense of volume, breathing, pulsating, expanding, contracting through his use of colors."[6] Thus Cézanne's late work is an essential part of the history of twentieth-century art. But more than that, it constitutes one of the greatest achievements this century's art has known thus far, one so rich and varied that it is still inadequately understood some seventy years later. . . .

In landscapes of the later nineties . . . Cézanne employs the familiar device of overlapping planes, clearly outlined and graded in color intensity, to create an illusion of space. He told [Karl Ernst] Osthaus that "the main thing in a picture is the effect of distance; the colors must reveal every interval in depth," and went on to "trace with his fingers the boundaries of the planes in his pictures, explaining precisely how far they succeeded in suggesting depth and where they failed."[7] . . .

In [a] letter of April 15, 1904, [to Émile Bernard] Cézanne also speaks of atmospheric perspective, of "the need to introduce into our light vibrations, represented by the reds and yellows, a sufficient amount of blueness to give the feel of air." The theme recurs in one of his last letters, where, in speaking of his "ideas and sensations," he exclaims, "long live the Goncourts, Pissarro and all those who have the impulse towards color, representing light and air."[8] But nowhere else does he mention his use of blue, which plays so prominent a part in suggesting mood as well as atmosphere in his landscapes of these years. In the *Pines and Rocks*, for example, a bright blue vibrates in the intervals between the reddish-brown trunks and branches, pulses amidst the equally vibrant green and yellow foliage, and merges imperceptibly with the pale gray sky, vividly conveying the circulation of air.

Cézanne
Le Château Noir. 1904–06
Illustrated on page 42

Theodore Reff, "Painting and Theory in the Final Decade" in *Cézanne: The Late Work*, **1977**, pages 25, 26

[Château Noir] had once been known as the Château du Diable, presumably because its former owner's alchemical demonstrations had frightened his provincial neighbors into imagining it was inhabited by the devil. (The name seems to have been popular, for it was also given to another house outside Aix.)[1] Visually, too, the Château Noir must have had a romantic appeal for Cézanne, not for its color, which was the yellow-orange of the Bidémus stone rather than black, but for its tall pointed windows of Gothic inspiration and its unfinished portions, which gave it the look of an abandoned ruin. In some of his views, it is seen through the densely overlapping branches of surrounding trees, their dark green and black enhancing its glowing orange tones, their complex, tangled shapes adding a note of agitated movement; in the deep orange facade, outlined in deep blue, the lighter blue windows shine mysteriously, and the Indian red door sounds a single note of passionateness. This restless, dramatic treatment of the surrounding trees is altogether different from their use as a structural device, a screen framing a distant view, in landscapes of the mid-eighties, though it is foreshadowed in one version of Mont Sainte-Victoire with a pine tree. By the late nineties, when these views of the Château Noir were painted, the interaction of branches and building has become so intricate that the whole surface is crisscrossed by brushstrokes moving in conflicting directions. The same taste for tangles of spiky lines appears in the drawing of the trees in a late picture of Mont Sainte-Victoire and in that of the onion stems in a contemporary still life. . . .

In addition to the house, the large estate of Château Noir, solitary and overgrown with heavy foliage, strewn with cut stones never used to complete its creator's grandiose scheme, offered Cézanne many congenial subjects in the late nineties. Pictorially, the circular form of an abandoned grinding wheel, the cylindrical form of the well, the long rectangular forms of masonry blocks provided an interesting foil to the roughness and irregularity of the rocks, trees, and foliage. With great subtlety [the

artist] distinguishes [the] different shapes and textures, arranging them, as it were, on a continuous scale from the geometric to the organic and forcing us to recognize their similarities as well as their differences. Thus the tree trunk begins to look as cylindrical as the well, and the cut stone block as angular and roughhewn as the boulder; and all are painted with the same flickering brushstroke and pervaded with the same brown and gray, orange and green tones. But the appeal of such a motif was more than purely pictorial: in the shadowy forest interior Cézanne found an intimate, solitary world for meditation, and in the almost chaotic profusion of forms, from which an order half natural and half human gradually emerges, a metaphor of his own mental process.

Georges-Pierre Seurat

Port-en-Bessin, Entrance to the Harbor. 1888
The Channel at Gravelines, Evening. 1890
Illustrated on page 43

Daniel Catton Rich, *Seurat: Paintings and Drawings,* **1958,** pages 15–16, 19, 20

Neo-impressionism might be defined as the light that failed. Its chief claim—based on certain laws of physics—was greater luminosity; actually the "division" of colors through dots and tiny strokes produced greys and neutrals that extinguished the very brilliance its artists desired. . . . The neo-impressionists, though acknowledging the contribution of the impressionists, found their predecessors careless and romantic. They disliked their fluid, dissolving vision, demanding a return to form and structure. They found pseudo-scientific formulas to justify their experiments, though like the impressionists, they employed the same subjects, landscapes and scenes of daily life. The new movement did accomplish one reform; carefully employed, its method created an effect of depth no impressionist could rival. This return to the third dimension from the impressionists' fleeting web of color and light was one of Seurat's chief contributions. . . .

While Seurat spent on the average of a year on each of his more ambitious compositions, which one by one seem to demonstrate the application of his theories, he objected to having them called pictures with a thesis. And almost every summer he left Paris to go to the coast of Brittany or Normandy "to wash," as he said "the studio light" from his eyes and "to transcribe most exactly the vivid outdoor clarity in all its nuances." During his lifetime Seurat's landscapes were often admired by those who refused to accept the daring stylizations of his larger canvases. They are deceptively simple and seem, at first glance, to be close to the impressionists in theme and effects of atmosphere. But upon further acquaintance they appear as original as his major works. Seurat often emphasized a wide, broad frontal plane; in some of his first landscapes this was made by a meadow beyond which, carefully simplified into geometric patterns, appear houses, roofs and a band of trees. He employed much the same plan for a number of his seascapes, where the sand or shore serves as a base and where in a series of horizontal planes, distant piers, ships or horizon again and again reinforce a mood of calm detachment. . . .

Seurat felt, to judge from reports by his contemporaries as well as from his own brief utterances, that he was applying with the invincible logic of the scientist, a series of optical principles to the making of works of art. Such consistency was part of his temperament; one must remember that he was rigidly trained in the strict, academic schools of the day, and when he discovered the laws of contemporary physics respecting color and light, he adopted them eagerly, substituting for the old worn out rules of picture-making the new rules of science. To the nineteenth century mind, science opened a door upon imagination and the creative future. Its promises were immense and many of the best artists of the century were vastly stimulated by the new vision of this expanding universe. In Seurat we have one of the first examples of the artist-scientist which was to become—in our century—a well-defined type. Seizing upon certain concepts of natural science, he is driven to continuous, unending experiment in the course of which he "explains" or rationalizes his point of view. Seurat, indeed, seemed to derive a certain aesthetic delight from the very practice of art *as* science.

Vincent van Gogh

The Starry Night. 1889
The Olive Trees. 1889
Illustrated on page 44

John Rewald, *Post-Impressionism: From van Gogh to Gauguin,* **1978,** pages 312, 321–22

In [a] letter the painter reported: "I did a landscape with olive trees and also a new study of a starry sky. Although I have not seen the last canvases painted by either [Paul] Gauguin or [Émile] Bernard, I am fairly convinced that these two studies which I just mentioned are done in a similar spirit [to theirs]. When you will have had these two studies before your eyes

for a certain time, as well as the one of ivy, then I may be able to give you a better idea than through words of the things that Gauguin, Bernard and I have sometimes discussed and that preoccupied us. This is not a return to the romantic or to religious ideas, no. Nevertheless, while deriving from Delacroix more than might appear, in color and through a draftsmanship that is more intentional than the exactness of *trompe-l'oeil*, one can express a rustic nature that is purer than the suburbs, the taverns of Paris. . . ."[1]

[Van Gogh's] *Starry Night*, with its sleeping houses, its fiery cypresses surging into a deep blue sky animated by whirlpools of yellow stars and the radiations of an orange moon, is a deliberate attempt to represent a vision of incredible urgency, to liberate himself from overpowering emotions rather than to study lovingly the peaceful aspects of nature round him. The same tendency and the same use of heavy outlines appear in several other paintings done at that time, particularly a landscape with silver-green olive trees in a rolling field with a range of undulating blue mountains in the background, over which hovers a solid white cloud. In a letter to his brother [Theo], van Gogh tried to explain what he had wanted to achieve: "The olive trees with the white cloud and the mountains behind, as well as the rise of the moon and the night effect, are exaggerations from the point of view of the general arrangement; the outlines are accentuated as in some of the old woodcuts." And he went on to say: "Where these lines are tight and purposeful, there begins the picture, even if it is exaggerated. This is a little bit what Bernard and Gauguin feel. They do not care at all about the exact form of a tree, but they do insist that one should be able to say whether its form is round or square—and, by God, they are right, exasperated as they are by the photographic and silly perfection of some painters. They won't ask for the exact color of mountains, but they will say: 'Damn it, those mountains, were they blue? Well then, make them blue and don't tell me that it was a blue a little bit like this or a little bit like that. They were blue, weren't they? Good—make them blue and that's all!'"[2]

Paul Gauguin
The Seed of the Areoi. 1892
Illustrated on page 45

William Rubin, *The William S. Paley Collection,* **1992,** pages 50, 53, 55

The painter's title [*Te aa no aerois*], which means the seed . . . of the Areoi—a Polynesian secret society that had disappeared long before Gauguin's stay in Tahiti—refers directly to the principal poetic symbol in the picture, the flowering seed that the young girl holds in her hand.[1] This motif stands for the procreative potential of the girl herself, less in her real-life role as Tehura, the painter's thirteen-year-old native mistress, than in the form Gauguin has imaginatively envisioned her: as Vaïraümati, the mythic earth-mother of the Areoi sect.[2]

. . . In his writings and statements, Gauguin led one to believe that he learned about . . . Maori legends directly from Tehura, thus implying that he was painting these subjects in the context of a living tradition.[3] But with one or two aged exceptions, to whom Gauguin did not have access, the last of the "storytellers" who knew these legends had died generations before Gauguin's trip to the Society Islands, and the old religions had long since been displaced by Christianity.[4] In fact, Gauguin discovered the myth not through personal contacts but in an early travel book he had borrowed, Jacques-Antoine Moerenhout's *Voyages aux îles du Grand Océan*—a text replete with mistaken accounts and anthropological errors. . . .

By painting Tehura as Vaïraümati, Gauguin implies that the way of life of the Tahitians of his day was still part of a continuous cultural cycle though, in fact, it had been profoundly altered by the advent of colonialism. He clung to this idea because his willfully anachronistic vision of Tahitian society provided him an ideal alternative model against which to set the supposedly debased European culture that he abhorred. Describing himself often as a *sauvage*, and asserting that he could not find happiness except in a "state of nature" (which he wanted to believe could still be found in Polynesia), his casting of Tehura as the mother-goddess of the Maori people placed him by extension, as her real-life paramour, in the role of the creator-god Oro. This poetic parallelism between the artist and a deity was not new to Gauguin's psychology; during his Brittany period, he had painted a self-portrait which posited a parallel between himself and the crucified Christ.[5] The reference there was to the artist as sufferer; here the allusion would be to his role as a creator. . . .

In *The Seed of the Areoi*, the resonance of complementaries (purple against yellow) in the background, and neighboring tones (red, yellow, and brown) in the foreground, forms an exquisite color chord, but of a kind that nevertheless struck the turn-of-the-century public as shocking. Perhaps to "rationalize" his work and thus make it more acceptable, the artist liked to claim he discovered his palette in the Tahitian landscape: ". . . the landscape

with its bright, burning colors dazzled and blinded me . . . [I]t was so simple to paint things as I saw them, to put on my canvas a red and a blue without any of the calculation [of his earlier work]."[6] But even at their brightest, the visual realities of the Poly-nesian village and landscape are far from the palette we see in Gauguin's paintings, and his suggestion that his color was merely—or even primarily—a transposition of what he *saw* ironically denies us the full measure of his genius.

Symbolism

Magdalena Dabrowski, *The Symbolist Aesthetic,* **1980,** pages 5, 6, 7

On September 18, 1886, the poet Jean Moréas published in the literary supplement to the Paris newspaper *Le Figaro* the "Manifesto of [literary] Symbolism." It was the first attempt to acquaint the public with a new movement that came to dominate the European literary and pictorial scene during the last two decades of the 19th century. The manifesto outlined the principal ideas of an expressive mode based on the rejection of visual reality and the evocation of feeling through form; its evolution had been the result of a marked cultural crisis in France during the 1870s and '80s. The flourishing of Symbolism in art belongs to the years from 1885 to 1900, but some aspects of the Symbolist sensibility were to survive as late as the beginning of the first World War.

Symbolism was not a specific formal style, as were Impressionism and Neo-impression (both of which continued to exist during this period), but rather a series of attitudes toward form and content characteristic of the artistic outlook of the final years of the century, when a mood of subjectivism permeated much of the art. The Symbolist mode embraced a number of diverse trends and individual efforts, which shared essentially the will to transcend the phenomenal world with the spiritual. It represented the search for a new form, new content based on emotion and new synthesis. The work of art was to be the consequence of emotion and inner spirit of the artist and not of his observation of nature, the visible reality. Nature could only be the inspiration for an artistic idea, and the greatest reality was believed to lie in the realm of imagination and fantasy. The idea transcended physical experience, and accordingly, the mode of expression changed from the transcription of a subject to the symbolic treatment of it. Although the subject matter was often the same as that in realist painting, it was trans-formed, by formal means, from an individual scene into a subject broader in meaning—philosophical, reflective, with a wider frame of reference. . . .

Symbolism's essential characteristic, detachment from reality, was underscored in 1886 by the critic Gustave Kahn in the journal *L'Événement,* where he described the principal intention of Symbolist art as "to objectify the subjective (the externalization of the Idea) instead of subjectifying the objective (nature seen through the eyes of a temperament) . . ." Clearly the aim was to create a kind of art expressing through "the idea" the artist's personal, inner feelings and attitudes in relation to the outer world. The "idea" was to be conveyed through the entire work of art and not solely through a specific subject matter, for only then could meaning be presented in broader terms, applicable to humanity at large. . . .

Symbolist concern for meaning was paralleled by its concern for an art theory that would provide the answers to the artists' desire for freedom of creation. The years 1885–86 were the formative ones for Symbolist art theory. It evolved under the influence of [Stéphane] Mallarmé, Edgar Allan Poe, and [Charles] Baudelaire and the Neoplatonism of Plotinus, whose doctrine was profoundly studied by the 1890 generation. The main theoreticians of Symbolism in art were Émile Bernard, Maurice Denis, and Paul Sérusier. Their essential premise was that there should be a synthesis of all the arts, a correspondence between forms and sensations. Those were the fundamental elements of artistic unity in a work of art. The theory of correspondences postulated parallel expressive roles for word, color, and sound. . . . Music especially was identified with inspiration and stimulation of imagination. . . . Pictorial composition was frequently described in terms of musicality, considered one of the major qualities expressive of the beauty of a work. . . .

In their aspiration to arrive at the synthesis of all the arts, the Symbolists were also inspired by

[Richard] Wagner's philosophy of *Gesamtkunstwerk*, or the "total work of art." The emotional impact of a work of art was to result from the combined expressive qualities of its poetry, music, and visual content.

James Ensor

Masks Confronting Death. 1888
Illustrated on page 46

Libby Tannenbaum, *James Ensor,* **1951,** pages 47–48, 52–54, 80–81

Ensor's name has become almost synonymous with masks. So completely were they finally to usurp his interest in the human figure itself that in his later years when the painter approached portraiture, his figures are conceived as a reanimation of the masks on a mechanical rather than an organic level in that the figures become puppets.

The source of the masks was the carnival which was most elaborately celebrated in Ostend [Belgium], where the natives have little work during the long dull winter season. . . . The mask was . . . dissociated from the carnival to become an abstraction of the frightening and the terrible. . . . Like all moralists, Ensor sought the allegory, and with society failing to provide any significant pattern which might measure and describe the world, he was thrown back upon his own experience. And here he was particularly fortunate in this deeply personal and at the same time traditional world of the masks which were sold in the family souvenir shop. This world of masks heralds the beginning of the expressionist movement: within it, Ensor is at complete liberty to distort for effect. And yet, intensification and exaggeration of expression being implicit in the very convention of the mask, he avoids the expressionists' need to justify their right to distort. Ensor is able to move swiftly in a direction which was opened to the artists of France and Germany only after a long and arduous tentative period of theorizing. Here in Ostend, he found in the carnival mask the vivid concentration of meaning for which [Paul] Gauguin was to search in Tahiti and the next generation in African art. The cruelties and absurdities of his personal milieu he was able to project on an abstracted and universal plane which makes him the first of the artists of the *Weltangst* which characterizes so much of late nineteenth- and twentieth-century expression. It is this isolated creation of an art out of the personal and the local that has made Ensor one of the baffling originals. It is his genius for recognizing the elements out of which a new art must be molded that marks his

significance as artist-innovator. . . .

Ensor was never himself a socialist. He was too distrustful of the resources of mankind in any positive direction. Outside his art, James Ensor's life is actually a singular personal record of lack of event rather than event. The only alternative to a life whose very premises dismayed him was the death which would assuredly come to him whether he willed it or not. If he was born into a withering souvenir shop in Ostend, there he would remain, a torn lace curtain across the shop window when he died almost a century later—but the masks, the sea shells, the hatreds and the jokes of the shop transmuted by genius.[1]

Edvard Munch

The Storm. 1893
Illustrated on page 47

John Elderfield, *The Masterworks of Edvard Munch,* **1979,** pages 7–8, 11

When Munch wrote the now famous statement in his Saint-Cloud diary of 1889—"no more interiors should be painted, no people reading and women knitting; they should be living people who breathe, feel, suffer, and love"—he was expressing a concern with emotional, meaningful, and antinaturalistic themes that was shared by very many members of his artistic generation. Like [Paul] Gauguin, [James] Ensor, and [Ferdinand] Hodler, moreover, he sought to realize these themes in intrinsically emotional, meaningful, and antinaturalistic subjects. The obvious contrast here is with [Vincent] van Gogh, who shunned subjects of this kind and for whom, therefore, there was no division between "people reading and women knitting" and "living people who breathe, feel, suffer, and love." When we compare Munch's art to van Gogh's, we see that the Norwegian required emotional characters to express emotional moods, and that the characters of his art are important not as individuals, but only as vehicles for the moods that they express. How successful they do their task seems largely to depend on whether they capture or merely personify these moods, whether what we see is more than just "a translation of abstract notions into a picture language, which is itself nothing but an abstraction from objects of the senses."

This is [Samuel Taylor] Coleridge's definition of allegory, to which he opposed symbolism's "translucence" of the specific in the individual and the general in the specific. Is this, then, to say that an art like Munch's succeeds to the extent it is symbolic rather

than allegorical? Such a definition would seem to provide for the exact alignment of the personal and the general that characterizes Munch at his best. Even at his best, however, Munch is allegorical in the sense of channeling and directing the power of his art to convey a didactic content. Even at those greatest moments when his art presents itself at its most archetypal and mythic, the myths and archetypes it contains are employed rhetorically rather than being simply embodied in the work, which is therefore in one way or another "literary" and moralizing in character. There is always some sense of distance between personal emotion, symbolic code, and pictorial structure because there is always a certain allegorical quotient in Munch's art. Again the comparison with van Gogh is suggested. Munch's very dependence upon intrinsically "important" themes meant that he was denied the absolute fusion of form, symbol, and subjective emotion available to van Gogh and bound instead to seek what Robert Goldwater called (using Holdler's terminology) a state of "parallelism" between them. It is a sign, however, of the greatness of Munch's best work, particularly of his paintings and prints of the 1890s, that the "parallelism" of the elements is so exact and so closely drawn as to defy their separation.

To look at his great pictures of the nineties is to realize that Munch has harnessed within his oeuvre, and often within individual works, two major symbolical themes of nineteenth-century art, each of which was coming to a climax when Munch was finding himself as an artist and each of which had acute personal significance for him. The source of power in his work seems indeed to reside in the way in which traumatic personal experiences allowed Munch to pass on the accumulated force of these themes and to tie them together. One was the theme of conflict between man and modern urban life; the other the theme of sexual conflict. To call one social and therefore public and the other psychological and therefore private is to avoid the fact that the social manifests itself psychologically and the psychological socially, but let these terms stand for the moment. . . .

The disjunctive character of Munch's art sets the pattern for modern Expressionism, which is likewise torn between stillness and rigidity on the one hand and vitality and chaos on the other, and between suppressed emotion and the brittle, easily shattered form in which it is encased. It also belongs, more generally, with modern Existentialist art in representing a fallen and fatalistic world of disconnected fragments resistant to being ordered—except that no sense of irony, and none therefore of resignation, attaches to this situation in Munch's case. Unprotected by irony, Munch's art takes refuge in subjectivity and in empathy. Isolated but never detached—and denied therefore the role either of reporter or of pure inventor—Munch cast himself as a kind of medium. Experiences invading the body would be transformed into a symbolic code that tells of both private emotion and public feeling. "If only one could be the body through which today's thoughts and feelings flow," he wrote in 1892, "that's what an author ought to be. A feeling of solidarity with one's generation, but yet standing apart. To succumb as a person yet survive as an individual entity, this is the ideal."

Munch
The Storm

Arne Eggum, *The Masterworks of Edvard Munch,* **1979,** page 24

The motif [of *The Storm*] is taken from Åsgårdstand with the Kiøsterud building in the background, well known from many of Munch's pictures. . . . The motif was inspired by the experience of a strong storm there. The storm is, however, depicted more as a psychic than a physical reality. The nervous, sophisticated brushstrokes, the somber colors, and the agitated nature are brought into harmony, rendering the impression of anxiety and turbulent psychological conflicts. *The Storm* is also a reflection of Munch's interest in the landscapes of Arnold Böcklin. . . . [T]he illuminated windows function as an important pictorial element. The eye is drawn toward them; in a strange way, they radiate psychic life. Munch emphasized controlling the effects rendered by the illuminated windows. He has scraped out the paint around the yellow areas to achieve the maximum effect. It is as though the house becomes a living organism with yellow eyes, creating contact with the surroundings. In front of the house, a group of women stands huddled together, all with their hands up against their heads like the foreground figure in the painting *The Scream.* Isolated from the group, closer to the center, stands a lonely woman, also with her hands against her head. Like the foreground figure in *The Scream,* she represents anxiety and violent spiritual conflicts. The mood and charged atmosphere indicate that the object of the anxiety is an erotic urge. In the summer months Åsgårdstand was visited by a great number of women, since most of the summer guests consisted of families whose men worked during the week in Christiania. By now, Munch had formulated an aesthetic which dictated

that in his most important motifs, he should represent pictures of recollection as well as the artist's psychological reactions to them. He also made a small woodcut of this motif.

Gustav Klimt
Hope, II. 1907–08
Illustrated on page 48

Kirk Varnedoe, *Vienna 1900: Art, Architecture & Design,* **1986,** pages 149–50, 155, 158–59

At the turn of the century, Klimt embodied both authority and rebellion. Born in 1862 as a goldsmith's son, he became a professional decorative artist in his teens, and in one instance executor for the designs of the "prince" of Viennese art in the Ringstrasse era, Hans Makart. After Makart's death Klimt, regarded as his "heir," became a favored painter for the ceilings of the later Ringstrasse buildings.[1] As an honored young professional, Klimt thus commanded special respect, in the 1890s, from forward-looking artists' clubs like the Siebener (the Seven) of Joseph Hoffmann and Koloman Moser.[2] But as an aging prodigy who had spent too many hours on scaffolds satisfying institutional tastes (and who had been passed over for a professorship in history painting), he was ripe to be converted to their idea that modern art had something better to offer.[3] In two major instances in the later 1890s—the paintings commissioned from him for the ceiling of the University of Vienna's Great Hall, and the formation of the Secession—Klimt decided to leave the path of his "correct" career, and cast his lot with youth and change. This *exemplum virtutis*, in combination with his fraternal artisan's spirit, gave him a certain secular sainthood, enhanced by the "martyrdom" he suffered at the hands of critics. His beard, sandals, and studio smock enhanced this image of piety, so piquantly incongruous with his reputation as a womanizer and with the hothouse sensuality of his work. Klimt was part Francis of Assisi, part Rasputin. . . .

A frustration with what were seen as the limitations of easel painting [similarly] goaded other ambitious European painters around 1900, longing for art to take on transcendent themes in grander forms. It remains an open question whether the very goal they pursued, of an art public in scale and ambition yet determinedly individual in inspiration and style, was itself feasible; but it seems clear that where many tried—[Edvard] Munch, [Paul] Gauguin, and [Paul] Signac among them—few succeeded in the way they had hoped. Klimt was nonetheless drawn,

not just by the hazard of commissions but independently, to the notion that by wedding itself to architecture in a new way, his painting could aspire to the status of great mural art of the past, and he could work in the nobler atmosphere of philosophy. . . .[4]

This kind of confusion and ornamental richness does not embellish the content of Klimt's art, it *is* the content. For Klimt the maintaining of irresolution—between figure and ground, flatness and depth, object and image—was a key way to heighten the experience of art.[5] It evoked the privileged state of a dreamlike floating in which fantasy liquefies the world, tinting and bending it to its own desires. (It is in this strategy that Klimt's paintings have affinities with psychedelic imagery of the 1960s.) The most extreme statements of this willed decorative disorientation lie in the "golden" phase of Klimt's work, from 1906 to 1909. In those works, metallic lead appliqués and embossed designs determined a collage-like surface life, assertively independent of figural content. They also drew on a repertoire of ancient and exotic decorative motifs to assemble a vocabulary of *Ur*-forms of geometry and biology—spirals, rectangles, lozenges, triangles, etc.—intended to evoke primal associations of male and female, mind and nature.[6]

These are the same combined goals—an anti-illusionist play directly on the viewer's sensorium, and an abstract formal language attuned to universal expression—that led other European artists in these same years to decisive certainties of sharp reduction and synthesis. In Klimt they gave rise to elaboration and ambiguity. While others looked to sources in archaic and exotic art for a new economy of volume and line, Klimt saw in the same sources the heightened splendor of complexity—not only the blunt empiricism of a head by Giotto, but that head and its flat golden halo together; not only the woodcut simplicity of Hokusai's form, but that simplification overprinted with multipatterned kimono forms; not the white purity of Greek art at Segesta, but the rich ornament of the recent Mycenaean finds. For him, the exotic, archaic, and primitive arts bore evidence of a primal human love of proteiform brilliance—the doubled intensity of earthy observation joined with fertile abstract invention and lust for materials. This was the common ground that, from nomadic metalwork to Byzantine mosaics, shaped a tradition of spiritually charged art he sought to recover.

Henri Rousseau
The Dream. 1910
Illustrated on page 49

Daniel Catton Rich, *Henri Rousseau*, **1942**, pages 69, 73

[Rousseau's] works possess a vitality which goes beyond decoration. Each has its special mood. . . . [His] use of form and color, symbolically, explains part of the fascination of his last great work, *The Dream*, painted in 1910 and exhibited in that year at the [Salon des] Indépendants. . . .

His awakened amorous spirit found sublimation, perhaps, in *The Dream*, to which he attached a poem:

Yadwigha in a lovely dream,
Having most sweetly gone to sleep,
Heard the snake-charmer blow his flute,
Breathing his meditation deep.
While on the streams and verdant trees
Gleam the reflections of the moon,
And savage serpents lend their ears
To the gay measures of the tune.

(Translated by Bertha Ten Eyck James)

There is a tradition that in his youth Rousseau had been enamored of a Polish woman named Yadwigha. . . .

His last great effort is a creative résumé of his entire career. In *The Dream* he . . . set the figure of Yadwigha on a red sofa in the midst of a jungle. This mixture of incongruous elements surprised even his friends and caused a sensation in the Independents. To a critic, André Dupont, who wrote for an explanation, Rousseau replied: "The sleeping woman on the sofa dreams that she is transported into the forest, hearing the music of the snake-charmer. This explains why the sofa is in the picture." But though the motif was thus cleared up for the literal, Rousseau was so much the artist that to André Salmon he confided: "The sofa is there only because of its glowing, red color."

The Dream is a summation of all those qualities which make Rousseau inimitable. Its organization of spaces and complex tones (an artist counted over fifty variations of green alone) is equaled by its sentiment. The plane of reality (the figure on the sofa) is inventively joined to the plane of the dream (the jungle). In it appears, in heightened form, every symbol of the last ten years of Rousseau's life, redesigned and related with a free intensity. The nude figure surrounded by enormous lilies is one of Rousseau's most perfect realizations, while the leopards peering from the jungle leaves are full of his expressive mystery.

"Tell me, M. Rousseau," [Ambroise] Vollard asked him, "how did you get so much air to circulate among those trees and the moonlight to look so real?"

"By observing nature, M. Vollard," replied the painter, true to his ideal to the last.

As he prepared the picture for exhibition, Rousseau expressed himself as pleased. To [Guillaume] Apollinaire he wrote: "I have just sent off my big picture; everyone likes it. I hope that you are going to employ your literary talents to avenge me for all the insults and injuries I have received" (letter of March 11, 1910). These words, spoken at the end of his life, are one of the few indications we have of how much Rousseau had suffered from being misunderstood.

On September 4, 1910, he died at a hospital in Paris at the age of sixty-six. His friends were out of the city and only seven people attended his funeral, among them Paul Signac, President of the Independents. A year later a tombstone was set up by Robert Delaunay, Apollinaire and M. Quéval, his landlord. And in 1913 [Constantin] Brancusi and the painter Ortiz de Zarate engraved on the stone the epitaph that Apollinaire had written:

Hear us, kindly Rousseau.
We greet you,
Delaunay, his wife, Monsieur Quéval and I.
Let our baggage through the Customs to the sky,
We bring you canvas, brush and paint of ours,
During eternal leisure, radiant
As you once drew my portrait you shall paint
The face of stars.

(Translated by Bertha Ten Eyck James)

Fauvism

John Elderfield, *The "Wild Beasts": Fauvism and Its Affinities,* **1976,** pages 13, 14, 15, 16

Genuinely new art is always challenging, sometimes even shocking to those not prepared for it. In 1905, the paintings of [Henri] Matisse, [André] Derain, [Maurice] Vlaminck, and their friends seemed shocking to conservative museum-goers; hence the eventual popularity of the term *les fauves,* or "wild beasts," by which these artists became known. But shock and surprise quickly disappear. To look again at these exquisitely decorative paintings is to realize that the term *Fauvism* tells us hardly anything at all about the ambitions or concepts that inform Fauvist art. "Wild beasts" seems the most unlikely of descriptions for these artists. The title Fauvism is in fact a misleading one for the movement to be discussed here.

Matisse and his friends were first called *fauves* when they exhibited together at the Paris Salon d'Automne of 1905. The artists themselves did not use the name. "Matisse tells me that he still has no idea what 'fauvism' means," reported Georges Duthuit later.[1] The Fauvist movement, it could be said, was the result of public and critical reactions to the artists' work. It began when their work first provoked widespread public interest, in the autumn of 1905, and lasted until approximately the autumn of 1907, when critics realized that the group was disintegrating. Critical recognition, however, inevitably lags behind artistic innovation. The Fauvist style (or better, styles) slightly preceded the Fauvist movement: the first true Fauve paintings were exhibited at the Salon des Indépendants in the spring of 1905; the last important Fauvist Salon was the Indépendants two years later. The Fauvist group, in contrast, preceded both the movement and the style, since it had begun to emerge even before 1900. . . . When compared with Post-Impressionist painting, the color and brushwork of the Fauves possess a directness and individual clarity that even now can seem, if not raw, then declamatory, and of astonishing directness and purity. "This is the starting point of Fauvism," Matisse said later, "the courage to return to the purity of means."[2] His talk of a return is significant. Fauvism was not only—and not immediately—a simplification of painting, though that is what it became. It was initially an attempt to recreate, in an age dominated by Symbolist and literary aesthetics, a kind of painting with the same directness and anti-theoretical orientation that the art of the Impressionists had possessed, but one created in cognizance of the heightened color juxtapositions and emotive understanding of painting that were the heritage of Post-Impressionism. In this sense, Fauvism was a synthetic movement, seeking to use and to encompass the methods of the immediate past. . . .

Fauvism was not a self-sufficient and relatively autonomous movement in the way most modern movements have been. Although it existed by virtue of friendships and professional contacts, it had no announced theories or intentions as did, say, Futurism. Nor had it a single common style that can be plotted rationally, as is the case with Cubism. Its perimeters, therefore, necessarily seem vague. In consequence, both exhibitions and studies devoted to the movement sometimes treat it with alarming latitude. For example, it has been considered but an aspect of the broad Expressionist impulse that affected early twentieth-century art,[3] or part of a new art of color that extended far beyond the boundaries of the Fauve group.[4] Indeed, Fauvism was not alone in certain of its general ambitions; it was, nevertheless, a unique artistic movement that requires definition as such. Where there is genuine difficulty is in establishing its relationship to the contemporary Parisian avant-garde, and in deciding whether friendship alone, or stylistic similarity alone, suffices to denote Fauve membership. . . .

The history of Fauvism is largely the history of this essentially private artist's [Matisse's] single sustained period of cooperation with the Parisian avant-garde, albeit for a very short period. Within this period, we see an emphasis upon the autonomy of color almost entirely new in Western art, a concern with directness of expression that countenanced mixed techniques and formal dislocations for the sake of personal feeling, and a truly youthful bravado that in its search for the vital and the new discovered the power of the primitive. We also see a rendering of external reality that found pleasurable stimulus in the "vacation culture"[5] subject matter of the Impressionists, but that pushed it at times either to the verge of a vernacular urban realism or toward a more ideal celebration of the *bonheur de vivre.* Finally, and perhaps most basic of all, is a belief in both individual and pictorial autonomy, which found a remarkable balance between the concern for purely visual sensation and for personal and internal emotion,

Henri Matisse

Landscape at Collioure. 1905
Illustrated on page 50

Marcel Duchamp (1950), in *Modern Masters: Manet to Matisse,* **1975,** page 88

As early as 1904 Henri Matisse began his search for new fields of expression, using thin, flat, colored surfaces, famed in a drawing of heavy lines—to oppose Pointillism, the last stronghold of Impressionism. The movement which was to be called Fauvism was sponsored by a number of young painters who felt the necessity of avoiding the impasse to which Impressionism and Pointillism had brought them. But Matisse, like all pioneers, was more than a theoretician of the moment. His first important reaction was in the treatment of form, starting from natural representation. He purposely ignored all conventions of anatomy and perspective in order to introduce whatever drawing he felt adequate to give maximum values to the flat hues of colors inserted within the intentional outlines. Coming just after the recognition of [Vincent] van Gogh, [Paul] Cézanne, and [Georges-Pierre] Seurat, Matisse's idea was a deliberate attempt to open new roads in the physics of painting. Around 1908 he showed several large compositions which contained all the elements of his masterly conception. Perspective had been discarded and replaced by the relationship of strong forms which produced a three-dimensional effect of its own. Figures and trees were indicated with heavy lines, building the arabesque adjusted to the flat areas of color. The ensemble created a new scenery in which the objective composition appeared only as a remote guide. Ever since these early achievements, Matisse had added to his physical treatment of painting a very subtle chemistry of brushwork which amplified the completeness of his latest work.

Henri Matisse

Woman Beside the Water. 1905
Illustrated on page 50

John Elderfield, *Henri Matisse: Masterworks from The Museum of Modern Art,* **1996,** page 52

This painting shows Matisse's wife wearing a Japan- ese costume, seated beside the ocean at Collioure. At least, that is the nominal subject. The figure is decomposed in its painting and merges with the landscape around it.

Color, being released from representation of the substance of things, is also released from the obligation to render tonal distinctions. In the absence of tonal tissue, Matisse gives us the colored skeleton of a subject, and a loosely articulated one at that. He refuses to exactly define the spaces between the parts of the subject. Leaving the links open was to charge the fixed image with a feeling of potential movement, and to thereby free it from the temporal moment from which it derived. Fauvism, Matisse insisted, was more than merely bright color. "That is only the surface; what characterized Fauvism was that we rejected imitative colors, and that with pure colors we obtained stronger reactions—more striking simultaneous reactions." The simultaneous retinal reactions of multiple, juxtaposed colors, vibrating against the white ground, is what blurs the figural image so that it seems to fuse into the landscape. The substance of the figure is corroded in the visual flux.

And yet, the visual flux harks back to the figure it is corroding. Madame Matisse sits there, or floats, rather, her gown even more aquatic in its pattern than the ocean behind her. We know that her husband admired Japanese prints. His wife, as pictured here, recalls a famous seventeenth-century commentator on such prints, who spoke of "a gourd floating along with the river current: this is what we call the *floating world.*"

Georges Braque

Landscape at La Ciotat. 1907
Illustrated on page 51

William Rubin, *Cézanne: The Late Work,* **1977,** pages 157, 158, 159

The late spring and summer of 1907 saw most of the Fauve painters in the Midi—[André] Derain at Cassis and Braque together with [Otto] Friesz at nearby La Ciotat. Braque visited frequently with Derain and kept up with the latter's new work. . . .

Braque was increasingly emphasizing the Cézannian component (already evident in his pictures of L'Estaque from the fall of 1906) within what remained a Fauve style. This Cézannism has caused Braque's Fauve pictures to be unfavorably compared with those of [Henri] Matisse and Derain. But the dismissal of Braque as a "minor Fauve"[1] automatically contributes to a misunderstanding of his subse-

quent development, as it posits a more radical change in the value of his work than was in fact the case. The sheer quality of Braque's . . . *Landscape at La Ciotat* raises him far above the level of the minor Fauves. . . . And though [it is] less flat and bright than paintings by the two remaining masters of the movement, such Braques should no more be interpreted as failed Matisses or Derains than the Cézannes of 1872–75 should be seen as failed Impressionist pictures.

What distinguishes these Braques is the presence of a kind of concealed modeling accomplished by lining up unexpected decorative hues according to their values—an extension, based on substitution, of Cézanne's modeling through color. Braque's tendency to align his own gamut of Fauve colors—founded on secondary and tertiary hues, frequently pastel—in value relationships that imply sculptural relief, an interest utterly alien to the more purely decorative concerns of Matisse and Derain in 1905–06, was no failing on his part, but an anticipation of his own Cubist future. As was the case with Cézanne's conservative version of Impressionism in the early 1870s, Braque was simply loath to give up the particular plasticity of modeled forms—with its attendant emotional and ethical implications. That *gravitas* and sobriety, secured by the illusion of relief, which links the beginnings of the Renaissance and modern traditions in the persons of Giotto and Cézanne,

accorded well with Braque's personality (as his subsequent history in Cubism bore out). Hence, Braque's conservative Fauvism must be understood as a deliberate and personal variant of the style—a "withholding of complete assent, and a restoration of that connecting tonal tissue that Matisse had abruptly terminated."[2]

This "restoration" is the basic measure of Braque's commitment to Cézanne, whose painting he had seen as early as 1902 and who was a factor in his development as early as 1904. But by the summer of 1907, Braque's Cézannism had become more than a question of implied modeling. In *Landscape at La Ciotat*, for example, he adapts from Cézanne the entire configuration of his picture, a configuration that he would subsequently make paradigmatic for Cubism. Braque takes Cézanne's high horizon, a perspective that lays out the picture more in height than in depth, and treats it in such a way that the forms seem to spill downward and outward toward the spectator from the hill at the top. In addition, Braque extensively uses his own rude adaptation of Cézanne's "constructive stroke" and, like the master of Aix, outlines his forms in Prussian blue. While profoundly Cézannesque, *Landscape at La Ciotat* nevertheless also contains, in the decorativism of the foliage, vestiges of an interest in [Paul] Gauguin,[3] whose art had earlier been at the center of Fauvism.

Later Symbolist Currents ———

Vasily Kandinsky
Panels for Edwin R. Campbell. 1914
Illustrated on pages 52, 53

Werner Haftmann, *German Art of the Twentieth Century,* **1957,** pages 67, 70

In the course of a profound, spiritual assimilation of the ideas growing out of the Jugendstil, [Vincent] van Gogh, the Neo-Impressionists, and the Fauves [Kandinsky] succeeded in evolving the abstract picture. His aim was now no longer to reproduce objects in painting, but to make painting itself the object; the new pictorial structure was marked by an inner resonance which moves sensibility in the same way as do representational pictures and the creations of nature. This event took place in 1910, and from that

date Kandinsky abandoned objective titles as well, choosing such designations as "Abstraction," "Improvisation," and "Composition."

"Composition" always denoted some analogy to music. In the early abstractions of 1910–11 one could even find a relationship to [Richard] Wagner's great operatic compositions. Just as Wagner's music is saturated with sensuous and symbolic allusions and evokes images of large scenery and figurative analogies in the listener's mind, so the waves of color in these first incunabula of abstract painting conjure up a whole inventory of material associations: symbols of walking forms, horsemen jumping, sturdy Russian churches, dramatic or bucolic scenic backgrounds. If the eye follows the epic course of the sonorous colors, it is continually confronted by these individual figurative symbols, leitmotifs, as it were, of a dramatic

composition for the stage: movements of mystical color which seek to make a dramatic state of the soul visible, but do not yet sufficiently trust their independence from representation to be able to entirely abandon objective reference. Such naturalistic and sentimental residues still muddy the overall formal organization. This fact emerges most clearly in the spatial organization which still has a naturalistic character, as of a corridor, in the perspective gradations from foreground to background. But the painting changes as early as 1911. The scheme of lines that determines the form is woven into the tempestuous colored background in a free arabesque. And now, too, the attempt to produce illusions of space disappear. The picture seems to soar away from terrestrial perspective, with its simple arrangement of foreground, middle ground, background, into a cosmic perspective in which this clear recession is replaced by and merges into a more complicated space. 1912–13 is the period in which Kandinsky vigorously came to terms with the pictorial organization of the young Frenchmen. In his paintings of 1913 we see illusionistic space give way to a shallow pictorial depth which does not observe traditional perspective, a system of stepwise layers of space and interpenetrating planes. The comparison with Cubism is obvious, but in that comparison we recognize the way in which Kandinsky gives this relatively rational system, with its calculated architecture, a very broad tension in a highly expressive way by irrationally puncturing and opening up space. Kinetic forms of motion bring a space-time element into the painting. In this way the orchestration of a new kind of picture is created, embracing both the rational and the irrational, the finite and the infinite, the static and the dynamic; the unbridled force of the Northern European-Eastern world of expression has erupted in an Orphic song. If one had to choose a stylistic designation for this art, it could only be called Abstract Expressionism.

Kandinsky
Panels for Edwin R. Campbell

Magdalena Dabrowski, in *The Magazine of The Museum of Modern Art,* **1999,** pages 2–3, 5

In 1889, upon entering a peasant hut during a trip to the Vologda region of Northern Siberia, Vasily Kandinsky experienced an aesthetic and emotional revelation. According to his memoirs, the entire interior was an environment of images and colors complemented by polychromed carved furnishings. Kandinsky felt he had entered a picture. In a variety of

works created over the next five decades, he tried to capture and re-create that feeling. The suite of four paintings by Kandinsky in the collection of The Museum of Modern Art, executed in 1914 . . . are one such attempt. They may also be thought of as a *Gesamtkunstwerk*, or total artistic environment, a concept popular at the end of the nineteenth century, in which art and architecture harmonize to create a completely unified whole. The intention was to envelop the spectator on all sides with the pictorial space.

By the end of November 1913, Kandinsky had already painted his first abstract compositions. Although Kandinsky was not widely famous, his work gained exposure in America in a key presentation of modern art, the 1913 International Exhibition of Modern Art, known as the Armory Show. Among the collectors who had embraced the cause of European modernism and begun acquiring examples of the most advanced art was a Chicago lawyer, Arthur Jerome Eddy (1859–1920). Eddy shared his admiration for Kandinsky's work with his friend Edwin R. Campbell (1874–1929), a doctor who had abandoned medicine and become the founder of the Chevrolet Motor Company. In May 1914 Kandinsky received from Campbell a commission to create four paintings for the foyer of his apartment at 635 Park Avenue in New York. The commission, the only one Kandinsky received in his career, came via Eddy, who on May 21, 1914, wrote to Kandinsky: "I have persuaded a friend here in New York to buy some of your work. He is taking the pictures entirely upon my urging him to do so and therefore I am very anxious they shall please him and his wife when they are in his home. He wants four paintings for the four walls of a reception hall. There are four panels in the walls and the paintings will each fill a panel." The letter, preserved in the archives of The Museum of Modern Art, specifies dimensions for the works, clarifying that they were to be of the same height but of different widths (appropriate to the dimensions of the specific walls). Even the compositional content was suggested by Eddy, who indicated that one of the paintings in his collection, *Landscape with Red Spots II* (1913), would be a suitable model for the Campbell works. "It is so brilliant in color that it makes a beautiful wall decoration," he wrote. "Now I think my friend would like four pictures painted in the same mood, strong brilliant pictures." The commission was to be executed very quickly, so that it would arrive in New York by September 1914.

Completed as requested, the suite did not reach New York until early 1916 due to the outbreak of World War I. The panels were presumably installed in Campbell's foyer in the fall of 1916. We do not,

however, have any evidence to that effect other than Eddy's description as to how they would have been framed and installed. Campbell divorced and moved out of the apartment in 1921 and died in 1929. The works disappeared entirely from view during the 1920s and 1930s, and were separated into two pairs. The first pair, *Number 199* and *Number 201*, resurfaced in 1940 in Florida and were acquired by the Guggenheim Museum in 1941. The second pair, *Number 198* and *Number 200*, appeared in 1953 in an auction in upstate New York as "Modern Abstract Paintings" and were purchased by The Museum of Modern Art in 1954.

Identified by art historian Kenneth C. Lindsay as the suite commissioned by Campbell, the paintings were finally reunited, by exchange, in 1983. (Lindsay also proposed that the panels represent the four seasons, characteristics of which are conveyed by the color schemes and moods of the paintings; we have no evidence, however, that Kandinsky thought of the works in these terms.) Following their reunification the works were systematically restored through surface cleaning and varnish removal . . . and were thus brought to their original, harmonious relationship.

Claude Monet

Water Lilies. c. 1920
Illustrated on page 54, 55

William Seitz, *Claude Monet: Seasons and Moments,* **1960,** pages 38, 40, 43, 45–46, 50, 52

In 1890, after the purchase of the farmhouse in which [Monet] lived at Giverny, he acquired a tract of flood land that lay across the road and the one-track railroad from his front gateway. On it grew some poplars, and a tiny branch of the Epte River provided a natural boundary. Excavation was immediately begun to result, after several enlargements of the plan, in a 100 by 300 foot pond through which the flow of water from the river was controlled by a sluice at either end. Curvilinear and organic in shape, it narrowed at the western end to pass beneath a Japanese footbridge. Willows, bamboo, lilies, iris, rose arbors, benches, and on one shore curving steps leading to the water were added, providing a luxuriant setting for the spectacle of cloud reflections and water lilies floating on the pond's surface. Except for a single gate, the water garden was fenced with wire upon which rambling roses were entwined; sealed off from the outside world it formed an encircling whole, a work of art with nature as its medium, conceived not as a painting subject, but as a retreat for delectation and meditation. . . .

In the open water Monet's gardeners were kept busy pruning groups of lily pads into circular units. Searching among them his eyes found arrangements that gradually began to exclude the shore entirely. By 1903 a new relationship of space and flatness had evolved. Its patterns are open, curvilinear, and expanding, and of a random naturalness; yet the clusters were nevertheless held in mutual attraction by a geometry as nebulous as that of the clouds whose reflections passed over the pond's surface. It is surprising how little "aesthetic distance" separates these images from photographic actuality; yet in their isolation from other things, and because of the mood they elicit, they seem, like pure thought or meditation, abstract.

It is an ironic reminder of the artist's predicament that Monet found as much anguish in struggling to represent his garden as he did satisfaction in contemplating it. . . .

The conception of an ovoid salon decorated with water landscapes probably entered Monet's mind (if he had not thought of it earlier) at this time. During the eighties he had experimented with enlarging landscapes to mural size, and combining small panels in a decorative scheme; but the enlargements lost their impressionist immediacy and the combinations lacked unity. In the water garden, however, he had already created a motif for which such a room would be the ideal equivalent. It was apparent, moreover, that the individual canvases of water lilies, though carefully composed and therefore satisfying in themselves, were also fragments that begged to be brought together in an encompassing whole. Reviewing the 1909 exhibition in the *Gazette des Beaux-Arts,* the critic Claude Roger-Marx included an "imaginary" conversation in which Monet spoke thus: "I have been tempted to employ this theme of *Nymphéas* in the decoration of a salon: carried along the walls, its unity, unfolding all the panels, would have given the illusion of an endless whole, of water without horizon or bank; nerves tense from work would be relaxed there . . . and to him who lived there, that room would have offered the refuge of a peaceable meditation in the center of a flowing aquarium."[1] . . .

[In 1918], when Monet was visited by the art dealers Georges Bernheim and René Gimpel (who had heard gossip about an "immense and mysterious decoration on which the artist worked") they saw assembled in the new studio "a strange artistic spectacle: a dozen canvases placed in a circle on the floor, one beside the other, all about two meters [78¾"] wide and one meter twenty [47¼"] high; a panorama made up of water and lilies, of light and sky. In that

infinitude, water and sky have neither beginning nor end. We seem to be present at one of the first hours in the birth of the world. It is mysterious, poetic, delightfully unreal; the sensation is strange; it is a discomfort and a pleasure to see oneself surrounded by water on all sides."[2] There were about thirty of these panels in all. . . .

The universe that Monet discovered in the suspended quiet of his water garden, and recreated in his last canvases, reawakens dulled sensibilities by cutting perception loose from habitual clues to position, depth, and extent. It is a world new to art, ultimately spherical in its allusions, within which the opposites of above and below, close and distant, transparent and opaque, occupied and empty are conflated. Nevertheless—notably in The Museum of Modern Art's breathtaking triptych[3]—equilibrium is maintained by an indeterminate horizontal; a shadowy equator before which the surrounding globe of sky, seen in the iridescent clouds that curve downward in an inverted image, becomes one with the water to form a common atmosphere. The pond's surface is only barely adumbrated by the unfinished constellations of lily pads that, like flights of birds, punctuate the expanding space.

In the darkness below, the life-rhythm that Monet worshipped is all but stilled. It is the tangibility of the work of art that keeps it alive—the saturated, shuttling color tones, the scraped and scumbled flatness of the canvas surface, the nervous tangles that will not retreat into illusion, and the few furtive stabs of white, yellow, pink, or lilac that we recognize as blossoms.

To Monet these final landscapes of water, like those of the Norman beaches, the Seine, or the open sea, were records of perceived reality, neither abstract nor symbolistic; but to him, from the beginning, nature had always appeared mysterious, infinite, and unpredictable as well as visible and lawful. He was concerned with "unknown" as well as apparent realities. "Your error," he once said to [Georges] Clemenceau, "is to wish to reduce the world to your measure, whereas, by enlarging your knowledge of things, you will find your knowledge of self enlarged."[4]

Post-Impressionism

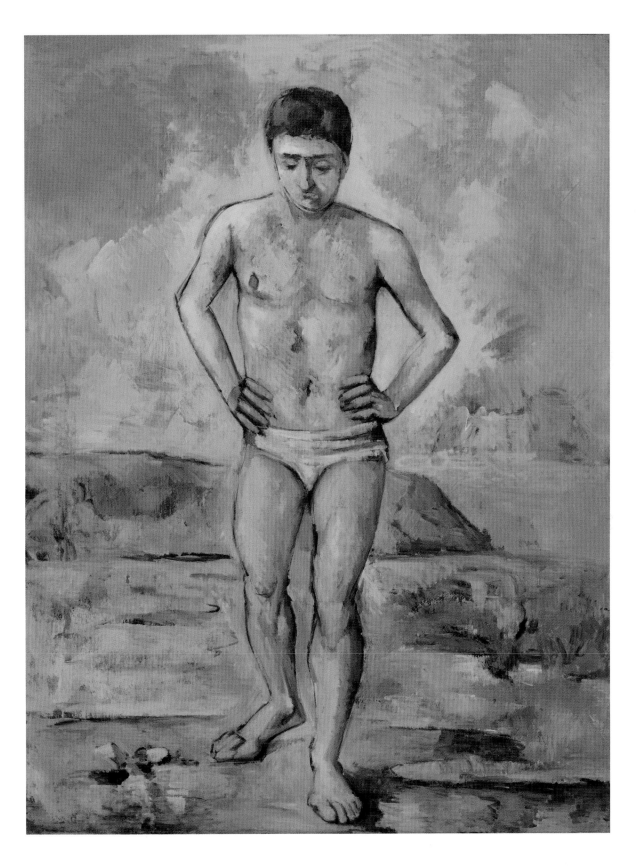

Paul Cézanne | FRENCH, 1839–1906
THE BATHER. c. 1885
OIL ON CANVAS, 50 x 38⅛" (127 x 96.8 CM)
LILLIE P. BLISS COLLECTION

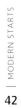

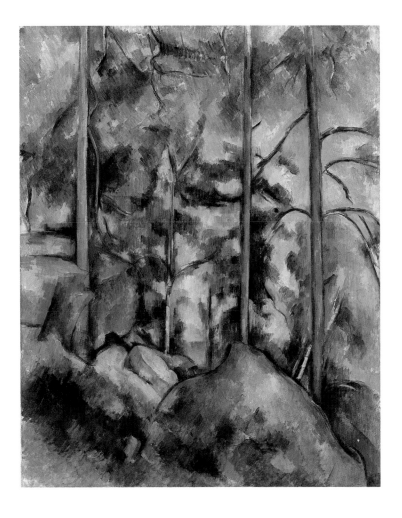

Paul Cézanne | FRENCH, 1839–1906
PINES AND ROCKS (FONTAINEBLEAU?). 1896–99
OIL ON CANVAS, 32 x 25¼" (81.3 x 65.4 CM)
LILLIE P. BLISS COLLECTION

Paul Cézanne
LE CHÂTEAU NOIR. 1904–06
OIL ON CANVAS, 29 x 36¼" (73.6 x 93.2 CM)
GIFT OF MRS. DAVID M. LEVY

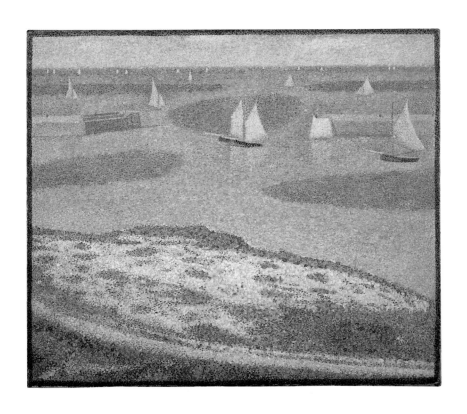

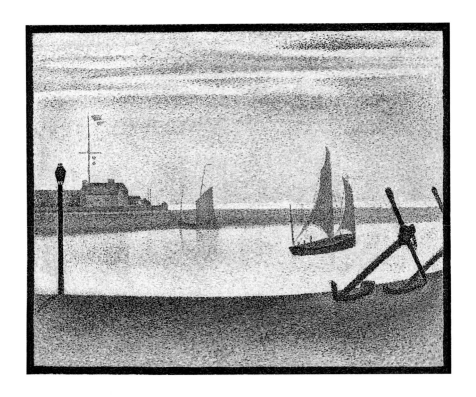

Georges-Pierre Seurat | FRENCH, 1859–1891
PORT-EN-BESSIN, ENTRANCE TO THE HARBOR. 1888
OIL ON CANVAS, 21⅝ x 25⅝" (54.9 x 65.1 CM)
LILLIE P. BLISS COLLECTION

Georges-Pierre Seurat
THE CHANNEL AT GRAVELINES, EVENING. 1890
OIL ON CANVAS, 25¾ x 32¼" (65.4 x 81.9 CM)
GIFT OF MR. AND MRS. WILLIAM A. M. BURDEN

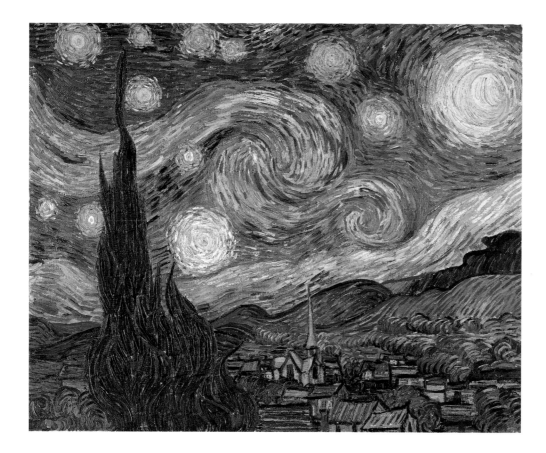

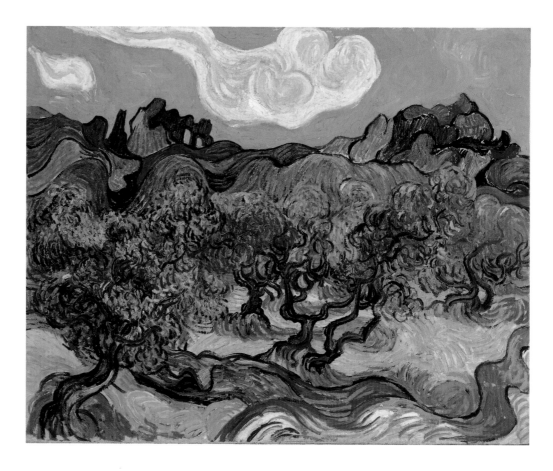

Vincent van Gogh | DUTCH, 1853–1890
THE STARRY NIGHT. 1889
OIL ON CANVAS, 29 x 36¼" (73.7 x 92.1 CM)
ACQUIRED THROUGH THE LILLIE P. BLISS BEQUEST

Vincent van Gogh
THE OLIVE TREES. 1889
OIL ON CANVAS, 28¾ x 36" (72.6 x 91.4 CM)
MRS. JOHN HAY WHITNEY BEQUEST

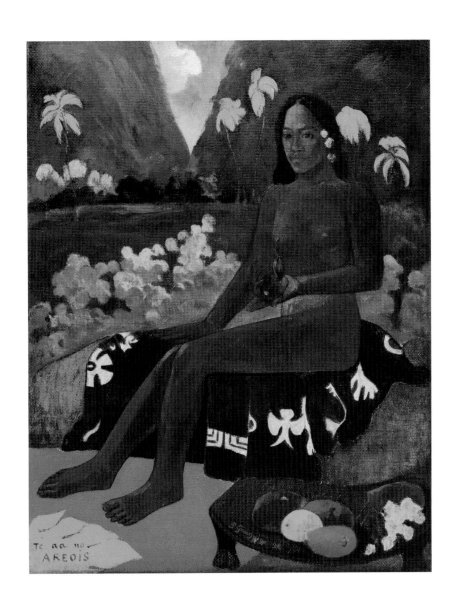

Paul Gauguin | FRENCH, 1848–1903
THE SEED OF THE AREOI [TE AA NO AREOIS]. 1892
OIL ON BURLAP, 36¼ x 28⅜" (92.1 x 72.1 CM)
THE WILLIAM S. PALEY COLLECTION

Symbolism

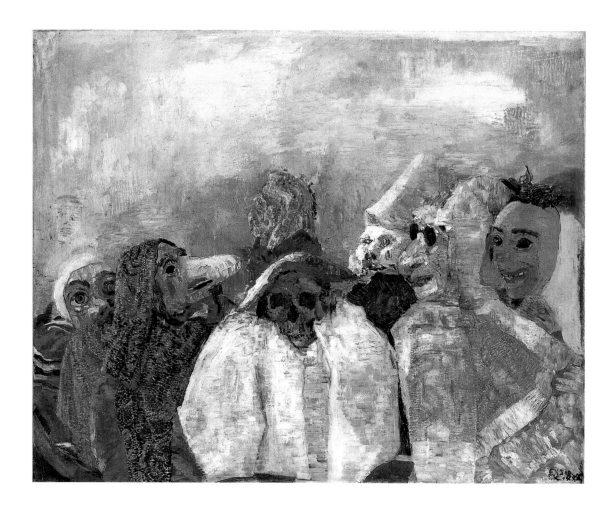

James Ensor | BELGIAN, 1860–1949
MASKS CONFRONTING DEATH [MASQUES DEVANT LA MORT], 1888
OIL ON CANVAS, 32 x 39½" (81.3 x 100.3 CM)
MRS. SIMON GUGGENHEIM FUND

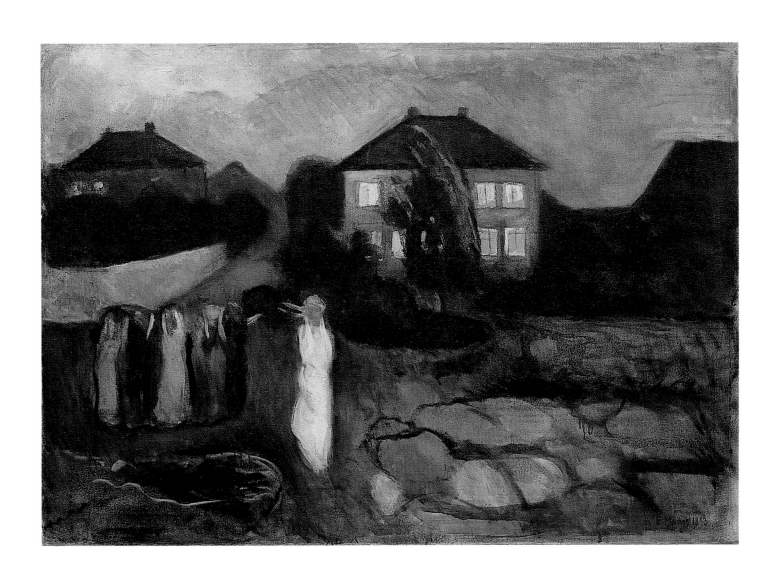

Edvard Munch | NORWEGIAN, 1863–1944
THE STORM. 1893
OIL ON CANVAS, 36⅛ x 51½" (91.8 x 130.8 CM)
GIFT OF MR. AND MRS. H. IRGENS LARSEN AND ACQUIRED THROUGH
THE LILLIE P. BLISS AND ABBY ALDRICH ROCKEFELLER FUNDS

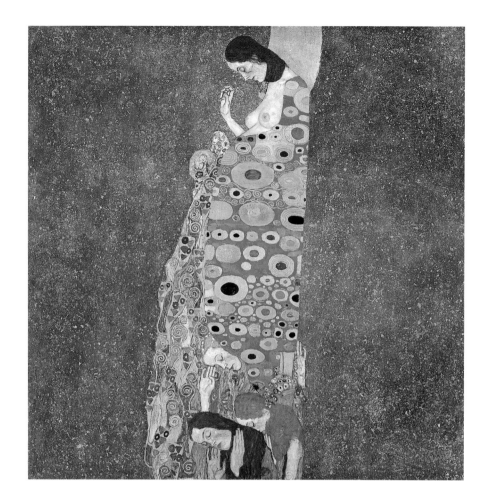

Gustav Klimt | AUSTRIAN, 1862–1918
HOPE, II. 1907–08
OIL, GOLD, AND PLATINUM ON CANVAS,
43⅓ x 43½" (110.5 x 110.5 CM)
MR. AND MRS. RONALD S. LAUDER AND HELEN
ACHESON FUNDS, AND SERGE SABARSKY

Egon Schiele | AUSTRIAN, 1890–1918
PORTRAIT OF GERTRUDE SCHIELE. 1909
OIL, SILVER, GOLD-BRONZE PAINT, AND PENCIL ON
CANVAS, 55 x 55⅛" (139.5 x 140.5 CM)
PURCHASE AND PARTIAL GIFT OF THE LAUDER FAMILY

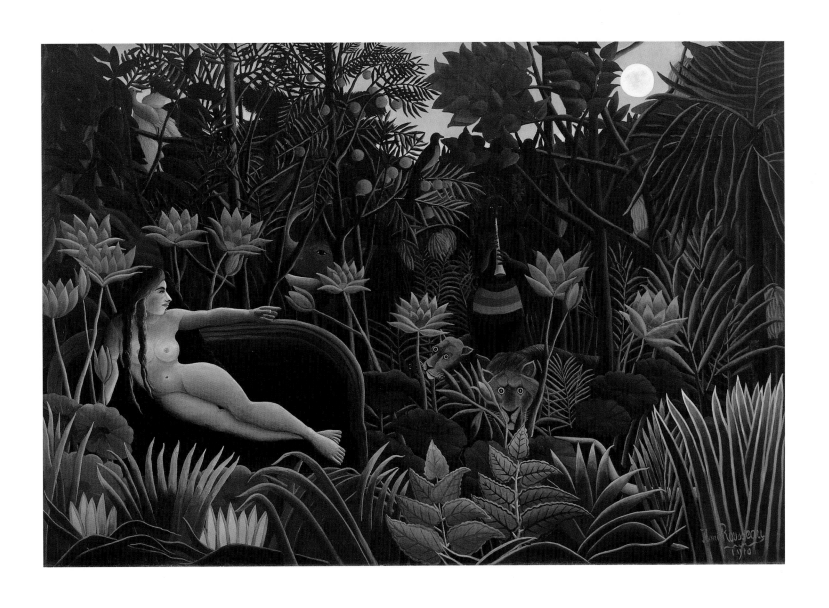

Henri Rousseau | FRENCH, 1844–1910
THE DREAM. 1910
OIL ON CANVAS, 6' 8½" x 9' 9½" (204.5 x 298.5 CM)
GIFT OF NELSON A. ROCKEFELLER

Fauvism

Henri Matisse | FRENCH, 1869–1954
LANDSCAPE AT COLLIOURE. 1905
OIL ON CANVAS, 15¼ x 18⅜" (38.8 x 46.6 CM)
GIFT AND BEQUEST OF LOUISE REINHARDT SMITH

Henri Matisse
WOMAN BESIDE THE WATER [LA JAPONAISE, MME. MATISSE]. 1905
OIL AND PENCIL ON CANVAS, 13⅞ x 11⅛" (35.2 x 28.2 CM)
PURCHASE AND PARTIAL ANONYMOUS GIFT

André Derain | FRENCH, 1880–1954
BRIDGE OVER THE RIOU. 1906
OIL ON CANVAS, 32½ x 40" (82.5 x 101.6 CM)
THE WILLIAM S. PALEY COLLECTION

Georges Braque | FRENCH, 1882–1963
LANDSCAPE AT LA CIOTAT. 1907
OIL ON CANVAS, 28⅛ x 23⅜" (71.7 x 59.4 CM)
ACQUIRED THROUGH THE KATHERINE S. DREIER AND
ADELE R. LEVY BEQUESTS

Later Symbolist Currents

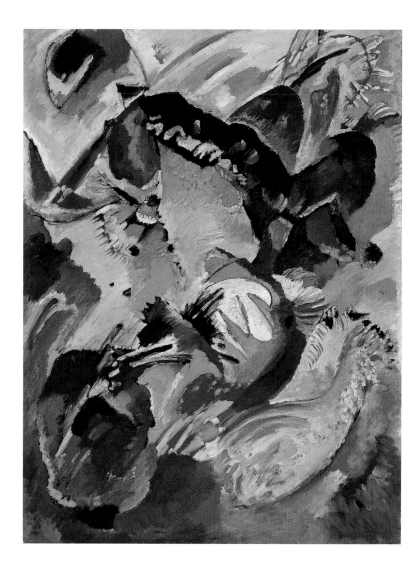

Vasily Kandinsky | FRENCH, BORN RUSSIA. 1866–1944
PANEL FOR EDWIN R. CAMPBELL NO. 1. 1914
OIL ON CANVAS, 64 x 31½" (162.5 x 80 CM)
MRS. SIMON GUGGENHEIM FUND

Vasily Kandinsky
PANEL FOR EDWIN R. CAMPBELL NO. 2. 1914
OIL ON CANVAS, 64¼ x 48¼" (162.6 x 122.7 CM)
NELSON A. ROCKEFELLER FUND (BY EXCHANGE)

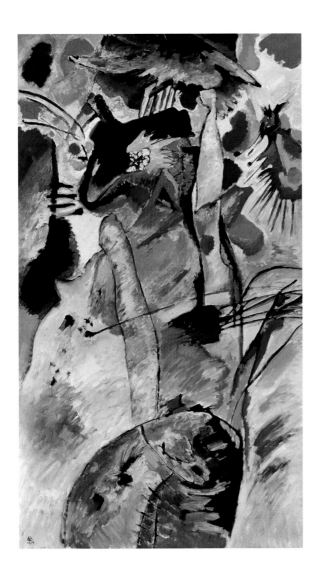

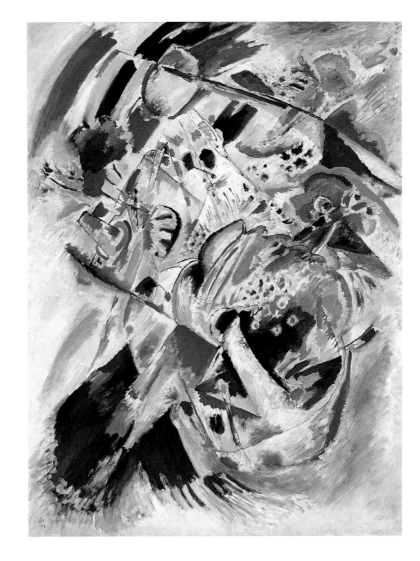

Vasily Kandinsky
PANEL FOR EDWIN R. CAMPBELL NO. 3. 1914
OIL ON CANVAS, 64 x 36¼" (162.5 x 92.1 CM)
MRS. SIMON GUGGENHEIM FUND

Vasily Kandinsky
PANEL FOR EDWIN R. CAMPBELL NO. 4. 1914
OIL ON CANVAS, 64¼ x 48¼" (163 x 123.6 CM)
NELSON A. ROCKEFELLER FUND (BY EXCHANGE)

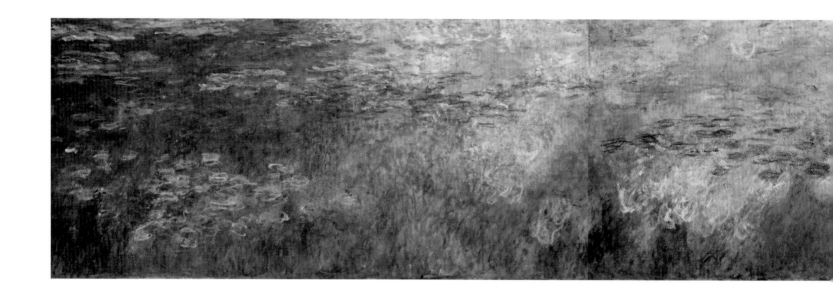

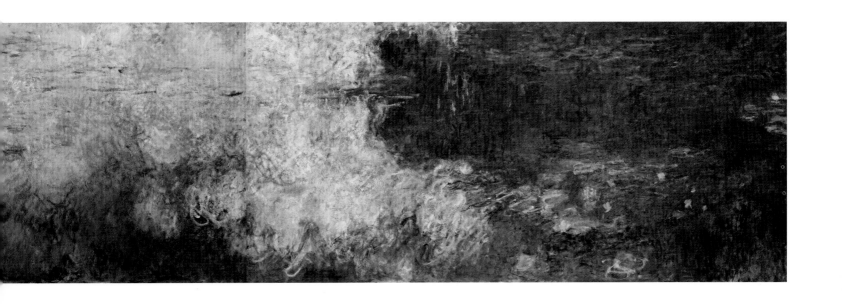

Claude Monet | FRENCH, 1840–1926
WATER LILIES. c. 1920
OIL ON CANVAS, TRIPTYCH, EACH SECTION 6' 6" x 14' (200 x 425 CM)
MRS. SIMON GUGGENHEIM FUND

Matisse Picasso

Immediately upon his appointment as Director of the newly formed Museum of Modern Art in June 1929, Alfred H. Barr, Jr. hoped to establish the Museum's international reputation by organizing exhibitions dedicated to the work of Henri Matisse and Pablo Picasso, undeniably the two most famous artists at the time. Coming in the wake of winning the prestigious Carnegie award, Matisse's 1931 exhibition at the Museum was not only the first ambitious solo show devoted to a European artist but also the first important Matisse exhibition presented at an American museum. Barr initially hoped to present the work of both Matisse and Picasso at that time, thus establishing them as equal forces against which to read the history of modern art. But with a major exhibition of Picasso's work in Paris scheduled for 1932, and the artist's unwillingness to commit to any project before then, Barr had to postpone his plans. What appeared to be a defeat for Barr at the time—namely, the organization of the first museum exhibition of Picasso's work in America—turned into a triumph in 1939 with *Picasso: Forty Years of His Art*. The catalogue of that exhibition, an expanded version of which was published in 1946 under the title *Picasso: Fifty Years of His Art*, was the first to attempt a comprehensive study of Picasso's work. With an emphasis on chronology and the problem of dating, Barr strove to give a "balanced" survey of Picasso's work in all mediums by means of reproductions and commentaries and the inclusion of reprints of Picasso's own statements. So exemplary was his charting of Picasso's stylistic development that Harvard University awarded Barr the doctorate he had been forced to abandon when he left to become Director of the Museum.

Picasso: Fifty Years of His Art was only surpassed by Barr's *Henri Matisse: His Art and His Public*, published in 1951 in conjunction with the artist's second exhibition. Originally planned as a modest revision of the catalogue of the 1931 retrospective, the book was hailed by John Elderfield in 1992 as the only rigorous art-historical study of Matisse's career and the greatest monograph that had appeared on a modern artist. Inspired by the same desire for order and completeness in the representation of an artist's stylistic development tied to biography that had motivated his book on Picasso, Barr vastly expanded the format to include a broad variety of documentary material. He also dealt with the complex issue of reception, as manifested in exhibitions and criticism of the time. The 1951 exhibition and publication coincided with a renewed esteem of Matisse's avant-garde status that he had lost to Picasso in the early days of Cubism.

It was only with the advent of a new generation of artists in postwar America in the 1950s and 1960s and their profound appreciation and interest that Matisse was once again recognized as a truly radical artist. According to Elderfield, Barr's art-historical understanding of Matisse as an artist whose development alternated between "realistic" and "abstract" styles, as advanced in the 1931 exhibition and catalogue, was crucial to this rehabilitation. But even Barr, after the retrospective, would not take a definitive stance on the artist when he wrote about Matisse in 1934 in *A Brief Survey of Modern Painting*. "[Matisse's] original sense of composition and his distinctive color cause many critics to call him the greatest living painter." As for Picasso, Barr could unequivocally affirm, in the same 1934 publication, that

he "is the most versatile and inventive and one of the greatest of living artists," whose triumphant transition from one stylistic innovation to the next Barr would continue to celebrate in two anniversary exhibitions for Picasso's seventy-fifth and eightieth birthdays.

William Rubin, who knew Picasso and was a premier documenter of the artist's work and life, continued Barr's example. The research informing the entries written for a 1972 publication on the Museum's Picasso holdings set new standards for scholarly excellence and represent to date the most comprehensive analyses of individual works in the collection.

This publication was followed in 1980 by Rubin's landmark Picasso retrospective, which filled the entire Museum, and the more specialized but equally revelatory *Picasso and Braque* and *Picasso and Portraiture* exhibitions in 1989 and 1996, respectively. The latter exhibitions are formidable examples of Rubin's interest in tackling particular art–historical "problems," the first, focusing on a particular style more formalist in its approach, the second, because of its closer ties to the artist's biography, more psychological.

Elderfield's contribution to the study of Matisse at the Museum in the wake of Barr is equally manifest in his publication on Matisse in the Museum's collection of 1978 and in his exhibition devoted to the artist's drawings, culminating in the seminal 1992 *Henri Matisse: A Retrospective*, the only other occasion on which the museum was turned over entirely to the presentation of one artist's work. Not quite sixty years after Barr's first Matisse exhibition, Elderfield took an approach very different from Barr's formalism of stylistic development by critically introducing the comparison with Picasso as an underlying condition of an evaluation of Matisse and critiquing the existence of a set of oppositional stereotypes that have shaped the images of both artists since the early days of their rivalry. This system of "analogous oppositions" of style, sensibility, and personality constitutes, as Elderfield argues in the exhibition catalogue, the very basis of our understanding of modernism. But it is not only modernism that is at stake: "The ultimate antagonism between Matisse and Picasso . . . tells of competing claims on a reality to which each assumes privileged access. . . . The sequence of opposed analogies comes down in the end to anciently contrasting views on the world that determine its reality." Thus departing from the stereotypical definition of the artists' relation to the visual world in which Matisse is defined as an "iconophile" and Picasso as an "iconoclast," Elderfield draws from a multiplicity of methodologies to introduce a synthetic reading of Matisse's art. He analyses the dominantly visual aspect of Matisse's art in relation to underlying textual, conceptual, physical, and constructive elements, in an attempt to try to "see Matisse whole," independent from chronological guideposts.

Finally, in 2002, *Matisse Picasso,* organized by a team of six curators, among them Elderfield and Kirk Varnedoe, set the scene for a unique and unparalleled visual dialogue between these two giants of modern art, thus breaking the lofty isolation of their genial celebration in one solo exhibition after another and introducing the idea of a complex artistic and personal dialogue that informed the work of Matisse and Picasso throughout their lifelong careers. Confirming their status as the two most important and influential artists of the early twentieth century, this relational reading also imbued them with a new humanity which made it possible to realize what Barr felt was impossible to do during his tenure as Director: an exhibition of Matisse and Picasso together at the same time.

— *Claudia Schmuckli*

Matisse

Henri Matisse

Dance (First Version). 1909

Illustrated on page 71

Henri Matisse

Still Life with Aubergines. 1911

Illustrated on page 72

John Elderfield, *Henri Matisse: Masterworks from The Museum of Modern Art,* **1996,** page 146

Kirk Varnedoe, *Masterworks from The Louise Reinhardt Smith Collection,* **1995,** page 28

On March 31, 1909, [Sergei] Shchukin wrote to Matisse from Moscow confirming the commission of two large decorative panels, *Dance* and *Music* (now in the Hermitage Museum). Shchukin had just returned from Paris, where he had seen the first version of *Dance,* which Matisse had painted very quickly in March 1909, in the hope of obtaining this important commission.

Matisse's conception of the subject of *Dance* is an ancient one, going back to Greek red-figure vases, but his immediate source was the ring of six dancers in the background of his arcadian composition of 1905–06, *Le bonheur de vivre.* Underdrawing visible beneath the paint in the lower left section of the present painting shows that Matisse began it with six figures before reducing it to five. We are given to suppose that the dance takes place on the top of a hill, but Matisse insisted: "When I put down green, that doesn't signify grass; when I put down blue, that doesn't mean sky. . . . All my colors sing together, like a chord in music." It was the expressive, not the depictive attributes of the colors that were important to him.

The depicted subject did have important contemporaneous associations. In 1909, Sergei Diaghilev arrived in Paris, and Isadora Duncan danced there—for the Symbolist generation, dance was the art in which form and meaning were organically combined. Matisse uses this subject to shape the form of the painting. Dancers and painting cohere simultaneously in the form of the dance. Yet his great painting is a landmark for additional reasons. Its extreme flatness, totally nonillusionistic space, and highly abstracted and schematic means of representation open the surface and expand it to the experience of color in a way virtually unknown in Western painting since Byzantine art.

When Matisse showed this painting at the Salon d'Automne of 1911, referring to it as an *esquisse décorative* (decorative sketch), the critic Louis Vauxcelles felt deprived. "Let's be frank," he said, "There's practically nothing there." He assessed the picture as a quick preparatory sketch and held that Matisse had no business showing it. "If that continues," Vauxcelles said, "Matisse will soon give us a blank canvas." Though we may disagree about the conclusions the critic drew—there is a great deal to give up here before one approaches virgin fabric, and the loose thinness of the handling now seems pleasurably agitated—he was right in one respect. This was very likely a preparatory study for a much larger and more ambitious picture, the *Interior with Aubergines* now in the Musée de Grenoble; in that large interior the same arrangement of eggplants, pears, vase, and sculpture sits on a table before the same fabric-draped screen in the center of the room.

There are, however, enormous differences between the conception and feeling of this sketch and the larger, far more expansive and crowded picture. The distemper paint of the *Interior* is matte and opaque, in contrast to the soaking, thinned-out medium here, which allows the agitation of every stroke to become a part of the decorative pulse of the scene. Where the larger picture is built in terms of emphatic contours, linear patterns, and silhouettes, in [this] picture the energy of line is decidedly secondary and forms are more often fringed with breathing zones of canvas. Everything is also in higher key here: a more powdery blue dominates against a lighter green in the main fabric, and the secondary cloth to the right is more yellow here, but more ochre in the full interior. The creamy tones of the vase and the white plaster figure are also far closer here—this seems to have occasioned the extraordinary aura of blood-red strokes that set off the miniature man.

Matisse frequently included his own sculpture in his still lifes, but the plaster figure here is apparently an example of the *écorché* (flayed figure) used frequently in art schools as a guide to anatomy (and then thought to be by Michelangelo). As various Matisse scholars have pointed out, [Paul] Cézanne once included this *écorché* in juxtaposition with a plaster Cupid, in a still-life painting Matisse could well have known. In the Cézanne as well as here, the flayed figure seems to introduce—perhaps as a surrogate for the artist—a suffering human presence. John Elderfield has suggested that when painting in Collioure in the summer of 1911, Matisse transferred the splendor of the sunlit southern landscape, which had formerly dazzled him, into this picture and the large *Interior*, and that, within the context of a synthesized domestic paradise, this agonized human presence takes on more substantive meaning.

Henri Matisse

Moroccan Garden. 1912
Illustrated on page 73

Magdalena Dabrowski, *French Landscape: The Modern Vision*, **1999,** pages 128, 129

In the decades around 1900 . . . the South of France exerted a magnetic pull on the modernist painters of the north. In January of 1912, Matisse went farther south still, following in the footsteps of [Eugène] Delacroix eight years earlier and making the first of two trips to Morocco.[1] His visit—he stayed until mid-April—coincided with the signing of the Treaty of Fez, on March 30, 1912, which made Morocco officially a French protectorate. Elements of life in Tangier during this period must have been heavily influenced by French culture, and familiar to Matisse; but there was also the visual heritage of the Arab or Moorish history, not to mention the light and heat of North Africa.

Matisse's visit to Morocco was clearly very rich, and left a deep impression on his work. Many years later, in a letter to his publisher Tériade of July 1951, he claimed that travel had essentially given him nothing except a new perception of light, but added, "The voyages to Morocco helped me . . . make contact with nature again better than did the application of a lively but somewhat limiting theory, Fauvism. I found the landscapes of Morocco just as they had been described in the painting of Delacroix and in Pierre Loti's novels. One morning in Tangiers I was riding in a meadow; the flowers came up to the horse's muzzle. I wondered where I had already had

a similar experience—it was in reading one of Loti's descriptions in his book *Au Maroc*."[2]

Matisse had visited Algeria in 1906, and had subsequently begun looking carefully at African art and had seen exhibitions of Islamic art (at the Musée des Arts Decoratifs, Paris, in 1907, and then in Munich in 1910). He had become increasingly interested in the traditions of the decorative arts, and after 1908 he had begun painting large compositions in which he tried to unite the harmonious well-being of the decorative with the philosophically ambitious traditions of painting. His stay in Morocco catalyzed this interest, and in the group of Moroccan landscapes that includes *Periwinkles/Moroccan Garden*, he tried to combine elements of the nature he saw in North Africa with the use of a decorative, arabesque line to organize the pictorial surface.[3] In an interview of 1925, Matisse remarked, "Slowly, I discovered the secret of my art. It consists of a meditation on nature, on the expression of a dream, which is always inspired by reality."[4]. . .

Periwinkles was methodically planned; an underdrawing in pencil, which remains quite visible, was then followed in paint. Matisse uses large areas of unmodulated color, devoid of incidental detail, and unifies them with swirling arabesque lines. These arabesques link the work to the Orientalist tradition, as does the sense of lush, tropical vegetation, and the color scheme—the thin layers of salmon pinks, the light and dark greens, the ochers, and the touches of periwinkle blue, all suffused with light and mellowness. The composition is almost abstract in its interplay of hard-to-identify color shapes. As landscape it is nonspecific, another of Matisse's personal visions of a timeless Arcadia, yet it is at the same time based on a real place that must actually have seemed to the artist an exotic paradise. Once again, a new locale had produced a new modern vision of landscape.

Henri Matisse

View of Notre Dame. 1914
Illustrated on page 74

Anne Baldassari, *Matisse Picasso*, **2002,** pages 125, 126

From his studio window at 19 quai Saint-Michel, Matisse, from the onset of the century, was able to choose for motif the cathedral of Notre-Dame.[1] When he began *View of Notre-Dame* in 1914 Matisse was watching the irresistible explosion of springtime in Paris, and would once again, in his own manner, go out "to the motif.". . . Matisse decides *in situ*, in a major and unprecedented stylistic change, to adapt a

principle alien to his own pictorial idiom. When he says "A rapid translation of the landscape can only give a moment of its life duration. By insisting on its character, I prefer to risk losing some of its charm and gain more stability,"[2] his statement had much in common with [Pablo] Picasso, who declared: "In my case painting is a sum of destructions."[3] In this respect both artists rise up in opposition to the Impressionist option as set out by [Stéphane] Mallarmé: "I seek only to reflect on the lasting and clear mirror of painting that which lives perpetually, and yet dies at each instant, that which exists only in the will of the idea, and yet which constitutes the sole, authentic and certain advantage of nature: the Aspect."[4] This immanent presence to the world can be considered to constitute the lost paradise of modern painting to which Matisse, before breaking free by the "mechanics of painting,"[5] once again submits himself by painting a naturalistic painting with luminous and airy accents. "What happiness to be an Impressionist. This is the painter in the sheer innocence of painting," as Picasso describes his native state.[6]

In *View of Notre-Dame*, the landscape is exactly framed by the rectangle of the window. Matisse has given the work the physical dimensions of the window, not only enclosing its frame and shutter within the painting, but also projecting the chequered pattern of its panes upon it.[7] The painting has thus quite literally made the point of view its object.[8] We are not viewing the simple coinciding of interior and exterior landscapes, but a homothetic relation between painting and the frame or stretcher of vision. The structural graph superimposing the triangular geometries composed by the window frame and the lines of force of the landscape are marked up in black on monochrome blue.[9] Painted in large, free brushstrokes, this blue lets the ground that has been left unpainted show through. As a pictorial palimpsest, the half-erased lines reweave the naturalistic version of the motif, and the square shape of the cathedral appears superimposed like a section drawing on the previous perspective view of the building. This underlying presence of the original image results in the final painting being abruptly projected forward, turning it into a surface phenomenon.

The functioning of the painting on two levels calls up the dialectic of planes in Picasso's *papiers collés*, playing on the disparity of codes and meanings. By superimposing naturalistic and synthetic notations, Matisse achieves a visual back and forth movement similar to Picasso's reworking of figure/ground and surface/depth relations. Matisse also gave predominance to voids over filled spaces in composition, which marked with the *papiers collés* a clear affir-

mation of the physical base, its format and materiality, as the primary prerequisite of vision. Besides the primacy of the surface and the void and the superimposition of levels of representation, *View of Notre-Dame* also borrows from Picasso's Cubism the oblique line at the heart of the painting. . . .

From different directions, Matisse and Picasso set down the same claim: nature must henceforth be set at a distance and the painting is the place for this distancing.[10] The Impressionist artist identifying with the world by effusion with it and through the loss of self, gives way to the modern painter, solitary, cut off from nature, absorbed, in competition with reality, in a self-referential elaboration of signs.

Henri Matisse
Goldfish and Palette. 1914
Illustrated on page 75

John Elderfield, *Henri Matisse: Masterworks from The Museum of Modern Art,* **1996,** page 80

The most puzzling zone of this remarkable painting is that to the right. However, in a postcard to the painter Charles Camoin, Matisse explained that it contains "a person who has a palette in his hand and who is observing." The reverse of that postcard comprised a reproduction of Albrecht Dürer's famous print of *St. Jerome in His Study*, where the saint is writing beside tall vertical windows, with a band of shadow between them. There is something utterly ascetic about Matisse's work, too. It looks back to the subject of his *Goldfish and Sculpture* of 1912, yet the grace and lightness of the earlier work has turned into severity and barely relieved darkness.

Goldfish and Palette was painted in a period when Matisse was in close contact with Cubist artists, especially with Juan Gris, whose influence may be discovered in the triangulated, cage-like treatment of the upper right corner. Matisse's painting is anti-Cubist, however, in the sense of the light it provides. The dark vertical band that connotes interior shadow is warmed by underpainting and by the soft mauves and greens of the partly scraped-over legs of the table on which the still life stands. The screening of the window created by this band traps space inside of the room, and prevents the window from opening optimistically onto the outside world. Indeed, outside the limits of this band nearly everything is cold and severe. Within it, however, the rich orange-and-yellow fruit and especially the red-and-magenta goldfish radiate a brilliant light that seems to infuse the scumbled white of the tabletop and the milky water

of the aquarium. In the first winter of the Great War, Matisse evokes nostalgic memory of earlier, more joyous versions of the same theme.

Henri Matisse
The Moroccans. 1915–16
Illustrated on page 76

Alfred H. Barr, Jr., *Matisse: His Art and His Public,* **1951,** page 173

The Moroccans was composed from memories of the winters of 1912 and 1913 spent in Tangier. The picture is divided into three sections, separate both as regards composition and subject matter: at the upper left one sees a terrace or balcony with a pot of large blue flowers at the corner, a small mosque beyond, and, above, the lattice of a pergola; below, on a pavement, is a pile of four yellow melons with their great green leaves; and at the right are half a dozen Moroccans, one of them seated in the foreground with his back turned, the others, extremely abstract in design, are reclining or crouching with burnouses drawn over their heads. These three groups might be described as compositions of architecture, still life and figures. They are like three movements within a symphony—with well-marked intermissions—or perhaps three choirs of instruments within the orchestra itself.

The three major groupings in the composition of *The Moroccans* are . . . isolated . . . and . . . ordered around an empty center and against a background which is two-thirds black with a left-hand third in color—though as Matisse remarked . . . he was using black as a "color of light" not darkness. The black in *The Moroccans* in fact does seem as brilliant as the lavender. . . . Linear perspective is almost eliminated, the artist having silhouetted the objects in tiers as in an Egyptian relief. He does however diminish the more remote forms, thereby implying distance without sacrificing the clarity and immediacy of the images.

The six colors, blue, plaster white, green, violet pink, black and ochre, are carefully balanced, interlocked and distributed. The two most positive of them, the green and the violet pink, are not only complementaries but are disposed on opposite sides of the canvas in vertical and horizontal areas. . . .

The analogies and ambiguities which enrich the composition of *The Moroccans* are ingenious. The four great round flowers in the architecture section echo the four melons in the still-life section. Yet these melons are so like the turban of the seated

Moroccan in the figure section that the whole pile of melons with their leaves has sometimes been interpreted as Moroccans bowing their foreheads to the ground in prayer. At the same time, to complete the circle, some of the figures are so abstractly constructed as to suggest analogies with the architecture section.

Thus Matisse, in one of his greatest paintings, sets up a polyphony of both formal and representational analogues.

Henri Matisse
Odalisque with a Tambourine. 1926
Illustrated on page 77

John Elderfield, *Henri Matisse: Masterworks from The Museum of Modern Art,* **1996,** page 147

In this painting, the model Henriette Darricarrère holds a pose akin to one we see in contemporaneous lithographs of her and in the sculpture *Large Seated Nude,* begun around the same time that the painting was made but not completed until four years later.

We know from photographs of Matisse's studio that this painting hung on his wall while he was working on the sculpture. The painting's densely worked, impastoed surface—the paint piled upon the bodily mass has a tactile presence that is unusual among the paintings of this period—as well as its clay-like tonality, associate it with sculpture. . . . The pinkish, gauze wrap around her shoulders and the eponymous tambourine with a red edge in the background tell us that Henriette is playing the part of an odalisque, which information serves to soften and eroticize the image.

The painting is not without its anecdotal details. The white curtain to the right of the open window is moved by a breeze. The model clutches her right leg in order to maintain a difficult pose. Yet the details that more properly engage our attention are those formed by the interlocking slabs of the paint that model the surface, some fully specific in their description, others hardly signifying at all. Here, Matisse shows himself to be a much tougher, more abstract painter in the middle of the Nice period than he is usually assumed to be.

Henri Matisse
Woman with a Veil. 1927
Illustrated on page 77

Isabelle Monod-Fontaine, *Matisse Picasso,* **2002,** pages 247, 248

It is precisely *Woman with a Veil*, painted in 1927 with Henriette, Matisse's principal model throughout the 1920s, as sitter, that closes [the] first Nice period of his career (1918–27). It is the last painting for which she posed, and it is indeed about leave-taking. The end of Matisse's relationship with this model coincides with the end of a long sequence of painting, quite homogenous in fact, and with respect to which *Woman with a Veil* stands out distinctly. Henriette had most often posed nude, or attired in nothing more than exotic accessories (veils, thin transparent blouses, bouffant pants or jewellery), transforming her into an odalisque. Here she is dressed from head to toe, from the pill-box hat extending into an invisible veil enclosing and splitting her face in two, to the chequered loose-fitting outfit hiding almost all of her body, leaving only the flesh of an arm bare. Matisse had generally painted her reclining, the gaze distracted or empty, the eyes depicted by two black almonds. Here she gazes intently at the artist, squarely eye to eye: her status as model has changed. By returning the gaze of him who had held her under it, the object of delight becomes once more the partner in a less strangely unilateral exchange, more balanced, but still not devoid of tension. In this respect, and this respect only, the sleeping Marie-Thérèse paintings [by Pablo Picasso] rehearse (almost to the point of embarrassment) the paroxysm of offered submission in some of Matisse's paintings of the 1920s.

For once, then, the face of Henriette Darricarrère—or to be more precise the motif of her face leaning on her arm—is the center of the painting. *Woman with a Veil* is thus one of the few painted portraits of Henriette, for Matisse had also drawn her often, sometimes in close-up. Between 1925 and 1929, he also did three versions of a sculpted portrait, three heads of Henriette[1] which are closely related to *Woman with a Veil*.

What indeed is most impressive about this painting is its sculptural quality, the insistence on the modeling of the face and arm, especially in the area where cheek and hand touch, on the shadows highlighting the huge rounded forehead, and on the roundness of the arm that seems to set off the face, supporting it as would a base, as though the *Jeannette* heads (see pages 78, 79), perched on top of their long

necks, were unconsciously coming back to haunt the pictorial process. The non-colour, an olive greyness chosen to render the flesh of the face and arm, heightens the impression of sculptural weight. . . .

Yve-Alain Bois goes as far as to consider that *Woman with a Veil* "reaches out to Cubism as efficiently as the works of the teens had engaged in a willing dialogue with it."[2] At least two elements do, in my view, appear to reinstate the relationship with Picasso interrupted since the war,[3] or even to address themselves directly to him. First of all there is the importance given to the rendering of volume, to the work of the "sculptor-painter,"[4] with the ensuing consequences for the use of colour, less striking, less "bouquet of anemones" than it had been during the first years of the Nice period. The second Picassian element in the painting is the criss-crossed bipartite piece of clothing, coloured half green and half red. This type of reversal is indeed rather Cubist in conception, all the more so given its reprise in the colours of the armchair, yellow on the left side and pink on the right, and especially in the face, neatly set off into two dissymmetrical zones of light and shadow. The central shadow, moreover, is so strongly highlighted that it can almost induce a simultaneous face and profile reading, following a motif often used by Picasso.

Henri Matisse
Jeannette, I, II, III, IV, V. 1910–16
Illustrated on pages 78, 79

Beatrice Kernan, in *Modernstarts,* **1999,** pages 71, 72, 73

In 1910 Matisse began the extraordinary series of Jeannette heads, works that give astonishing plastic form to his articulated theories. The five heads of Jeannette were created at uneven intervals, over a six-year period. It has been said that each work in the series is both complete and provisional.[1] Each is an independent work of art; and each is also an integral part of a series that developed organically as one completed work, spawned or inspired a successor, until the sequence reached its unpredestined end.

The earliest works in the series, *Jeannette (I)* and *Jeannette (II)*, are portraits made from the model in early 1910. The sitter, Jeanne Vaderin, was a young woman recovering from an illness and Matisse's neighbor in the Paris suburb of Issy-les-Moulineaux. She is also the subject of the painting *Girl with Tulips* (Hermitage Museum, St. Petersburg) and its charcoal study. *Jeannette (I)* shares with the drawing

graphically delineated, handsome features—asymmetrical eyes, strongly articulated brows, and an aquiline nose—set within a carved oval face. The relative conservativism and restraint of *Jeannette (I)* may be owing to Matisse's somewhat tentative address to full-scale portraiture in the round, a genre in which he had only once previously worked, ten years earlier. *Jeannette (II)*, modeled from a plaster cast of *Jeannette (I)*, is more animated and broadly conceived. The adaptations simplify and synthesize: the neck is surgically removed to focus attention on the head; the hair is massed, the brow and oval cheeks smoothed, and the arching nose is given new prominence, its sweep reinforced by a rising continuous line that divides to form eyebrows. *Jeannette (I)* and *Jeannette (II)* form a pair and partake somewhat in the dialectic that informs Matisse's paired, or partnered, paintings, where a particularized first version is followed by a more synthetic, second work.

With *Jeannette (III)*, completed the next year, the portrait project is radically reconceived. No longer tied to the model, *Jeannette (III)* is—like its successors—a freely invented variation, a bold research into the expressive power of construction, volume, and form. The monolithic head is reformulated as a three-part construction of head, bust, and base—an arrangement reinforced by the division of the hair into three volumetric masses and the tripartite orchestration of the eyes and nose. The separate volumes and forms of the head, which adhere in dynamic syncopation in a frontal view, resolve, in profile, in a strikingly unified polygonal whole. Just at the moment when Matisse departs most radically from tradition, he revisits it. The pneumatic volumes of the hair in *Jeannette (III)* appear to find their source in expressive unswept clusters that crown Rodin's *Bust of Henri Rochefort* (1894–98), a plaster version of which Matisse had purchased eleven years before.[2]

In *Jeannette (IV)*, made after the plaster cast of its predecessor, the assertive features of *Jeannette (III)* are enlarged and developed to an exaggerated and animated extreme. Seen in profile, the angular clusters of hair and the carved breakline nose radiate, pinwheel-like, around the carved projecting cheek. The bust and head are narrowed in a frontal view, creating a vertical thrust that is reinforced by the upward gravitation of features. As in *Jeannette (III)*, the rising, burgeoning volumes analogize a flower on the verge of full bloom. The works recall the drawing *Girl with Tulips (Jeanne Vaderin)*, where the metaphorical link between female well-being and fertility and the energy of plant life was, most explicitly, proposed.

Jeannette (V), made as many as five years after *Jeannette (IV)*,[3] is entirely unprecedented in its plastic formal invention. It reveals the liberating influence of Cubism, and of tribal art, not only in its part-to-part organization and its abstraction but also, and more importantly, in the freedom with which Matisse approaches his motif. Taking as his starting point the plaster cast not of *Jeannette (IV)*, as one might expect, but that of the more architectonic *Jeannette (III)*, Matisse excises the hair and flattens the left eye to reassert the head as a single form. He then excavates its core, uncovering its irreducible parts—almost abstract masses and planes, the features in their most elemental form. The plant-woman association of the previous work is here invested with new energy and fecundity.

The Jeannette heads are distinct and autonomous works, just as they are states, or stages, in a progression. The sheer invention of the individual variations—and their coexistence as a group—focuses attention on the process of making and on the process of formation within each work.

The serial progression of the heads is . . . one of increasing intensification and . . . reaches its conclusion in radical synthesis and expression. The serial momentum of the Matisses—self-willed and self-reflexive—produced some of the most innovative formal speculations in sculpture of the twentieth century. The final, culminating work, *Jeannette (V)*, is the most formally and psychologically potent in the series; it is a sculpture of unprecedented daring and concentration, less than two feet in height yet monumental in its contained, expressive force.

Picasso

Pablo Picasso

Boy Leading a Horse. 1905–06
Illustrated on page 80

William Rubin, *Picasso in the Collection of*
The Museum of Modern Art, **1972,** page 34

Late in 1905, Picasso began some studies of figures
and horses, which at first reflected the ambience of
the circus. Soon, however, the varied motifs com-
bined in the artist's imagination to form an image
that evoked a more remote world, pastoral and
antique in spirit. The large work Picasso had in
mind, *The Watering Place,* was never realized,
though a gouache study for it exists.[1] The monumen-
tal and superbly assured *Boy Leading a Horse* is a
full-scale rendering of one of its central groups.

The classical, more sculptural turn that Picasso's
art took late in 1905 was probably influenced by
[Paul] Cézanne, thirty-one of whose paintings had
been exhibited in the Salon d'Automne of 1904 and
ten more at that of 1905. The monumentality of the
boy, whose determined stride possesses the earth, the
elimination of anecdote, and the multiaccented, over-
lapping contouring all speak of the master of Aix.[2]

But Picasso had also been looking at Greek art in
the Louvre, and under this influence he showed him-
self increasingly responsive to the kind of revelatory
gesture that is the genius of classical sculpture. In
the *Study for Boy Leading a Horse* in the Baltimore
Museum of Art the youth directs the animal by plac-
ing his hand on its neck; but in later studies and in
the final painting Picasso chose a gesture whose
sheer authority—there are no reins—seems to com-
pel the horse to follow. This "laureate gesture," as it
has been called, draws attention by analogy to the
power of the artist's hand.[3] Sculptures of idealized,
striding male nudes were given as prizes to the win-
ners of the ancient Olympics; that Picasso intended
to allude to such laureates can be shown by tracing
this very model back through *Girl on Horseback, and*
Boy to *Boy with a Pipe,* where his head is wreathed
in flowers.

Picasso's interest in classicism at this time was
probably stimulated by the view of Jean Moréas, a
leader in the neoclassical literary movement that
developed out of, but finally reacted against, Symbol-
ism. Moréas was a regular, along with [Guillaume]
Apollinaire and [André] Salmon, at the soirées that

Picasso attended Tuesday evenings at the Closerie
des Lilas. The painter's search for an antique
image—as distinguished from his contemporary
restatement of ancient themes such as the sleeper
watched—may also have been stimulated by the
painting of [Pierre] Puvis de Chavannes,[4] whose work
was featured along with that of Cézanne in the Salon
d'Automne of 1904. But in *Boy Leading a Horse* we
see that Picasso's classical vision is imbued with a
natural *areté* unvitiated by the nostalgia of Puvis'
"rosewater Hellenism."[5]

In *Boy Leading a Horse* Picasso makes no conces-
sion to charm. The shift of emphasis from the senti-
mental to the plastic is heralded by a mutation of the
Rose tonality into one of terra cotta and gray, which
accords well with the sculpturelike character of the
boy and horse. The pair is isolated in a kind of
nonenvironment, which has been purged not only of
anecdotal detail but of all cues to perspective space.
The rear leg of the horse dissolves into the back
plane of the picture, and the background is brought
up close to the surface by the magnificent scumbling
on the upper regions of the canvas.

Pablo Picasso

Bather. 1908–09
Illustrated on page 81

Kirk Varnedoe, *Masterworks from the Louise*
Reinhardt Smith Collection, **1995,** page 32

Painted late in 1908 and early in 1909, this large can-
vas represents one of Picasso's most elaborate and
imposing attempts to expand on the innovations of
the Museum's *Les Demoiselles d'Avignon* by formu-
lating a new anatomy consistent with the precepts
of emergent Cubism. *Bather* followed shortly after
Georges Braque's *Large Nude* (private collection,
Paris), which tackled some of the same problems in
weaker fashion, but it anticipated, in ways both gen-
eral and specific, aspects of Picasso's imagery that
would evolve decades later.

As elsewhere in Picasso's depictions of women . . .
the self-consciously harmonious and seductive grace
implicit in the "beauty pose" collide so incongruously
with Picasso's radical restructuring of anatomy that
the combination yields a disorienting, even grotesque
effect. Part of the shock comes from isolating this

65

impossible personage within such a blandly plausible seaside vista. Instead of uniting figure and ground in the shallow, relieflike array of faceted forms more typical of Picasso's work at the time, the proto-Cubist reconfigurations here are confined by the body's closed contours in a way that recalls the freestanding Cubism of Picasso's one contemporary sculpture—a modeled head that also shares with the *Bather* an atypical dominance of curves and arcs in the articulation of its forms. The antinaturalistic anatomy is then set against a deep, uninflected space, which seems less a vestige of the barren beaches of Picasso's Blue Period than an anticipation of his monstrous visions of monumental bone figures set on oneiric littorals in the 1920s.

In contrast to the colossally ponderous, thick-limbed types who had dominated Picasso's figural work in 1908, this body has a hard musculature that emphasizes the mobile and cleft joints of its relatively spindly limbs. Yet it is disproportionately thickened by Picasso's appending, along its right edge, extra slices of the (in principle obscured) back and far buttock—as if to include a three-quarter rear view as well. These passages appear anomalous: remove them and the figure has a far more consistent and natural, if strangely stylized, anatomy. Leo Steinberg and others have pointed out, however, that their seeming oddity links the *Bather* to Picasso's ongoing obsession with defeating the standard limits of apprehension and optical "possession" by simultaneously depicting the front and back, or visible and invisible, sides of the body. Similarly, Robert Rosenblum has pointed out that, in the sharp separation of light from shadow that divides this face, Picasso first manifested the fusion of frontal and profile views that would later become an important expressive device in images such as the Museum's *Girl Before a Mirror* of 1932 (see page 87). The artist's more "advanced," more fully Cubist reprise of virtually the same pose a few months later . . . has actually lost the pungency of such raw inventions.

Pablo Picasso

Girl with a Mandolin. 1910
Illustrated on page 82

Kirk Varnedoe, *Picasso: Masterworks from The Museum of Modern Art,* **1997,** page 58

During the summer of 1910, Picasso pushed his Cubist stylizations toward a point of near-total abstraction, dissolving solid forms into an open, linear armature of shifting planes. This picture, which was studied (exceptionally) from a posing model, seems by contrast to present an evident dialogue between a shallow architecture of featureless slabs and more traditionally modeled volumes. Scholars have differed as to whether this indicates a transitional work done in the spring, or a work of the autumn in which Picasso began to pull back from the brink of abstraction. Picasso's testimony that Fanny Tellier, the model for this painting, quit prematurely—apparently in protest over the slow progress of the many sessions—adds a further element of doubt. How much further might the painter have elaborated passages like the neck and face, which seem uncharacteristically plain and whole amidst the general fragmentation of forms? The motif of the woman with a musical instrument, set against what appears to be a studio backdrop of canvases stacked against each other, likely derives from similar scenes painted by the nineteenth-century artist J.-B.-C. Corot, which Picasso could have seen in an exhibition in fall 1909. Picasso was drawn to these images of a female model contemplating a work of art in the studio setting, and variations on the theme would recur throughout his career. Corot's atmospherics have been overturned here, though in favor of a Cubist insistence on a gridlike organizing lattice that governs the geometricized facets of both the body and its surroundings. Later works would go much further with the formal puns and analogies that could link mandolins, violins, and guitars to the female body; such stringed instruments would become central, recurring emblems of Cubism. Their presence, here and elsewhere, underlines the strange paradox by which such a radically transforming revolution in art could be realized in terms of the traditional themes and intimate atmosphere of the studio portrait and still life—an explosive cataclysm of representation set forth, in tender chiaroscuro, with the contemplative air of chamber music.

Pablo Picasso

Card Player. 1913–14
Illustrated on page 83

William Rubin, *Picasso in the Collection of The Museum of Modern Art,* **1972,** page 86

Synthetic Cubism is commonly considered less abstract than its Analytic predecessor, but this is true only in a limited sense. The generally greater legibility of its images certainly makes it more representational; but its *schematic* mode of representation is more inherently abstract than the *illusionistic*

mode that had prevailed in Analytic Cubism. Even where the forms in pictures in the latter style are most broken up and difficult to read, they are defined by a kind of drawing and shaping and set within an atmospheric space derived ultimately from the language of pictorial illusionism inherited from the past. By contrast, Synthetic Cubism is characterized by a nonillusionist flatness, which it helped establish as central to the twentieth-century esthetic, and which is in no way undermined by representation per se.

Card Player exemplifies the greater legibility of Synthetic Cubism as against that of the Cubism of 1911–12. The mustachioed player is seated at a wooden table, his legs visible between those of the chair at the bottom of the picture. In his left hand he holds a playing card face up—three are face down on the table—and in his right, a pipe. On the table are a glass, a bottle behind it, and a newspaper. The newspaper masthead is truncated so as to facilitate a triple entendre, its letters serving to identify the name of the newspaper (*Le Journal*), the objective nature of the action (JOU from *jouer*, "to play"), and the subjective nature of the experience (JOI, from *joie*, "joy"). Although the action is indicated in both pictorial and literary ways, the picture is not a narrative one, as are traditional depictions of card playing. Its centrality, frontality, flatness and motionlessness are almost Byzantine, and remind us of the persistently iconic character of high Cubist imagery.

The influences of *papier collé* are . . . evident in *Card Player* . . . The simulated wood graining of the table, the Greek key motif on the wainscoting, the playing cards, the fragment of *Le Journal* and the shapes of the composition in general and of the player's head in particular might each be considered, in effect, a trompe l'oeil of collage. Even the pointillist stippling that represents the shaded side of the player's neck was probably suggested by newsprint or sandpaper, although such stippling is used as a decorative convention for shading in a more freely dosed manner elsewhere in the picture. . . .

The coloring of *Card Player* is . . . typical of Picasso's work in 1913 . . . insofar as the light-dark scaffolding that organizes the picture (passing from white to black through ocher, gray and blue) is more obviously dominant. The saturated red of the left arm and the green of the wainscoting are isolated, bright accents that "season" the picture and are easily absorbed into its prevailing light-dark structure.

Pablo Picasso

Harlequin. 1915
Illustrated on page 84

William Rubin, *Picasso in the Collection of The Museum of Modern Art,* **1972,** page 98

At the end of 1915, when Picasso painted this monumental, disquieting *Harlequin*, his beloved Eva lay dying in a hospital on the outskirts of Paris. In a letter of December 9 to Gertrude Stein, the artist spoke of his anxiety over Eva's illness and described himself as having little heart for work—or even time for it, as he spent much of the day commuting to the hospital by *Métro*. "Nevertheless," he concluded, "I have done a painting of a harlequin which in the opinion of myself and several others is the best thing I have ever done."[1] This remark, quite uncharacteristic of Picasso, is an indication of the importance he attached to *Harlequin*, a painting which indeed marks the redirection of Synthetic Cubism on the specifically personal path that would culminate six years later in *Three Musicians* (see page 85).

In addition to personal tragedy there was the war. . . . That Picasso should have chosen to paint a commedia dell'arte figure at a time of deep personal and general social distress might seem merely a confirmation of the customary hermeticism of his imagery. But a hostile spirit that may well reflect the tenor of the times has slipped into this *Harlequin*. The decorative character of the red, green and tan costume is neutralized by the rigid rectilinearity of the configuration and the somber blacks of the background and figure, which permit chillingly stark contrasts of black and white. In this setting, Harlequin's toothy smile seems almost sinister.

The planes of *Harlequin* are flat, unshaded and broadly brushed in a manner appropriate to the scale of the work. There is, however, a purely schematic and quite whimsical contradiction of this flatness in the parody of perspective by which the diamond shapes of Harlequin's costume increase in size from right to left, a suggestion of bulging reinforced by the curve of his belt. . . .

The stylization of the light and shaded areas of figures as contrasting flat planes, already an established convention by the end of 1912, is freely elaborated in *Harlequin* in such a manner that the motley, the blue, the black and the brown-and-white planes all represent the figure, although they are on different levels in space and are tilted on different lateral axes. The angular white side of the head is drolly united with the round black one by their common mouth. Harlequin's white right arm—the fingers

indicated by tiny black lines—leans on a piece of furniture; his left hand—articulated by white dots—holds a rectangular white plane, the freely brushed surface of which gives it an unfinished look. . . .

The pitching of Harlequin's figure simultaneously on four different lateral axes suggests the motion of the dance—specifically, the stiff, angular, mechanical-toy choreography in works like *Coppelia*. This reading is reinforced by the relation of the simultaneity of axes (and, indeed, by the multiplication of planes denoting the figure itself) to the images of dancing couples that date from approximately the time of *Harlequin*.[2] If these studies antedate the painting, they suggest that the configuration of *Harlequin* was arrived at by fusing two figures; at the very minimum, they confirm that Picasso thought of the multiple axiality in terms of a kind of *jaquemart's* dance.

Pablo Picasso

Three Musicians. 1921
Illustrated on page 85

Kirk Varnedoe, *Picasso: Masterworks from The Museum of Modern Art,* **1997,** page 80

In 1921, Picasso summered in the château town of Fontainebleau near Paris. Painting in a rented garage, he dedicated himself to several large canvases, including two versions of this composition (the other is now in the Philadelphia Museum of Art). They were the most imposing works Picasso had conceived in the style of Synthetic Cubism—a style that, in the aftermath of World War I, had come to seem rather outmoded. It was instead the neoclassicism the artist had initiated in the later 1910s (and used in alternating parallel with Synthetic Cubist stylizations) that was being increasingly celebrated, for its timely revivification of noble French and Mediterranean traditions. Indeed, many writers have seen *Three Musicians* as a summation of, and grand farewell to, a passing epoch in Picasso's art. But there may be other reasons, too, for the monumental somberness conveyed by the painting's dominantly dark palette and spectral light, and by the uncommonly grave, iconic address of this three-man band. Noting that the mingling of commedia dell'arte figures with a religious personage evokes a masked ball or carnival occasion, Theodore Reff has argued that Picasso here situated his own favorite avatar, the harlequin, as the guitar player between two poets who were comrades of his youth: on the left, a bulky Pierrot would represent Guillaume Apollinaire, who

had died in 1917, and on the right, a more diminutive masked man in monk's garb would evoke Max Jacob, whose close friendship with Picasso had crumbled years before, and who had in fact entered a Benedictine monastery in the spring of 1921. The Philadelphia version of this nostalgic "reunion," or wake for the artist's bohemian youth, is more brightly upbeat. Here, with a more austere interlocking of broad, zigzagging planes and piquant details (such as the tiny hands), and with the addition of a dark dog beneath, the trio seems to play its jazzlike harmonies in a more muted key. The whimsical freedoms and decorative jauntiness of earlier Synthetic Cubist works persist, but the total air is one of haunting solemnity.

Pablo Picasso

The Studio. 1927–28
Illustrated on page 86

William Lieberman, *Modern Masters: Manet to Matisse,* **1975,** page 244

Although curved contours characterize many of his works of the late 1920s, Picasso passed to opposite and completely linear extremes in *The Studio*. This large and precisely calculated composition of rectangles and straight lines seems at first glance to be an abstract picture. It is not.

We see an artist at work, a theme frequent in Picasso's art. In a room stands the painter, palette and brush in either hand. At the right is his subject—a table, again dressed by a red tablecloth, on which rest a *compotier* with a single fruit and, on a base, a white plaster head. The eyes and mouth of the sculpture are placed vertically, as are those of the artist himself. The sharp, aggressive angles which outline the figure, cloth, bowl, and bust are stabilized by the strict rectangles of the mirror and picture frame on the wall and, at left and right, the larger easel and door. In addition, Picasso emphasizes the rectangular format of the picture by a black line and, parallel to it, a thin strip of frame painted white. The still life on the table is comparable to that in the earlier studio of 1925. Here, however, it is realized completely without modeling or detail and with a flatness of paint as well as of design.

Straight lines, dislocated dots of eyes, thumb hole, and table-leg tips recall drawings by Picasso in 1926 which were engraved as woodcuts and added to his illustrations to [Honoré] Balzac's *Le Chef-d'Oeuvre Inconnu* etched the following year. The spare and linear discipline of the delineation also relates the painting to a specific sculpture of the same period,

notably Picasso's monument to his deceased and beloved friend, the poet Guillaume Apollinaire. The maquette for the monument was constructed in light iron rods.

Pablo Picasso
Girl Before a Mirror. 1932
Illustrated on page 87

Robert Rosenblum, in *The Magazine of The Museum of Modern Art,* **1996,** pages 7, 8

It is before a magical mirror that Marie-Thérèse [Walter] [Picasso's companion in the late 1920s and early 1930s] stands in her most famous transformation, painted on March 14 [1932]. *Girl Before a Mirror* embraces . . . a multitude of symbols . . . which endlessly enriches the traditional motif of feminine vanity before a looking glass. . . .

Marie-Thérèse's head is . . . a marvel of compression, merging, for instance, one of the most pervasive cultural myths about women inherited from the later nineteenth century, the polarity between the virgin and the whore, archetypes that haunted Picasso from his earliest years, when he could alternate between Madonna-like mothers and female creatures of sexual depravity. So it is that the profile view of the head extends to an enclosing contour of white radiance that bleaches the stripe pattern to an ethereal pallor and suggests the chastity of both halo and veil. The half-hidden frontal view, however, becomes a cosmetic mask of sexual lure: the half-mouth lipsticked, the cheek rouged, the skin brazenly gilded. Such a duality, of course, echoes in countless other directions, including the evocative imagery of the sun and moon's cycles around the earth. In this context of astronomical rhythms, it is not surprising that the theme of the girl before a mirror has even been described as "a girl before her mirror image counting the days when her period is due to find out whether or not she could be pregnant, thus becoming connected with the moon and the sun and concerned with giving life and facing death."[1] This intense physiognomic contrast gives visual form to the ever more popularized Freudian concept of clashing but coexisting aspects of the human mind, a tug between the conscious and the subconscious, the overt and the repressed.

Such invisible worlds, imagined by Freud and Jung, plumbed far into a dark, instinctual level that for Picasso, as for the culture into which he was born in the late nineteenth century, seemed far more potent in the female of the species, the procreative goddess who is foretold in this image of a young girl embracing and peering into a destiny that would wed her to the cycles of nature. . . .

If the contemplative girl, in the ripeness of puberty, still appears constrained and virginal in the angular corseting of her swelling body, the uterine image in the mirror releases such repressions, even warping the uncomfortably acute color-pyramid upon which she must support her tensely watchful head. Moreover, the promise of sexual union and procreation revealed in Picasso's familiar genital puns (such as the visual rhyming of upright arm and breasts with erect phallus and testicles)[2] is fulfilled in the mirror, where one breast, part fruit and part ovum, seems fertilized by a black spot, generating a coiling green shoot. And if a life cycle is beginning, it is also ending, for the mirror image is haunted by the specter of death. In fact, Picasso's mirror image almost literally illustrates the English phrase "from womb to tomb": before our eyes, the tough enclosure of burgeoning life, with fetal head and developing internal organs, becomes a mummy's shrouded coffin, with an Egyptoid spirit head painted upon it. And, as always Picasso is observing and guarding his female possession. As Jung had recognized in the same year, Picasso's alter ego might well be identified with Harlequin. Here, in fact, as so often before in his work, the diamond harlequin pattern, now of the wallpaper, can become a coded symbol of the artist's own presence, a heraldic field that proclaims her territory and that, when reaching, at the left, the body of his now mythical beloved, burns with the national colors of Spain, red and yellow.

Matisse

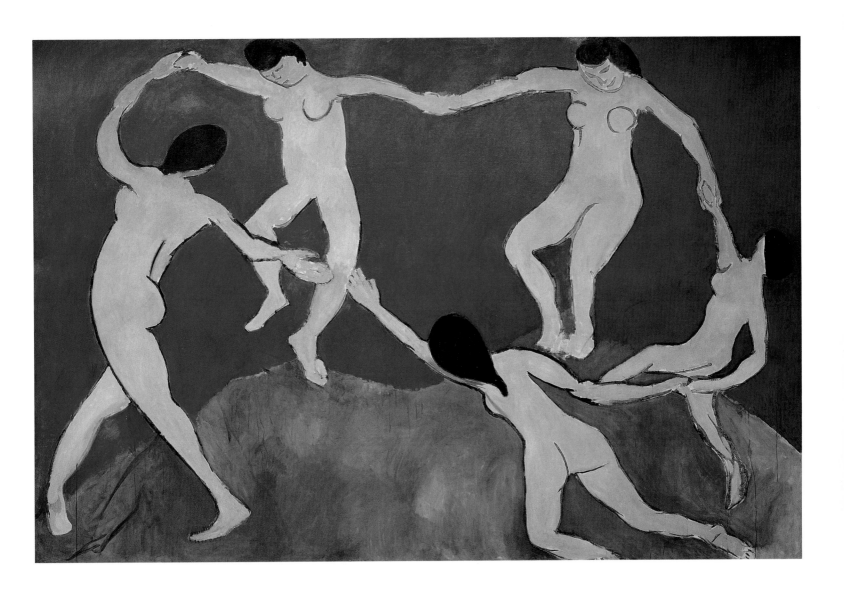

Henri Matisse | FRENCH, 1869–1954
DANCE (FIRST VERSION). 1909
OIL ON CANVAS, 8' 6½" x 12' 9½" (259.7 x 390.1 CM)
GIFT OF NELSON A. ROCKEFELLER IN HONOR OF ALFRED H. BARR, JR.

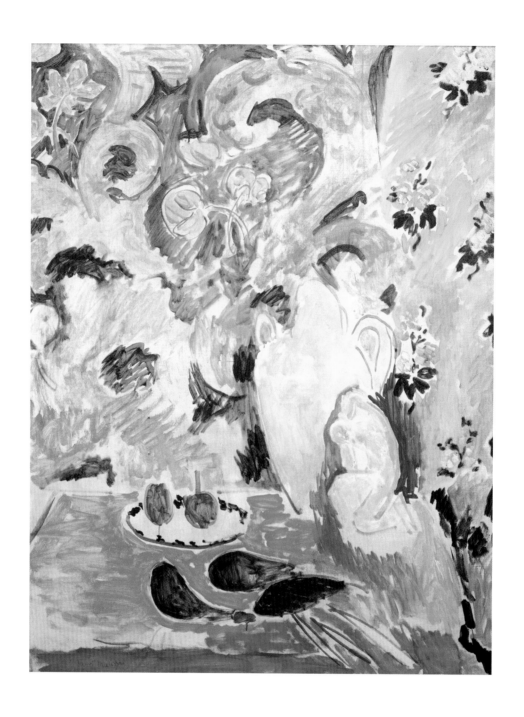

Henri Matisse | FRENCH, 1869–1954
STILL LIFE WITH AUBERGINES. 1911
OIL ON CANVAS, 45¾ x 35⅛" (116.2 x 89.2 CM)
LOUISE REINHARDT SMITH BEQUEST

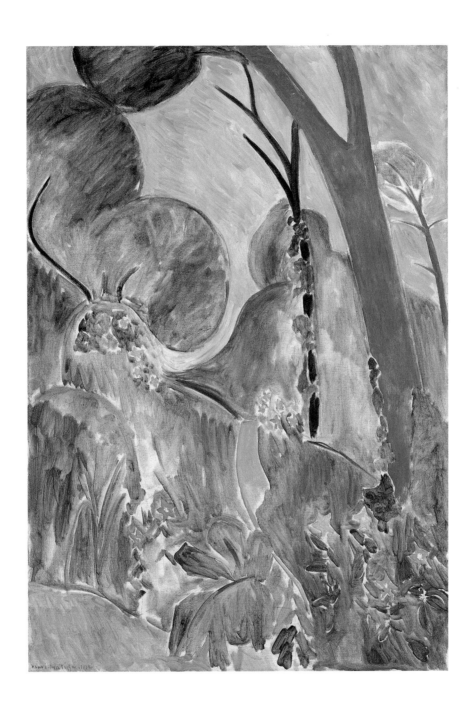

Henri Matisse
MOROCCAN GARDEN. 1912
OIL, PENCIL, AND CHARCOAL ON CANVAS,
46 x 32½" (116.8 x 82.5 CM)
GIFT OF FLORENE M. SCHOENBORN

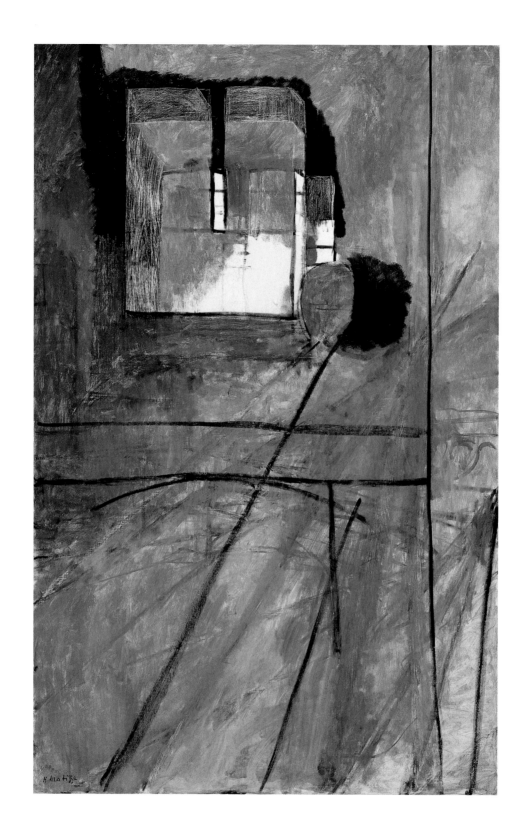

Henri Matisse | FRENCH, 1869–1954
VIEW OF NOTRE DAME. 1914
OIL ON CANVAS, 58 x 37⅞" (147.3 x 94.3 CM)
ACQUIRED THROUGH THE LILLIE P. BLISS BEQUEST, AND THE HENRY ITTLESON,
A. CONGER GOODYEAR, MR. AND MRS. ROBERT SINCLAIR FUNDS, AND THE
ANNA ERICKSON LEVENE BEQUEST GIVEN IN MEMORY OF HER HUSBAND,
DR. PHOEBUS AARON THEODOR LEVENE

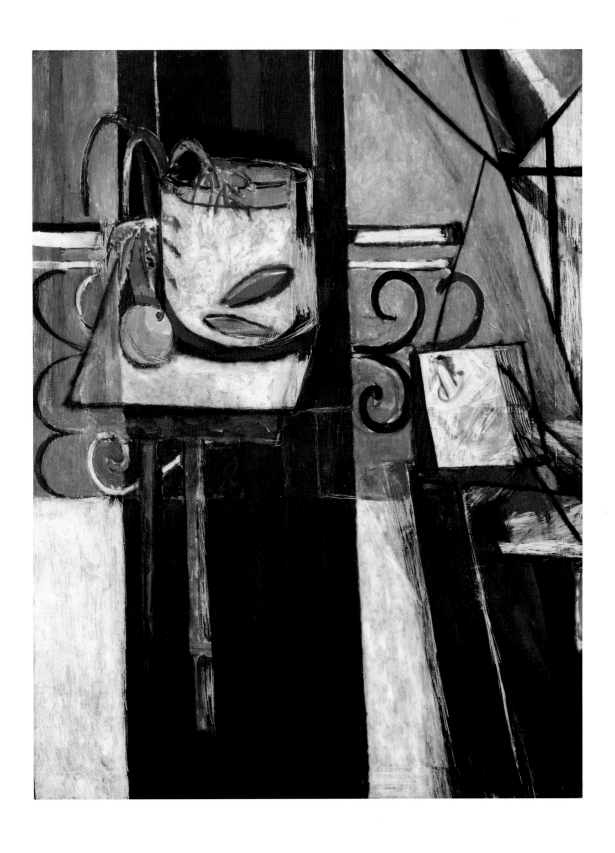

Henri Matisse
GOLDFISH AND PALETTE. 1914
OIL ON CANVAS, 57¾ x 44¼" (146.5 x 112.4 CM)
GIFT AND BEQUEST OF FLORENE M. SCHOENBORN AND SAMUEL A. MARX

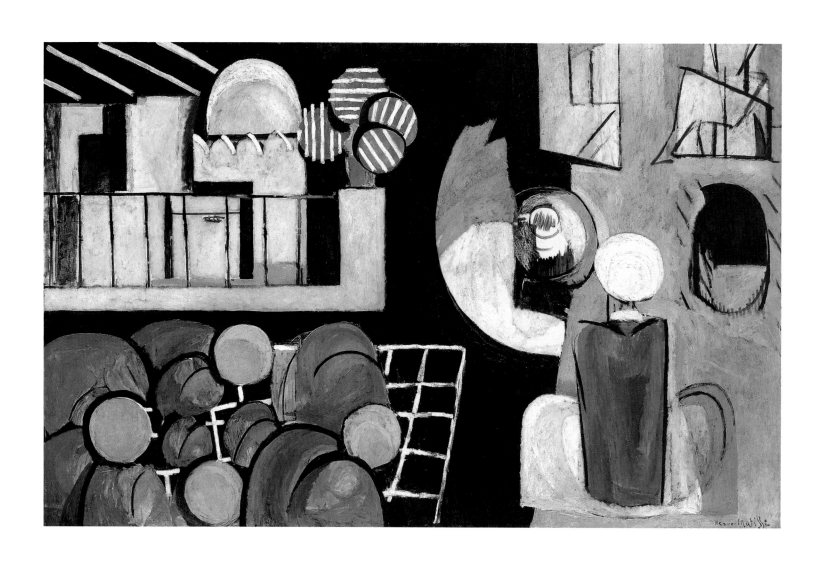

Henri Matisse | FRENCH, 1869–1954
THE MOROCCANS, 1915–16
OIL ON CANVAS, 71⅜" x 9' 2" (181.3 x 279.4 CM)
GIFT OF MR. AND MRS. SAMUEL A. MARX

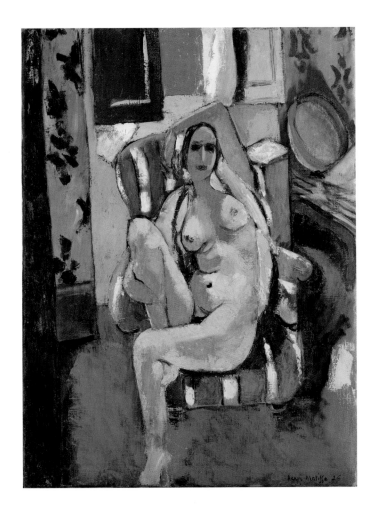

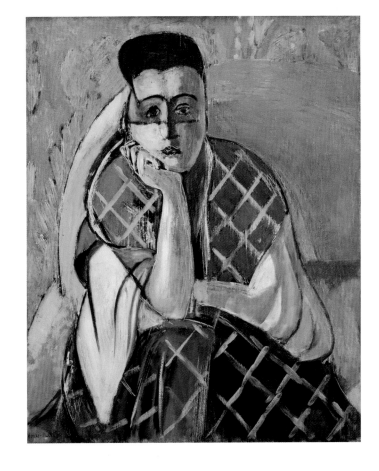

Henri Matisse
ODALISQUE WITH A TAMBOURINE. 1926
OIL ON CANVAS, 29⅛ x 21⅞" (74.3 x 55.7 CM)
THE WILLIAM S. PALEY COLLECTION

Henri Matisse
WOMAN WITH A VEIL. 1927
OIL ON CANVAS, 24½ x 19¾" (61.6 x 50.2 CM)
THE WILLIAM S. PALEY COLLECTION

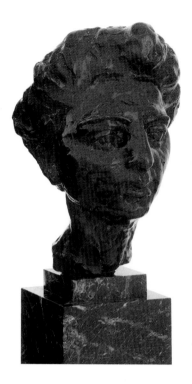

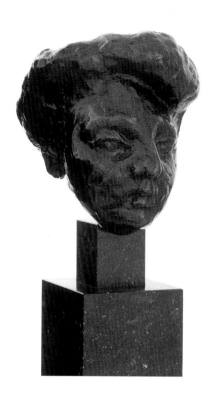

Henri Matisse | FRENCH, 1869–1954
JEANNETTE, I (JEANNE VADERIN, 1ST STATE). 1910
BRONZE, 13 x 9 x 10" (33 x 22.8 x 25.5 CM)
ACQUIRED THROUGH THE LILLIE P. BLISS BEQUEST

Henri Matisse
JEANNETTE, II (JEANNE VADERIN, 2ND STATE). 1910
BRONZE, 10⅜ x 8¼ x 9⅝" (26.2 x 21 x 24.5 CM)
GIFT OF SIDNEY JANIS

Henri Matisse
JEANNETTE, III (JEANNE VADERIN, 3RD STATE). 1911
BRONZE, 23¾ x 10¼ x 11" (60.3 x 26 x 28 CM)
ACQUIRED THROUGH THE LILLIE P. BLISS BEQUEST

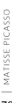

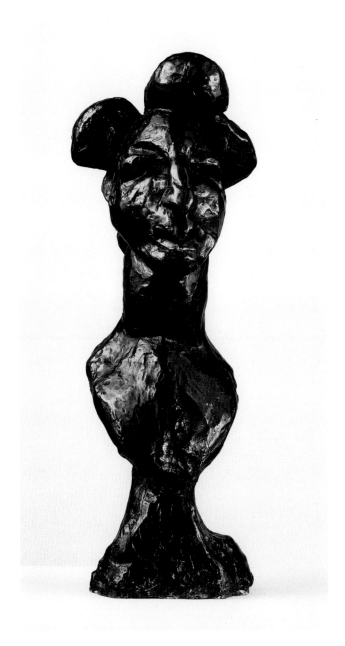

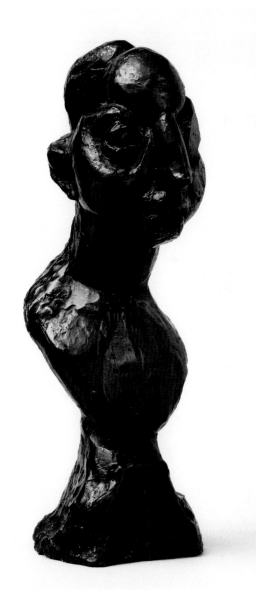

Henri Matisse
JEANNETTE, IV (JEANNE VADERIN, 4TH STATE). 1913
BRONZE, 24⅛ x 10¼ x 11¼" (61.3 x 27.4 x 28.7 CM)
ACQUIRED THROUGH THE LILLIE P. BLISS BEQUEST

Henri Matisse
JEANNETTE, V (JEANNE VADERIN, 5TH STATE). 1916
BRONZE, 22⅞ x 8⅜ x 10⅝" (58.1 x 21.3 x 27.1 CM)
ACQUIRED THROUGH THE LILLIE P. BLISS BEQUEST

79

Picasso

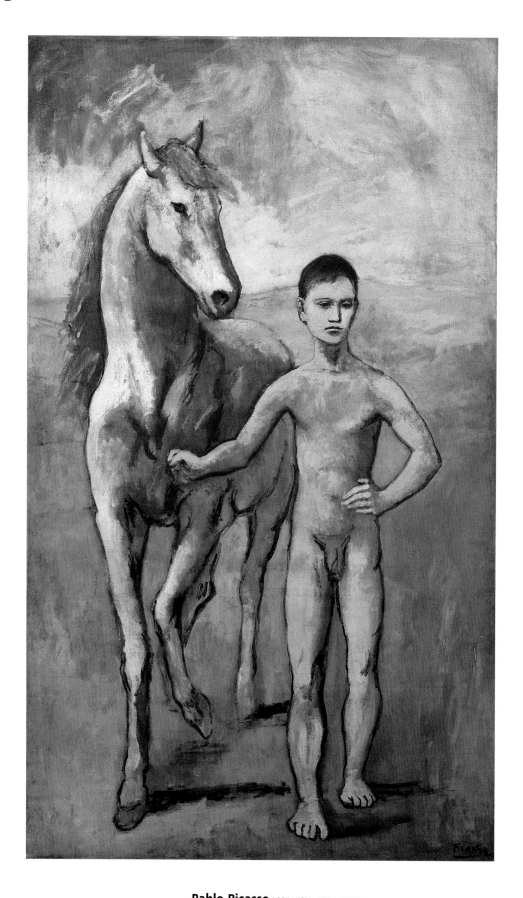

Pablo Picasso | SPANISH, 1881–1973
BOY LEADING A HORSE. 1905–06
OIL ON CANVAS, 7' 2⅜" x 51⅜" (220.6 x 131.2 CM)
THE WILLIAM S. PALEY COLLECTION

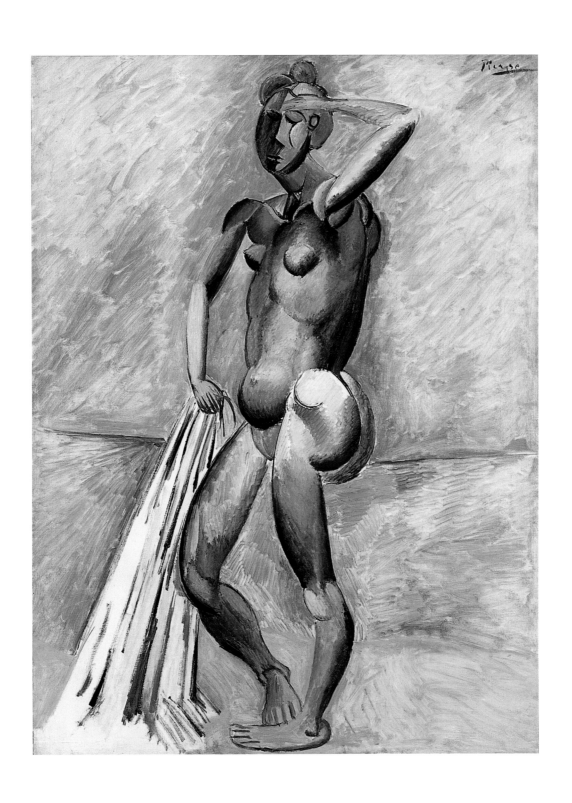

Pablo Picasso
BATHER. 1908–09
OIL ON CANVAS, 51¼ x 38⅛" (129.8 x 96.8 CM)
LOUISE REINHARDT SMITH BEQUEST

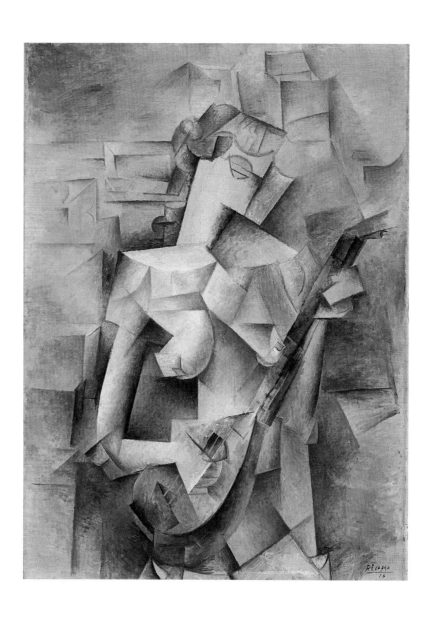

Pablo Picasso | SPANISH, 1881–1973
GIRL WITH A MANDOLIN [FANNY TELLIER]. 1910
OIL ON CANVAS, 39½ x 29" (100.3 x 73.6 CM)
NELSON A. ROCKEFELLER BEQUEST

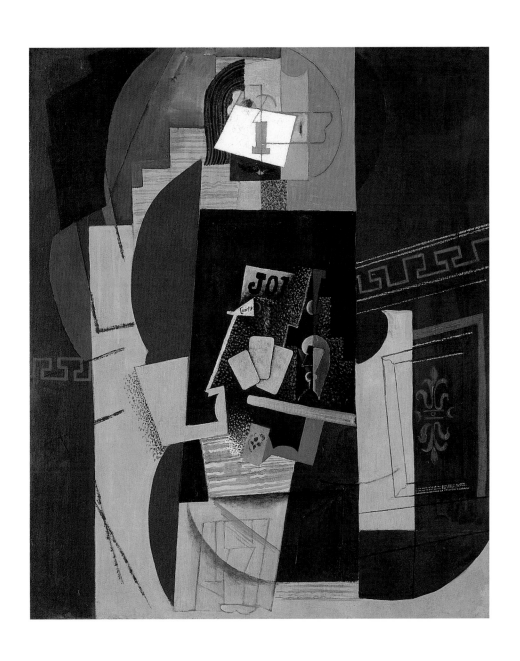

Pablo Picasso
CARD PLAYER. 1913–14
OIL ON CANVAS, 42½ x 35¼" (108 x 89.5 CM)
ACQUIRED THROUGH THE LILLIE P. BLISS BEQUEST

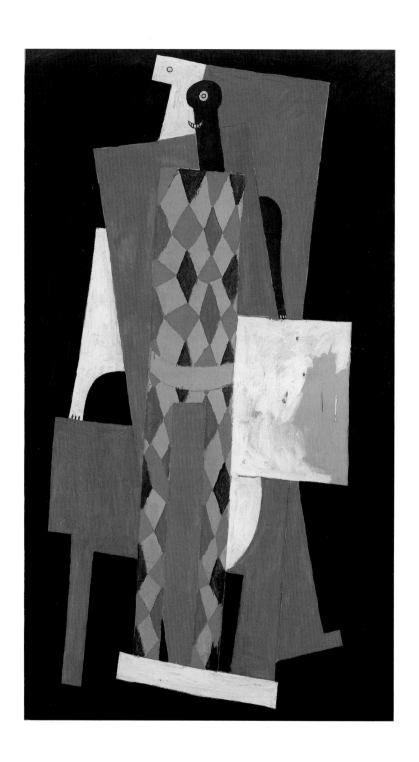

Pablo Picasso | SPANISH, 1881–1973
HARLEQUIN. 1915
OIL ON CANVAS, 6' ¼" x 41⅜" (183.5 x 105.1 CM)
ACQUIRED THROUGH THE LILLIE P. BLISS BEQUEST

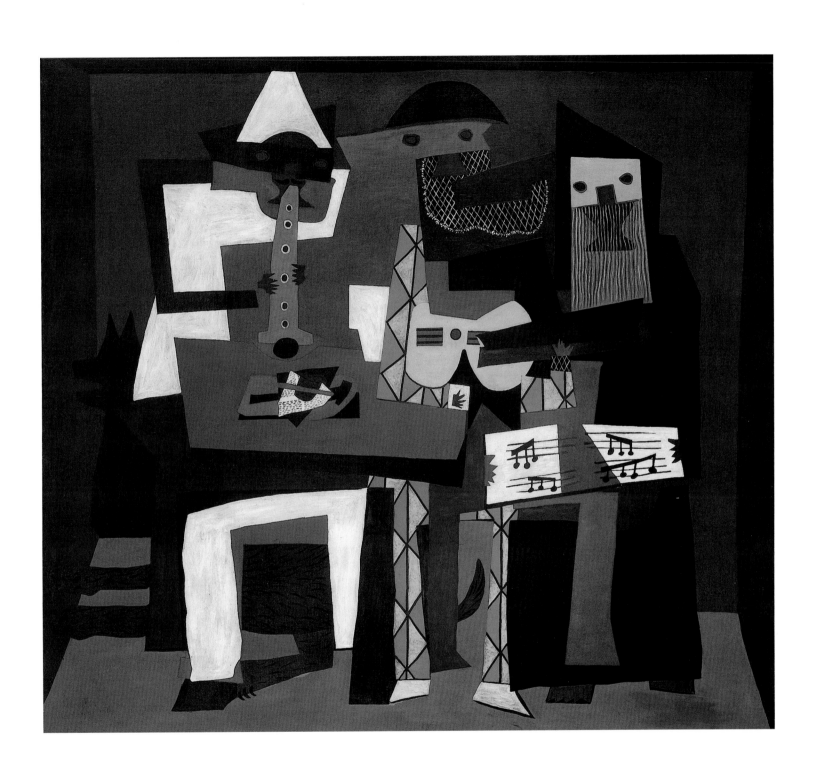

Pablo Picasso
THREE MUSICIANS. 1921
OIL ON CANVAS, 6' 7" x 7' 3¾" (200.7 x 222.9 CM)
MRS. SIMON GUGGENHEIM FUND

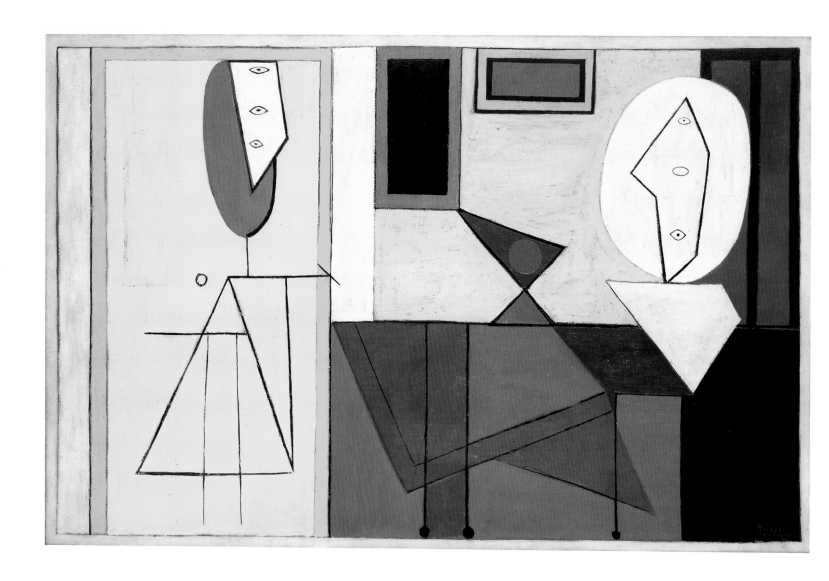

Pablo Picasso | SPANISH, 1881–1973
THE STUDIO. 1927–28; dated 1928
OIL ON CANVAS, 59" x 7' 7" (149.9 x 231.2 CM)
GIFT OF WALTER P. CHRYSLER, JR.

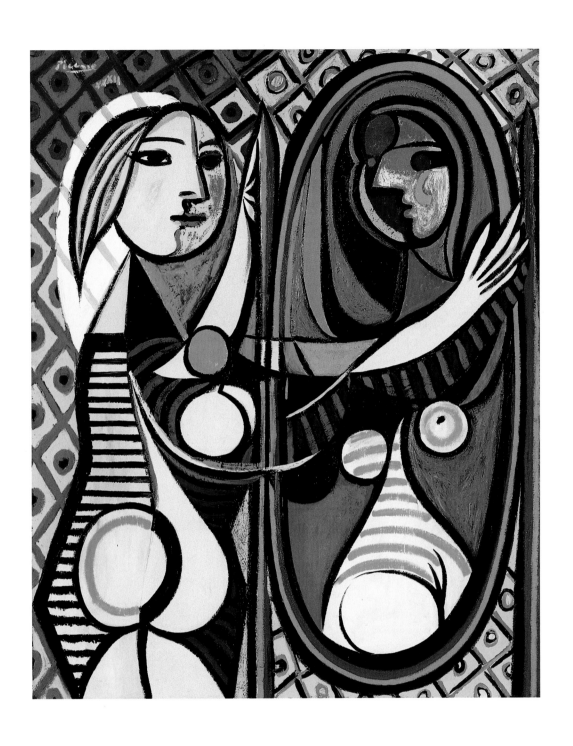

Pablo Picasso
GIRL BEFORE A MIRROR. 1932
OIL ON CANVAS, 64 x 51¼" (162.3 x 130.2 CM)
GIFT OF MRS. SIMON GUGGENHEIM

Cubism and Abstract Art

In 1936 The Museum of Modern Art presented the seminal exhibition *Cubism and Abstract Art*, organized by its Director, Alfred H. Barr, Jr. On the dust jacket of the exhibition catalogue, Barr published his now-famous diagram charting the chronological evolution of two strains of abstract art: the "non-geometrical" stemming from Vincent van Gogh and Paul Gauguin and the "geometrical" deriving from Paul Cézanne and Georges-Pierre Seurat. The works of art included in the present section, dating from 1908 to 1942, can mostly be classified by the "isms" of this latter category, starting with Cubism, branching off into Futurism, followed by Suprematism and Constructivism, Orphism, Purism, and de Stijl. Missing from Barr's account is the development of abstraction in America, an omission justified in his preface by a recent show devoted to the subject at the Whitney Museum of American Art.

Cubism and Abstract Art was a pioneering effort to clarify and systematize divergent aspects of abstraction for a broad public. Barr's type of formalism continued in his writings of the 1940s and 1950s, to a great extent shaping art-historical treatment of twentieth-century avant-garde movements, just as the Museum galleries initiated visitors to its particular narrative of modernism. After Barr's exhibition, the story of Cubism continued to be told by the Museum. However, authors of more recent Museum publications on Cubism have sought to situate the works of art within historical and cultural contexts rather than to focus on the formal innovations of the style. The most notable successor to Barr in the study of Cubism was William Rubin, whose Museum exhibition and catalogue *Picasso and Braque: Pioneering Cubism* (1989) document and illuminate the dynamics of the relationship between these two artists and the extraordinary pictorial invention that resulted from it. Additionally, Rubin's 1972 text on individual Picasso paintings remains among the most eloquent and useful analyses of these oft-discussed works.

Beginning with Barr in the 1930s up to the collection surveys of the 1990s, the Museum's texts on Futurism basically maintain an art-historical analysis. The movement seems not to have engaged the Museum's interest in the way Cubism did. Aside from Barr's 1936 catalogue cited above, there were only two Museum exhibitions addressing the movement in the years following Barr's landmark presentation—*Twentieth-Century Italian Art* (1949) and *Futurism* (1961).

The work of the Romanian sculptor Constantin Brancusi does not fit into any of the "isms" cited above and is included here in a section of its own. A charming anecdote recounted by Barr in 1953 tells of the many sittings Brancusi required of Mlle Pogany, as remembered by the subject herself. Barr's text was part of an announcement of new acquisitions that included this work, which had been offered to the Museum by the sitter (page 124). A more recent acquisition is Brancusi's *Endless Column* (page 125), which was bequeathed in 1983. A special installation of Brancusi's work was shown at the Museum in 1996.

Barr's interest in Russian Constructivist and Suprematist art began as early as 1928, on his first trip to the Soviet Union and one year before he became Director. In 1935 he was able to purchase several Kazimir Malevich compositions in Germany, which he found hidden in a cellar as a precaution against Hitler's confiscation of modern art. One of the works, Malevich's

groundbreaking painting *Suprematist Composition: White on White* (page 127), was featured in a 1942 exhibition in which the canvas was shown with Aleksandr Rodchenko's *Non-Objective Painting: Black on Black* (page 130) for the first time in twenty-three years. Recently (1998) a major retrospective of the work of Rodchenko was shown at the Museum.

De Stijl, a style formed in Holland during World War I, was included in Barr's 1936 *Cubism and Abstract Art* exhibition. Singled out for special notice were the de Stijl artists Piet Mondrian and Theo van Doesburg. A comprehensive retrospective of the work of Mondrian was held at the Museum in 1948, followed, in 1994, by another major exhibition of the artist's work. Barr wrote in 1943 in *What Is Modern Painting?* that Mondrian's pictures affected the design of modern architecture, posters, printing, and many ordinary objects, while James Johnson Sweeney, in his catalogue of the Mondrian exhibition five years later, emphasized the artist's move away from Cubism toward pure abstraction through the reduction of form and color.

Geometric abstract art being produced in France in the 1930s was publicized by a Paris-based group, Cercle et Carré, which hoped to counter the growing interest in and preference for Surrealism. The French artist Sophie Taeuber-Arp and the Uruguayan painter Joaquin Torres-García were both members of this group. In Carolyn Lancher's 1981 Museum publication on Taeuber-Arp, she distinguishes the artist from her contemporaries by her embrace of abstraction, without allying it to any particular doctrine. Professor Florencia Bazzano Nelson's essay in *Latin American Artists of the Twentieth Century* (1993), the first major Museum publication to survey Latin American artists since 1943, is an exhaustive look at the theoretical and metaphysical interests underlying Torres-García's incorporation of Cubism, Neo-Plasticism, and Surrealism to establish an art of "universal values" to bring back to his native country.

In the early years of the Museum, American abstract artists often received little notice. In 1951, responding to an invitation to describe "what abstract art means to me," the artist George L. K. Morris recalls picketing the Museum to protest the lack of paintings on view by American abstract artists, adding that several works by the picketers eventually entered the collection. The Museum was not alone in presenting American modernism in terms of its European predecessors and counterparts since the center of the art world did not shift from Paris to New York until after World War II. Kirk Varnedoe, writing on Stuart Davis's *Odol* (page 138) in 1990, remarks upon the adoption of a French Cubist aesthetic to depict the distinctly American vernacular of advertising and consumer packaging. Holger Cahill, in the earliest reference to Georgia O'Keeffe (*American Painting and Sculpture 1862–1932* [1932]), writes that "Georgia O'Keeffe . . . shows in her work a combination of delicacy and austerity which is essentially feminine." Though obviously characteristic of its time, the above statement is interesting in light of the fact that of the eight women artists chosen for the present catalogue, three are represented in this section by works of rigorous geometric form.

The texts selected for this section of the catalogue document The Museum of Modern Art's commitment to the display of abstract art and to its ongoing mission to enhance the viewer's comprehension of the emergence of abstraction. Beginning in the teens, multiple facets of abstraction were unfolding, either simultaneously with, or in response to, one another. These different modes of breaking with traditional representation cannot be easily subsumed in one account, as evidenced by the multiplicity of directional lines in the midsection of Barr's 1936 chart. Yet, together they convey the radical transformation of pictorial and sculptural language and a questioning of the very materials of its production.

— Mary Chan

Cubism

William Rubin, *Picasso and Braque: Pioneering Cubism,* **1989,** pages 15, 16, 26, 27

The pioneering of Cubism by [Pablo] Picasso and [Georges] Braque is the most passionate adventure in our century's art. . . . Not since Rembrandt's has any painting so captured the elusive shading of human consciousness, the complex anatomy of thought, the paradoxical character of knowledge. . . .

From 1910 through 1912 especially, the incremental advances in each artist's work, and the network of linkages between them, provide what may be the clearest revelation we have had of the nature of pictorial thought. This twentieth-century embodiment of Leonardo's definition of painting as *cosa mentale* was Cubism's most important bequest to subsequent generations, and the work of Duchamp is no less indebted to it than is that of [Piet] Mondrian.[1]

The fact that Cubism unfolded essentially through a dialogue between two artists extending over six years makes it a phenomenon unprecedented, to my knowledge, in the history of art. Not surprisingly, much that has been said about the Cubism of Picasso and Braque turns on the comparative quality of their respective work. To the extent such argument overlooks the more readily quantifiable differences in their styles and methods, however, it seems to me something of a canard. Not that I regard the two artists as equals. Braque is one of the great modern painters, but we must go back to the most prodigious Renaissance masters for the like of Picasso. We have come to expect more from Picasso, and in the Cubist period, under the pressure of the dialogue with Braque, we get it consistently. But the point is that what we get from Braque is not less of the same, but something different. . . . Their [Picasso and Braque's] differences, in temperament, mind, and pictorial gift, contributed to a shared vision of painting that found them both at their best when they were closest to one another—a vision which neither, I am convinced, could have realized alone. . . .

The friendship of Picasso and Braque may have been a classic instance of an attraction of opposites, but the nascent language they increasingly held in common served equally well their contrasting needs.

For Picasso, whose facility was demonic, and whose poorest work shows him merely coasting on it, Cubism was a kind of deliverance. It obliged him consistently to forgo the refuge of virtuosity for an art which, at least in 1908–09, any reasonably trained novice could execute—if he knew where to put the marks. . . . Thereafter, and undeviatingly until World War I, Picasso accepted as axiomatic the Cézannian commitment to conception—that is to say, invention—as the heart of painting, to the exclusion of everything related to execution. Talent was out, along with anything else that could mask or obscure the pictorial idea.

Cubism also sentenced Picasso to an emphatic focusing-down insofar as its essentially iconic nature forced him to work against the grain of one of his greatest strengths, and pleasures—that of pictorial storytelling. The Cubist years are unique in Picasso's career in being virtually devoid of overt narrative imagery. . . .

If Cubism forced Picasso severely to narrow the range of his subjects, it nevertheless fostered a compensatory profundity in his explorations of them. The banal yet very personal objects that are the motifs of his and Braque's Cubism constituted a studio world that gradually incorporated an iconography drawn from the more gregarious milieu of the café. The artists cultivated a profound affection for these objects, all of which were to be touched and used as well as seen; Picasso, for example, thought it "monstrous" that women should paint pipes "when they don't smoke them."[2] In their patient scrutiny of these articles, endlessly disassembled and reconceived, the two artists sought a rendering at once more economical and synoptic than sight. And this involved them in deliberations more protracted than any in which either painter would later engage. Their quest ended by making the very process of image-formation virtually the subject of their pictures, placing their enterprise at a far remove from that of other vanguard artists. . . .

The importance Braque attributes to the picture field, as against Picasso's stress on the physiognomic of particular forms, is also expressed in the priority he gives the spatial continuum. Picasso starts with

the objects that inhabit this continuum. Braque, as he himself said, was "unable to introduce the object until I had created the space for it."³ Braque's insistence on dissolving distinctions between figure and ground, a characteristic of his Cubism throughout, follows from this position, and also partly explains why his pictures are wont to be more painterly (*malerisch*) than Picasso's, in which the brushwork tends to produce harder, more sculptural surfaces. The radical fragmentation of objects that took place in 1910 allowed Braque further to subsume their contours in a synthesizing light and space, and he led the way in establishing the new kind of all-over painterliness that displaced the essentially sculptural illusionism of 1908–09 Cubism. The culmination of this pictorialism was the luminous space of the two artists' 1911 Céret pictures, which also marked the moment of highest coincidence between the Cubist language and Braque's individual painterly gift. While Picasso also exploited the new fusion of figure and ground to great advantage in his work of 1910–11, his real interest in the fragmentation of objects lay in the opportunity it gave for pushing their physiognomic into a world of new signs.

It is precisely in the invention of signs that the power of Picasso's imagination makes itself most manifest in Cubism. In morphological terms, Braque's art is essentially, if inventively, reductive.⁴ He seeks a sign that is easily assimilated to the fabric of the picture—hence at once not overly distinguished in its individual profile, while maximally conditioned in its size, shape, and placement by the framing edge and the implicit grid structure derived from it. The signs Braque invents, such as the panels of simulated woodgraining he introduced in the winter of 1911–12, tend to be generated by the surface qualities rather than the shapes of his motifs. Picasso's signs are derived from the physiognomic of objects, and he often presses their individuation in imaginative ways until they appear, at least by the end of 1912, almost arbitrary. Although Braque invented *papier collé*, Picasso's ability to carry further its sign possibilities resulted in a more variegated and colorful exploitation of the medium. Synthetic Cubism was to open upon a different constellation of possibilities than the Analytic Cubism of the preceding years. And the Braque who was a full partner in the high Analytic Cubism of 1908–11, and played a crucially inventive role in the transition of 1912, was less able than Picasso to develop within the non-illusionistic sign language of the Synthetic mode of 1913.

Georges Braque
Road near L'Estaque. 1908
Illustrated on page 112

Theodore Reff, in *Picasso and Braque: A Symposium,* **1992,** pages 27, 28

Braque turned in . . . [1907–08] not only to models of classical style, but also to motifs of what might be called classical content, motifs in which architectural and natural forms are held in equilibrium and at the same time evoke the ancient unchanging civilization of the Mediterranean world with its ordered cultivation and simple geometric constructions. Even pictures without the explicitly Roman form of the viaduct, such as *Road near L'Estaque* . . . reveal a taste for this classical balance of the natural and the humanly constructed. It is the kind of landscape, reassuring in its simplicity and stability, that [Paul] Cézanne himself had found at L'Estaque and Gardanne, and both J.-B.-C. Corot and [Nicolas] Poussin before him in the Roman Campagna. It is a landscape humanized by the presence of small dwellings—the famous *fabriques* of which Poussin had spoken, and which André Salmon, speaking of [Othon] Friesz's classicizing landscapes, would call "the first stones of the Cubist temple"—dwellings that Braque in his turn introduced "to develop the idea of humanity which they stood for."¹

This traditional humanistic idea of landscape is altogether different from the modern industrial one that Braque had favored in the Fauve period. In 1906 it was the port and factories of L'Estaque, seen as a place of dynamic modern activity, a correlative to his energetic execution and bold colors, that he had preferred, just as he had done in painting the bustling ports of Le Havre and Antwerp and the industrialized Canal Saint-Martin in Paris. The same could be said of Friesz, with whom Braque worked in those places, and of [Raoul] Dufy painting the port of Le Havre and [André] Derain the Thames in London, with its docks and bridges and constant flow of steamships, tugboats, and barges.

Almost entirely neglected in the literature on early Cubism, this change in subject matter reflects, I think, the more fundamental change in values. . . . [T]he modern port or city, both site and symbol of the dynamism and cosmopolitanism of its urban industrial society, is replaced by the rural town or remote countryside, more traditional and conservative in connotation. And this change, paralleling the change from a perceptual to a conceptual mode that we have seen in Braque (and can also see in other Fauves), in turn implies a loss of confidence both in

modern society and in the modernist faith in personal experience that had sustained the Fauve painters in their most daring innovations, replacing that faith with one in more collective sources of security, in notions of race, nation, tradition, and classicism.

Georges Braque
Still Life with Tenora. 1913
Illustrated on page 114

Henry R. Hope, *Georges Braque,* **1949,** pages 58, 59, 60, 62, 64

Both [Pablo] Picasso and Braque felt dissatisfied with the possibilities of the oil medium and the limitations it imposed. For three or four years they had rejected nearly all color and had been producing paintings of almost monochromatic effect. . . . At some time during the year [1913] he [Braque] introduced bits of green or gray marbleized surfaces into some of his pictures and also rectangular strips painted in imitation of wood grain.

A great deal has been written about the sources of these devices in his commercial painting apprenticeship. However, he had been painting for twelve years before they appeared in his work. It is significant that none of them appears in his paintings of the *fauve* or Cézanne periods. The new attitude toward painting which was then developing out of cubist theories and experiments gave Braque this opportunity to draw upon his past experience. First it had been the *trompe l'oeil* nail, then the block lettering, and now marbleizing and wood graining. In retrospect, this sequence appears to be logical and perhaps inevitable. Nevertheless, it was a happy chance that the otherwise unrelated phenomena of house-painting conventions and a new theory of representing volumes in space were to join as formative elements in Braque's painting of these years. It brought about a new and rich phase in the maturing of his own style and led directly to some of his great post-war paintings.

Who made the first collage? This is a question which will never find a satisfactory answer unless it is stated in the same evolutionary terms. For it was in this atmosphere of cubist theory and under the same impulses that the first papier collés or collages were made. Picasso, whose extraordinary talent and passion make him as much a draftsman as a painter, and as much a sculptor as a draftsman, had many times experimented with sculpture. At that moment he had been experimenting with painted metal and possibly other materials. Braque in the meantime had been making paper sculpture, folding it into shapes like certain geometric details in his paintings. None of these has survived but we can guess what they looked like from the fact that Picasso in a letter of that date addressed Braque as "*Mon vieux Vilbure,*" referring to Wilbur Wright. These paper sculptures seem to have suggested possible adaptations to painting which led to the making of the first collage.

As Braque remembers it, this was at Sorgues in September of 1912. Picasso had already returned to Paris. He and Marcelle [Humbert] stayed on at the *Villa Bel Air.* His eye was attracted by some wallpaper at an Avignon shop, printed to resemble the close grain of quartered oak. He bought some, took it to the studio and began experimenting with it. . . .

In many of the first collages the drawn details are in black and white, in short, they are drawings with pasted paper, but others combine strips of newspaper and various other papers. Later many of Braque's collages are composed on large rectangular boards or canvases which have been sized and painted flat white . . . If some of Braque's oil paintings of 1910 and 1911 bear a close resemblance to the work of Picasso, the collages have qualities particularly his own . . . The most successful by Braque achieve a sense of elegance and serenity . . . The musical instruments and wine glasses have a kind of cardboard reality like playing cards; these thin, delicate shapes appear to hover over the surface in a boundless white space.

Braque
Still Life with Tenora

Robert Rosenblum, in *Modern Art and Popular Culture: Readings in High & Low,* **1990,** pages 126, 127

The mysterious woodwind that turns up again and again on Cubist tabletops and that has been consistently misidentified as a clarinet (despite the obvious dissimilarity of its mouthpiece)[1] is, in fact, a folkloric instrument from Catalonia, a *tenora,* which Picasso had heard in performance in the Pyrenees and which both he and Braque often included in their still lifes as what must have been an ethnic memento of Spanish culture, comparable to their many allusions to the bullfight and other Spanish motifs. And here, too, the choice not of a clarinet, for which Mozart himself had written concert and chamber music, but of a crude woodwind from a lower cultural stratum was characteristic of the constant fluctuation in Cubist art between high-brow cultural traditions and grass-roots reality, whether in the heart of Paris or in the remoteness of the Pyrenees. Any survey of the

musical references in Picasso and Braque's work indicates the double-track allusions to both the music of the concert hall . . . and that of popular café-concerts, whose songs and dances find their titles, refrains, and even scores fragmented throughout the writings and pastings in Cubist art.[2]

Pablo Picasso

Landscape. 1908
Illustrated on page 112

Kirk Varnedoe, *Masterpieces from the David and Peggy Rockefeller Collection,* **1994,** pages 13, 58

Landscape . . . reflects Picasso's willful attempt to put art more evidently under the dominion of the mind. In contrast to the undulating softness of [Georges] Braque's contoured zones of soft hills, vegetation, and gently blunted architecture, Picasso's picture presents a denuded vista of rocks, spiky bare branches, and sharply angular architectural masses; and in order to concentrate more insistently on volume and spatial structure—as opposed to effects of light and atmosphere—the artist imposed a somber, near-monochrome color scheme. Picasso was never a painter much concerned with landscape; in works of the Blue and Rose periods, and again in the beach scenes of the 1920s, natural settings tended to be nothing more than barren metaphysical vistas. As he moved toward Cubism's fusions of foregrounds and backgrounds, though, this emotionally neutral motif of a conjoined tree and house—a screen of forms fanning out across the canvas to occlude deep space—must have seemed especially apt. . . .

In this and several of the other works he painted in the small town of La Rue-des-Bois, outside Paris, [he] engaged in the unlikely and even perverse project of trying to combine the formulaic simplicity and particularity of the "naïve" painter Henri Rousseau with the sophisticated structures of [Paul] Cézanne.

This picture's distinctive green palette as well as its schematic linear style and the shaded modelling of the tree branches owe a debt to the jungle fantasies of Rousseau, whose hauntingly earnest, slapstick-simple violations of academic conventions Picasso so treasured. The ambiguously fractured planes and inconsistently shaded masonry of creases and angles in the picture present, however, a creative mistranslation of the device of *passage* by which Cézanne, especially in his later work, elided adjacent planes to confound consistent readings of spatial advance and recession.

Pablo Picasso

Ma Jolie. 1911–12
Illustrated on page 113

William Rubin, *Picasso in the Collection of The Museum of Modern Art,* **1972,** pages 68, 70

[This picture dates] from the period spanning summer 1910 and spring 1912, during which Picasso and [Georges] Braque, with whom he was then working closely, developed the mode we may call high Analytic Cubism. Such paintings are difficult to read, for while they are articulated with planes, lines, shading, space and other vestiges of the language of illusionistic representation, these constituents have been largely abstracted from their former descriptive functions. Thus disengaged, they are reordered to the expressive purposes of the pictorial configurations as autonomous entities.

This impalpable, virtually abstract illusionism is a function of Cubism's metamorphosis from a sculptural into a painterly art. Sculptural relief of measurable intervals has here given way to flat, shaded planes—often more transparent than opaque—which hover in an indeterminate, atmospheric space shimmering with squarish, almost neo-impressionist brushstrokes.[1] That this seems finally a shallow rather than a deep space may be because we know it to be the painterly detritus of earlier Cubism's solid relief.

The light in early Cubist paintings did not function in accordance with physical laws; yet it continued to allude to the external world. By contrast, the light in these high Analytic Cubist pictures is an internal one, seeming almost to emanate from objects that have been pried apart. Accordingly, the term "analytic" must here be understood more than ever in a poetic rather than scientific sense, for this mysterious inner light is ultimately a metaphor for human consciousness. The Rembrandtesque way in which the spectral forms emerge and submerge within the brownish monochromy and the searching, meditative spirit of the compositions contribute to making these paintings among the most profoundly metaphysical in the Western tradition.

The degree of abstraction in these images is about as great as it will be in Picasso's work, which is to say that while the pictures approach nonfiguration, they maintain some ties, however tenuous or elliptical, with external reality. Even without the advantage of its subtitle—*Woman with a Zither or Guitar*[2]—we would probably identify the suggestions of a figure in *"Ma Jolie."* The sitter's head, though devoid of physiognomic detail, can be made out at the top center of the composition; her left arm is bent at the

elbow—perhaps resting on the arm of a chair whose passementerie tassels are visible just below—and her hand probably holds the bottom of a guitar whose vertical strings are visible in the center. Together with the wine glass at the left and the treble clef and musical staff at the bottom of the picture, all this suggests an ambience of informal music-making. . . .

Partly to draw attention by contrast to its luminous space, and thus reconfirm this highly abstract art as one of illusion, Picasso followed Braque in placing large trompe-l'oeil printed or stenciled letters on the surfaces of many pictures of this period.[3] . . .

"Cubism," as Picasso observed, "is an art dealing primarily with forms." But its subjects, he added, "must be a source of interest."[4] Lettering plays a crucial role in communicating these, and its often witty references to external reality relieve the pictures' formal asceticism. The words "*Ma Jolie*," for example, are from the refrain line of a popular song of 1911,[5] but they were also a pet name of Picasso's new companion Marcelle Humbert ("Eva"), about whom he wrote to his dealer [Daniel-Henry] Kahnweiler that he loved her very much and would write it on his pictures.[6] Placed at the bottom center of the picture like a mock title,[7] these easily legible words form a whimsical contrast with the nearly indecipherable image of the "pretty one" to whom they appear to refer.[8]

Pablo Picasso

Guitar. 1913
Illustrated on page 114

Deborah Wilk, in *Modernstarts*, 1999, pages 309, 310

The guitar was a popular subject for avant-garde artists at the beginning of the twentieth century. In the early modernist art of the Cubists, the guitar, commonly found in the café and the artist's studio, bespoke a bohemian life. For Pablo Picasso and Juan Gris, the instrument evoked the Spanish culture of their homeland, where the guitar is thought to have originated. In addition to communicating place, the Spanish flamenco and classical guitar were both extremely popular in the late-nineteenth and early-twentieth centuries.

Stringed instruments also belong to the fine-art tradition of still life and genre painting, where they frequently have amorous connotations. Picasso's guitars are no exception. He acknowledged that the curvaceous form of the guitar was associated with the female body, an idea then current in art and literary circles.

In the language of Cubism, the guitar provided a potent and playful subject for visual punning: how much of its fragmented form could represent the whole instrument? A curved silhouette becomes shorthand for the body of the guitar. A circle and parallel lines can read as sound hole and strings. Ironically, the part of the guitar that is a void often becomes the most solid and recognizable part. . . .

In *Guitar*, a collage of 1913, Picasso introduced wallpaper, a mass-produced object, in an attempt to disrupt traditional methods of representing the observable world and to insert a material deemed unacceptable in art. Visual and verbal puns abound. Floral wallpaper cut in the shape of a guitar reappears in rectilinear form, perhaps to indicate a table or wall, and has the visual effect of flattening the space. A rectilinear swath of box-patterned wallpaper, in this context, stands for the guitar's neck and fretwork, while a circle of newsprint represents the sound hole. Picasso includes the front page of the Barcelona newspaper *El Diluvio*, which is truncated to read "Diluv," a sly pun on the Musée du Louvre in Paris, where modern art was not exhibited. The front page also contains an advertisement for an oculist, a possible reference to disparaging critics who joked that the disintegrating objects of Cubism were the result of poor vision.

Juan Gris

Guitar and Flowers. 1912
Illustrated on page 115

Alfred H. Barr, Jr., *Masters of Modern Art*, 1954, page 73

Though it is very difficult at times to distinguish between the work of [Georges] Braque and [Pablo] Picasso done in 1911–1912, the paintings of Juan Gris differ markedly from those of both his elders. Gris' work is further removed from impressionism's freedom of composition and brushstroke. And he is much more systematic. In *Guitar and Flowers*, for instance, he uses an obviously geometric scheme of design through which the composition is given an initial order by dividing the canvas in half four ways: vertically, horizontally and twice diagonally. He then proceeds to adorn and partially to conceal his geometry by means of the consistently fragmented images of a table cover, fruit, a guitar, a vase of flowers and a curtain, drawn aside at the right. The paint is laid on in regular strokes, the color restrained.

The result may seem calculated and rather cold. Yet, when the painting is studied, its clarity and sustained intensity of rhythm put it on a par with the

diametrically different Braque, with all its good taste and sense of masterly improvisation.

Gris
Guitar and Flowers

James Thrall Soby, *Juan Gris,* **1958,** pages 12, 13, 15, 20

Gris was now [1906] living in what soon became the center of the cubist uprising [Paris], and he could not have failed to be impressed by the research and activity of his colleagues, especially [Pablo] Picasso. He himself did not begin painting seriously until 1910 and then primarily in watercolor. It was not until the following year that he allowed any of his friends to see his new works in oil—those works which are amazingly authoritative for a man of his relative inexperience. He was six years younger than his three peers in cubism, Picasso, [Georges] Braque, and [Fernand] Léger. . . .

Perhaps because of his comparative youth, Gris was not obliged to grope his way painstakingly toward a full acceptance of the cubist esthetic. The way had been paved for him by Picasso, whose famous *Demoiselles d'Avignon,* with its cubistic passages, had been painted the year after Gris' arrival in Paris; by Braque, who in 1908 abandoned fauvism for early cubism; even by Léger, who by 1910 had long outgrown his earlier preoccupation with realism tempered by Neo-Impressionism. The example of Picasso and Braque was there for Gris to follow. He did so with conviction and relish once his mind was made up. Thereafter it was the problem of Gris, a stubborn, dedicated man, to hold his own against a meteoric virtuoso (Picasso) and a supreme French craftsman (Braque).

Gris brought to this task a refinement of calculation and a highly original color sense which have finally won him his separate place in cubism's front rank. . . . Whereas Picasso and Braque at that time preferred earthy tans and muted grays, Gris' palette, though no less austere, was more metallic, with a sheen (in the best sense of the word) not often found in the analytical-cubist works of his colleagues. Gris' paintings of 1911–12 are colder than theirs . . .

In the *Guitar and Flowers* we see the beginning of that quite sudden tonal enrichment which was to lead Gris, Picasso and Braque away from analytical toward synthetic cubism. The picture's sharp prisms are partly conceived in those olive grays and pale greens of which the painter was fond. But now blues and russet browns are added, and there is a new luxury of surface, achieved through stippling in certain areas.

Marc Chagall
I and the Village. 1911
Illustrated on page 116

Marc Chagall, in *The Bulletin of The Museum of Modern Art,* **1946,** pages 32–34

"Already during the other war [World War I] I remember wondering about painting. I was still very young and did not picture art as a profession or a job. It did not seem to me that pictures were destined solely for decorative or domestic purposes. I remember saying to myself 'Art is in some way a mission—and don't be afraid of this old word. What ever may have been achieved by the technical and realistic revolution in painting, it has merely scratched the surface. Neither so-called "real-color" or "conventional color" truly color the object. It is not what we describe as perspective that gives depth. Neither shadow nor light illumine the subject and the third dimension of the cubists does not yet allow a vision of the subject from all sides.'

"This in short was the sentiment which seized me in Paris in 1910. But if you talk this way in a technical, realistic period of art, you are accused of descending into literature. Was I, myself, not trying to get away from 'literature,' from symbolism in art?

"It was precisely 'literature' that I saw not only in the great compositions of the old 'romantics,' but also in the simple still-lifes of the impressionists and cubists, since 'literature' in painting to my way of looking at it is all that can be explained. It seemed to me that by 'killing' a still life or a landscape in some way—not only in deforming their surfaces—it would be possible to give them new life.

"And just as I was accused of descending into 'literature,' before the war of 1914, today people call me a painter of fairy tales and fantasies. Actually my first aim is to construct my paintings architecturally—exactly like the impressionists and cubists have done in their own fashions and by using the same formal means. The impressionists filled their canvases with patches of light and shadow; the cubists filled theirs with cubes, triangles, and curves. I try to fill my canvases in some way with objects and figures treated as forms—forms resounding like noises—forms of passion—designed to add a new dimension which neither the geometry of the cubists, nor the patches of the impressionists can achieve.

"I am against the terms 'fantasy' and 'symbolism.' Our whole inner world is reality perhaps even more real than the world of appearances. If we call everything that appears illogical 'fantasy,' 'fairy-tales,' etc., we really admit that we do not understand nature.

Impressionism and cubism are comparatively easy to understand because they present but a single aspect of an object to our consideration: simple contrasts of light and shadow. But a single aspect of an object is inadequate to the summing up of the complete subject-matter of a picture. Every object has diverse aspects. I am not against cubism: I have admired the great cubists and I have profited from cubism."

Chagall
I and the Village

James Johnson Sweeney, *Marc Chagall,* **1946,** pages 7,15

When Chagall first arrived in Paris in 1910, cubism held the center of the stage. French art was still dominated by the materialist outlook of the 19th century. Fifty years earlier naturalism and realism had opened the way to impressionism. Impressionism's analyses of light on objects had led to cubism's analyses of the objects themselves. Little by little the manner of representing an object had come to have a greater interest than the subject—the physical character of the painting more importance than its power to awake associational responses in the observer. Chagall arrived from the East with a ripe color gift, a fresh, unashamed response to sentiment, a feeling for simple poetry and a sense of humor. He brought with him a notion of painting quite foreign to that esteemed at the time in Paris. His first recognition there came not from painters, but from poets such as Blaise Cendrars and Guillaume Apollinaire. To him the cubists' conception seemed "earthbound." He felt it was "necessary to change nature not only materially and from the outside, but also from within, ideologically, without fear of what is known as 'literature.'" . . .

[In] *I and the Village* . . . cubism's respect for the plane of canvas is . . . clearly illustrated. . . . And this picture offers an ideal exemplification of Chagall's statement: "I fill up the empty space in my canvas as the structure of my picture requires with a body or an object according to my humor." The composite strikes one first, then the details: first the large profiles, then smaller reminders of life in Vitebsk: the milkmaid, the farmer and his companion and the neighborhood church. Chagall, like the expressionists, uses color and line to underscore emotion, but also makes the details serve as emotional comments, footnotes or glosses.

Robert Delaunay
Simultaneous Contrasts: Sun and Moon. 1913
Illustrated on page 117

John Elderfield, *European Master Paintings from Swiss Collections,* **1976,** page 102

Delaunay . . . was inspired not by the solidity but the flux in modern life: "Sky over the cities, balloons, towers, airplanes. All the poetry of modern life: that is my art."[1] . . .

The disk form had first appeared in Delaunay's painting as early as 1906, possibly as a result of his exposure to [André] Derain's London paintings of 1905 which used prominent spectral suns;[2] but this form began to be used consistently only with his Sun and Moon series of 1913. . . .

Color contrasts, Delaunay said, were the "constructional elements of pure expression."[3] He had begun as a Neo-Impressionist painter and read the color theories of M.E. Chevreul, from whom he derived his own theory of "simultaneous contrasts."[4] Whereas the strokes and blocks of pure color in Neo-Impressionist paintings fused together in the spectator's eye and created, therefore, "binary" contrasts, "simultaneous" contrasts retained the separate identities of colors as they interacted simultaneously upon the eye. In their interaction, the effect of movement was engendered. The static presentation of the outside world created by Neo-Impressionism was thus replaced by a display of moving colored light.

Roger de La Fresnaye
The Conquest of the Air. 1913
Illustrated on page 117

Helen M. Franc, *An Invitation to See,* **1992,** page 52

Aviation was still in its infancy when this picture was painted. In 1908, Wilbur Wright had broken records with a fifty-six-mile, one-hundred-and-forty-minute flight from La Fresnaye's native town of Le Mans, and in the following year Louis Blériot made the first air crossing of the English Channel. [Pablo] Picasso and [Georges] Braque were both aviation enthusiasts, and in 1912 frequently used for the latter the nickname "Wilbourg," adapted from "Wilbur." . . .

The interest of La Fresnaye in aviation was more than casual, for his brother Henri was director of the Nieuport aircraft manufacturing plant near Meulan, the village represented in the landscape at the lower left of the picture. The two men seated at the table (possibly the artist himself and his brother) are

engaged in conversation, presumably on the topic referred to in the title. That this is a conceptual rather than a representational treatment of the theme is evident by the disproportionately large size of the two figures and their indeterminate location with respect to the landscape. Furthermore, the tiny balloon floating aloft, its rounded shape repeating that of the clouds, is only a symbol of aeronautical triumphs and not a depiction of the most up-to-date technological advances. The sun and moon appear as two circles among the clouds. The sailboat at the right, besides connoting a favorite sport of the brothers, also suggests a parallel between man's intellectual ability to tame the forces of the wind so that he can navigate upon the waters and his new mastery of air currents that enable him to fly. The huge tricolor asserts La Fresnaye's nationalistic pride and confidence in the role that France was destined to play in the future of aviation. . . .

For this large painting, La Fresnaye used Cubism's geometrized forms and dissected space to create a monumental composition on an heroic theme.

Fernand Léger
Propellers. 1918
Illustrated on page 118

George L. K. Morris, in *The Bulletin of The Museum of Modern Art,* **1935,** pages 2, 3, 5

The very unfamiliarity with which a work of Léger will assert itself from other paintings of the Paris School provides a key to its comprehension; for Léger is, of all the contemporary painters, the one most truly modern. . . . Léger has derived but little from either past civilizations or his contemporaries; he cannot even, like [J.-B.-C.] Corot and [Georges] Braque, be snugly fitted into the French tradition. His aesthetic contributions always stand quite naked and apart, and when he does have intercourse with the past it is completely transparent, without being absorbed, in any eclectic sense, by his creative system.

Of the few contacts that Léger must concede, his relation to the Cubist group has been the one most erroneously expanded. Indeed, since critics need must peg each artist on to a specific branch or stem, he is often put forward as a Cubist painter,—sometimes as a leader in the movement. Actually, Léger was never a Cubist at all. . . .

As a way of painting, Cubism was from the first misunderstood; it is popularly regarded as the dividing of an object into cubes. In reality it has very little to do with cubes; it has to do with *planes,*—not the color-planes of [Paul] Cézanne, but planes that tilt according to the tonal transition. The Cubists proceeded to break the object more and more for added movement, sensing the violence with which the eye will swing into the rhythm fixed by the direction of breakage. Cézanne could only break his object through glances, (he himself has said that he could not paint without a model). Likewise the Cubists, though less eye-conscious than Cézanne, never completely turned their glance from Nature. Their paintings—although free from direct visual resemblance to that which they represent—have always a connection with reality, in fact are usually portraits or landscapes. And, most unexpectedly of all, the misty spectre of Impressionism glides throughout the Cubist pictures, shedding highlights, cast-shadows, and blurred transitions in its path. The measured lift of shifting planes tilted in illimitable variation,— it is from this that the finest Cubist paintings derive their imperial complexity and repose.

There is nothing comparable to this spaciousness in Léger, who had thrown Impressionist tendencies overboard at the start, who had never put aside his cold though garish colors. His forms are always clear and sharp, and the conception of the object has remained as mental as a Coptic fresco. It is the object that removes him farthest from the Cubists, and it is the object for its own sake that has become the *grande passion* of Léger's artistic consciousness; he has reduced his art of late to an ever-tightening rendition of objects; he will recount how in this mechanical age a painting must stand comparison with the other things sold in the cities; he has sought to paint them all—pipes, disks, parts of the machines—with such freshness and precision that they can compete with the modern craftsman's products. Human beings and fragments of foliage intrude throughout the pictures, and from no love of Nature Léger paints them, but merely as other perfectly functioning mechanisms that he meets upon the streets.

Fernand Léger
Three Women. 1921
Illustrated on page 119

Robert Storr, *Modern Art despite Modernism,* **2000,** page 54

Rather than losing his faith in modernity during the war, Léger reconfirmed it and retooled his work in preparation for developing a schematic but robust naturalism. Like his Cubist confederates, Léger stuck

to traditional formats—figure studies, interiors, still lifes, and landscapes—and like them, he injected his forms with a classical rigor. Vibrant, good-natured, and vaguely droll, Léger's neoclassicism, however, exhibits very little antiquity and a lot of industrial streamlining. His renditions of the postwar *éternel féminin* are ample, impassive, and unapologetically vulgar. As distinct from the languorous reclining nudes of [Henri] Matisse or the Sabine women of [Pablo] Picasso, the bumpy odalisques in Léger's *Three Women* resemble three Rubensian graces stylishly coiffed, poured into shiny, tubular, steel corsets or body stockings, and posed in an Art Deco apart-ment. They are big, big city women who thoroughly enjoy their swank surroundings.

They may also be working-class women accustoming themselves to an undreamed of luxury, for, more so than any of the Cubists, Léger was a man of the Left. When he spoke of "discovering the people of France" among the laborers and artisans in his regiment, Léger was not indulging in chauvinism, as so many artists of the interwar years were to do, but rather announcing his eagerness to cast his lot with that of his wartime comrades-in-arms and his peacetime comrades in the streets.

Futurism

Joshua Taylor, *Futurism,* **1961,** pages 9, 10, 11, 17

With cries of "Burn the museums!" "Drain the canals of Venice!" and "Let's kill the moonlight!" the Futurist movement burst upon the consciousness of an astonished public in the years 1909–1910. For the first time artists breached the wall erected between conventional taste and new ideas in art by carrying their battle directly to the public with the noise and tactics of a political campaign. Taking their cue from the anarchists with whom as youths they were in sympathy, the self-styled Futurists published shocking manifestoes negating all past values, even art itself. Fighting their way towards a new liberty against apathy, nostalgia, and sentimentality, they became for a very wide public the symbol of all that was new, terrifying, and seemingly ridiculous in contemporary art. . . .

That so violently launched a movement should come out of Italy is not altogether surprising, for in no other country did the youth feel so completely subjugated to the past, deprived of a world of its own. The complacent Italian public was content with guarding a tradition and obstinately refused to notice new events in art and literature, at home or elsewhere.[1]

As for the term Futurism, there is no mystery about its origin, nor was it a word thrust by chance upon the artists as were "Impressionism," "Fauvism," and "Cubism." It was coined in the autumn of 1908 by the bilingual Italian poet, editor, and promoter of art, Filippo Tommaso Marinetti, to give ideological coherence to the advanced tendencies in poetry he was fur-thering in the controversial periodical, *Poesia.* . . .

In February 1909, Carlo Carrà, Umberto Boccioni, and Luigi Russolo, met with Marinetti . . . and proposed that painters also be included in the movement. With Marinetti's enthusiastic support the three young artists drew up a manifesto of their own. . . . On the manifesto's "official" publication dated 11 February 1910, appeared . . . the name of Giacomo Balla, . . . teacher of both Severini and Boccioni. These five, Balla, Boccioni, Carrà, Russolo, and Severini, became "the Futurist painters.". . .

Because the Futurist painters early adapted to their own use some of the formal language of Cubism, their painting has often been considered a kind of speeded up version of that classically oriented movement. In spite of the obvious testimony of Futurist writing and, more significantly, the painting itself, critics have persisted in seeing Futurism as an analytical procedure like early Cubism, differing only in its aim to represent motion, a goal better realized in moving pictures. . . .

Motion for the Futurist painter was not an objective fact to be analyzed, but simply a modern means for embodying a strong personal expression. As different as their procedures were, the Futurists came closer in their aims to the *Brücke* or, better, to [Vasily] Kandinsky and the *Blaue Reiter*, than to the Cubists. And in their iconoclasm and concern for the vagaries of the mind, they had not a little in common with Dada and the Surrealists. . . .

"Dynamism" was a magical word for the Futurists. It signified the difference between life and death,

between participation in an evolving, expanding universe and withdrawal into an eddy of personal isolation. They looked upon the world with the same eager expectation as the Transcendentalists, but the world they saw was not the quieting realm of tree and sky; it was the world of modern science that triumphed over nature, promising always something new in its rapid development towards an undetermined end. Dynamism was at its heart. Theirs was a transcendentalism founded on a whole new universe. "We are the primitives of a new, completely transformed, sensibility," they boasted. The new sensibility accorded emotional value to a mechanized world. . . .

Futurism was not a style but an impulse, an impulse that was translated into poetry, the visual arts, music, and eventually into politics. "Futurism is only the praise, or if you prefer, the exaltation of originality and of personality," Marinetti declared to an interviewer in 1911; "the rest is only argument, trumpeting, and blows of the fist."[2] The nature of the Futurist impulse in politics, it might be added, should not influence the assessment of its achievement in art.

Giacomo Balla
Swifts: Paths of Movement + Dynamic Sequences. 1913
Illustrated on page 120

MoMA Highlights, **1999,** page 72

"All things move, all things run, all things are rapidly changing," wrote the Futurists, one of them Balla, in 1910. Elaborating on Cubism's experiment in fracturing forms into planes, the Futurists further tried to make painting answer to movement: while the Cubists were concentrating on still lifes and portraits—in other words, were examining stationary bodies—the Futurists were looking at speed. They said: "The gesture which we would reproduce on canvas shall no longer be a fixed *moment* in universal dynamism. It shall simply be the dynamic sensation itself."

The backdrop to this painting is fixed architecture—a window, a drainpipe, a balcony—but the arcs that snake across the foreground are pure rush. The shapes of the swifts (are there four or forty of them?) repeat in stuttering bands, but their substance seems to evaporate: melting into light, the birds are lost in the paths of their own swooping soar. "Dynamic sensation," in Balla's time, was newly susceptible to scientific and visual analysis. Balla knew the photography of Étienne-Jules Marey, which

described the movements of animals—including birds—through closely spaced sequences of images; *Swifts* emulates Marey's scientific visual analysis, which, in Balla's time, subjected "dynamic sensation to scrutiny," but adds to it a sense of exhilarated pleasure.

Umberto Boccioni
Dynamism of a Soccer Player. 1913
Illustrated on page 123

Lucy Lippard, in *Three Generations of Twentieth-Century Art,* **1972,** page 22

By adapting the transparencies and shallow space of Analytical Cubism, with which he had become familiar at the 1911 Salon d'Automne in Paris, Boccioni in this painting fulfilled his intention of showing forms that interpenetrated with their surroundings. In so doing, he translated the rectilinear grid of Cubism into an almost baroque composition of swirling forms. In accordance with the cinematic principles set forth in the [Futurist] *Manifesto,* the player's successive positions are rendered simultaneously. The suggestions of his anatomy dissolve into radiating planes of atmospheric light. Divisionist brushwork . . . is here translated into staccato lines of force. As he developed the centrifugal patterns that communicate the soccer player's motion through space, Boccioni found the canvas too small for his conception and sewed additional pieces onto three sides, enlarging its area by approximately one-fifth.

The painting was first exhibited in the United States in the show of their work that the Futurist artists themselves organized as part of the Panama-Pacific International Exposition in San Francisco in 1915. Until 1953 . . . the *Dynamism of a Soccer Player* remained in the possession of Filippo Tommaso Marinetti, the progenitor of Futurism, and his widow, Donna Benedetta.

Umberto Boccioni
Unique Forms of Continuity in Space. 1913
Illustrated on page 122

Sarah Ganz, *Body Language,* **1999,** page 69

With Umberto Boccioni's *Unique Forms of Continuity in Space* of 1913 body and environment interpenetrate. The figure steps forth, its center of gravity thrust forward, while contours of flesh are shaped by and dissolve into the air through which the body moves. Boccioni called for a sculpture of environ-

ment in his "Technical Manifesto of Futurist Painting" of 1910, stating that "the gesture which we would reproduce on canvas shall no longer be a fixed *moment* in universal dynamism. It shall be the dynamic sensation itself. . . . We therefore cast aside and proclaim the absolute and complete abolition of definite lines and closed sculpture. We break open the figure and enclose it in environment."[1] The confluence of metal, flesh, and air presents a figure at once ensconced in fluttering flames and weighted down by the heavy blocks on which it stands as well as the apparent effort required to penetrate the space through which it moves.

The voice of [Henri] Bergson permeates Boccioni's ideas and those of the Futurist manifestos; the application of philosophical inquiry to the body particularly attracted the Italian artist . . . *Unique Forms of Continuity in Space* seems to materialize Bergson's claims for the body as the vehicle through which space and environment are perceived: "Consider the movement of an object in space. My perception of the motion will vary with point of view . . . but when I speak of an absolute movement, I am attributing to the moving object an inner life and so to speak, states of mind."[2] The glistening bronze figure suggests progress through time and space; its undulating contours . . . intimate mobility and duration beyond the represented moment. Although the figure was born of aspirations toward modernity and dynamism, its armless, sexless appearance is evocative of antiquity, including the winged *Victory of Samothrace.*

Brancusi

Constantin Brancusi
Mlle Pogany. 1913
Illustrated on page 124

Alfred H. Barr, Jr., New Acquisitions, **1953**

Over a year ago [c. 1952] the Museum received a letter from a lady in Camberwell, Australia. She wrote that almost forty years ago, before the first World War, Brancusi had made her portrait in Paris. The bronze might be for sale if a museum were interested. This Museum was very much interested, for the letter was signed Margit Pogany. After long negotiations the purchase was made, and three weeks ago the bust arrived in New York after its long voyage.

Miss Pogany has written how Brancusi came to do her portrait. In 1911 while she was an art student in Paris she came to know the sculptor. Two years later she asked him to do her portrait. She sat several times for him, but at each sitting after completing what she thought was an excellent likeness he would throw the clay back into the bin.

Early in 1912 when she left Paris the bust had not yet been begun, but finally in 1913 it was completed. Brancusi gave her the choice of a marble or bronze. She chose the latter.

Later, in 1919–20, Brancusi made several variants in polished bronze and in marble of a second version of the *Mlle Pogany,* somewhat more abstract and elaborate, especially in the treatment of the hair. These are far better known than this original bronze which may, in fact, never have been publicly exhibited before.

Constantin Brancusi
Endless Column. 1918
Illustrated on page 125

Francis M. Naumann, *The Mary and William Sisler Collection,* **1984,** pages 50, 53, 54, 55

Throughout his life, Brancusi was reluctant to consider his individual sculptures as wholly independent creative efforts, but rather preferred to regard his finished works as simply intermediary stages in the realization of a given theme. Just a few months before his death in March 1957, however, he told a reporter that he thought the *Endless Column* was one of his most resolved and definitive works, a sculpture in which he had approached perfection.[1] . . .

As other major themes in Brancusi's work evolved through years of experimentation and refinement, the formal and iconographic program of the *Endless Column* developed through a series of methodical changes, both in the final configuration and physical presentation of the work. . . .

The only version of the column from this period to survive intact is the example preserved [here]. Brancusi's method for sculpting this work was in all likelihood the same as for the making of later

columns, documented in several photographs of the artist at work in his studio. After having determined the precise size of each rhomboid element, he marked their equally spaced increments along the outer surface of an old oak beam. With a large cross-cut saw he then carefully scored these divisions along the surface of the beam, cutting into the wood up to, but not beyond, the points where each rhomboid tapered to its narrowest width. Finally, straddling the beam from one side, Brancusi then removed the unwanted wood with a series of accurate and determined strokes, administered by the broad blade of a large, crescent-shaped ax. The resultant rhomboidal modules are approximately twenty inches in height, ten inches in width, and taper to just about five inches at their narrowest point, producing a ratio of 4:2:1, or, when read conversely, 1:2:4. The simplicity of these proportions was clearly intentional, and is perfectly in keeping with the simplicity of the column's vertical and bilateral symmetry. "Simplicity is not an end in art," Brancusi wrote, "but one arrives at simplicity in spite of oneself, in approaching the real sense of things."[2]

But the "real sense" of what "thing," we might ask, was Brancusi hoping to approach in making these columns? If we can rely on Brancusi's own statements about his work, then one of his most persistent goals was to reveal the essence of the material from which a sculpture was made. "The sculptor must allow himself to be led by the material," Brancusi later told a friend, "the material will tell him what he should do."[3] That Brancusi consistently selected wood as his medium for these early columns is significant, since he maintained that the integrity of a given material must be preserved in the final sculpture. "Wood," he told a reporter in the early 1920s, "is already and under all circumstances inherently sculptural. One must not destroy it, one must not give to it an objective resemblance to something that nature has made in another material. Wood has its own forms, its individual character, its natural expression; to want to transform its qualities is to nullify it and to render it sterile."[4] It is likely, therefore, that the geometric clarity, overall symmetry, verticality, and repetitive elements in the column's design were meant to allude to these same qualities in wood, both in its natural state as a tree and when hewn into a long, rectangular beam.

The artist provided a date of 1918 for the carving of this column, and there is no reason to question it.[5] But did Brancusi initially conceive of this work as a fully independent sculptural form, or was he still envisioning the column simply as an elaborate base for another sculpture? Evidence suggests that for some years after its making Brancusi continued to treat even the 1918 version of the column as a base. . . .

There was no longer a need for such a pedestal, however, in Brancusi's first realization of the column on a monumental scale . . . Moreover, by this time Brancusi must no longer have envisioned the column merely as a support for another sculpture; the sheer height and repetitive geometry would have made the concept of infinite expandability an inseparable feature of the design. For Brancusi such an interpretation of the sculpture would naturally have tended to enhance these same characteristics in the earlier columns, qualities that were already an integral, though perhaps less obvious feature of their design.

Brancusi
Endless Column

James Thrall Soby (mid-1960s?), in *Studies in Modern Art 5*, **1995,** pages 203–04

One of his [Brancusi's] most famous projects [is] the *Endless Column.* The tallest of these columns is in metal and stands ninety-eight feet high in the Rumanian town of Tîrgu Jiu, near Brancusi's birthplace.[1] But even the smallest of the "endless columns" is a tour de force of ingenious balance which an engineer like Buckminster Fuller might well envy. They look as though they might topple over and they never do; they are as strong and immovable as the version Brancusi once carved from a live poplar on the estate of a friend. They are rooted not only in a non-existent earth but in a profound philosophical conviction which nothing can sway. "You see," Brancusi said by way of explanation, "even the Pyramids end somewhere in a point. My columns need not end anywhere but can go on and on."[2] [The] strongest impression I had on my last visit to this studio was the incredibly subtle variety Brancusi was able to give his few preferred subjects—the egg, the bird, the fish, the human head. I realized that this variety had little to do with the basic material he used, whether marble, polished bronze or wood. It was managed by nearly invisible shifts in emphasis on a given form, by changes in scale which many could see but also by alterations of contour and balance which even an expert would find hard to trace or define. I came to the conclusion in the end that Brancusi was one of the last of the true mystics, a fact which his worldliness and rough humor did their best to conceal. More than any artist I've ever known he had an inner life immune to penetration by the outer world. But he is alive in his sculpture to a degree beyond the reach of aesthetic awareness.

Constantin Brancusi

Bird in Space. 1928
Illustrated on page 124

Helen M. Franc, *Invitation to See,* **1992,** page 51

In . . . *Bird in Space* the form has become simplified to a high degree, consonant with Brancusi's dictum: "Simplicity is not an end in art, but we arrive at simplicity in spite of ourselves as we approach the real sense of things." He sought not merely to portray a bird but to capture "the essence of flight," and the underlying theme, as in [Kazimir] Malevich's Suprematist airplane, was the conquest of space. But whereas Malevich exalted the idea of liberation through flight into space by a machine, represented by geometrical shapes, Brancusi embodied similar concepts in a living organism, a bird, streamlined but subtly asymmetrical in its outlines. The highly polished surface of *Bird in Space* disguises the density of its bronze material; its luminosity catches the light,

and changing reflections intensify the effect of upward motion as the observer moves around it. . . .

This *Bird in Space* is set upon a two-part stone pedestal—the upper element a cylinder, the lower one a cruciform block. An old photograph, however, shows that it originally rested upon a base of paired truncated pyramids, one inverted above the other—an indented form suggested by the serrations of African wood sculpture, which influenced many of his works. Over the years he elaborated this form in several versions of the *Endless Column.*

The stone cylinder and cross-shaped block that now serve as pedestal for this *Bird in Space* contrast with the sculpture they support in several significant respects: a composite versus a unitary form; the matte surface of stone versus the high glitter of polished metal; manmade, geometrical shapes versus organic, subtly inflected contours; and the heavy mass of the stone base, bound by gravity to the earth, versus the bird's implied weightlessness as it soars freely into space.

Russia and the Bauhaus ———

Kazimir Malevich

Woman with Water Pails: Dynamic Arrangement. 1912–13
Illustrated on page 128

John Russell, *The Meanings of Modern Art,* **1981,** page 241

Unlike so many of his colleagues he [Malevich] had never been to Western Europe; but from the magazines, and from studying the great French pictures which were freely available to him in the collections of [Sergei] Shchukin and [Ivan] Morozov in Moscow, he knew more than most Frenchmen about what had lately happened in Paris. But when he came to paint the Russian peasant we see what might be called the pawmark of the Russian bear—the heavy, stamping, pounding rhythms that come through so memorably in the Russian dance in *Petrouchka,* which [Igor] Stravinsky had composed in 1911. Such paintings have a double inspiration: on the one hand, the French Post-Impressionists' use of pure flat color and simplified drawing, on the other, the emphatic plain statement of the Russian *lubok,* or popular print.

Malevich's peasant subjects of 1911–12 should, in fact, be related to something that turned up all over the civilized world before 1914—the wish to reinvigorate painting by reference to primitive or demotic modes of expression. Malevich knew a great deal about older European art, but he agreed with the dissident group of painters in St. Petersburg who had said in 1905 that no art of general communication could be fashioned from what they called "a sauce of history." If primeval energies were to hand, they should be tapped; if popular imagery, popular songs, popular forms of narrative were valid for the whole community in ways denied to more sophisticated forms of statement, then they too should be annexed for art.

Kazimir Malevich

Suprematist Composition: Airplane Flying. 1915
Illustrated on page 126

Helen M. Franc, *An Invitation to See,* **1992,** page 50

[Malevich] called his art Suprematism to signify "the

supremacy of pure feeling or perception in the pictorial arts." He explained its premises, saying: "The artist can be a creator only when the forms in his picture have nothing in common with nature . . . Forms must be given life and the right to individual existence." The Suprematist compositions of Malevich and his followers were the first purely geometrical abstractions. He did not use the term "abstract" for such works, however, but called them "non-objective," to indicate their complete liberation from representation; and he proclaimed Suprematism to be "the new realism in painting."

Like [Naum] Gabo, Malevich opposed [Vladimir] Tatlin's anti-aesthetic, utilitarian approach to art. His goals were visionary and utopian, emphasizing an art of feelings and emotions. He was interested in aerial photography, and in both his theoretical writings and his paintings, such as this one, he identified flight with man's "great yearning for space, . . . to break free from the globe of the earth." "It was nothing other than a yearning for speed . . . for flight . . . which, seeking an outward shape, brought about the birth of the airplane," he declared. The blank background was essential for the realization of his concept: "The blue color of the sky has been defeated by the Suprematist system, has been broken through, and entered white, as the true real conception of infinity, and therefore limited from the color background of the sky," he wrote. "I have torn through the blue lampshade of color limitation, and come out into the white; after me, comrade aviators sail into the chasm— I have set up semaphores of Suprematism. . . . Sail forth! the white, free chasm, infinity, is before us."

With no horizon line to orient the viewer, in this Suprematist composition the geometrical elements that represent the airplane float freely in space. There is no clearly defined "up" or "down," for the canvas is allowed to rotate. Photographs taken at various times and places during Malevich's lifetime show it installed so that the diagonal thrust of the composition proceeds from lower right to upper left, as here, and at other times it goes in the opposite direction, from lower left to upper right.

Kazimir Malevich
Suprematist Composition: White on White. 1918
Illustrated on page 127

Press release, The Museum of Modern Art, **1942**

Some of the earliest abstract art ever produced will be shown in a group of eleven compositions by the first great master of geometrical abstract painting, the Russian Kasimir Malevich, who in 1913 began to base his art (which he called Suprematism) upon the square and the circle. Several of the Malevich compositions were brought to the United States in 1935 by Alfred H. Barr, Jr., Director of the Museum of Modern Art. He had found them in a German cellar hidden from the Hitlerian wrath against all modern art. Mr. Barr bought them and, to get them safely out of Germany, wrapped several of the canvases around his umbrella, hid drawings in magazines, and thus was able to take them out of the country unnoticed. Also exhibited will be works by Alexander Rodchenko, who was probably the first to call his paintings Non-objectivist. . . .

Mr. Barr made the following statement in regard to the exhibition: "Russian abstract art done both before and after the revolutions of 1917 is richly represented by the work of seven masters, including [Mikhail] Larionov the Rayonist, Malevich, the Suprematist, and Rodchenko, probably the first to take the name Non-objectivist. Malevich's seven paintings, four drawings and five analytical charts form probably the only exhibited collection of the work of this important pioneer who is no longer honored in his own country.". . .

NOTE: Chief among Malevich's followers was Alexander Rodchenko, who in 1915 broke away from his master and founded the "Non-objectivist" group. At the famous Tenth State Exhibition in Moscow in 1919, works by both Malevich and Rodchenko were prominently exhibited. Rodchenko found out before the opening that Malevich was going to submit the composition *White on White* (a white square on a white canvas), and in a spirit of rivalry he painted and submitted his *Black on Black* (see page 130). . . .

The battered condition of both paintings is evidence of their refugee wanderings. For in the years following the 1919 Exhibition, abstract art fell gradually into official disfavor in Moscow. No longer encouraged to paint Non-Objectivist canvases, Rodchenko was persuaded that he would be more useful to society in typography and photography, in which he was still active when last heard from before the outbreak of war. His paintings lay unseen, uncared for, and forgotten for many years before coming to this country. On his part, Malevich retired to Leningrad and later sent his paintings to a still hospitable Germany where an exhibition of his work was held about 1927. But with the advent of Hitler, his paintings again went into hiding until Mr. Barr rescued them seven years ago.

Malevich

Suprematist Composition: White on White

Ellsworth Kelly, *Artist's Choice: Fragmentation and the Single Form,* **1990,** n.p.

By 1915 Malevich was isolating a single black or red square against a white ground, and three years later he painted a white square on white. Recently I realized how closely related the Malevich squares on white are to early Russian icons. Most icons have large borders, a built-in "frame" that is sometimes in slight relief around the icon itself. In his black and red square paintings, Malevich, in effect, blocked out and completely abstracted the specific religious content within the squared border-frames, making color his content. In the icons, holy figures are often found standing or sitting on a platform that is tilted in isometric perspective, assuming a diamond shape like that in Malevich's *White on White* of 1918. The similarities of Malevich's Suprematist paintings to the traditional icons of his Russian culture are structural, formal, and even metaphysical in that there is a shared commitment to picturing transcendental realities.

Liubov Popova

Painterly Architectonic. 1917
Illustrated on page 129

MoMA Highlights, **1999,** page 84

In *Painterly Architectonic*, one of a series of works by this title, Popova arranges areas of white, red, black, gray, and pink to suggest straight-edged planes laid one on top of the other over a white ground, like differently shaped papers in a collage. The space is not completely flat, however, for the rounded lower rim of the gray plane implies that this surface is arching upward against the red triangle. This pressure finds matches in the shapes and placements of the planes, which shun both right angles and vertical or horizontal lines, so that the picture becomes a taut net of slants and diagonals. The composition's orderly spatial recession is energized by these dynamic vectors, along which the viewer's gaze alternately slides and lifts.

Influenced by her long visits to Europe before World War I, Popova helped to introduce the Cubist and Futurist ideas of France and Italy into Russian art. But, no matter how abstract European Cubism and Futurism became, they never completely abandoned recognizable imagery, whereas Popova developed an entirely nonrepresentational idiom based on layered planes of color. The catalyst in this transition

was Kazimir Malevich's Suprematism, an art of austere geometric shapes. But where Suprematism was infused with the desire for a spiritual or cosmic space, Popova's concerns were purely pictorial.

Aleksandr Rodchenko

Non-Objective Painting: Black on Black. 1918
Illustrated on page 130

Magdalena Dabrowski, *Aleksandr Rodchenko,* **1998,** pages 23, 24, 28, 30

From his early years as an artist, Rodchenko was interested in more than merely formal artistic explorations; he was preoccupied with the idea of an art of the future. This became particularly important after his move to Moscow [in 1913] and his entry into the circle of the avant-garde. As he writes in his memoirs, he felt far less close to the aesthetes of the World of Art group, with their bourgeois tastes, than to artists who were neglected by the collectors and attacked in the newspapers, artists such as [Kazimir] Malevich, [Vladimir] Tatlin, [Vladimir] Mayakovsky, and Velimir Khlebnikov, artists whose work subverted the established aesthetic canons, tastes, and values—artists like him.[1] "We were for the new world," he wrote, "the world of industry, technology and science. We were for the new man; we felt him but did not imagine him clearly. . . . We created a new understanding of beauty, and enlarged the concept of art. And at that time such battle—I believe—was not a mistake."[2] This battle had barely begun by October of 1917, when the artists' "leftist" ideas were joined to the ideals of the Revolution. . . .

Further research into such physical attributes of painting, and into the dynamic relationships among those attributes, appears in Rodchenko's "Black on Black" series, in all of which the artist investigates mutations of the same structural problem: how to organize interlocking circular and parabolic or elliptical elements, colored in a close range of blacks, in the most economical way, yet at the same time in the most expressive one. He also explores the inherent potentials of *faktura* in this series. The differing textures of individual elements; the interplay of these textures, and of the forms to which they are applied; the play of light on them—all these result in transformations of the surfaces and expressive qualities of Rodchenko's paintings. Differences in texture, for example, set some forms in greater relief, while others seem to act as the stronger forms' "shadows," or even to dissolve into the background. The content of the paintings becomes the dynamic interaction of basic geometric forms in closely valued hues against

a uniformly colored pictorial surface. The works bear no relation to any traditional mimetic or narrative values, and their highly reductive pictorial vocabulary manifests the ultimate radicalism of Rodchenko's innovations.

These experiments further show Rodchenko's interest in discovering new pictorial options through both technical transformations of the painting's surface and the creation of dynamic spatial effects by solely pictorial means. In the process he examines the properties of color, in its absolute as well as its relative values—that is, both the fundamental characteristics of a color and those of its different shades. Aleksandr Lavrent'ev has suggested that Rodchenko's "Black on Black" paintings represent his response to Malevich's famous *Black Square*, which had been prominently displayed in the *0:10* exhibition back in 1915 and had been much discussed since then by the avant-garde.[3] As Malevich began the non-objective phase in painting, so Rodchenko responded to the dialectic of non-objectivity.[4] In fact, however, Rodchenko was responding not only to the iconic image and meaning of *Black Square* but also to Malevich's quintessential statement on the absolute in art, which he attempted to achieve in his most reductivist work, *White on White* of 1918 (see page 127). The "Black on Black" works counter Malevich's icon of spirituality with symbols of nothingness. . . .

In the black paintings, then, black is divested of its function as color and becomes subsumed into the element that engenders new meaning—the *faktura* or surface treatment, the material substance identified with the parameters of the picture plane.

In addition, a crucial new aspect comes to the fore, namely the concept of professionalism of execution. Objective elements displace subjective judgment as criteria of the work's artistic value; in fact they become vital components in the viewer's process of evaluation. The physicality of the painting as an object, and the physicality of the execution, become the new criteria in the appreciation of the work of art. Material itself—in this case paint—and the method of its application influence the perception of the object. This unprecedented approach to the painting as an object in itself marks a major development in Rodchenko's art, and indeed a crucial innovation in the history of the avant-garde. It also represented their utopian conception of the aesthetic needs of the new mass viewer.

László Moholy-Nagy
Q 1 Suprematistic. 1923
Illustrated on page 131

John Russell, *The Meanings of Modern Art,* **1981,** pages 247, 248

Moholy-Nagy was a one-man compendium of the postwar pacific International. He had shared a studio with Kurt Schwitters, he had attended the Constructivist Conference which had been called by [Theo] van Doesburg in Weimar in 1922, he knew [El] Lissitzky, he was familiar with the achievement of [Kazimir] Malevich. . . .

It may, in fact, be Moholy-Nagy in the end who most thoroughly validates the Bauhaus' reputation for modernity. By the second half of the 1920s people were already remarking on the fact that the school was dominated by people whose careers had begun before 1914, and that the arts-and-crafts element in the Bauhaus had always augured oddly for an institution which prided itself on being up-to-date. With Moholy-Nagy, no such complaints were possible. He, if anyone, was alert to all the possibilities of his time. (In 1922 he had painted a picture by telephone, giving orders so exact that they could be carried out by any skilled executant.) In his books *The New Vision: From Material to Architecture* and *Vision in Motion* an attentive reader will find a running fire of ideas and injunctions as to how best to bring about the reintegration of art and society.

Moholy-Nagy said in 1922 that "the art of our century, its mirror and its voice, is Constructivism." In this he followed Lissitzky, [Naum] Gabo and [Vladimir] Tatlin, all of whom were convinced that new materials called for a new art, and a new art which would above all be dynamic and kinetic in its allegiances; a clean break was to be made with the static apartness of older art, and with its traditional stance on wall or floor.

De Stijl

Piet Mondrian

Color Planes in Oval. 1913–14
Illustrated on page 132

James Johnson Sweeney, *Mondrian,* **1948,** pages 10, 13

Mondrian's fundamental aim in art was to transcend the particular to express the universal. He was the great uncompromising classicist of the early 20th century. Romantic art deals with the particular; for Mondrian the particular was a trammel, a fetter. He felt that naturalistic forms in painting were limited forms by the very definition of their specific references: "the particularities of form and natural color evoke subjective states of feeling which obscure pure reality." For Mondrian reality was that essential quality we find in nature, not its surface appearances. The appearances of natural things were constantly changing, but this living quality, this inner reality of nature, was constant—universal. In his opinion a truly universal art should provide through its own medium an equivalent for this inner reality, or living quality, rather than merely a reflection of surface features. In other words, he wanted a cleaner universal basis of expression than naturalistic representation could give him—a purer base for the universal expression of the classicist than any painter before him had achieved. This is what he meant by his frequently repeated insistence that we must "destroy the *particular* form." This is why he pursued the tangent of the arc, described by the Cubist movement, toward a further simplification of elements, instead of returning with it to a relative naturalism after its first severe disciplinary phase had served its end.

Cubism was not the solution. But besides pointing a step in the direction of destroying the particular form it also clarified Mondrian's basic problem for him. Through Cubism he came to realize that he might achieve an equivalent for the living quality or inner reality of nature through an interplay of contrasting pictorial elements and through the tension of their relationships. He saw that in a picture the only dependable source of energy for such an interplay of forces lay in a persistent, equilibrated contrast between an invariable element and a group of variables. He found that for him the only constant relation in painting was the right angle. Variety he saw most universally expressed through contrasting

simple forms and primary colors, never naturalistically limited. And on these bare premises all the work of Mondrian's last twenty-five years was based.

Piet Mondrian

Composition in White, Black, and Red. 1936
Illustrated on page 135

Alfred H. Barr, Jr., *What is Modern Painting?* **1943,** page 27

Piet Mondrian is Dutch by birth and he loves cleanliness and fine workmanship. He likes cities with their rectangular patterns of streets, buildings, windows. The *Composition in White, Black and Red*, which seems so simple, took months to paint; for each rectangle is a different size, each black line a different thickness, and the whole is put together and adjusted to a hair's breadth with the conscience and precision of an expert engineer—though with this fundamental difference: that the engineer works for practical results, Mondrian for artistic results—which in his case might be called the image of perfection.

Yet Mondrian's pictures almost in spite of themselves have achieved practical results to an amazing extent. They have affected the design of modern architecture, posters, printing layout, decoration, linoleum and many other things in our ordinary everyday lives. (Mondrian, by the way, is not a cold intellectual; though he is over seventy he loves swing music; his latest abstract painting is called *Broadway Boogie Woogie* and lives up to its title.)

Theo van Doesburg

Rhythm of a Russian Dance. 1918
Illustrated on page 133

Helen M. Franc, *An Invitation to See,* **1992,** page 64

A few years after [Kazimir] Malevich started from scratch to create a "pure" art from simple geometrical forms, a group of artists in the Netherlands achieved total abstraction by working in the opposite direction. They began with naturalistic forms and, by analyzing their essential elements, gradually reduced—or abstracted—them to compositions constructed entirely of rectilinear shapes.

Rhythm of a Russian Dance is the culmination of a detailed analysis that van Doesburg carried out through a sequence of seven preceding studies. He moved progressively from his first naturalistic sketch of a dancer to the final painting, which is composed of flat bars arranged at right angles to one another in such a way that their shapes, and the spatial intervals between them, are an abstract transcription of the rhythmic, staccato dance movements.

Van Doesburg was the organizer and principal theorist of a group of painters and architects, whom he brought together in 1917 under the name of de Stijl ("the Style"). Their aesthetic principles restricted the artists' means to the basic minimum of the straight line and right angle (symbols of man's intellectual dominance over the diffuse, capricious forms of nature) and to the three primary colors red, yellow, and blue, together with the neutrals black, gray, and white. They regarded the painting thus created as the new, universal art of the future and named it Neo-Plasticism. It was described as "*abstract-real*" because it stands between the absolute-abstract and the natural, or concrete-real. It is not as abstract as thought-abstraction, and not as real as tangible reality. It is aesthetically living plastic representation: the visual expression in which each opposite is transformed into the other."

Four Abstract Artists

Sophie Taeuber-Arp
Composition of Circles and Overlapping Angles. 1930
Illustrated on page 136

Carolyn Lanchner, *Sophie Taeuber-Arp,* **1981,** pages 9, 13, 14

For Sophie Taeuber-Arp, pictorial abstraction was not at the end of an exploration but at the beginning. In this she is set apart from most of her peers in the generation that pioneered the development of abstract language in painting. Most arrived at their mature styles between 1910 and 1920 through a progressive schematization of the forms of objective reality. Wassily Kandinsky's worry that color and form might not be "compositionally fitted for survival" was not hers.[1] It is partly owing to this untroubled acceptance of the innate expressive effectiveness of the means of painting that her work, even at its most severely geometric, exhibits a sense of freedom often startling in the context of its formal rigor. . . .

But for Taeuber-Arp, the transition to an art without recognizable image apart from geometric form was less fraught with doubt than for her contemporaries, less consciously an extrapolation of Cubist vocabulary; and, because it was free of romanticist interpretations of the machine or nature, it was nonprogrammatic. As she did not come to see abstraction as an end in itself, she, like Klee, was able to work simultaneously with abstract and representational means.[2] . . .

As [Piet] Mondrian may be considered the artist of the right angle, Taeuber may be considered the artist of the circle. For Mondrian, the right angle represented the meeting and resolution of extremes; for Taeuber, the circle was the cosmic metaphor, the form that contains all others. . . .

Although in no sense anthropomorphic, the geometric forms of Taeuber-Arp's work of the thirties often appear animated as if by their own inner batteries. . . .

As [Hugo] Weber has pointed out, "the choreographic element" was of fundamental importance in all of Taeuber-Arp's work.[3] Her ability to create an art in which the rule of ordered, rhythmic harmony is undisturbed by the sometimes anarchic play of forms owes much to her study of the dance, and it is in her work of the thirties that this influence is most strongly felt. [Ludmila] Vachtova notes: "Sophie's memory of the dance and transposition of movements that are at one moment dramatic, eccentric, and then are governed by a delicate rhythm, lead to an art of *unregelmässig-Regelmässigkeit* [freely translated, to a nonregular regularity, an eccentricity within conformity], uninterrupted harmony obtaining."[4]

Joaquin Torres-García
Composition. 1931
Illustrated on page 137

Florencia Bazzano Nelson, in *Latin American Artists of the Twentieth Century,* **1993,** pages 72, 75, 76

What Torres-García called Constructive Universalism rested on two principles: the universalist notion

that an artistic tradition has existed since remote times that expresses essential truths through geometrically determined archetypes, and the classical idea that the work of art is a ground where opposing cosmic forces can be combined harmoniously. On these principles Torres-García elaborated a monumental but coherent metaphysical and aesthetic system. His beliefs were so firm and his message so timely that his avant-garde Americanist project influenced several generations of artists. . . .

The symbolic quality of Torres-García's Constructive Universalism is one of its most notable features. The use of symbols became an essential aspect of his system, and it is the most important point of difference between his work and that of other Constructivists. His symbols are self-referential graphic ideas that do not represent anything but themselves because the idea is completely identified with the form.[1] Torres-García's symbols are, by his own reckoning, comparable to Platonic forms because they are *"materializations of the universal spirit,"*[2] which, having the magical virtue of translating spiritual states, awake analogous emotions in the soul[3] and "make the spirit present."[4] He also believed that his symbols expressed the vast world of the unconscious, a conviction that indicates the often overlooked connection of his work with Surrealism.[5] . . .

Surrealism also affected Torres-García's relationship with adherents of other Constructivist movements.[6] Torres-García could only agree partially with their aim of consolidating "a common front against 'the tyranny of the individual' in art" because he still deemed the unconscious necessary in the "constructive" process.[7] Torres-García also disagreed with their opposition to all art of the past, a stance proposed by Naum Gabo and Antoine Pevsner in the "Realistic Manifesto" of 1920, and with their emphasis on logical reasoning based on scientific facts, and their call for standardization and utilitarianism.[8] Thus, Constructive Universalism differed greatly from its European counterparts because Torres-García defined and understood constructivism not only in terms of the avant-garde but also as continuing a tradition of universal art that privileged metaphysical concerns above all others.

George L. K. Morris
Rotary Motion. 1935
Illustrated on page 137

George L. K. Morris, in *The Museum of Modern Art Bulletin,* **1951,** page 4

[J. A. M.] Whistler's observation has been often quot-

ed,—that an artist who paints Nature without a high degree of selection is like a "pianist who *sits* on the keyboard." Had Whistler been familiar with abstract art, he might have cautioned further against someone who "sits on his palette." If a painter *should* sit on the palette he'd probably produce something strong and brutal—there might even be a suggestion of agony. But can an artist thus found a base of operations on which to build a changing world and when the shock is over, how will it strike the eye in repose? Anyway, it should never be uniqueness we are after, but the basis of style.

This brings me to a second aspect. No one ever hated modern art more violently than our late critic, Mr. Royal Cortissoz. Yet I will honor him for a penetrating notation, which I frequently recall. He once summed up a modern exhibition with the outburst "This may be all very interesting, but Oh, the *looks* of it!" He puts forward so memorably a truth which can never be over-stressed—that painting is basically an optical experience. (And by "looks of it" we must hang on to our instincts for quality, and not false conceptions of appearance.) After this instantaneous effect, fine pictures of course require long and repeated study—but to a surprising degree the initial tell-tale glance will carry through. And for abstract art this test is merciless. There is no hiding from it through subject-interest; confusion can cloud it for a moment, but we are interested in something that will last.

Much more could be said about the two ingredients of abstract art—the emotional impulse and the structural fabric that is essential to make it credible. In primitive art the ability to fuse the two is quite natural and appropriate. No wonder the Cubists started from Negro sculpture—and they themselves produced a unity that was welded as tightly as a fist. How do we find this ourselves? There is not much to follow beyond one's qualitative sense. And now I am approaching the territory where words can hardly follow. Taste and quality are as difficult to trace consciously as to delineate the exact points of superiority between a rare vintage-wine and a bottle of Coca-Cola. Yet it is a sense of quality which governs entirely the two points I have been stressing. One false note in an abstract picture can turn vintage-wine into a nasty medicine, and we must be ever alert for the taste. Moreover there are no rules for drawing the boundaries. Still, I will close with a generalization—that art produces two opposing forces, like the intake and outlet of the breath; it takes one individual impulse to activate a painting with life—the second fastens it with control, and makes possible a firmer activity toward the next creation.

Four American Modernists ——

Stuart Davis
Odol. 1924
Illustrated on page 138

Kirk Varnedoe, *High & Low,* **1990,** pages 292, 293, 294

France in 1920 was still relatively underdeveloped as a society of industry and urban centers. But Paris was at the forefront of artistic innovation, and had been for decades; and from this vantage, the future was visible, or at least depictable, as it was not from others. In their ability to represent what they thought of as the spirit of modern life, French artists depended at least as much on models of artistic construction and color that were wholly un-urban and unconcerned with the iconography of popular culture—the landscape paintings of [Paul] Cézanne or [Vincent] van Gogh in Provence, for example— as on the data of daily experience. In America, however, the trappings of modern material life came earlier and were more dominant in the major cities, but no new manner of painting provided an appropriate way to take them on.

[Fernand] Léger and his Purist associates were drawn to America as a model for modernity, in the power of its industrial forms (grain silos as well as skyscrapers) and in the promise of a more rational production and distribution of goods. The United States had also long been regarded as the homeland of advertising, the society most attuned to everything commercial. (In [Pablo] Picasso's costumes for the 1917 ballet *Parade*, while the "French manager" holds a clay pipe of the type which so often stood for the pleasures of idle reflection in his café still lifes, the "American manager" holds a megaphone, as a relentlessly loud carnival barker calling up the crowd.) American modernists, though, largely learned to see this through outsiders' eyes. They were drawn to the work of their European contemporaries as a model for assimilating and representing the look of their own society, especially in advertising.

The two central exemplars of this connection, Stuart Davis and Gerald Murphy, absorbed Léger's geometrized planes of color and monumentalizing simplicity. But they combined the café table and the billboard by joining that style to a Cubist iconography of the more private pleasures offered by modern

mass production and packaging—cigarettes, newspapers, safety matches, and shaving razors—and to a Cubist appreciation for the look of individual logos. Davis's *Odol* or Murphy's *Razor*, for example, would never be mistaken for European art of the period. . . . The American works are less interested in the classic, generic item of popular use, or in a standardized form of communication, than in the varied look of product design and brand identity. *Odol* has a head-on acceptance of the package design that seems flat-footed on the one hand, and on the other possessed of a bald power that looks ahead to later Pop painting.

Gerald Murphy
Wasp and Pear. 1927
Illustrated on page 139

William Rubin, *The Paintings of Gerald Murphy,* **1974,** page 42

Murphy considered *Wasp and Pear* "probably the best" of his pictures, and in some respects it is. . . . [T]he insect and fruit have more freely invented arabesqued silhouettes, for which the background acts rather as a foil. The progression through a shallow space from the rear planes where the insect's comb is located to the bulging surface of the pear in the center of the field is more consistent and more controlled than in previous works, and indicates a surer grasp of Cubism.

The notebook entry for *Wasp and Pear* reads:

Picture: hornet (colossal) on a pear (marks on skin, leaf veins, etc.)
(*battening* on the fruit, clenched . . .

This is Murphy's only convincing rendering of an organic, living thing. . . . Murphy had always been a careful observer of nature—"Have you ever seen the lining of a potato bug's wings?" he wrote Sara during their courtship[1]—and he "never forgot the large technically drawn and colored charts" of fruits, animals, and insects which he had encountered by chance during his wartime training.[2] But despite the precision of his drawing and the accuracy of the textbook-like microscopic enlargement of the wasp's leg,[3] Murphy had no Audobonesque scientific concern in this image. His emphasis is on inventive pat-

terning, as in the head and transparent wing of the wasp, and to that end he was perfectly content to omit the insect's rear wings.

Georgia O'Keeffe
Lake George Window. 1929
Illustrated on page 139

Helen M. Franc, *An Invitation to See,* **1992,** page 123

Like [Giacomo] Balla, O'Keeffe has taken a single motif from perceived reality and, by isolating it from its surroundings, intensified its visual and emotional impact. At first sight, her *Lake George Window* seems far closer to photography than his *Street Light;* and it is tempting to push the analogy to camera work, in view of the fact that O'Keeffe's art was first exhibited in 1916 at the famous avant-garde "291" gallery directed by the master photographer Alfred Stieglitz, whom she subsequently married. On closer inspection, however, what seems paramount in this painting is the rigid selectivity of O'Keeffe's approach, which is highly stylized, deleting any details that might mar the immaculate precision of the forms and the surface of the canvas. By contrast, a photograph of the same Lake George farmhouse by Stieglitz is more complex in composition and is taken at an angle, with a raking light to accentuate the textures of the clapboards.

O'Keeffe presents the structure in a strictly frontal, symmetrical view and drastically reduces its three-dimensionality. Commenting on this painting, Lloyd Goodrich has said: "Though entirely realistic, its severe simplification, stark rectangular forms and austere color harmony, and the fine relations of all elements, give it the quality of a handsome abstract design."

Patrick Henry Bruce
Painting. c. 1929–30
Illustrated on page 138

William C. Agee, *Patrick Henry Bruce,* **1979,** pages 2, 28, 30, 37

Although Bruce's work first became more widely known through the exhibition "Synchromism and Color Principles in American Painting, 1910–1930," . . . he never allied himself with any school, even unofficially. On the contrary, he broke with one teacher after another, ultimately renouncing [Robert] Delaunay as well, to go his own way in search of a personal and unique style that is an original contribution to Cubism as well as to color abstraction. In his final search for the "absolute," Bruce came to reject much that he was taught and practically everything he saw, preferring to spend his time studying the Old Masters at the Louvre rather than talking at the cafés of Montparnasse that he frequented during his youth. A demanding artist to begin with, he became ever more demanding both of himself and of others. . . .

In 1933 Bruce destroyed all but twenty-one of [his geometric still lifes] [1] . . . We do not know how many he had actually painted by 1933 although he had exhibited thirty-four between 1919 and 1930. They are neither signed nor dated, and the sequence and chronology . . . [are] based on stylistic analysis and on a few documents and eyewitness accounts. . . .

We still tend, reflexively and simplistically, to associate gometry with the cold, the impersonal, and the unfeeling. It is a measure of the richness—as well as the complexity and ambiguity—of Bruce's work that his geometric paintings appeal to the senses, evoking old artifacts that Bruce deeply loved; gathered from many countries and cultures, each has its own set of historical and personal connotations and references. They are objects that represent the intimacy and pleasures of his private world. . . .

In [this painting] . . . the shapes stand on their own, each conceived as a fully modeled entity. Here it should be noted that the bulk and separate space accorded each object always distinguishes Bruce's paintings from the more flattened and schematic shapes in the still lifes of [Amédée] Ozenfant, Le Corbusier, and [Fernand] Léger. In earlier paintings Bruce had employed a wide range of pearlescent, almost pastel hues, but in the late vertical bar paintings and the last two pictures, Bruce returned to richer and more simplified color, consisting of the primaries and a few of their variants. The primaries in the last painting form the dominant chord and are heightened and contrasted by the deep black of the table, by creamy whites, and the gray of the cylinder; they are also set off by the light greens of the vertical planes at front and rear, as well as by the subtle gradation of the several zones of red toward the pink of the glass. The yellow straw strikes a binding and resounding note that is almost sublime. In the late pictures Bruce never graduated or contrasted hues within a given area, and values were kept at an equally high but modulated pitch. His touch became lighter, surfaces were kept more even, and he achieved a full, though not heavy, paint texture. It was in this painting that Bruce found the richness and balance that he took for his model for the paintings that he continued to work on steadily until he left for America in 1936.

Cubism

Georges Braque | FRENCH, 1882–1963
ROAD NEAR L'ESTAQUE. 1908
OIL ON CANVAS, 23⅛ x 19¾" (60.3 x 50.2 CM)
GIVEN ANONYMOUSLY (BY EXCHANGE)

Pablo Picasso | SPANISH, 1881–1973
LANDSCAPE. 1908
OIL ON CANVAS, 39⅛ x 32" (100.8 x 81.3 CM)
GIFT OF MR. AND MRS. DAVID ROCKEFELLER

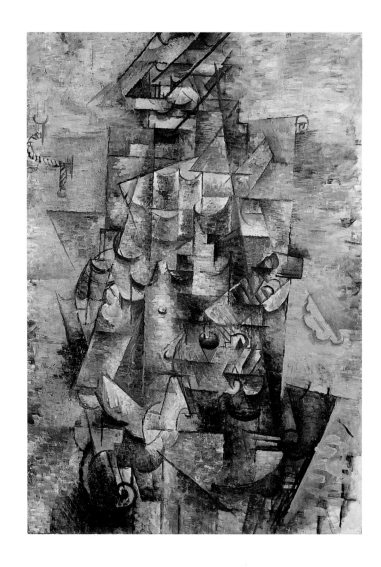

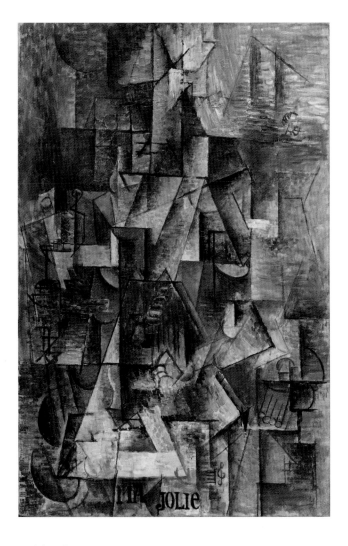

Pablo Picasso
MA JOLIE. 1911–12
OIL ON CANVAS, 39⅜ x 25¾" (100 x 65.4 CM)
ACQUIRED THROUGH THE LILLIE P. BLISS BEQUEST

Georges Braque
MAN WITH A GUITAR. Begun summer 1911;
completed early 1912
OIL ON CANVAS, 45¾ x 31⅞" (116.2 x 80.9 CM)
ACQUIRED THROUGH THE LILLIE P. BLISS BEQUEST

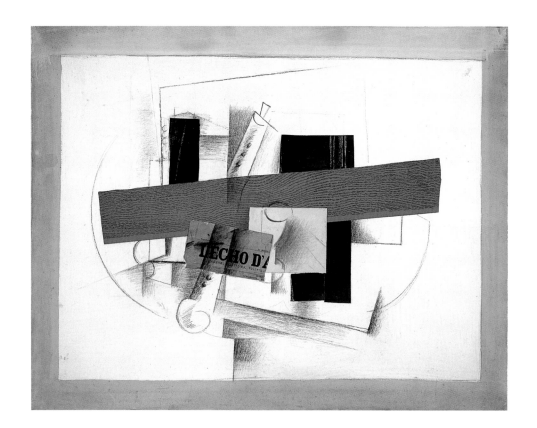

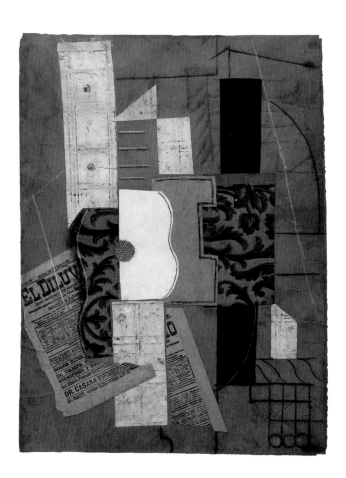

Georges Braque | FRENCH, 1882–1963
STILL LIFE WITH TENORA. 1913
PASTED PAPER, OIL, CHARCOAL, CHALK, AND PENCIL
ON CANVAS, 37½ x 47⅛" (95.2 x 120.3 CM)
NELSON A. ROCKEFELLER BEQUEST

Pablo Picasso | SPANISH, 1881–1973
GUITAR. 1913
PASTED PAPER, CHARCOAL, INK, AND CHALK ON BLUE
PAPER MOUNTED ON RAGBOARD, 26⅛ x 19½" (66.4 x 49.6 CM)
NELSON A. ROCKEFELLER BEQUEST

Juan Gris | SPANISH, 1887–1927
GUITAR AND FLOWERS. 1912
OIL ON CANVAS, 44⅛ x 27⅝" (112.1 x 70.2 CM)
BEQUEST OF ANNA ERICKSON LEVENE IN MEMORY OF
HER HUSBAND, DR. PHOEBUS AARON THEODOR LEVENE

Marc Chagall | FRENCH, BORN BELARUS. 1887–1985
I AND THE VILLAGE. 1911
OIL ON CANVAS, 6' 3⅝" x 59⅝" (192.1 x 151.4 CM)
MRS. SIMON GUGGENHEIM FUND

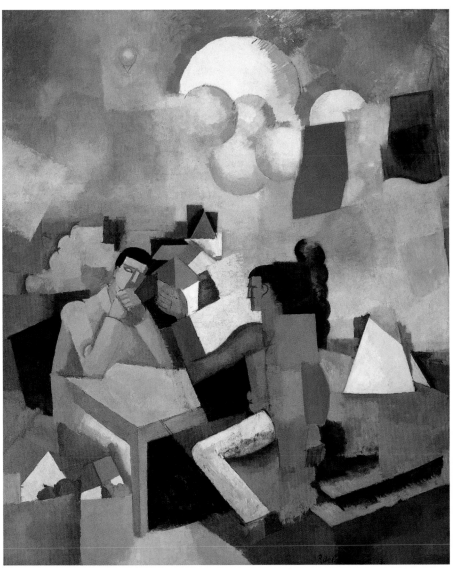

Robert Delaunay | FRENCH, 1885–1941
SIMULTANEOUS CONTRASTS: SUN AND MOON
[SOLEIL, LUNE, SIMULTANÉ 2]. 1913; dated on
painting 1912
OIL ON CANVAS, 53" (134.5 CM) IN DIAMETER
MRS. SIMON GUGGENHEIM FUND

Roger de La Fresnaye | FRENCH, 1885–1925
THE CONQUEST OF THE AIR. 1913
OIL ON CANVAS, 7' 8⅛" x 6' 5" (235.9 x 195.6 CM)
MRS. SIMON GUGGENHEIM FUND

117

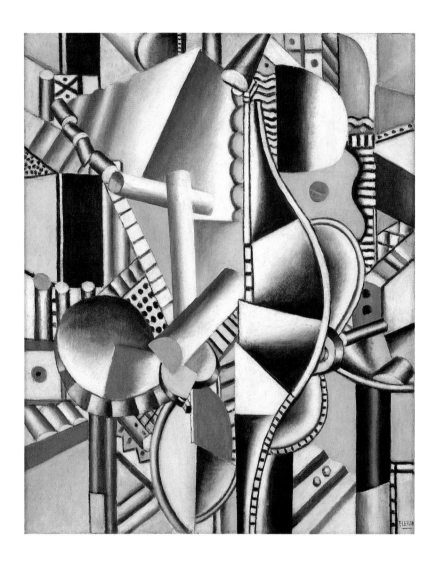

Fernand Léger | FRENCH, 1881–1955
PROPELLERS. 1918
OIL ON CANVAS, 31⅞ x 25¼" (80.9 x 65.4 CM)
KATHERINE S. DREIER BEQUEST

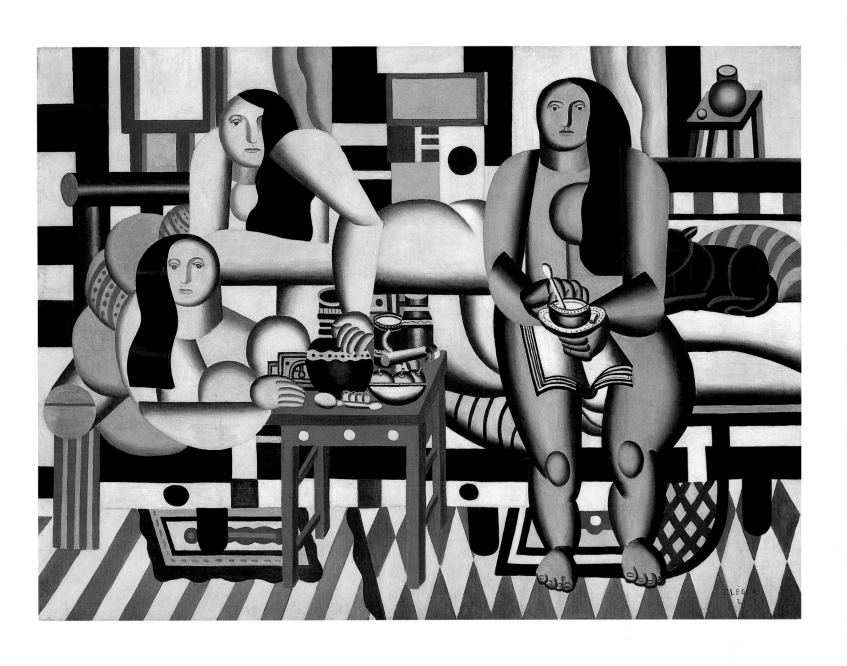

Fernand Léger
THREE WOMEN [LE GRAND DÉJEUNER]. 1921
OIL ON CANVAS, 6' ¼" x 8' 3" (183.5 x 251.5 CM)
MRS. SIMON GUGGENHEIM FUND

Futurism

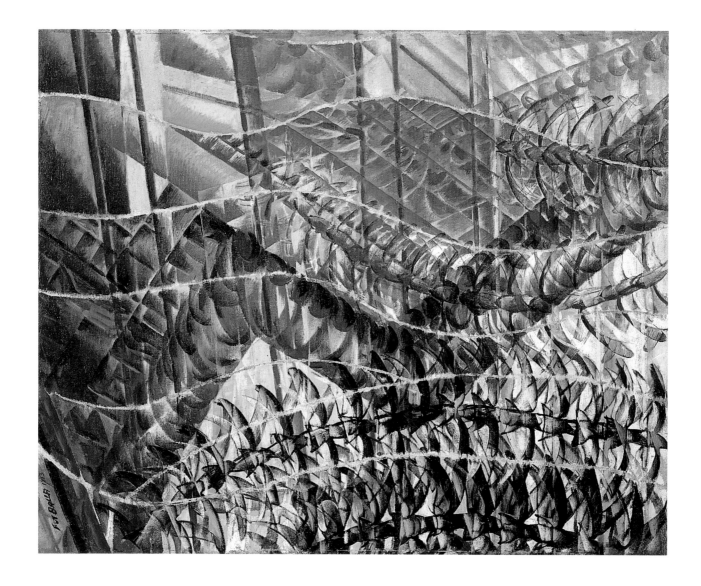

Giacomo Balla | ITALIAN, 1871–1958
SWIFTS: PATHS OF MOVEMENT + DYNAMIC SEQUENCES. 1913
OIL ON CANVAS, 38⅛ x 47¼" (96.8 x 120 CM)
PURCHASE

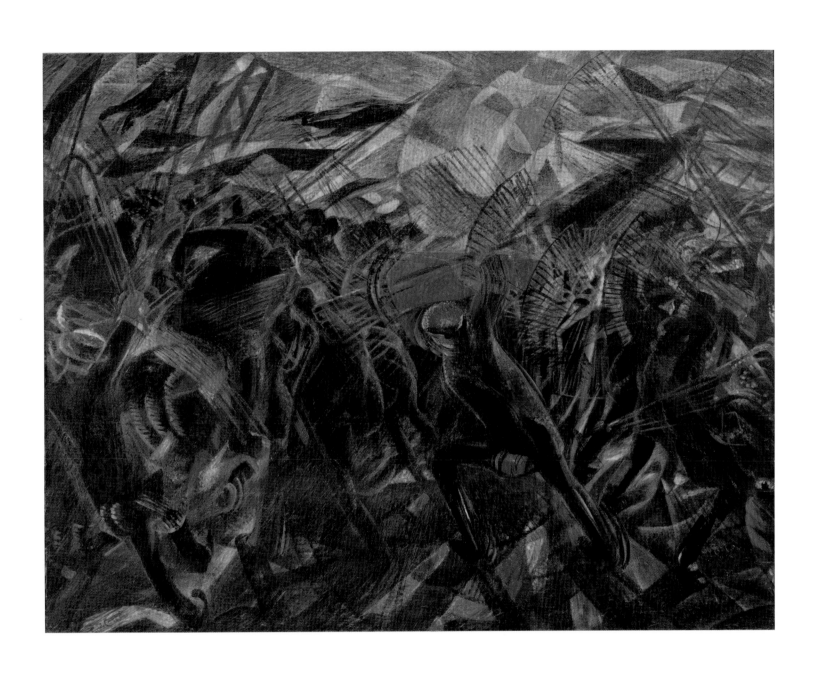

Carlo Carrà | ITALIAN, 1881–1966
FUNERAL OF THE ANARCHIST GALLI. 1911
OIL ON CANVAS, 6' 6¼" x 8' 6" (198.7 x 259.1 CM)
ACQUIRED THROUGH THE LILLIE P. BLISS BEQUEST

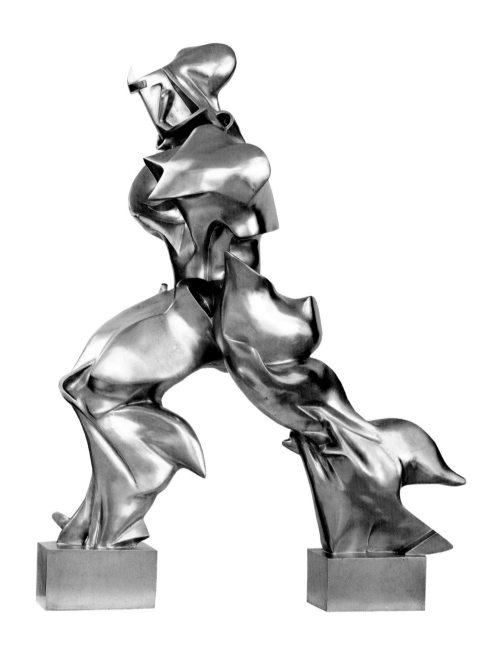

Umberto Boccioni | ITALIAN, 1882–1916
UNIQUE FORMS OF CONTINUITY IN SPACE. 1913
BRONZE (cast 1931), 43 7/8 x 34 7/8 x 15 3/4" (111.2 x 88.5 x 40 CM)
ACQUIRED THROUGH THE LILLIE P. BLISS BEQUEST

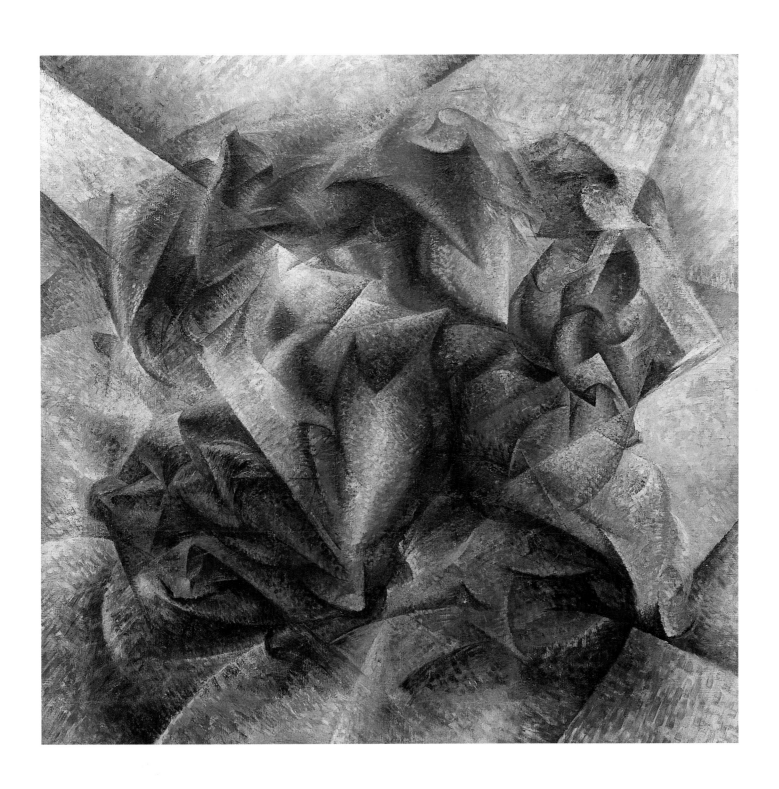

Umberto Boccioni
DYNAMISM OF A SOCCER PLAYER [DINAMISMO DI UN FOOTBALLER]. 1913
OIL ON CANVAS, 6' 4⅛" x 6' 7⅛" (193.2 x 201 CM)
THE SIDNEY AND HARRIET JANIS COLLECTION

123

Brancusi

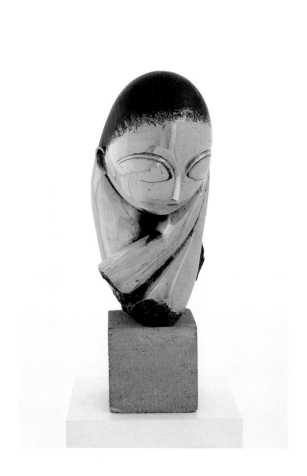

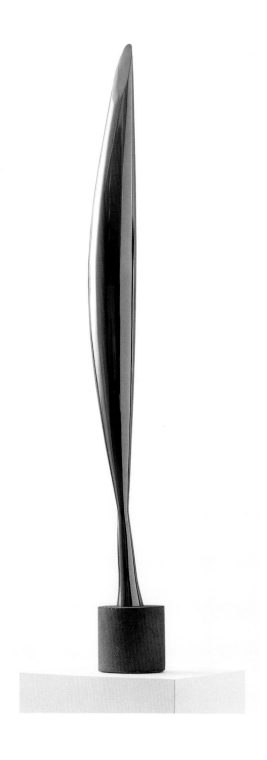

Constantin Brancusi | FRENCH, BORN ROMANIA. 1876–1957
MLLE POGANY. VERSION I, 1913 (after a marble of 1912)
BRONZE, 17¼ x 8½ x 12½" (43.8 x 21.5 x 31.7 CM)
ON LIMESTONE BASE, 5¼ x 6⅛ x 7⅜" (14.6 x 15.6 x 18.7 CM)
ACQUIRED THROUGH THE LILLIE P. BLISS BEQUEST

Constantin Brancusi
BIRD IN SPACE. 1928
BRONZE (unique cast), 54 x 8½ x 6½" (137.2 x 21.6 x 16.5 CM)
GIVEN ANONYMOUSLY

Constantin Brancusi
ENDLESS COLUMN. VERSION I, 1918
OAK, 6' 8" x 9⅞" x 9⅝" (203.2 x 25.1 x 24.5 CM)
GIFT OF MARY SISLER

125

Russia and the Bauhaus

Kazimir Malevich | RUSSIAN, BORN UKRAINE. 1878–1935
SUPREMATIST COMPOSITION: AIRPLANE FLYING. 1915; dated 1914
OIL ON CANVAS, 22⅞ x 19" (58.1 x 48.3 CM)
ACQUISITION CONFIRMED IN 1999 BY AGREEMENT WITH THE ESTATE OF KAZIMIR
MALEVICH AND MADE POSSIBLE WITH FUNDS FROM THE MRS. JOHN HAY
WHITNEY BEQUEST (BY EXCHANGE)

Kazimir Malevich
SUPREMATIST COMPOSITION: WHITE ON WHITE. 1918
OIL ON CANVAS, 31¼ x 31¼" (79.4 x 79.4 CM)
ACQUISITION CONFIRMED IN 1999 BY AGREEMENT WITH THE ESTATE OF KAZIMIR
MALEVICH AND MADE POSSIBLE WITH FUNDS FROM THE MRS. JOHN HAY
WHITNEY BEQUEST (BY EXCHANGE)

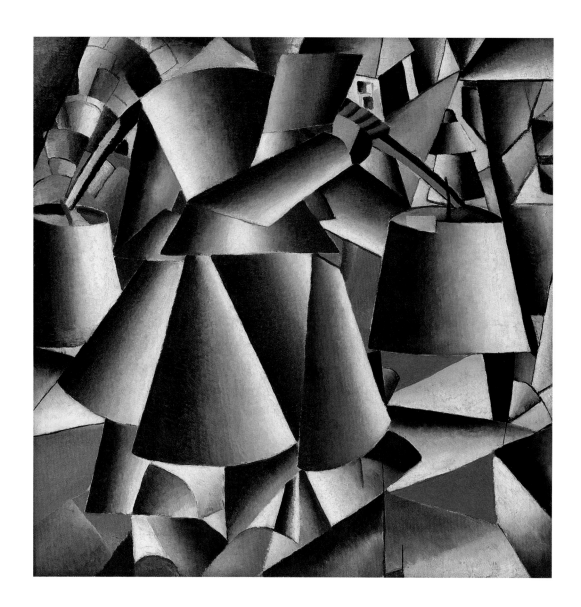

Kazimir Malevich | RUSSIAN, BORN UKRAINE. 1878–1935
WOMAN WITH WATER PAILS: DYNAMIC ARRANGEMENT. 1912–13; dated 1912
OIL ON CANVAS, 31⅝ x 31⅝" (80.3 x 80.3 CM)
ACQUISITION CONFIRMED IN 1999 BY AGREEMENT WITH THE ESTATE OF KAZIMIR MALEVICH AND
MADE POSSIBLE WITH FUNDS FROM THE MRS. JOHN HAY WHITNEY BEQUEST (BY EXCHANGE)

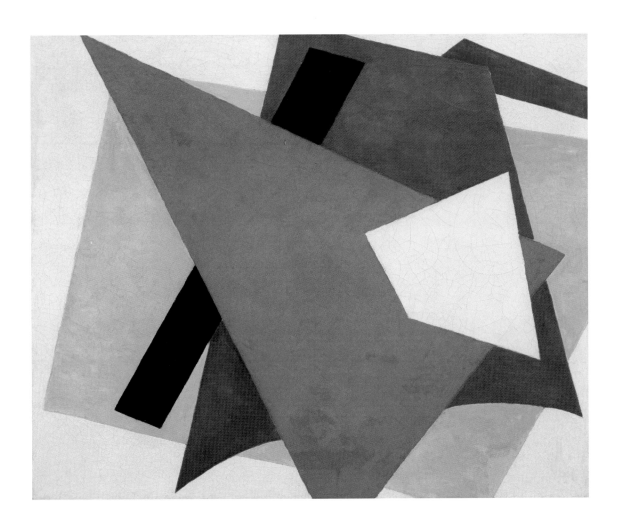

Liubov Sergeievna Popova | RUSSIAN, 1889–1924
PAINTERLY ARCHITECTONIC. 1917
OIL ON CANVAS, 31½ x 38⅛" (80 x 98 CM)
PHILIP JOHNSON FUND

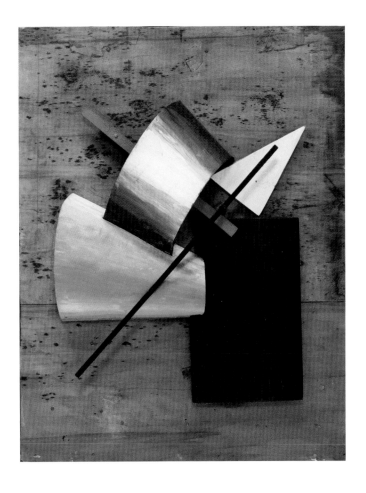

Ivan (Jean Pougny) Puni | RUSSIAN, BORN FINLAND. 1892–1956
SUPREMATIST RELIEF-SCULPTURE. 1920s reconstruction of 1915 original
PAINTED WOOD, METAL, AND CARDBOARD, MOUNTED ON WOOD PANEL,
20 x 15½ x 3" (50.8 x 39.3 x 7.6 CM)
THE RIKLIS COLLECTION OF McCRORY CORPORATION

Aleksandr Rodchenko | RUSSIAN,
1891–1956
NON-OBJECTIVE PAINTING: BLACK ON BLACK. 1918
OIL ON CANVAS, 32¼ x 31¼" (81.9 x 79.4 CM)
GIFT OF THE ARTIST, THROUGH JAY LEYDA

László Moholy-Nagy | AMERICAN, BORN HUNGARY. 1895–1946
Q 1 SUPREMATISTIC. 1923
OIL ON CANVAS, 37½ x 37½" (95.2 x 95.2 CM)
THE RIKLIS COLLECTION OF McCRORY CORPORATION

De Stijl

Piet Mondrian
COLOR PLANES IN OVAL. 1913–14
OIL ON CANVAS, 42⅜ x 31" (107.6 x 78.8 CM)
PURCHASE

Piet Mondrian | DUTCH, 1872–1944
COMPOSITION WITH COLOR PLANES, V. 1917
OIL ON CANVAS, 19⅜ x 24⅛" (49 x 61.2 CM)
THE SIDNEY AND HARRIET JANIS COLLECTION

Theo (C. E. M. Küpper) van Doesburg | DUTCH, 1883–1931
RHYTHM OF A RUSSIAN DANCE. 1918
OIL ON CANVAS, 53½ x 24¼" (135.9 x 61.6 CM)
ACQUIRED THROUGH THE LILLIE P. BLISS FUND

Piet Mondrian | DUTCH, 1872–1944
PAINTING, I. 1926
OIL ON CANVAS; diagonal measurements,
44¼ x 44" (113.7 x 111.8 CM)
KATHERINE S. DREIER BEQUEST

Piet Mondrian
COMPOSITION IN WHITE, BLACK, AND RED. 1936
OIL ON CANVAS, 40¼ x 41" (102.2 x 104.1 CM)
GIFT OF THE ADVISORY COMMITTEE

Four Abstract Artists

Burgoyne Diller | AMERICAN, 1906–1965
FIRST THEME. 1942
OIL ON CANVAS, 42 x 42" (106.6 x 106.6 CM)
GIFT OF SILVIA PIZITZ

Sophie Taeuber-Arp | SWISS, 1889–1943
COMPOSITION OF CIRCLES AND OVERLAPPING ANGLES. 1930
OIL ON CANVAS, 19½ x 25¼" (49.5 x 64.1 CM)
THE RIKLIS COLLECTION OF McCRORY CORPORATION

Joaquín Torres–García |
URUGUAYAN, 1874–1949
COMPOSITION. 1931
OIL ON CANVAS, 36⅛ x 24" (91.7 x 61 CM)
GIFT OF LARRY ALDRICH

George L. K. Morris | AMERICAN,
1905–1975
ROTARY MOTION. 1935
OIL ON CANVAS, 30⅛ x 28¼" (76.5 x 71.6 CM)
THE RIKLIS COLLECTION OF McCRORY CORPORATION

Four American Modernists

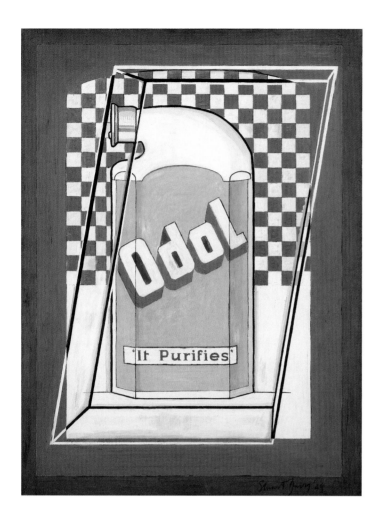

Stuart Davis | AMERICAN, 1892–1964
ODOL. 1924
OIL ON CARDBOARD, 24 x 18" (60.9 x 45.6 CM)
MARY SISLER BEQUEST (BY EXCHANGE) AND PURCHASE

Patrick Henry Bruce | AMERICAN, 1881–1936
PAINTING. c. 1929–30
OIL AND PENCIL ON CANVAS, 23¼ x 36⅛" (60.3 x 92.4 CM)
G. DAVID THOMPSON, MRS. HERBERT M. DREYFUS,
HARRY J. RUDICK, WILLI BAUMEISTER, EDWARD JAMES,
AND MR. AND MRS. GERALD MURPHY FUNDS

Georgia O'Keeffe | AMERICAN, 1887–1986
LAKE GEORGE WINDOW. 1929
OIL ON CANVAS, 40 x 30" (101.6 x 76.2 CM)
ACQUIRED THROUGH THE RICHARD D. BRIXEY BEQUEST

Gerald Murphy | AMERICAN, 1888–1964
WASP AND PEAR. 1927
OIL ON CANVAS, 36¼ x 38⅛" (93.3 x 97.9 CM)
GIFT OF ARCHIBALD MacLEISH

Fantastic Art, Dada, Surrealism

By the time Alfred H. Barr, Jr., Director of The Museum of Modern Art, presented his landmark exhibition *Fantastic Art, Dada, Surrealism* in December of 1936, Dada had disappeared while Surrealism's internationalization was well under way. The American public had been introduced to the Surrealist movement in 1931 at an exhibition at the Wadsworth Atheneum in Hartford, Connecticut, and one year later at the Julien Levy Gallery in New York. There had also been an important Surrealist exhibition in London in the summer of 1936. These notable shows notwithstanding, Barr's exhibition was the first major effort to contextualize Dada and Surrealism, and this ambitious attempt to present these movements as part of the canon of twentieth-century art came as a shock to the general public, which vacillated between bewilderment and positive interest.

Barr's exhibition presented Dada and Surrealism as part of a longstanding tradition of "fantastic art" that he associated with "the marvelous and irrational" and that he traced back to the fifteenth century. He provided a genealogy of influences for these two movements, including the art of children and of the "insane," folk art, photographs of fantastic architecture, and even films. Conceived in these universalist terms, the exhibition covered a period of over four hundred years and included seven hundred works by nearly one hundred artists. But with its concept of affinities and its organization by chronology and style, the show occasionally suggested rather far-fetched origins of Surrealist and fantastic themes. Barr was aware of such tenuousness, as his preface to the catalogue acknowledges: "Study of the art of the past in the light of Surrealist esthetic is only just beginning. Genuine analogies may exist but they must be kept tentative until our knowledge of the states of mind of, say, Bosch or Bracelli [sixteenth- and seventeenth-century artists] has been increased by systematic research and comparison. One may suppose, however, that many of the fantastic and apparently Surrealist works of the Baroque or Renaissance are to be explained on rational grounds rather than on a *Surrealist* basis of subconscious and irrational expression." Barr's characterization of Surrealism as an "esthetic" was highly appropriate, however, for Surrealism, like Dada, was not a style but a way of looking at life—politically, philosophically, as well as esthetically.

The concept of Barr's exhibition was a direct result of his idea of "art history without words," a synoptic narrative of how modern art developed through the ages. In his ideal vision, the development of modern art followed an evolutionary model in which movements were to compete for survival. This notion is clearly reflected in his description of Surrealism's beginnings: "Dada died in Paris about 1922, but from its ashes sprang Surrealism, under the leadership of the poet André Breton. The Surrealists preserved the anti-rational character of Dada but developed a far more systematic and serious experimental attitude toward the subconscious as the essential source of art." Following this logic, Surrealism's exit was just a matter of time.

In fact, the movement's devaluation began in the mid-1940s, when many postwar critics considered Surrealism a deviant art movement, not properly modernist at all. Attempting to create visual poetry, Surrealism was blamed for dragging modernism back to the past, when art had been used to illustrate texts rather than to convey its own special qualities. Surrealist works were thought to be impertinently visual, too concerned with embracing the infantile, too

corrupt. Surrealism was also panned for its popular and commercial success, which made the movement and its members even more suspect.

Thirty years after Barr's multimedia celebration of the irrational, William Rubin organized the 1968 Museum exhibition *Dada, Surrealism, and Their Heritage*. The premise for Rubin's exhibition centered on Marcel Duchamp and Joan Miró; the former reigned over the Dada section, while the latter became the point of departure for the Surrealist venture. Rubin's attempt to produce a concise statement about the development of Dada and Surrealism involved coming to terms with Surrealism's formal diversity, encompassing the abstractions of Miró on the one hand, and the realism of Salvador Dali and René Magritte on the other. Acknowledging the fact that Surrealism was above all a way to look at life that "fostered activities in the plastic arts so variegated as almost to preclude the use of the terms as definitions of style," Rubin nonetheless proceeded to formulate a theory of the Surrealist style.

Reinventing a distinction Breton had formulated, he defined two poles of Surrealist endeavor—the "abstract/automatist," rooted in the automatic practices of the early 1920s, and the "academic/illusionist," connected with the dream imagery of the later 1920s and 1930s. But whereas Breton himself had not valued one branch more than the other, Rubin used the construction of these two poles to fit Surrealism into a history of modernism that began with Cubism. In highlighting Miró and the automatist branch, he advanced the movement—or at least parts of it—as a visual catalyst for the American abstractionists: "The American painters' experience of Surrealism in the early and middle forties enabled them to 'open up' the language they had inherited from Cubism and Fauvism . . . they expunged the quasi-literary imagery that had earlier related their paintings to Surrealism. . . . [T]he visionary spirit of their wholly abstract art retained much of Surrealism's concern with poetry albeit in a less obvious form." Thus, a "purified" form of Surrealism mediated between the "great abstract movements" prevalent before World War I and after World War II.

Rubin's narrative outlining the development of Dada and Surrealism is folded into a discourse on iconography and style with a strong focus on painting, especially abstract imagery. In retrospectives of the work of Matta (1957), Miró (1973), and André Masson (1976), organized by Rubin, he reaffirmed his theory of the Surrealist style. He also saw the influence of Surrealism reflected in sculpture, an example being the work of Louise Bourgeois. In his foreword to the 1982 catalogue of a retrospective of the artist's work, he stated that Bourgeois, a Frenchwoman who had emigrated to America in the late 1930s, "knew the language of Surrealism well enough to perceive that, in sculpture, it had far from exploited its possibilities. The organic, biomorphic language of the abstract side of Surrealist art wants to be three-dimensional . . . [Bourgeois] understood this, and picked up where certain veins of Surrealist art had left off." Deborah Wye, who organized the exhibition, took a different tack, distancing herself from stylistic analysis of Bourgeois's work and emphasizing instead the profoundly autobiographical content and the human aspects of her art.

Dada and Surrealist art, which was first exhibited in 1936 at the Museum, continues to be reevaluated by this institution. In recent years, there have been three major retrospectives of artists associated with the Surrealist circle: Paul Klee (1987), Miró (1993), and Alberto Giacometti (2001). These three artists had earlier been shown at the Museum in 1941, 1973, and 1965, respectively, signaling the importance the Museum accords them in the history of modern art. Robert Storr, in the 2000 exhibition *Modern Art despite Modernism*, re-examined the "antimodernist impulse" revealed in the works of the Surrealists Magritte and Dali.

— *Iris Mickein*

New York Dada

Marcel Duchamp

The Passage from Virgin to Bride. 1912
Illustrated on page 160

Lawrence D. Steefel, Jr., in *Marcel Duchamp,* **1973,**
pages 70, 73

Marcel Duchamp's interest in the machine and the mechanistic is best understood as a consequence of his pursuit of a poetic of impersonality in which there will be a positive separation for the artist between "the man who suffers and the mind that creates."[1] Seeking to distance himself from his own fantasies, Duchamp sought a means of converting pathos into pleasure and emotion into thought. His mechanism of conversion was a strange one, but essentially it consisted of inventing a "displacement game" that would project conflicts and distill excitements into surrogate objects and constructs without whose existence his mental equilibrium might not have been sustained. Using personalized though expressively impersonal conventions ... Duchamp disciplined the artistic products of his excited fantasy by a progressive mechanization of their aesthetic valence. By using the machine as an increasingly distinct and rigid counter against the turbulent vastness of unchanneled association and unfiltered dream, Duchamp created an art of nonsense that "hygienically" freed his mind from all those capsizing factors which had previously haunted him as a Laforguian "sad young man."[2] ...

Leading us, the viewers, back toward the condition from which Duchamp had originally worked himself out, images like *Nude Descending a Staircase, The Passage from the Virgin to the Bride,* and Readymades like the *Bicycle Wheel* (page 162), *With Hidden Noise,* or *In Advance of the Broken Arm* frustrate our good intentions and insult our common sense. Framed as they are by a superficially logical set of titles to be correlated with what ought to, but does not, make sense, Duchamp's visual puzzles lead us to expect that with sufficient effort and technical intelligence we can integrate his problems by sheer persistency of task. If we can only transcend his inconsistencies by extrapolating his consistencies, or

so we fondly think, we can master the situation and find ourselves at rest. For most if not all viewers, however, this is a deceptive and irrational hope, for the ultimate heuristic thrust of Duchamp's dissembling work is to lead us continually to a brink of consummatory expectation only to "short circuit" our cognitive grasp."[3] . . .

In the mechanomorphic period which follows Duchamp's first introjection of mechanical and machinelike "substances" into the "body" of his art, we find a significant intensification of formal concentration matched by a growing sense of distance between our emotional reactions to the forms and to what the imagery is presumably "about." To a crucial extent, for the viewer who becomes involved with Duchamp's imagery of 1912, which mechanizes the body more strictly as it becomes more visceral and abstract, the problem of what the machine means to Duchamp becomes of less immediate interest than the problem of coping with the perceptual and conceptual paradoxes of "seeing" the art. Duchamp's "perplexes" of the year 1912 are pervaded by mechanization and machine forms (mostly armored turret forms and thrashing rotor mechanisms in *The King and Queen Surrounded by Swift Nudes,* anatomized filaments and robotoids in *The Passage from the Virgin to the Bride,* and cruciblelike distillery apparatus in the *Bride*). It is the labyrinthine elaboration of these mechanisms, more than their "actions," that compels our attention and dazzles our minds.[4] Closer in potential affect to the language labyrinths of Jean-Pierre Brisset, with their elaboration of animal cries into human language, than to any other non-Duchampian verbal or pictorial form,[5] Duchamp's "putting to the question" of parental authority (*The King and Queen*), the loss of virginity (*The Passage*) and the matrix (literally "womb") of desire (the *Bride*) combines an aggressive and regressive obsession with the complexity of primal energies and relationships and a ruthless distancing of interest about these most intimate affairs.[6]

Marcel Duchamp

Network of Stoppages. 1914
Illustrated on page 160

Marcel Duchamp, in *The Bulletin of The Museum of Modern Art,* **1946,** pages 19, 20, 21

"The great trouble with art in this country [America] at present, and apparently in France also, is that there is no spirit of revolt—no new ideas appearing among the younger artists. They are following along the paths beaten out by their predecessors, trying to do better what their predecessors have already done. In art there is no such thing as perfection. And a creative lull occurs always when artists of a period are satisfied to pick up a predecessor's work where he dropped it and attempt to continue what he was doing. When on the other hand you pick up something from an earlier period and adapt it to your own work an approach can be creative. The result is not new; but it is new insomuch as it is a different approach.

"Art is produced by a succession of individuals expressing themselves; it is not a question of progress. Progress is merely an enormous pretension on our part. There was no progress for example in J.-B.-C. Corot over Phidias. And 'abstract or naturalistic' is merely a fashionable form of talking—today. It is no problem: an abstract painting may not look at all 'abstract' in 50 years. . . .

"The basis of my own work during the years just before coming to America in 1915 was a desire to break up forms—to 'decompose' them much along the lines the cubists had done. But I wanted to go further—much further—in fact in quite another direction altogether. This was what resulted in *Nude Descending a Staircase,* and eventually led to my large glass, *La Mariée mise à nu par ses célibataires, même.* . . .

"The reduction of a head in movement to a bare line seemed to me defensible. A form passing through space would traverse a line; and as the form moved the line it traversed would be replaced by another line—and another and another. Therefore I felt justified in reducing a figure in movement to a line rather than to a skeleton. Reduce, reduce, reduce was my thought;—but at the same time my aim was turning inward, rather than toward externals. And later, following this view, I came to feel an artist might use anything—a dot, a line, the most conventional or unconventional symbol—to say what he wanted to say. The *Nude* in this way was a direct step to The Large Glass, *La Mariée mise à nu par ses célibataires, même.* And in the *King and Queen* painted shortly after the *Nude* there are no human forms or indications of anatomy. But in it one can see where

the forms are placed; and for all this reduction I would never call it an 'abstract' painting. . . .

"Futurism was an impressionism of the mechanical world. It was strictly a continuation of the Impressionist movement. I was not interested in that. I wanted to get away from the physical aspect of painting. I was much more interested in recreating ideas in painting. For me the title was very important. I was interested in making painting serve my purposes, and in getting away from the physicality of painting. For me [Gustave] Courbet had introduced the physical emphasis in the XIX century. I was interested in ideas—not merely in visual products. I wanted to put painting once again at the service of the mind. And my painting was, of course, at once regarded as 'intellectual' 'literary' painting. It was true I was endeavoring to establish myself as far as possible from 'pleasing' and 'attractive' physical paintings. That extreme was seen as literary. *My King and Queen* was a chess king and queen. . . .

"Dada was an extreme protest against the physical side of painting. It was a metaphysical attitude. It was intimately and consciously involved with 'literature.' It was a sort of nihilism to which I am still very sympathetic. It was a way to get out of a state of mind—to avoid being influenced by one's immediate environment, or by the past: to get away from clichés—to get free. The 'blank' force of dada was very salutary. It told you 'don't forget you are not quite so "blank" as you think you are.' Usually a painter confesses he has his landmarks. He goes from landmark to landmark. Actually he is a slave to landmarks—even to contemporary ones.

"Dada was very serviceable as a purgative. And I think I was thoroughly conscious of this at the time and of a desire to effect a purgation in myself. I recall certain conversations with [Francis] Picabia along these lines. He had more intelligence than most of our contemporaries. The rest were either for or against [Paul] Cézanne. There was no thought of anything beyond the physical side of painting. No notion of freedom was taught. No philosophical outlook was introduced. The cubists, of course, were inventing a lot at the time. They had enough on their hands at the time not to be worried about a philosophical outlook; and cubism gave me many ideas for decomposing forms. But I thought of art on a broader scale. There were discussions at the time of the fourth dimension and of non-Euclidean geometry. But most views of it were amateurish. [Jean] Metzinger was particularly attracted. And for all our misunderstandings through these new ideas we were helped to get away from the conventional way of speaking—from our café and studio platitudes."

Marcel Duchamp

Bicycle Wheel. 1913
Illustrated on page 162

Joseph Kosuth, *Contemporary Art in Context,* **1990,** page 47

Duchamp is difficult to talk about because his work is so rich in its complexity. For me, it changed the way artists see their activity: we no longer believe, simply, in certain institutionalized forms of authority in art.

There is a brief to be made as an artist against certain forms, because those forms constitute fixed meanings. Readymades that are naturalized as the language of art are not seen, in fact, as ready-made. Any artist who goes to art school, who is given a canvas and paint, realizes that you didn't invent those mediums. It's given to you, and that's a Readymade. But because our conception of art acknowledges the authority of that form, it's considered a naturally given one.

Institutions of art . . . are another framing device. One of my favorite stories . . . happened some years ago, when Duchamp died. They [The Museum of Modern Art] put together a small installation of some Duchamps from the collection. One was a Rotorelief[1]: it was set on a pedestal and next to it was a text by Mr. William Rubin which discussed why this was a masterpiece of the twentieth century, declared that it smashed forever the boundaries between painting and sculpture, it was not a painting, it was not a sculpture, and went on like that in a very interesting and intelligent way. On the pedestal was a big sign that said "Please do not touch the sculpture."

In one way, this reflects a problem of any museum that serves the public, but it points to something fundamental. Basically, art is making meaning. In a sense, it's philosophy made concrete, in a period in which one can no longer believe in speculative philosophy, which has become an academic activity. Art alone answers certain questions and deals with certain issues in the world. It clarifies and makes visible how our consciousness is formed in mass culture, and takes mass culture and uses it in a way that reveals the whole internal mechanism of culture. That is a very important human role of art in a period when we don't have the spiritual satisfaction that a traditional religion can give us and the kind of cultural perks that come from homogeneous culture in which, as you get older, life is more meaningful and death is meaningful. Science as a religion deprives us of that, and so, as we continue, we are finding art is more and more valuable to people.

Francis Picabia

I See Again in Memory My Dear Udnie. 1914
Illustrated on page 161

John Tancock, in *Marcel Duchamp,* **1973,** page 161

With Picabia, . . . the erotic atmosphere of [Marcel Duchamp's] paintings is what made the most lasting impression. There was no trace of this liberating element in two of his most successful "Cubist" paintings of 1912, *Dances at the Spring* and *Procession, Seville.* By 1912, however, with paintings such as *Udnie (Young American Girl)* and *Edtaonisl (Ecclesiastical),* the formal language had been greatly expanded in keeping with the more personal nature of the theme—Picabia's voyage to the United States aboard the same ship as the dancer Mlle Napierkowska and a Dominican priest who was fascinated by her. Finally in *I See Again in Memory My Dear Udnie,* c. 1914, the erotic implications of the two previous paintings became fully explicit. Reliving in memory the series of events on board ship, Picabia relied even more heavily on the Duchamp of 1912. His reverie on the "star-dancer" is expressed in sequences of forms that range from the geometrical to the biomorphic, from the totally abstract to the almost specific (in forms that resemble electrical appliances). Yet, when compared to its major source, the display of passion in the painting is much more public, altogether less hermetic, than the transformation taking place within Duchamp's *Bride.* Picabia's bolder, more flamboyant forms enact events on an erotic plane, but as spectacle rather than as mysterious event.

Man Ray

The Rope Dancer Accompanies Herself with Her Shadows. 1916
Illustrated on page 163

John Tancock, in *Marcel Duchamp,* **1973,** pages 161, 162

Man Ray, . . . until he met [Marcel] Duchamp in 1915, had contented himself with the traditional media and had painted in a style that was considerably influenced by Cubism. He became extremely close to Duchamp and was readier than any of his contemporaries to put Duchamp's principles into practice. "I want something where the eye and hand count for nothing," Duchamp had said to Walter Pach in 1914.[1] Pach could not accept the total rejection of painterly faculties, but Man Ray, who had been trained as an architectural draftsman, understood exactly what Duchamp meant. Anxious to free himself from painting and its "aesthetic implications,"[2] he turned immediately to

collage (a technique that enabled him to achieve striking effects without the apparent intrusion of the artist's hand) and, in one major painting, *The Rope Dancer Accompanies Herself with Her Shadows*, to pseudo-collage.[3]

May Ray's objects clearly owed a great deal to Duchamp's Readymades, especially the more complicated examples, yet in their inventiveness and abundance they reveal the entirely different bent of his character. . . .

For Duchamp, the significance of Readymades lay in the fact that their number was severely limited, although once chosen they could be duplicated. Man Ray, on the other hand, saw no reason to be so sparing with his talents and regarded his object as yet another way of making a point.

Two Fantasts

Giorgio de Chirico
The Enigma of a Day. 1914
Illustrated on page 166

James Thrall Soby, *Giorgio de Chirico*, 1955, pages 70, 71

That the frock-coated statue has been included often in forgeries of de Chirico's early works must be due to the fact that *The Enigma of a Day* played so crucial a part in the surrealist movement which brought the artist a truly international fame. The picture was an important visual backdrop to the intense surrealist activity of the years 1924 to 1935. During that decade it hung in the apartment of surrealism's overlord, André Breton. Breton and his colleagues were frequently photographed in front of the large canvas, and in *Le surréalisme au service de la révolution* they published replies to a questionnaire in which members of the surrealist group were asked to decipher and locate various objects, both real and illusory, within the painting.[1] The replies no less than the questions were extremely subjective, as might be expected. They nevertheless furnish impressive proof of the picture's hold on surrealist thought and reverie. To Breton and his associates, *The Enigma of a Day* typified an inhabitable dream. Its silence and eerie light established the mood of a great deal of subsequent surrealist art; its drastic elongations of perspective, exemplified by the abrupt scaling-down of the background figures in relation to the foreground sculpture, became a recurrent poetic device in the paintings of [Yves] Tanguy, [Salvador] Dali, [René] Magritte, [Paul] Delvaux and numerous other surrealists of a slightly later generation. Indeed, in every direction except that of automatism (the free-wheeling inventions of [Joan] Miró, [André] Masson & Co.), this and other paintings of de Chirico's early career opened the way to surrealist art in general. These paintings served as well to encourage a revival of atmospheric effect and human sentiment among the Parisian neo-romantic painters of the mid-1920s . . .

In *The Enigma of a Day* the deep perspective radiates in pie-shaped wedges of light and shade from a center at the extreme lower left of the composition and is contained by a curve, as in geometric sectors of a circle. In the *Gare Montparnasse* (page 167)—also sometimes called *The Melancholy of Departure*—sharp, oblique angles, on the contrary, entirely determine the allocation of light and shade. And in his handling of perspective in this picture, de Chirico deliberately takes extreme liberties. The broad, receding path of light at the right retains its parallel borders to its end instead of narrowing to a point, as science and pictorial tradition demand. The psychological justification of the distortion is apparent. Failing to find a terminating point in space, the observer's eye is forced to follow the bright ramp downward again, toward the vertical piers and odd geometric forms of the lower level. How deep is the overhang of the upper platform which rests at the right on weirdly slanting pillars? At one point, directly beneath the clock, an answer is supplied by a single black line. Elsewhere the measure of depth is thoroughly ambiguous; geometry has been willfully altered for purposes of poetic suggestion.

Giorgio de Chirico
The Song of Love. 1914
Illustrated on page 164

William S. Rubin, *Dada, Surrealism, and Their Heritage*, 1968, page 80

De Chirico's undermining of the rational classical world was expressed iconographically through enigmatic combinations of objects, usually autobiographical

and often sexual in content. The association of the head of the *Apollo Belvedere*, a surgeon's glove, a ball, and a steam locomotive in the exquisitely colored *Song of Love* has the simplicity and poignancy of Lautréamont's famous image. We feel that these objects have been retrieved from the edge of memory. Some of them recall de Chirico's childhood in Greece and the world of his engineer father. In *The Philosopher's Conquest*, the juxtaposition of cannon, balls, and artichokes evokes a veiled eroticism that is more usually expressed in de Chirico's paintings by the towers and arcades of his dream architecture.

De Chirico was the first to translate Lautréamont's poetic paradigm into painting; [Marcel] Duchamp's images on glass and compound Readymades came later. While the Surrealists—[René] Magritte excepted—were to use the principles as a springboard for hybrid fantasies and fantastical metamorphoses, de Chirico rarely altered or abstracted the objects he represented. As in dreams, the approach to reality was selective, but the prosaism of dream imagery was maintained. "Yet even if the exterior aspect of the object is respected," [André] Breton observed, "it is evident that this object is no longer cherished for itself, but solely as a function of the signal that it releases . . . [de Chirico] retains only such exterior aspects of reality as propose enigmas or permit the disengagement of omens and tend toward the creation of a purely divinatory art."[1]

Giorgio de Chirico

The Evil Genius of a King. 1914–15
Illustrated on page 165

James Thrall Soby, *Giorgio de Chirico,* **1955,** pages 98, 100

De Chirico did not fully develop the mannequin theme until 1915. Meanwhile he had begun a series of three still lifes whose objects are especially cryptic. The series includes *The Sailors' Barracks, The General's Illness* and *The Evil Genius of a King.* All three of these pictures are related in compositional formula to the *Still Life: Turin, Spring* and *The Fête Day* in that their foreground areas rise steeply, forming a sort of ramp or platform high above the background street level with architecture. These paintings, instead of enticing the observer to enter an illusory, over-all picture space, as in the earlier series of Italian squares, force him to climb to a dizzy vantage point above the ground.

All three paintings in the series under discussion include a standing, vertical board, like that in *The*

Song of Love but swung sideways, which divides their compositions asymmetrically; their still-life vocabulary is, as noted, unusually fantastic. If certain objects in them may be identified with some degree of certainty, others seem thoroughly "unreal." The ball, tube and shuttlecock or paper hat in *The General's Illness*; the epaulet, egg, ball, baton, pipe and checkerboard of *The Sailor's Barracks*; the party favors, ball and flower of *The Evil Genius of a King*—these are objects such as de Chirico might have seen on his solitary walks through Paris. But other still-life forms seem to have little basis in tangible reality. In both cases the objects are depicted with extreme precision and for a definite reason. Just as the cubists at this time were affixing sand, bits of string and other commonplace materials to their canvases in order to affirm an essential contact with reality, so de Chirico was eager to propose his fantasies in the most convincing possible manner. But above all he wished the poetry of his art to consist in unexpected juxtapositions taking place in an unlikely locale. He must have conceived of the artist's function as that of documenting metaphysical shifts in the continuity of everyday, settled reality. [Guillame] Apollinaire's respect for the element of "surprise" in painting again comes to mind.

Paul Klee

Actor's Mask. 1924
Illustrated on page 168

Alfred H. Barr, Jr., *Paul Klee,* **1941,** pages 5, 6

Much has been written . . . about Klee's art. Indeed few living painters have been the object of so much speculation. For a work by Klee is scarcely subject to methods of criticism which follow ordinary formulae. His pictures cannot be judged as representations of the ordinary visual world. Usually, too, they cannot be judged merely as formal compositions, though some of them are entirely acceptable to the esthetic purist.

Their appeal is primarily to the sentiment, to the subjective imagination. They have been compared, for this reason, to the drawings of young children at an age when they draw spontaneously from intuitive impulse rather than from observation. They have been compared to the fantastic and often truly marvelous drawing of the insane who live in a world of the mind far removed from circumstantial reality. Klee's work sometimes suggests the painting and ornament of primitive peoples such as: palaeolithic bone carvings, Eskimo drawings and Bushman paintings, the pictographs of the American Indian. Drawings made subconsciously or absentmindedly or while under

hypnosis occasionally suggest Klee's devices. In fact, Klee had himself at times made "automatic" drawings with some success. The child, the primitive man, the lunatic, the subconscious mind, all these artistic sources (so recently appreciated by civilized taste) offer valuable analogies to Klee's method.

But there are in Klee's work qualities other than the naïve, the artless, and the spontaneous. Frequently the caricaturist which he might have been emerges in drawings which smile slyly at human pretentiousness. Often he seduces the interest by the sheer intricacy and ingenuity of his inventions. At times he charms by his gaiety or makes the flesh creep by creating a spectre fresh from a nightmare.

Of course he has been accused of being a "literary" painter. For the person who still insists upon regarding painting as decorative, or surface texture, or pure, formal composition the accusation is just. But Klee defies the purist and insists as do [Giorgio de] Chirico and [Pablo] Picasso upon the right of the painter to excite the imagination and to consider dreams as well as still life material for their art.

Klee is a master of line which seems negligent but is unusually expressive. . . .

Klee made a study of masks in theatrical and ethnographic museums, and experimented with their power to startle and bind the imagination. *Actor's Mask* reminds one of Melanesian ceremonial masks in its startling, hypnotic effect. . . .

Klee has used a variety of media, all of them handled with remarkable skill and inventiveness. He combines watercolor and ink, oil and gouache, using diverse surfaces including paper, canvas, linen, burlap, silk, tin and compoboard. Like the Cubists and Surrealists he has made many experiments with textures.

Nothing is more astonishing to the student of Klee than his extraordinary variety. Not even Picasso approaches him in sheer inventiveness. In quality of imagination also he can hold his own with Picasso; but Picasso of course is incomparably more powerful. Picasso's pictures often roar or stamp or pound; Klee's whisper a soliloquy—lyric, intimate, incalculably sensitive.

Klee
Actor's Mask

Lucy Lippard, in *Three Generations of Twentieth-Century Art,* **1972,** page 38

The actor's mask was one of the earliest themes in Klee's phenomenally rich iconography, going back to his drawings and Comedian etchings of 1903–1904

and reflecting the influence of James Ensor, an important one for Klee in his early years. The theme is an outgrowth of Klee's love for the theater (together with music, perhaps the most constant of his interests), which led him to study in theatrical and ethnographical museums, and later to make puppets. The *Actor's Mask,* painted in 1924, reflects this study of primitive cultures through its strong resemblance to certain Melanesian masks, a resemblance that is even clearer in some later works of Klee. The impassive frontal stare characteristic of all Klee's figures and heads, both animal and human, is in itself a reflection of an ancient mask aesthetic. There is an extremely close connection between man and animal in his work, a connection that at times amounts to a confusion of the two, such as one finds in primitive cultures and in children's tales. Here, the eyes resemble the hypnotic gaze of a cat.

As the critic Andrew Forge has noted, "Unlike the early etchings, which are drawings of imaginary faces and masks, in the *Actor's Mask,* mask and face are one. The strata-like formation out of which the features grow is ancient. It is as though time had slowly pressed out the eyes, the mouth. Pressure seems to bear across the face in the parallel red lines."[1] Thus the striated patterning of the face is suggestive both of tattooing and of geological strata, giving the face a primordial appearance. Such striations were later to be specifically identified with landscape in the series of images that Klee produced following his trip to Egypt in the winter of 1928/29.

Paul Klee
Cat and Bird. 1928
Illustrated on page 169

William S. Rubin, in *MoMA: A Publication for Members of The Museum of Modern Art,* **1976,** n.p.

Paul Klee's predilection for the small format picture represents the logical consequence of an imagery derived from conception rather than perception. Dealing with the imagined rather than the seen, his art was engendered from what we might call the "screen" of the mind's eye, which, by nature, feels small. Indeed, as the Gestalt psychologists demonstrated long ago, this screen *must* be very small since it is commonly felt to be located just *inside* the forehead, above the eyes.

These considerations are especially relevant to an understanding of Klee's *Cat and Bird,* a marvelous small oil painting. . . . [I]n this picture Klee relies on our awareness, perhaps subconscious, of where this

"screen" is located; otherwise, we would not grasp that the bird represented in the painting is not in front of the cat's head but inside it—quite literally, on his mind. Our apprehension that the bird is a thing imagined rather than seen by the cat is reinforced by Klee's treatment of the pupils of the cat's eyes, which appear unfocussed on any exterior object. The obsessional nature of the cat's interest in the bird is further expressed by the rendering of the cat's head so that it almost fills the picture surface. Indeed, the cat's head is pressed so close to the picture-plane that its top seems anchored to the upper edge; while at the bottom the cat's whiskers reach out like delicate, seismologically responsive antennae to the corners of the field. . . .

Many of Klee's oil paintings belong to series or groups . . . whereas *Cat and Bird* is a unique image in his *oeuvre* as regards its handling if not its motif.

Paul Klee
Castle Garden. 1931
Illustrated on page 169

Ann Temkin, in *Paul Klee*, **1987,** pages 14, 15, 16, 17

Klee's materials and techniques do indeed suggest an element of craft allied more closely to the folk artist than to the professional. Beginning in 1914, he devised combinations of paints, glues, fabrics, and papers that defy present analysis, despite the recipe-like notations he made in his oeuvre catalogue.[1] Oils and watercolors were painted on grounds that had been richly built up with plaster, chalk, and encaustic. Supports included the finest handmade paper and linen, but also wrapping paper, cotton remnants, and, during his military duty, aircraft canvas. . . .

Nature played a dominant role in Klee's own aesthetic. His closeness to nature is central not only to the subjects of his work, but to his concept of the working process. In 1923 Klee would plainly state his grounds in "Ways of Nature Study": "The artist is a man, himself nature and a part of nature in natural space."[2] . . .

The painters' ability to reject the dictates of resemblance directly related to the poets' aim to shake off a syntax and vocabulary chained to literal meaning. The apparently nonsensical poetry of Dada sought for letters and sounds the same renaissance that the painting of Klee and [Vasily] Kandinsky had provided for line and color. This achievement was central to the Dadaists' iconoclasm. They saw language as the shaper of history; a reform of language had to precede societal change. . . .

During the second decade of the century, the desire to rejuvenate their respective art forms prompted the artists of the avant-garde to focus fresh attention on the most basic elements of their formal mediums and vocabulary. It also provoked a different, but integrally related, strategy: the deliberate confounding of the boundaries between the verbal and plastic arts. The long-standing segregation of the various art forms seemed to artists of the day as arbitrary as conventions of pictorial space or poetic meter. Indeed, when the avant-garde looked outside post-Renaissance Western culture—to Oriental, medieval, and folk art—they confronted strong traditions in which the roles of images and words were inextricable.

Surrealist Dream Images —

William S. Rubin, *Dada, Surrealism, and Their Heritage*, **1968,** pages 63, 64

The word "surrealism" had been used first by [Guillaume] Apollinaire in 1917 in a context that coupled avant-garde art with technological progress;[1] his neologism possessed none of the psychological implications that the word would later take on. . . . "Up to a certain point," [André] Breton wrote in November 1922, "one knows what my friends and I mean by Surrealism. This word, which is not our invention and which we could have abandoned to the most vague critical vocabulary, is used by us in a precise sense. By it, we mean to designate a certain psychic automatism that corresponds rather closely to the state of dreaming, a state that is today extremely difficult to delimit."[2]

By autumn of 1924, Breton had assumed exclusive rights to the magic word and in the Surrealist manifesto published then he gave it formal definition:

SURREALISM. noun, masculine. Pure psychic automatism, by which one intends to express verbally, in writing or by any other method, the real functioning of the mind. Dictation by thought, in the absence of any control exercised by reason, and beyond any aesthetic or moral preoccupation.

ENCYCL. *Philos.* Surrealism is based on the belief in the superior reality of certain forms of association heretofore neglected, in the omnipotence of dreams, in the undirected play of thought. . . .[3]

As Surrealist painting emerged in its heroic period—between the first (1924) and the second (1929) manifestoes—it bipolarized stylistically in accord with the two Freudian essentials of its definition. Automatism (the draftsmanly counterpart of verbal free association) led to the "abstract"[4] Surrealism of [Joan] Miró and [André] Masson, who worked improvisationally with primarily biomorphic shapes in a shallow, Cubist-derived space. The "fixing" of dream-inspired images influenced the more academic illusionism of [René] Magritte, [Yves] Tanguy, and [Salvador] Dali. We tend to think of Miró and Masson primarily as painters (*peintres*), in the sense that the modernist tradition has defined painting; we think of the latter artists more as image-makers (*imagiers*). The styles of all Surrealist painters are situated on the continuum defined by these two poles. That of Max Ernst—the "compleat Surrealist"—oscillated between them. Both kinds of painting were done virtually throughout the history of the movement, though the automatist-"abstract" vein dominated the pioneer years and the period of World War II. In between, oneiric illusionism held sway.

The common denominator of all this painting was a commitment to subjects of a visionary, poetic, and hence, metaphoric order, thus the collective appellation, *peinture-poésie*, or poetic painting, as opposed to *peinture-pure*, or *peinture-peinture*, by which advanced abstraction was sometimes known in France. Surrealists never made nonfigurative pictures. No matter how abstract certain works by Miró, Masson, or [Jean] Arp might appear, they always allude, however elliptically, to a subject. The Cubists and Fauvists selected motifs in the real world but worked *away* from them. The Surrealists eschewed perceptual starting points and worked *toward* an interior image, whether this was conjured improvisationally through automatism or recorded illusionistically from the screen of the mind's eye.

Max Ernst

Two Children Are Threatened by a Nightingale. 1924
Illustrated on page 171

Illustrated on page 171

John Russell, *The Meanings of Modern Art,* 1981, page 206

It was Max Ernst, in 1924, who best fulfilled the Surrealists' mandate. Ernst did it above all in the construction called *Two Children Are Threatened by a Nightingale*, which starts from one of those instincts of irrational panic which we suppress in our waking lives. Only in dreams can a diminutive songbird scare the daylights out of us; only in dreams can the button of an alarm bell swell to the size of a beach ball and yet remain just out of our reach. *Two Children* incorporates elements from traditional European painting: perspectives that give an illusion of depth, a subtly atmospheric sky, formalized poses that come straight from the Old Masters, a distant architecture of dome and tower and triumphal arch. But it also breaks out of the frame, in literal terms: the alarm or doorbell, the swinging gate on its hinge and the blind-walled house are three-dimensional constructions, physical objects in the real world. We are both in, and out of, painting; in, and out of, art; in, and out of, a world subject to rational interpretation. Where traditional painting subdues disbelief by presenting us with a world unified on its own terms, Max Ernst in the *Two Children* breaks the contract over and over again. We have reason to disbelieve the plight of his two children. Implausible in itself, it is set out in terms which eddy between those of fine art and those of the toyshop. Nothing "makes sense" in the picture. Yet the total experience is undeniably meaningful; Ernst has re-created a sensation painfully familiar to us from our dreams but never before quite recaptured in art—that of total disorientation in a world where nothing keeps to its expected scale or fulfills its expected function.

René Magritte

The Menaced Assassin. 1926
Illustrated on page 170

Illustrated on page 170

John Russell, *The Meanings of Modern Art,* 1981, page 221

The unconscious did not present itself to him [Magritte] as a dancing dervish. Yet when it came to restating the science of signs no one was more radical than he. He did it under auspices with which the

reader will by now be familiar. Nowhere is the dreamer more vividly portrayed or more bizarrely accompanied. The spirit of Edgar Allan Poe hovers over and over again, with *The Narrative of Arthur Gordon Pym* conspicuous in one painting and the whole of another one devoted to Poe's *Domain of Arnheim*. Magritte realized, too, that the mass-audience thriller (see his *The Menaced Assassin*) was one of our century's new sources of myth. He had a delight in word games which had been the mark of the Surrealists since long before the name of Surrealism was first invented; and he knew that when language is subverted the whole of life is subverted with it. He was interested in the word *as sign*—and as a sign that should not be taken for granted. When he wrote "This is not a pipe" beneath a painted image of a pipe, people took it at first as a harmless little joke; but as time went on it turned out that the joke was not so harmless after all, and that Magritte had questioned the whole nature of acceptance where the science of signs was concerned. "Go back and start again" is the message which he relays to those who look at his pictures; and by looking again, and looking again, and looking more closely, we arrive at a new understanding of the role of the sign in human life. Magritte, in this sense, can be related to linguistic philosophy as other Surrealists can be related to the psychopathology of the individual, or to the state of the European collective unconscious at a particular moment in time, or to the liberation of the play instinct in everyday life, or to one of the many other preoccupations of the 1920s and '30s which found their highest and most telling expression in art.

René Magritte
The False Mirror. 1928
Illustrated on page 171

Helen M. Franc, *An Invitation to See,* **1992,** page 95

Magritte was strongly influenced by [Giorgio] de Chirico and, like him, sought to reveal the hidden affinities linking objects that are normally dissociated. His pictures present a challenge to the "real" world by turning everyday logic topsy-turvy, substituting a different kind of order, which our unconscious mind recognizes as having a rationale of its own.

In *The False Mirror*, equivalences are established between the eye and the cloud-filled sky that forms its iris, the pupil being the black disk that floats like a sun in the center. Isolated from any anatomical reference to a depicted face, the huge eye not only fills the entire height and breadth of the canvas but also seems to extend beyond the picture's edge at left and right. The image owes much of its compelling effect to this inflated scale and to the meticulous finish with which it is painted, recalling works by the Flemish old masters of Magritte's native Belgium. In his adherence to illusionistic technique, Magritte anticipated the "hand-painted dream photographs" of his fellow Surrealist [Salvador] Dali.

In contradistinction to [Odilon] Redon, Magritte always insisted that his art could not be equated with symbolism, for this would imply a supremacy of the invisible over the visible. "My paintings have no reducible meaning: they *are* a meaning," he declared.

The title of this picture was give to it by Paul Nougé, a writer who was a member of the Surrealist group that Magritte helped to found in Brussels shortly before his sojourn in the environs of Paris, where *The False Mirror* was painted. Magritte's visualization of the mind's eye has become a kind of modern icon, frequently copied or adapted, as in the CBS trademark.

Yves Tanguy
Mama, Papa Is Wounded! 1927
Illustrated on page 172

William Rubin, *Dada, Surrealism, and Their Heritage,* **1968,** pages 101–02

Yves Tanguy was the only autodidact among the illusionist Surrealists. Unlike [René] Magritte and [Salvador] Dali who, after art school training, experimented with various forms of Cubism, Tanguy went from the whimsical primitivism of such paintings as *Fantômas* to the tightly painted academic illusionism of his mature style without ever passing through modernist painting. His characteristic manner crystallized in 1927, and from then until his death in 1955 it underwent no change except for a tightening in execution after 1930, and a gradual intensification of color.

This consistency of style paralleled the persistence of his vision, a "mindscape" resembling desert wasteland or ocean floor which remained with him for life. In the [works of the late 1920s] this world is sparsely populated with forms that are a conversion of [Jean] Arp's flat biomorphic patterns into three-dimensional illusions a few years before Arp himself was to realize his own personal form-language as sculpture in the round. . . .The proliferation and enlargement of [the] biomorphs, which are characteristic of Tanguy's paintings of the thirties, led in the following decade to structures affecting an architectural grandeur. . . .

The poetry of Tanguy's mature imagery differs from that of the other illusionist Surrealists, and even from that of most of the "abstract" painters in the group; it is less specifically literary. Though on occasion his forms are anthropomorphic . . . they are never particularized with features or anatomical details. Nor can his forms ever be identified as recognizable objects, as can the shapes of [Joan] Miró and [André] Masson, to say nothing of those of Magritte and Dali. If Tanguy's style is realistic, his visual poetry is abstract.

Salvador Dali

Illumined Pleasures. 1929
Illustrated on page 173

Press release, The Museum of Modern Art, **1934**

Mr. Dali [in a lecture at The Museum of Modern Art on January 11, 1934] said in part: "I find it perfectly natural when my friends and the general public pretend not to understand the meaning of my pictures. How would you expect anybody to understand the significance of my pictures when I myself, who have made them, I myself regret to say do not understand them either. I must admit that I am the first to be surprised and often terrified by the extravagant images that I see appear with fatality on my canvas. In truth I am but the automaton which registers, without judgment and with all possible exactitude, the dictates of my subconscious, my dreams, the hypnological images and visions, my paranoiac hallucinations, and, in short, all those manifestations, concrete and irrational, of that sensational and obscure world discovered by Freud, which I don't for a moment doubt is one of the most important discoveries of our epoch, reaching to the most profound and most vital roots of the human spirit. The fact that I myself at the moment of painting my pictures know nothing of their meaning is not to say that the images in question are without sense. On the contrary their meaning is so profound, systematic, and complex, that they require an absolutely scientific interpretation. In short, the only way to reduce a surrealist picture to current terms would be to submit it to the most rigorous psychoanalysis. But such understanding of the picture is only scientifically accessible, and not in the least necessary for the public. On the contrary, the public must draw all its pleasure from the unlimited sources of mystery, enigma, and anguish that such images always offer the spectator, for they are addressed actually to each spectator's own subconscious, speak exactly the secret and symbolical language of the subconscious, which is to say that surrealist images are perfectly understood by that which is deepest in the spectator and make exactly the immediate poetic effect for which they are destined, even when the spectator consciously protests and believes that he has experienced no emotion whatsoever. To know just what effect a surrealist image has produced it would be necessary to subject the spectator to a long analysis, it would be necessary to know his dreams and all the modifications experienced by his psychic life after viewing a surrealist image. For on the conscious level he is always ready to defend himself against this kind of imagery by the well-known method of suppression."

Salvador Dali

The Persistence of Memory. 1931
Illustrated on page 173

MoMA Highlights, **1999,** page 154

The Persistence of Memory is aptly named, for the scene is indelibly memorable. Hard objects become inexplicably limp in this bleak and infinite dreamscape, while metal attracts ants like rotting flesh. Mastering what he called "the usual paralyzing tricks of eye-fooling," Dali painted with what he called "the most imperialist fury of precision," but only, he said, "to systematize confusion and thus to help discredit completely the world of reality." It is the classical Surrealist ambition, yet some literal reality is included too: the distant golden cliffs are the coast of Catalonia, Dali's home.

Those limp watches are as soft as overripe cheese—indeed "the camembert of time," in Dali's phrase. Here time must lose all meaning. Permanence goes with it: ants, a common theme in Dali's work, represent decay, particularly when they attack a gold watch, and become grotesquely organic. The monstrous fleshy creature draped across the painting's center is at once alien and familiar: an approximation of Dali's own face in profile, its long eyelashes seem disturbingly insectlike or even sexual, as does what may or may not be a tongue oozing from its nose like a fat snail.

The year before this picture was painted, Dali formulated his "paranoiac-critical method," cultivating self-induced psychotic hallucinations in order to create art. "The difference between a madman and me," he said, "is that I am not mad."

Abstract Surrealism

Jean Arp
Enak's Tears. 1917
Illustrated on page 175

William Rubin, *Dada, Surrealism, and Their Heritage,* **1968,** pages 39, 40, 41

Though many Dadaist and Surrealist artists were practicing poets, Arp is one of the very few whose poetry stands in both quality and quantity as an important contribution in its own right. The involvement of the painters of these movements with poetry produced a variety of rapports between the two arts, some of which endowed their *peinture-poésie* with new and unexpected dimensions, but others of which tended to vitiate their painting through a dilution of aesthetic modes. Arp's collages, reliefs, and sculpture share with his poetry an iconography . . . a gentle whimsy, and a feeling of naturalness, but nowhere is their plasticity compromised.

For three years prior to the emergence of his personal style in the winter of 1915/1916, Arp had worked within the discipline of Cubism. Then in collages, and in machine-sawn reliefs such as the *Portrait of Tzara* of 1916 and *Enak's Tears* of 1917, the prevailing rectilinear structures of the Cubist work dissolved under the pressure of a new curvilinear, "organic" morphology.

This biomorphism had its roots in Art Nouveau, although there it was primarily linear in style and botanical in its associations. Arp established it in terms of closed flat forms that were endowed with anthropomorphic allusions as well. . . .

In the face of Analytic Cubism's searching but ultimately assured equilibrium and stasis, Arp's reliefs unwind in an improvisational, meandering manner that implies growth and change. Here is no longer the sober, classical scaffolding of the external world of architecture. The forms of the *Portrait of Tzara* and *Enak's Tears*, while describing nothing specifically, multiply associations to physiological and botanical processes, to sexuality, and through their very ambiguity, to humor.

Although biomorphism initiated a new vocabulary of forms, it did not in itself constitute a style in the sense that Impressionism or Cubism did; nor did it generate any new comprehensive principle of design or distribution of the total surface, or of the illusion of space, in pictures. Rather it provided constituent shapes for paintings in a variety of styles. When more than one or two such shapes are used by the "abstract" Surrealists we almost always find them disposed in relation to one another and to the frame in a Cubist manner. Thus, while we may speak of the form-language or morphology of Arp, [André] Masson, and [Joan] Miró as anti-Cubist, this does not apply to the over-all structure of their compositions, since on that level these painters cling to organizational principles assimilated from the Cubism that all of them had practiced earlier.

Joan Miró
The Hunter. 1923–24
Illustrated on page 176

William Rubin, *Miró in the Collection of The Museum of Modern Art,* **1973,** pages 20, 23, 24

The Hunter, also known as *Catalan Landscape,*[1] is Miró's first painting realized wholly within the profile of his personal style, the first free of the manifest influences of Cubism and Fauvism. Its gracile drawing, which links the entire surface in its filigree tracery, is of a tenuousness that remains unsurpassed in his work. And its imagery witnesses the introduction of many signs and symbols that were to become familiar in the landscape of *miromonde.* . . .

The landscape of *The Hunter* is dominated by a beige circle that stands for the trunk of a large carob tree; this tree sprouts but a single leaf that stands, in turn, for all its foliage. The leaf is an example of indicating a set by a single extract; the circle no doubt derives from a memory-image "selection" of roundness as the trunk's most essential attribute. The perspective of the horizontal cross section of the trunk, exactly at right angles to that of most other constituents of the picture, is consistent within the standard "inconsistencies" characteristic of memory images.

Also seeming to grow out of the tree is a giant eye whose pupil is exactly on the horizon line, as if the scene were laid out in perspective according to that eye's position[2]—a situation that identifies it with the eye of the painter himself. Indeed, the extraordinary adventures and metamorphoses of the disembodied eye, as it traverses so many of Miró's pictures of the twenties, reinforce its identification with the artist's persona—a not unknown symbolism,[3] and one

which would certainly occur to a painter whose very name means "he saw." Autonomous eyes, eyes growing out of landscape elements, and supplemental eyes growing out of animals were familiar to Miró from Romanesque art and from the paintings of Hieronymus Bosch.[4] Closer to Surrealism were the mysterious disembodied eyes to be found in the work of [Odilon] Redon[5] and—in the years just prior to *The Hunter*—of Max Ernst.[6] But while the giant eye in *The Hunter* may be read as growing out of the tree—and this has been its standard interpretation—it may also be read as situated at "infinity" on the distant horizon (this would explain why it is only partially visible through the carob tree); indeed, Miró himself does not necessarily identify the eye in this picture with the carob tree.[7]

Joan Miró
Hirondelle/Amour. 1933–34
Illustrated on page 174

William Rubin, *Miró in the Collection of The Museum of Modern Art,* **1973,** page 64

Hirondelle/Amour ("Swallow/Love") is one of four paintings of 1934 that were occasioned by a commission for a group of tapestry cartoons.[1] In executing these pictures, however, Miró made no concession to the techniques of the weaver and conceived them entirely as paintings in their own right. The painting is the product of a more spontaneous procedure than had been used the previous year for the large paintings based on collages. The drawing, though less "automatic" than in certain 1925–26 paintings, not only recaptures the spontaneity of that era, but exhibits greater exuberance and rhythmic continuity—and this within an overall context of more commanding pictorial authority. The forms seem to spill from Miró's brush as it figure-skates its way across the blue ground which we read as sky. Most of the illusionist space of the 1933 paintings has disappeared. No longer isolated in static suspension but galvanized by continuous rhythms, the now slightly shaded design elements are locked into the picture plane in reciprocal relation to the blue ground, so that the configuration binds the entire surface.

Miró's hand seems to reenact the ecstasy of flight. Among the figures that tumble from it as it glides across the canvas is a swallow; without lifting the brush dipped in the black of his contour lines, he writes the word *hirondelle*. Just below, in a free association to his sensations of joy, freedom, and simple celebrity, he writes *amour*. Functioning as decorative

linear passages as well as poetic allusions, these words recall the graphism of Miró's "picture-poems" of the twenties,[2] except that here the words are not set in syntactical arrangements but function rather as simple exclamations.

It is impossible to identify most of the shapes in *Hirondelle/Amour* as specific motifs. At the bottom, to be sure, there is the suggestion of a human head juxtaposed helter-skelter with stylized signs that in Miró's other paintings often stand for breasts and for hair. And at the top—swooping, hovering, darting—is unquestionably a flock of birds. In between, however, seeming to rise from the constraints of gravity and aspiring to the weightlessness and freedom of flight, are forms which suggest human limbs that alternately issue into hands or feet—or metamorphose into birds. It was probably with regard to pictures such as *Hirondelle/Amour* that [Alberto] Giacometti, one of Miró's closest friends at the time it was painted, was later to say, "For me, Miró was synonymous with freedom—something more aerial, more liberated, lighter than anything I had ever seen before."[3]

André Masson
Battle of Fishes, 1926
Illustrated on page 176

William Rubin, *André Masson,* **1976,** pages 15, 16, 21, 22, 25, 26

The often hybrid subjects of Masson's pictures of the middle twenties suggest a constant state of generation, eclosion, and metamorphosis. Horses become celestial signs . . . while architecture dissolves into humanoid forms; the limbs and extremities of human figures issue into birds or fish, their organs become flowers or fruit. A sense of pervasive movement, and sometimes even violence, emerges from these transformations. . . . The pictures teem with elements that seem to be growing and changing. But this *élan vital* is in constant confrontation with processes and symbols of dissolution and destruction—an alternation that produced the poetic and the visual rhythms of the pictures, their characteristic "pneuma." . . .

The new forms which forced their way into the Cubist structures of the 1924 Massons represented on both the plastic and poetic level a transposition into painting of *trouvailles* of his automatic drawings. These drawings . . . come as close as anything Surrealism produced to the dictionary definition of the term as given in the first manifesto (which some of them antedate).[1] Masson had no particular subject matter in

mind as he began these drawings; the hand wandered freely, producing a web of markings out of which subject elements were subsequently, in effect, "provoked.". . .

The automatic drawings provided, then, a reservoir of both forms and subjects for Masson's paintings of 1924–25. The paintings, however, were necessarily executed in a measured, unautomatic way. This lag seems increasingly to have bothered Masson in 1926, and he cast about for a way in which the process of painting could be made to accommodate linear automatism and thus profit from the freshness and directness of the drawings. The problem lay in "drawing" with a brush: constant reloading broke the continuity of the line as well as the sequence of psychic impulses, while the drag of the brush hindered its speed and its consistency . . . [Vasily] Kandinsky had faced this problem in the more rapidly improvised of his pictures of 1912–14; he solved it by drawing on the canvas with pen and pencil. [Jackson] Pollock would confront it over two decades later. . . .

Masson's solution to this problem . . . involved drawing directly from the tube and pouring a liquid medium (often spreading it with the hand). In the sand paintings of 1926–27,[2] Masson first poured glue in patches and lines over the surface of his canvas, using his fingers to spread it here and there in a sort of automatic drawing. The sand which he subsequently sprinkled over the entire surface remained on the gluey areas and fell away from the rest when the stretcher was tilted. . . . The apparently random spillings and patches formed by the glue and sand constituted a suggestive ground that conditioned the second phase of the configuration—the inscription of automatic drawing. The drawing might be accomplished by spilling a very liquid medium of the sand . . . or by drawing directly with the tube. . . . In instances where the canvas was primed, as in *Battle of Fishes*, linear detailing might be added with charcoal or pencil. . . .

Battle of Fishes is the most individually rich illustration of the universe that is evoked collectively by the sand paintings. Only a small part of its surface is covered with sand. . . . This provides the environment for a group of sharklike creatures that devour one another. The configuration preserves all the randomness of its automatic beginnings, not only in the sand passages, but in the contouring and rubbing of pencil and charcoal inscribed around them. Yet it is finally no less ordered—if differently and less immediately perceived as such—than the oil paintings of 1924–25. This purely artistic order, which is arrived at in the later stages of the work, served psychologically for Masson as a symbolic counterthrust to the disruptive elements of his personality, whose unconscious and instinctual drives are the subjects of the pictures.

Matta
The Vertigo of Eros. 1944
Illustrated on page 177

William Rubin, *Matta,* **1957,** pages 4, 6

The title, *The Vertigo of Eros (Le Vertige d'Éros),* a pun on the phrase "*Le Vert-Tige des Roses*" (The Green Stem of the Roses), relates to a passage in which [Sigmund] Freud located all consciousness as falling between Eros and the death wish—the life force and its antithesis. Afloat in a mystical light which emanates from the deepest recesses of space, an inscrutable morphology of shapes suggesting liquid, fire, roots and sexual parts stimulates an awareness of inner consciousness such as we trap occasionally in revery and dreams. Yet this imagery is wholly opposed to [Salvador] Dali's "hand-painted dream photographs" or [René] Magritte's dreamlike mutations and confrontations of objects in external reality. The components of everything we "see" in a dream, whatever their juxtaposition or distortion, are present in waking life. The flames and giraffes of Dali's noted enigma are in themselves visually commonplace. But Matta's language transcends this ultimately prosaic level of imagery. His invented shapes constitute a new morphology that reaches back behind the level of dream activity to the central and latent source of life, forming an iconography of consciousness before it has been hatched into the recognizable coordinates of everyday experience.

Light rather than color is the unifying factor in *The Vertigo of Eros.* It is light that suggests its unfathomable spaces, represses or exposes its symbols. By 1944 the colorful mountains, flames and congealed elements of the "inscapes" have dissolved into an *a priori* continuum of light in which float a galaxy of smaller and more tenuously linked forms. Simultaneously astral and genital egg shapes are foci or energy centers, articulating a vision in which light forms a common denominator like that divined by Eliphas Levi, a mystic for whose speculations Matta felt a deep affinity. In his *History of Magic* Levi writes: "There exists a mixed agent, natural and divine, corporeal and spiritual, a universal plastic mediator, a common receptacle of the vibrations of movements and the images of form. . . . this universal agent of the works of nature is *astral light.*"

Surrealist Sculpture

Alberto Giacometti
Woman with Her Throat Cut. 1932
Illustrated on page 178

Peter Selz, *Alberto Giacometti,* **1965,** pages 8, 9, 10, 11

"To render what the eye really sees is impossible" [said Giacometti] . . . Everyone before him in the whole history of art, he continued, had always represented the figure as it is; his task now was to break down tradition and come to grips with the optical phenomenon of reality. . . .

Like other artists of his generation he is engaged more in the adventure than concerned with the result. Each work is a step for him, a study for new work, for the task of achieving the impossible: to render reality truly as it appears to the eye and yet to make a sculpture or a painting which, somehow, can find its place in the history of art. . . . His frank erotic symbolism, the near-abstraction of his work, his exploitation of the dream and reliance on the unconscious, brought him into close contact with the Surrealists, and for a brief time he took part in their exhibitions and wrote for their publications. But whereas they seemed satisfied once they had found a certain style and imagery, Giacometti continued to experiment, discovering new forms and symbols, such as the frightening *Hand Caught by a Finger,* a fiendish system of gear which, if they did function, would grind the hand to bits. The violent and destructive aspects of his imagination and an obsession with sexual murder is revealed most clearly in the *Woman with Her Throat Cut,* a nightmarish image, part woman, part animal, part machine. In the *Invisible Object,* on the other hand, his frightened self and his perpetual fear of the void find a mysterious climax. Simultaneously with work of this Surrealist nature, Giacometti also explored the solidity of objects, making his remarkable *Cubist Head,* which once again shows his fascination with man's glance.

Alberto Giacometti
Hands Holding the Void. 1934
Illustrated on page 182

Kirk Varnedoe, *Masterworks from The Louise Reinhardt Smith Collection,* **1995,** page 46

By Giacometti's own testimony, this haunting sculpture of a woman greatly disturbed him and marked a turning point in his life as an artist. It was his first full-length figure and the last major work he made within the orbit of Surrealism; dissatisfaction with the modeling of this body helped propel him to begin once more to work from a live model and to base his art on seeing, as opposed to fantasy and memory.

Scholars have generally agreed that the figure borrows elements from Egyptian sculpture and tribal art. . . . Additionally, the cagelike surrounding "throne" may conflate memories of early Italian Madonnas with the influence of Malangan carvings from New Guinea. The ringleader of orthodox Parisian Surrealism, André Breton, followed the phases of this sculpture's creation with intense interest and recounted that a decisive impetus came from his and Giacometti's flea-market discovery of a peculiar military protective mask from World War I.

As Rosalind Krauss has pointed out, Breton's story is slanted toward his cherished notion that the greatest poetry arises from chance encounters and mysterious found objects, but Giacometti's later insistence that this half-crouching pose derived from that of a child glimpsed in the streets suggests an opposite bias. After he had denounced his Surrealist sculptures as unworthy, Giacometti moved to assimilate *Hands Holding the Void* more closely to the naturalism of his later work, both by this tale of origin and by removing (from this 1954–55 casting of the 1934 plaster) an enigmatic animal head, avian or lupine, which originally adorned the middle crossbar of the "throne" and reinforced the sculpture's sinister air of Symbolist mysticism.

In all likelihood the title *Hands Holding the Void* carries an intentional pun in its French version: *mains tenant le vide* is very close to "*maintenant le vide*" or "now the void," implying the sense of uncertainty and impending crisis that the artist apparently felt in 1934. However titled, the work is profoundly enigmatic in mood. Wide-eyed and slack-jawed as if caught, Pompeii-style, in a moment of permanently astonished fear, this angular, insectile figure rigidly echoes its surrounding frame and is immobilized by the plank pressing on its shins—as if in rigor mortis a stiffened cadaver had been hoisted to verticality. As she perches precariously on the narrow, elongated chair that William Rubin aptly associated with the dream architecture of Giacometti's *The Palace at 4 A.M.,* menace and vulnerability commingle around this priestess of an unknown cult to form an atmosphere as troublingly elusive as the empty ether between her hands.

Jean Arp

Human Concretion. 1935
Illustrated on page 185

William S. Rubin, *Dada, Surrealism, and Their Heritage,* **1968,** pages 120, 121

"Concretion," wrote Arp in a statement that tells as much about his method as his morphology, "is the result of a process of crystallization: the earth and the stars, the matter of the stone, the plant, the animal, man, all exemplify such a process. Concretion is something that has grown."[1] The idea of "growth" reflects the additive, improvisational manner in which Arp modeled his sculpture, which distinguishes it from the reductionism of [Constantin] Brancusi. Arp is interested less in the purified essence of the motif than in the multiplication of poetic associations. Brancusi's sculpture process is centripetal, paring away to the simplest, most economical forms; Arp's is centrifugal, the work appearing to grow organically from a nucleus. In order to facilitate such an improvisational method, Arp worked almost entirely in clay and plaster. The stone, terra-cotta, or high tension bronze versions of his sculptures were made from these originals; the material chosen was a matter of relative indifference to Arp so long as it was handsome and could be smoothly finished. In fact, except for a unique series of torn-paper collages, this suppression of all traces of facture was a common denominator in his style from its inception.

Whereas some of the artists who were closest to Surrealism experienced difficulty sustaining their work after the movement's demise, Arp, who had never particularly drawn upon its resources, went on to create some of his greatest sculptures in the years after World War II. *Human Lunar Spectral,* perhaps the most monumental of his works, evokes a form midway between a man and a meteorite. An extraordinary fantasy of a torso, it affirms Arp's place as the last great sculptor in a tradition that reaches back through Brancusi and [Auguste] Rodin to the Greeks.

Alexander Calder

Gibraltar. 1936
Illustrated on page 180

Alexander Calder, in *The Museum of Modern Art Bulletin,* **1951,** page 8

My entrance into the field of abstract art came about as the result of a visit to the studio of Piet Mondrian in Paris in 1930.

I was particularly impressed by some rectangles of color he had tacked on his wall in a pattern after his nature.

I told him I would like to make them oscillate—he objected. I went home and tried to paint abstractly—but in two weeks I was back again among plastic materials.

I think that at that time and practically ever since, the underlying sense of form in my work has been the system of the Universe, or part thereof. For that is a rather large model to work from.

What I mean is that the idea of detached bodies floating in space, of different sizes and densities, perhaps of different colors and temperatures, and surrounded and interlarded with wisps of gaseous condition, and some at rest, while others move to peculiar manners, seems to me the ideal source of form.

I would have them deployed, some nearer together and some at immense distances.

And great disparity among all the qualities of these bodies, and their motions as well.

A very exciting moment for me was at the planetarium—when the machine was run fast for the purpose of explaining its operation: a planet moved along a straight line, then suddenly made a complete loop of 360° off to one side, and then went off in a straight line in its original direction.

I have chiefly limited myself to the use of black and white as being the most disparate colors. Red is the color most opposed to both of these—and then, finally, the other primaries. The secondary colors and intermediate shades serve only to confuse and muddle the distinctness and clarity.

When I have used spheres and discs, I have intended that they should represent more than what they just are. More or less as the earth is a sphere, but also has some miles of gas about it, volcanoes upon it, and the moon making circles around it, and as the sun is a sphere—but also is a source of intense heat, the effect of which is felt at great distances. A ball of wood or a disc of metal is rather a dull object without this sense of something emanating from it.

When I use two circles of wire intersecting at right angles, this to me is a sphere—and when I use two or more sheets of metal cut into shapes and mounted at angles to each other, I feel that there is a solid form, perhaps concave, perhaps convex, filling in the dihedral angles between them. I do not have a definite idea of what this would be like, I merely sense it and occupy myself with the shapes one actually sees.

Then there is the idea of an object floating—not supported—the use of a very long thread, or a long arm in cantilever as a means of support seems to best approximate this freedom from the earth.

Thus what I produce is not precisely what I have

in mind—but a sort of sketch, a man-made approximation.

That others grasp what I have in mind seems unessential, at least as long as they have something else in theirs.

Calder
Gibraltar

Alfred H. Barr, Jr., *Masters of Modern Art,* **1954,** page 146

Early in 1932, just before they were first exhibited, Calder asked Marcel Duchamp what he should call his new moving constructions.[1] Duchamp immediately answered "mobiles." A year earlier, Jean Arp had named Calder's first static construction "stabiles." The nomenclature of Calder's art could scarcely have had more distinguished sponsors, though [Piet] Mondrian was a greater inspiration to Calder, and [Joan] Miró had greater influence upon his art.

Meret Oppenheim
Object. 1936
Illustrated on page 179

Jenny Holzer, *Contemporary Art in Context,* **1990,** pages 55, 56

[This is] an everyday object but it's also an otherworldly thing. It could come from another civilization—maybe it did—and I think it's fair to say that this is a mundane object rendered sublime, absurdly sublime.

One reason I have continued to . . . enjoy it is because it was made by a woman. . . . I suppose, too, it was just handy to know that this piece was made relatively early in modern art, and was made successfully. As a woman artist, it does give you courage to go on to see that someone else has pulled it off before.

Another thing I like about this is the fact that it's very concise. . . . The scale, I think, in this case helps it. It's a nonart material: basic fur and teacup. . . . I think that women tend to be drawn to nonart materials . . . because women often deal with what I would call real-world subject matter—things that happen in the world—and so nonart materials are appropriate for these kinds of concerns. It's a generalization to say that all women work that way, but I think it's enough of a trend that it's interesting to note it. Still, Oppenheim is not as well known as she should be, I suspect. I think she got confined to the lower tier because of her sex.

The piece is sinister. It seems like a cup that could fight back. I suppose fur implies teeth, and so the cup could bite you. I also like that it's repulsive. That's always a good quality in art. I won't even say one reason for its repulsiveness, but I was thinking that when you're eating, there is nothing more disgusting than when you get a hair in your mouth. This is really an in-depth study in repulsion. . . . I like that the fur would be a way to muffle sound. It's like she killed off the chit-chat part of the tea ceremony. I like also that it would be insulated by the fur—the thermos effect.

I think that [confounding expectations] is a rich vein for artists to work in. . . . But I think it's also fine to make things that are genuinely shocking and that are about serious subjects. And I think if you use contradiction in the form or in the language itself, or in the placement of the work, that this is conducive to dealing with hard subjects and making good art. . . .

This is a latter-day projection onto the object, but I think this could be an early example of Conceptual art because . . . the thing can live in your mind once you've seen it. Although it is wonderful to see, you can carry it in your mind without actually looking at it. It's also a nice piece of art because you can make it yourself at home. That goes back to the nonart materials. . . .

Finally, what I like about this object is its quality of aggressiveness. . . . It certainly would throw a wrench into things if you brought this cup to afternoon tea; it wouldn't be the polite ceremony that tea parties are supposed to be. . . . I think that this piece tells you that life is not what it seems.

Isamu Noguchi
Bird C (Mu). 1952–58
Illustrated on page 184

Andrew Carnduff Ritchie, *Sculpture of the Twentieth Century,* **1952,** page 35

In America Isamu Noguchi, son of a Japanese poet, is the chief representative of organic abstraction. [Constantin] Brancusi, his spiritual master, derived many of his abstract ideas from Oriental sculpture. Noguchi acquired his directly from study in the Orient. The pictographic symbolism of his *Cronos* is of a power and authoritativeness unattainable perhaps by any artist of purely Western blood.

The organic abstract tradition, which this first group of younger sculptors is following, is chiefly preoccupied with the solidity of volumes and, even when these are perforated, the perforations are used

to emphasize still further the substantial nature of the remaining mass. Space in this conception of form is in a sense a negative factor, or rather it only takes on reality, is created in fact, by the presence of form. The constructivist and surrealist traditions, on the other hand, have emphasized the positiveness of space and in their most advanced manifestations have reduced the substantial or formal aspects of their creations to a minimum and have in effect drawn in space rather than modeled or carved in materials.

Joseph Cornell
Untitled (Dieppe). c. 1958
Illustrated on page 181

Carter Ratcliff, in *Joseph Cornell*, **1980,** pages 43, 53, 54, 63, 64, 65

Joseph Cornell is a virtuoso of fragments, a maestro of absences. Each of his objects—a wine glass, a cork ball—is the emblem of a presence too elusive or too vast to be enclosed in a box. These missing presences crowd the imagination, for most of his boxes contain a myriad of things. Even the emptiest—the all-white dovecotes and gridworks—look full of departed personages. . . .

Cornell's chains of linked images are best followed in a state of revery. The Surrealists weren't interest in such gentle proceedings. They preferred the disjunctions of dream, by which they appear to have meant everything from genuine nightmare to a carefully cultivated romance with the absurd. . . .

Boxes are common in Dada and Surrealism. [Marcel] Duchamp is crucial to Cornell because he is the first of the Parisians to make effective use of glass. For Duchamp, glass is the substance of irony, the means by which detachment can be symbolized and effected all at once. Cornell learned from this how to make voyeurism—the despotism of "the bodily eye"—presentable. Even more crucially, he learned from Duchamp how to give aesthetic weight to mechanically replicated images. . . .

If the differences between Cornell's readymades and Duchamp's are followed far enough, one arrives at an odd vantage point where Duchamp looks otherworldly in his ironic detachment and Cornell, entranced by the flow of mass-produced images, looks like an allegorical figure of The Individual Spirit Confronting the Machine Age. What Cornell confronts and masters is a historical process basic to the development of modern culture. It is a process in which a mechanical model of the mind meshes ever more efficiently with mechanical means of manu-facturing goods—including images, of course. The result is the mass production of the picturesque. . . .

Seen as a fragmentation of fragmentariness, Cornell's art looks like an inventory of modern culture's endlessly varied desire for wholeness. Cornell gives his art a narrower purpose—to evoke the absence of the nymph and of the more safely desired ineffable.

Louise Bourgeois
Sleeping Figure, II. 1959
Illustrated on page 183

Deborah Wye, *Louise Bourgeois*, **1982,** pages 13, 14, 22

Bourgeois is articulate about the underlying psychological motivations for her art. In this regard, she is situated within the Surrealist tradition, which sees the exploration and expression of the unconscious as art's primary aim (she also shares the Surrealists' literary and poetic predilections). The work of art serves a psychological function for Bourgeois, for she believes that making art is the process of giving tangible form to, and thus exorcising, the gripping, subconscious states of being that fill one with anxiety—a belief that places her in line with the Expressionist tradition, as well.

By fulfilling this function, Bourgeois's art achieves emotional intensity. She captures those exorcised feelings in her work and thereby animates it. The result, whether four inches in diameter or forty feet long, is sculpture with an inner force resembling magnetic powers. Her work has the kind of indwelling energy of an amulet with good-luck charms, an object with a hex on it, a chalice having a religious aura, or even a tombstone. Her sculpture radiates a vital spark that thoroughly absorbs the viewer, as if something inside the object were alive. This emanation rivets the viewer. Through a suggestiveness of form or resonance of representation, her sculpture conveys a quite specific experience—whether anxious, frightening, or repellent; poignant, humorous or calming. Bourgeois's achievement of such potent emotional intensity within a wide range of inventive and meaningful images is ultimately the real mystery of her artistic powers. . . .

As Bourgeois pointed out in the fifties: "My work grows from the duel between the isolated individual and the shared awareness of the group. At first I made single figures without any freedom at all. . . . now I see my work as groups of objects relating to each other. . . . But there is still the feeling with which I began—the drama of one among many."[1]

New York Dada

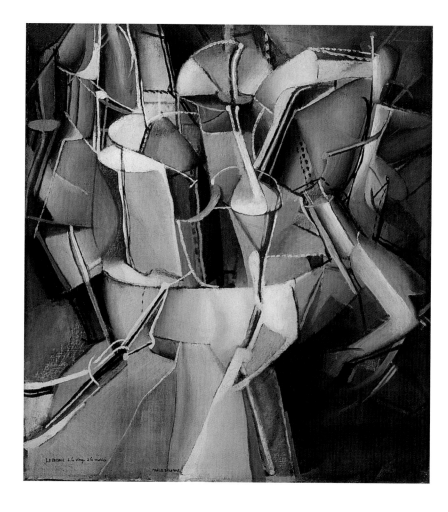

Marcel Duchamp | AMERICAN, BORN FRANCE. 1887–1968
THE PASSAGE FROM VIRGIN TO BRIDE. 1912
OIL ON CANVAS, 23⅞ x 21¼" (59.4 x 54 CM)
PURCHASE

Marcel Duchamp
NETWORK OF STOPPAGES [RÉSEAUX DES STOPPAGES]. 1914
OIL AND PENCIL ON CANVAS, 58⅝" x 6' 5¼" (148.9 x 197.7 CM)
ABBY ALDRICH ROCKEFELLER FUND AND GIFT OF MRS. WILLIAM SISLER

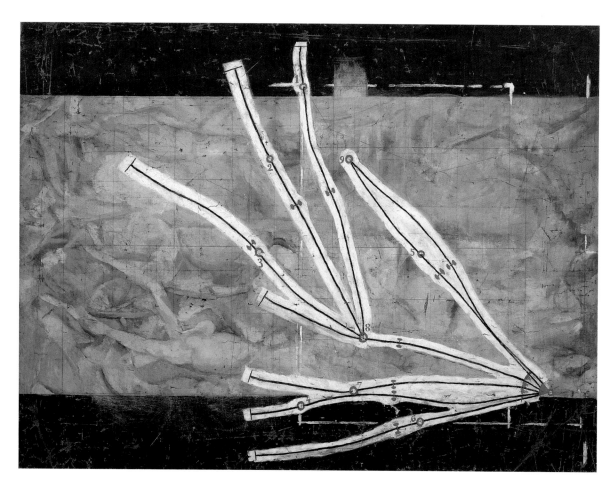

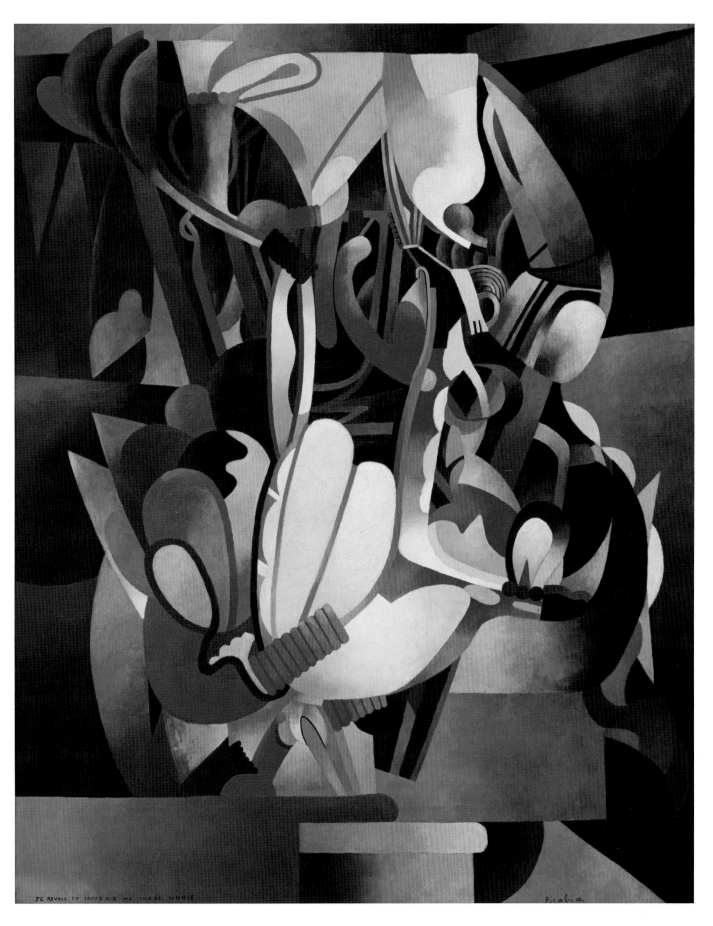

Francis Picabia | FRENCH, 1879–1953
I SEE AGAIN IN MEMORY MY DEAR UDNIE
[JE REVOIS EN SOUVENIR MA CHÈRE UDINE]. 1914
OIL ON CANVAS, 8' 2½" x 6' 6¼" (250.2 x 198.8 CM)
HILLMAN PERIODICALS FUND

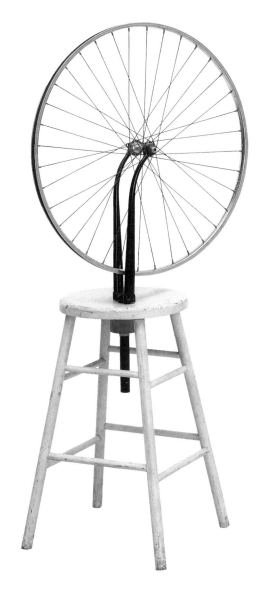

Marcel Duchamp | AMERICAN, BORN FRANCE. 1887–1968
BICYCLE WHEEL. 1951; third version after lost original of 1913
ASSEMBLAGE: METAL WHEEL, 25½" (63.8 CM) DIAMETER, MOUNTED ON PAINTED
WOOD STOOL 23¼" (60.2 CM) HIGH; OVERALL, 50½ x 25½ x 16⅞" (128.3 x 63.8 x 42 CM)
THE SIDNEY AND HARRIET JANIS COLLECTION

162

Man Ray (Emmanuel Rudnitsky) | AMERICAN,
1890–1976
INDESTRUCTIBLE OBJECT (or OBJECT TO BE DESTROYED). 1964;
replica of 1923 original
METRONOME WITH CUTOUT PHOTOGRAPH OF EYE ON PENDULUM,
8⅞ x 4⅜ x 4⅞" (22.5 x 11 x 11.6 CM)
JAMES THRALL SOBY FUND

The Rope Dancer Accompanies Herself With Her Shadows

Man Ray (Emmanuel Rudnitsky)
THE ROPE DANCER ACCOMPANIES HERSELF WITH HER SHADOWS. 1916
OIL ON CANVAS, 52" x 6' 1⅞" (132.1 x 186.4 CM)
GIFT OF G. DAVID THOMPSON

163

Two Fantasts

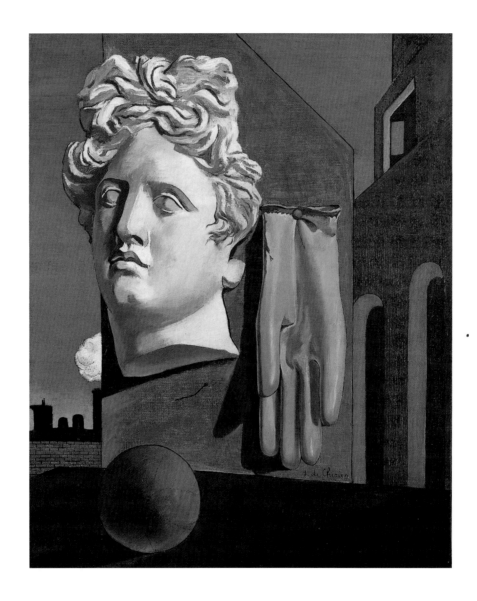

Giorgio de Chirico | ITALIAN, BORN GREECE. 1888–1978
THE SONG OF LOVE. 1914
OIL ON CANVAS, 28¼ x 23⅜" (73 x 59.1 CM)
NELSON A. ROCKEFELLER BEQUEST

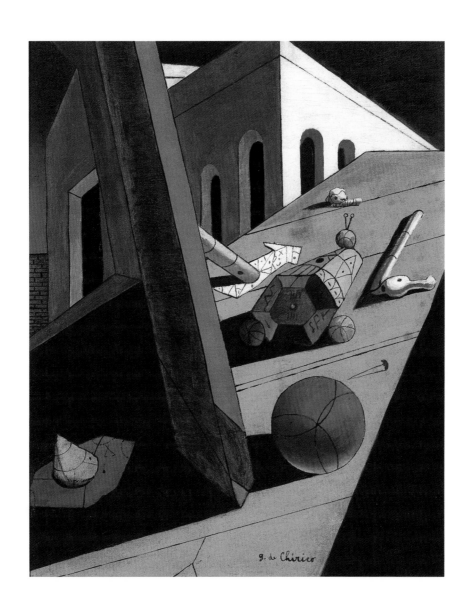

Giorgio de Chirico
THE EVIL GENIUS OF A KING. 1914–15
OIL ON CANVAS, 24 x 19¾" (61 x 50.2 CM)
PURCHASE

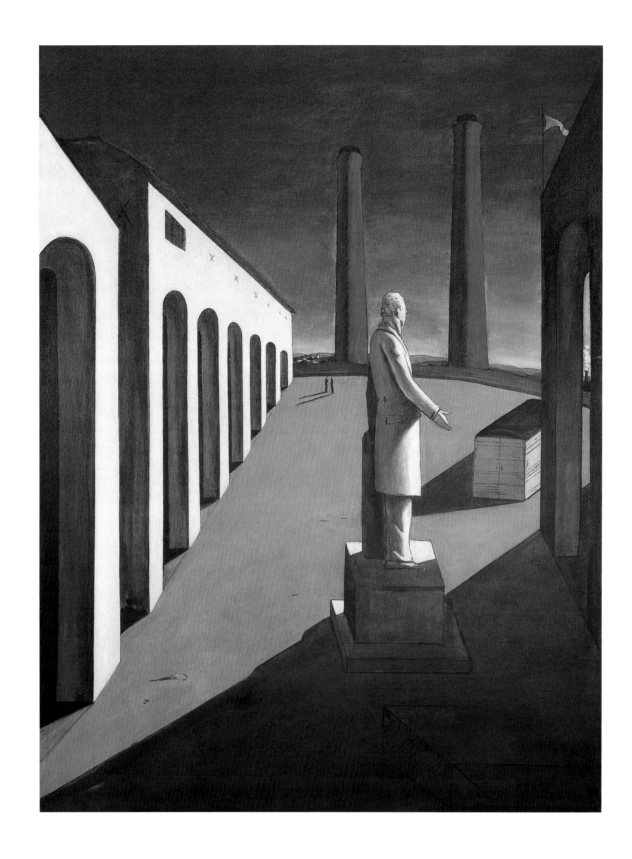

Giorgio de Chirico | ITALIAN, BORN GREECE. 1888–1978
THE ENIGMA OF A DAY. 1914
OIL ON CANVAS, 6' 1¼" x 55" (185.5 x 139.7 CM)
JAMES THRALL SOBY BEQUEST

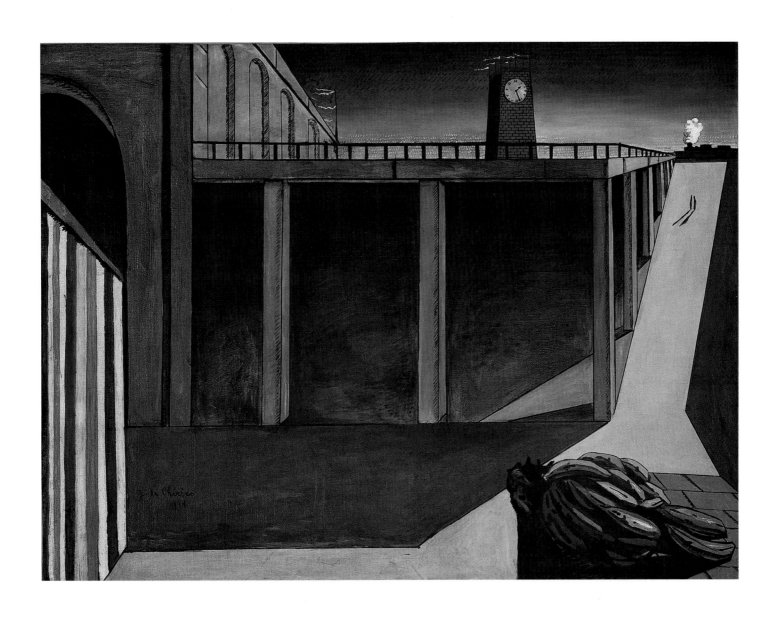

Giorgio de Chirico
GARE MONTPARNASSE [THE MELANCHOLY OF DEPARTURE]. 1914
OIL ON CANVAS, 55⅛" x 6' (140 x 184.5 CM)
GIFT OF JAMES THRALL SOBY

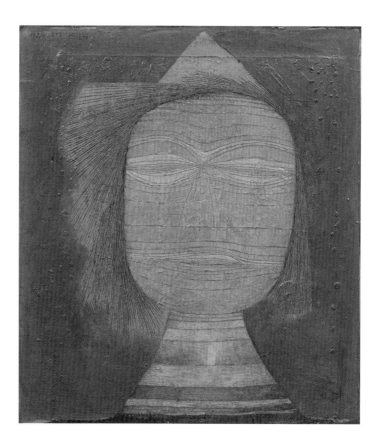

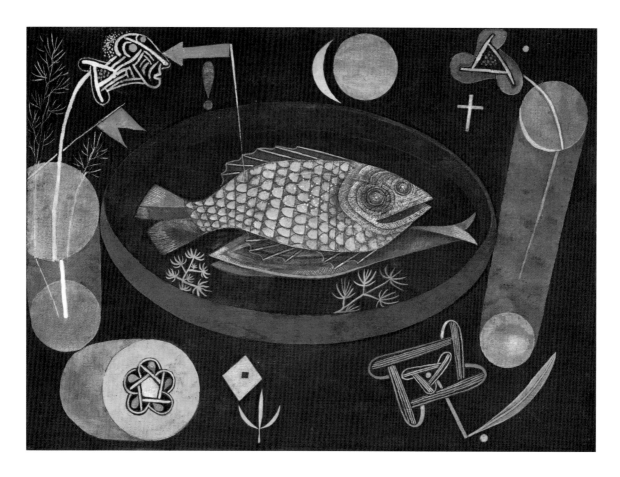

Paul Klee | GERMAN. BORN AND DIED
IN SWITZERLAND. 1879–1940
ACTOR'S MASK [SCHAUSPIELERMASKE]. 1924
OIL ON CANVAS MOUNTED ON BOARD. 14⅛ x 13⅜" (36.7 x 33.8 CM)
THE SIDNEY AND HARRIET JANIS COLLECTION

Paul Klee
AROUND THE FISH [UM DEN FISCH]. 1926
OIL ON CANVAS, 18⅞ x 25⅛" (46.7 x 63.8 CM)
ABBY ALDRICH ROCKEFELLER FUND

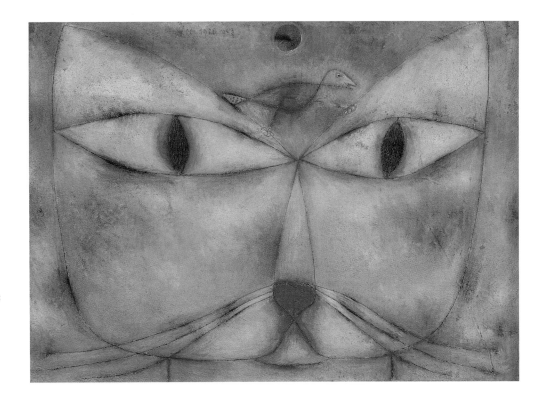

Paul Klee
CAT AND BIRD [KATZE UND VOGEL]. 1928
OIL AND INK ON GESSOED CANVAS, MOUNTED
ON WOOD, 15 x 21" (38.1 x 53.2 CM)
SIDNEY AND HARRIET JANIS COLLECTION FUND
AND GIFT OF SUZY PRUDDEN AND JOAN H. MEIJER
IN MEMORY OF F. H. HIRSCHLAND

Paul Klee
CASTLE GARDEN [SCHLOSSGARTEN]. 1931
OIL ON CANVAS, 26⅛ x 21⅝" (67.2 x 54.9 CM)
SIDNEY AND HARRIET JANIS COLLECTION FUND

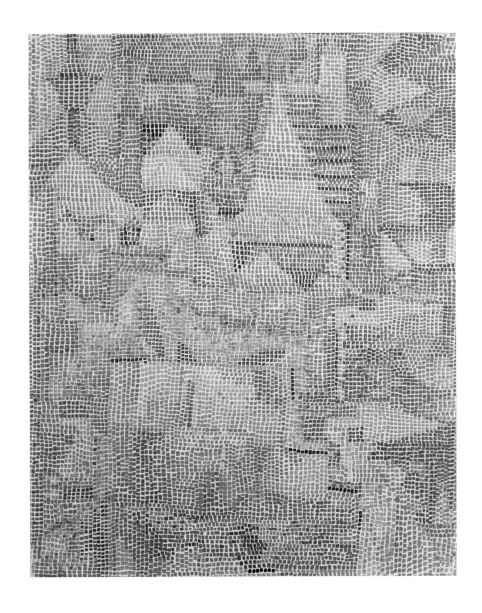

Surrealist Dream Images

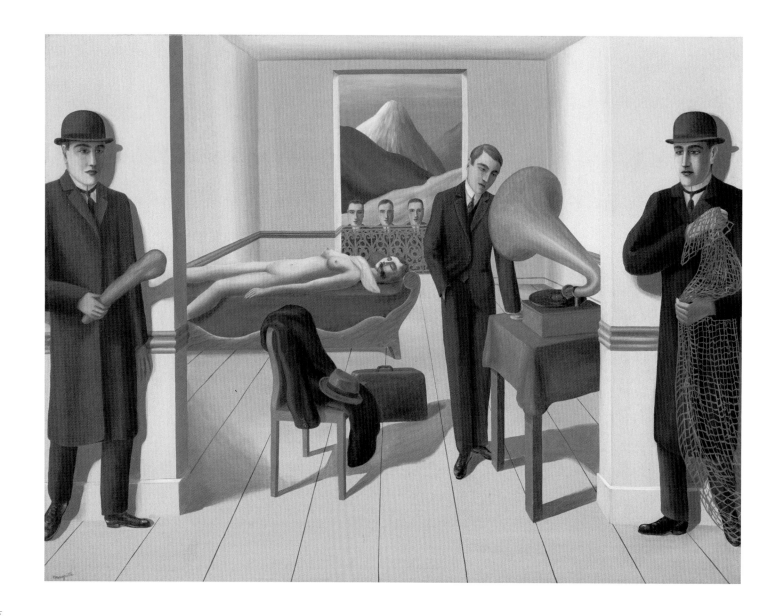

René Magritte | BELGIAN, 1898–1967
THE MENACED ASSASSIN [L'ASSASSIN MENACÉ]. 1926
OIL ON CANVAS, 59⅛" x 6' 4⅞" (150.4 x 195.2 CM)
KAY SAGE TANGUY FUND

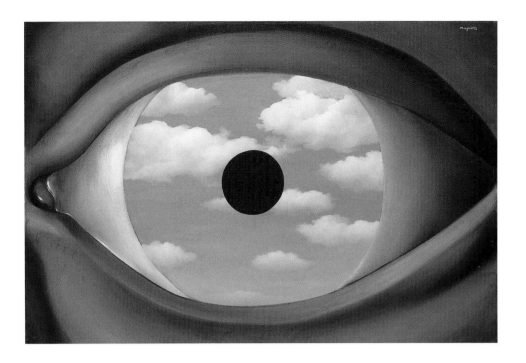

René Magritte
THE FALSE MIRROR [LE FAUX MIROIR]. 1928
OIL ON CANVAS, 21¼ x 31⅞" (54 x 80.9 CM)
PURCHASE

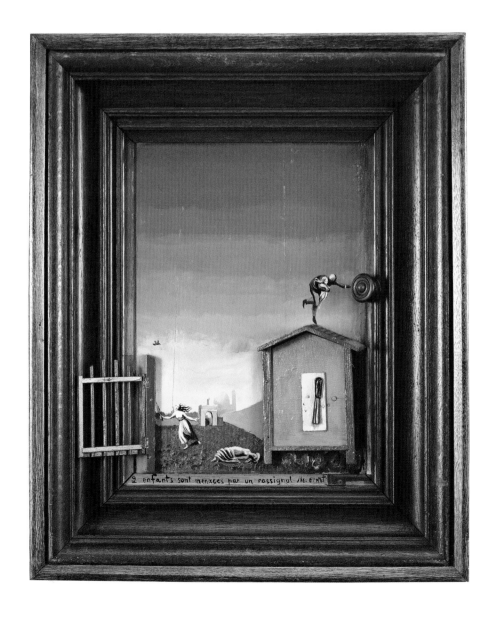

Max Ernst | FRENCH, BORN
GERMANY. 1891–1976
TWO CHILDREN ARE THREATENED BY
A NIGHTINGALE. 1924
OIL ON WOOD WITH WOOD CONSTRUCTION,
27½ x 22½ x 4½" (69.8 x 57.1 x 11.4 CM)
PURCHASE

171

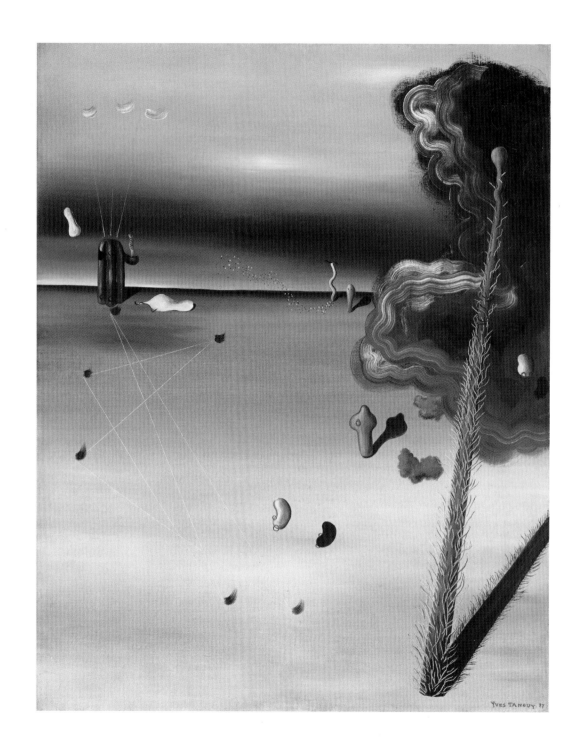

Yves Tanguy | AMERICAN, BORN FRANCE. 1900–1955
MAMA, PAPA IS WOUNDED! [MAMAN, PAPA EST BLESSÉ!]. 1927
OIL ON CANVAS, 36¼ x 28½" (92.1 x 73 CM)
PURCHASE

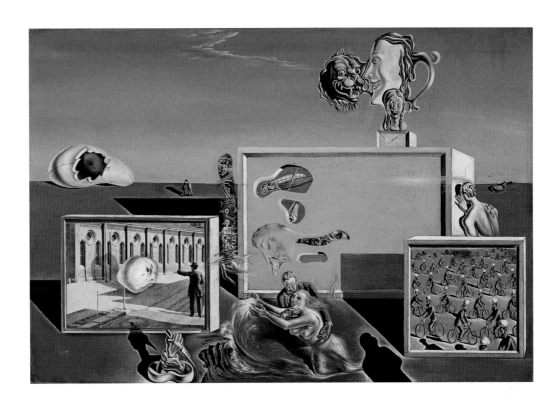

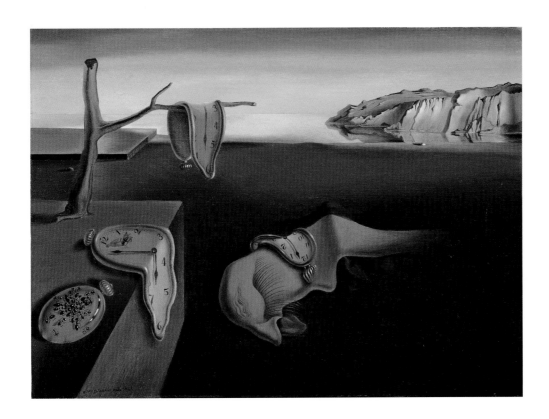

Salvador Dali | SPANISH, 1904–1989
ILLUMINED PLEASURES. 1929
OIL AND COLLAGE ON COMPOSITION BOARD, 9⅜ x 13¾" (23.8 x 34.7 CM)
THE SIDNEY AND HARRIET JANIS COLLECTION

Salvador Dali
THE PERSISTENCE OF MEMORY [PERSISTANCE DE LA MÉMOIRE]. 1931
OIL ON CANVAS, 9½ x 13" (24.1 x 33 CM)
GIVEN ANONYMOUSLY

173

Abstract Surrealism

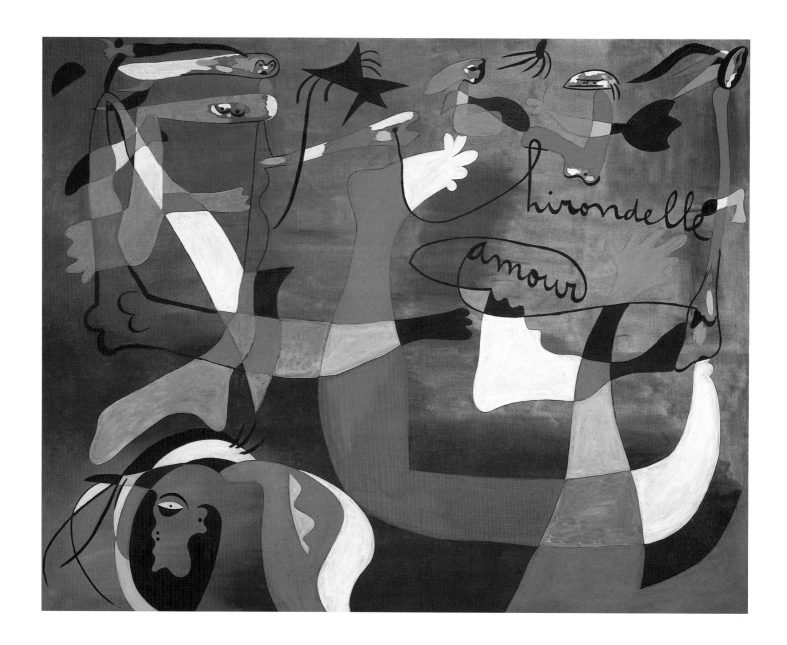

Joan Miró | SPANISH, 1893–1983
HIRONDELLE/AMOUR. 1933–34
OIL ON CANVAS, 6′ 6½″ x 8′ 1½″ (199.3 x 246.7 CM)
GIFT OF NELSON A. ROCKEFELLER

174

Jean (originally Hans) Arp | FRENCH, BORN
ALSACE. 1886–1966
ENAK'S TEARS (TERRESTRIAL FORMS). 1917
PAINTED WOOD RELIEF, 34 x 23⅛ x 2⅜" (86.2 x 58.5 x 6 CM)
BENJAMIN SCHARPS AND DAVID SCHARPS FUND AND PURCHASE

Joan Miró
PERSON THROWING A STONE AT A BIRD. 1926
OIL ON CANVAS, 29 x 36¼" (73.7 x 92.1 CM)
PURCHASE

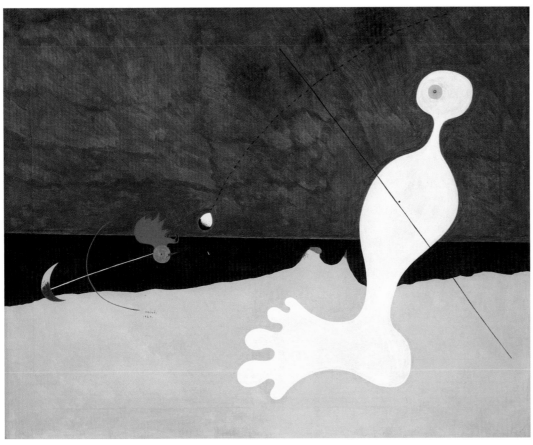

175

Joan Miró | SPANISH, 1893–1983
THE HUNTER (CATALAN LANDSCAPE). 1923–24
OIL ON CANVAS, 25½ x 39½" (64.8 x 100.3 CM)
PURCHASE

André Masson | FRENCH, 1896–1987
BATTLE OF FISHES. 1926
SAND, GESSO, OIL, PENCIL, AND CHARCOAL ON CANVAS,
14¼ x 28¾" (36.2 x 73 CM)
PURCHASE

Matta (Roberto Sebastián Antonio Matta Echaurren) | CHILEAN, 1911–2002
THE VERTIGO OF EROS [LE VERTIGE D'EROS]. 1944
OIL ON CANVAS, 6' 5" x 8' 3" (195.6 x 251.5 CM)
GIVEN ANONYMOUSLY

Surrealist Sculpture

Alberto Giacometti | SWISS, 1901–1966
WOMAN WITH HER THROAT CUT [FEMME ÉGORGÉE]. 1932
BRONZE (cast 1949), 8 x 34½ x 25" (20.3 x 87.6 x 63.5 CM)
PURCHASE

Meret Oppenheim | SWISS, BORN BERLIN. 1913–1985
OBJECT [LE DÉJEUNER EN FOURRURE]. 1936
FUR-COVERED CUP, SAUCER, AND SPOON; CUP, 4⅜" (10.9 CM) IN DIAMETER; SAUCER, 9⅜"
(23.7 CM) IN DIAMETER; SPOON, 8" (20.2 CM) LONG; OVERALL HEIGHT 2⅞" (7.3 CM)
PURCHASE

Alexander Calder | AMERICAN, 1898–1976
GIBRALTAR. 1936
CONSTRUCTION OF LIGNUM VITAE, WALNUT, STEEL RODS, AND
PAINTED WOOD, 51⅞ x 24¼ x 11⅜" (131.7 x 61.3 x 28.7 CM)
GIFT OF THE ARTIST

Joseph Cornell | AMERICAN, 1903–1972
UNTITLED (DIEPPE). c. 1958
WOOD BOX WITH GLASS OVER PAINTED BACKGROUND CONTAINING CORK BALL,
METAL RODS, METAL BRACELET, NAILS, AND STAMP, WITH BOOK PAGES ON
REVERSE, 8 x 12½ x 3¼" (20.3 x 31.7 x 9.5 CM)
MARY SISLER BEQUEST

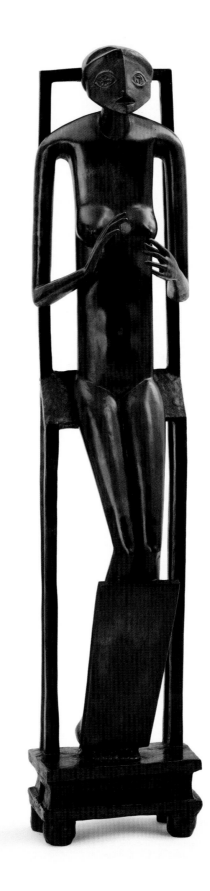

Alberto Giacometti | SWISS, 1901–1966
HANDS HOLDING THE VOID (INVISIBLE OBJECT).1934
BRONZE (cast c. 1954–55), 59⅞ x 12⅞ x 10" (152.1 x
32.6 x 25.3 CM)
LOUISE REINHARDT SMITH BEQUEST

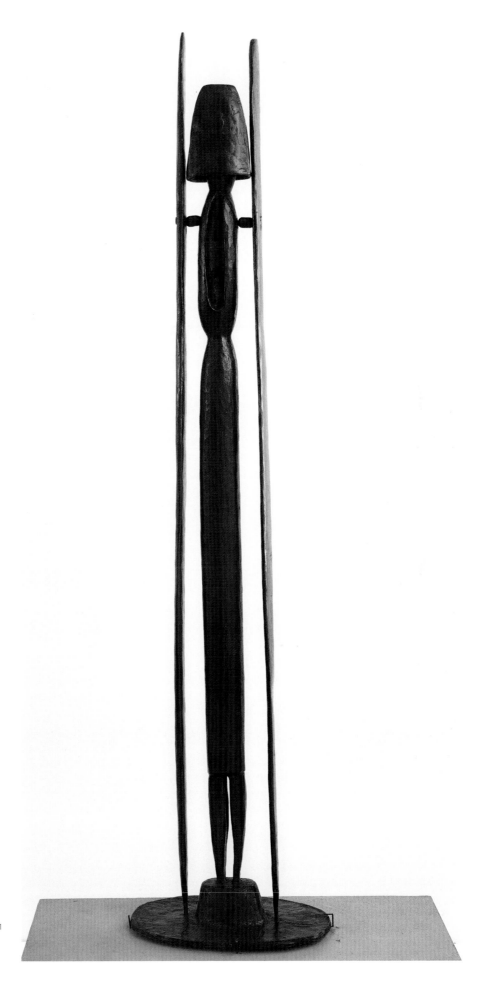

Louise Bourgeois | AMERICAN, BORN FRANCE, 1911
SLEEPING FIGURE, II. 1959
BRONZE (cast 1959), 6' 3¼" x 17½" x 12⅛" (191.1 x 44.5 x 30.8 CM)
PURCHASE

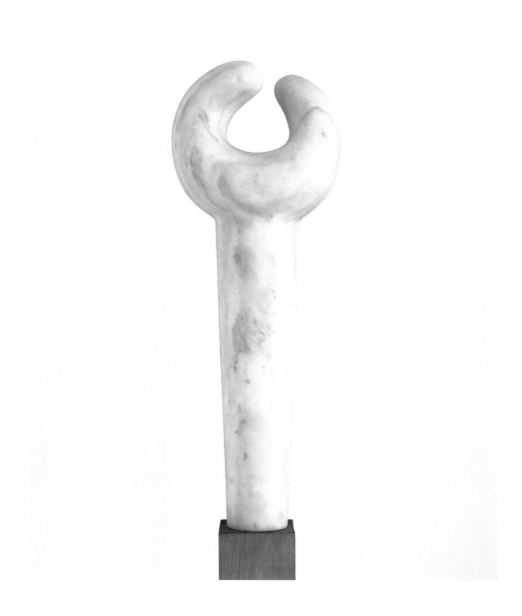

Isamu Noguchi | AMERICAN, 1904–1988
BIRD C (MU). 1952–58
GREEK MARBLE, 22¼ x 8½ x 4¼" (57.8 x 21.6 x 21.1 CM)
IN MEMORY OF ROBERT CARSON, ARCHITECT (GIVEN
ANONYMOUSLY)

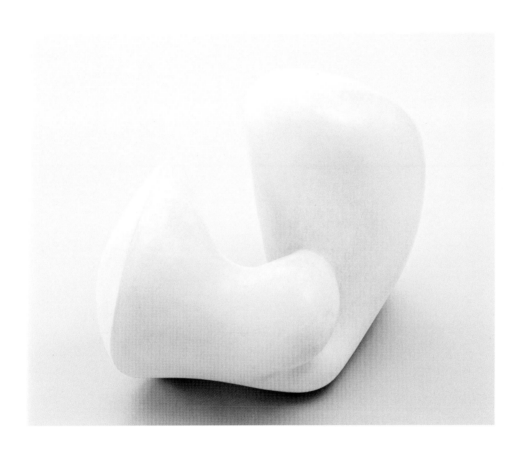

Jean (originally Hans) Arp | FRENCH, BORN ALSACE. 1886–1966
HUMAN CONCRETION. 1949 cast of 1935 original
CAST STONE, 19½ x 18¾ x 25½" (49.5 x 47.6 x 64.7 CM)
PURCHASE

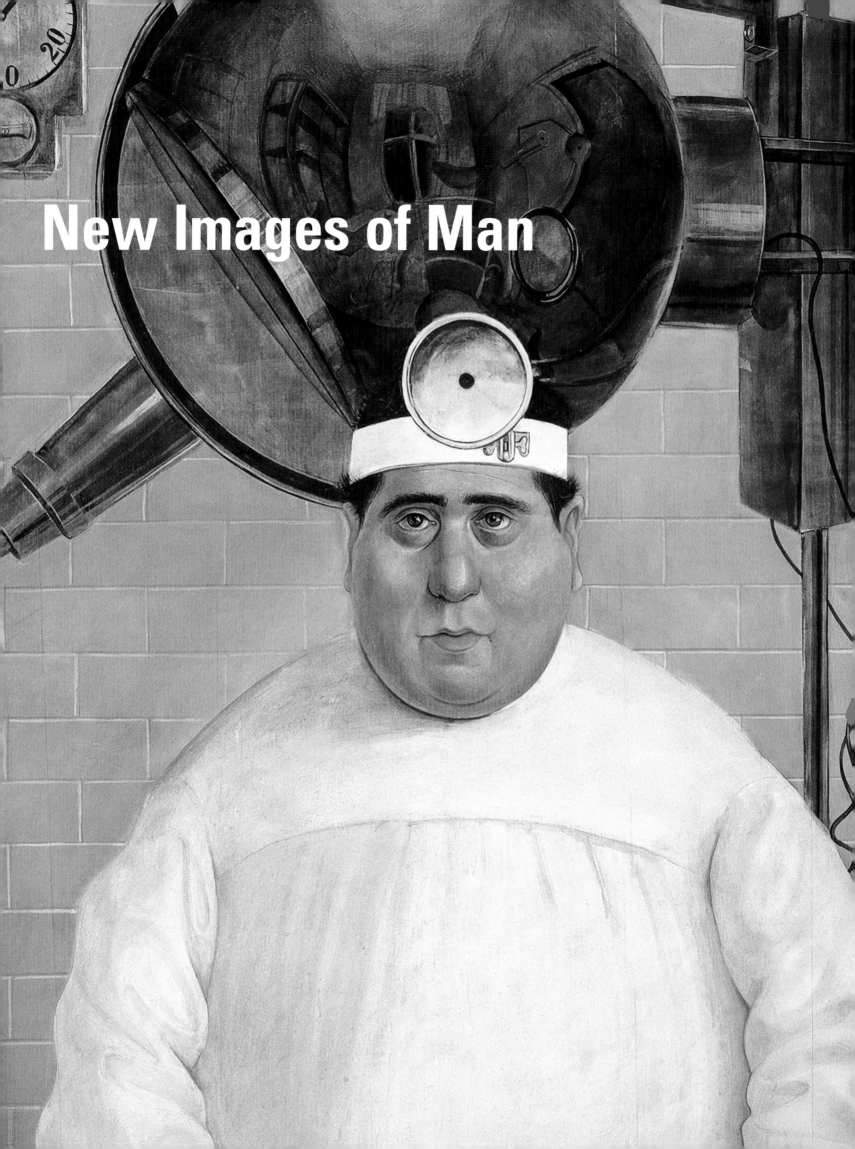

New Images of Man

"Why does the modern artist deliberately create a fragment?" asked the art historian Robert Goldwater discussing the human form in his 1969 book *What is Modern Sculpture?* (a belated complement to Director Alfred H. Barr, Jr.'s 1943 *What is Modern Painting?*). His question is apt, for the body had been subjected to a series of attacks on its corporeal integrity from Impressionism's cropped narratives, Symbolism's patterning of form for decorative effect, Cubism's presentation of the body from multiple viewpoints, Futurism's dynamic splintering, and finally Dada and Surrealism's predilection for uncanny distortions and obsolescence of body parts. Such fragmentation of the human form was symptomatic of the modern experience—its loss of wholeness, disjunction from the past, social and political bifurcation, as well as two World Wars that physically rendered the world in pieces.

While fragmented forms expressed modernity, they simultaneously suggested classical sculpture, which had been prized since the Renaissance as a remnant of anatomical perfection. It was in homage to such sculpture that Auguste Rodin arrived at his *St. John the Baptist Preaching* and *Monument to Balzac* (pages 199, 200). Expanding upon a nude locus of expression in the former work, Rodin transformed the "anonymous body" into a historical one. As Andrew Carnduff Ritchie observed in his 1952 survey *Sculpture of the Twentieth Century*, Aristide Maillol followed Rodin's example by building upon classical sculpture and the Renaissance admiration for its achievements by simplifying form to suggest essential woman, an allegory that presents the Mediterranean as Arcadia, classical, and female (page 201). While Ritchie emphasized Maillol's project as a will toward abstraction in keeping with contemporary developments in painting, in Barr's appraisal in *Painting and Sculpture in The Museum of Modern Art* (1948), Maillol upheld and "revived the classic European tradition of figure sculpture, natural in style, balanced, sensual and serene." Similarly, Lincoln Kirstein's 1948 Elie Nadelman retrospective emphasized the artist's simplified, somewhat whimsical forms as abstractions derived from acute analysis of and a prevailing sympathy for the human form rather than enacting violence toward it (see page 203).

If figurative tenacity in sculpture implied an allegiance to the medium's historical lineage, then its violation suggested the influence of modern painting. Although Ritchie argues for the mutually beneficial relationship between painting and sculpture, he suggests that it is in painting that new styles originate, only to later find their counterpart in sculpture. William Rubin similarly suggests in his catalogue for the 1984 show *"Primitivism" in 20th Century Art* that the relationship of modern sculpture to non-Western idioms is mediated by painting and therefore trails painting in innovation. Amedeo Modigliani offers a notable exception to this theory that sculpture is revolutionarily subordinate to painting. The artist considered himself more a sculptor than a painter, and while his paintings are often portraits, his sculptural projects are governed by formal and symbolic interests supported by the linearity and attenuated features found in African dance masks (page 204). Conversely, Cubism's subordination of illusionism for analysis was facilitated by translating the protrusions and recesses of African sculpture onto the flat plane of a canvas. Jacques Lipchitz's Cubist sculpture retranslates this process and its subjects back into three dimensions. The interpenetrating planes in *Man with a Guitar* (page 205) suggest two dimensions rather than sculpture in the round, recalling its canvas precedent.

During the interwar period, artists began to reconsider the possibilities of figuration, to permit narrative content to take precedence over form and color. According to Barr, prior to World War I paintings were simple in conception and meaning; there was beauty to their formal elements but little expression of human emotion and no interest in religion, politics, economics, etc. Following this thinking, the autonomy of the work of art was achieved only through removing art from the realm of human affairs, subordinating social and psychological expression to formal concerns. Although painting and its subjects prior to World War I were, in fact, deeply shaped by economics, politics, and a heightened awareness of the historical moment, Barr chose to see this calm before the storm as a period when painting flourished in an apolitical vacuum that permitted its progression toward abstraction. When "artistic reactions against art for form's sake" reconsidered "the vast and neglected possibilities of realism and romanticism," painting sacrificed its autonomy, beauty, and redemptive quality.

Trying to understand these complicated developments that caused his teleology of modernist abstraction to become disorderly, Barr in his 1931 catalogue for the exhibition *Modern German Painting and Sculpture* not only contrasted prewar hermetic formalism to wartime figuration, but also saw these as essentially French and German tendencies. The sobriety, satire, and symbolism found in portraits and narratives by *Neue Sachlichkeit* (New Objectivity) artists Max Beckmann, Otto Dix, and George Grosz suggested to Barr an acute attention to the material world in the spirit of the German Renaissance masters. In 1933 Barr witnessed the first wave of defamatory exhibitions of avant-garde art staged throughout Germany, precursors to the infamous *Entartete Kunst (Degenerate Art)* show of 1937. Although censored paintings by *Neue Sachlichkeit* artists may not have suggested the "perfection" of modernist abstraction to Barr, they were evidence of the "truth" of brutal world events and "freedom" of expression that totalitarian regimes sought to suffocate.

Yet the interwar reemergence of narrative painting was by no means a German phenomenon, as even Barr's pioneering heroes of modernist abstraction returned to figuration. The harsh fissures and voids of Cubism hardly seemed appropriate in the aftermath of World War I that had literally rendered the world in pieces. Prewar pictorial fragmentation was replaced by the consoling synthesis of parts and the return to traditional subject matter. The luxurious retreats offered by Modigliani's *Reclining Nude* and Pierre Bonnard's *Nude in Bathroom* (page 210) suggest a comforting antithesis to the bombed-out buildings and private interiors physically as well as psychologically jeopardized by aerial bombardments. In like manner, Balthus staged the players of Parisian domestic society in *The Street*, yet this is not Paris as modern metropolis in the aftermath of war, but as quaint village untouched by politics (page 211).

While the German return to figuration was read as an essentially Teutonic strategy of realism and romanticism, its French counterpart was seen as the pictorial correlative to the "return to order," presenting images of escape to a golden age before war, recalling the classical tradition and Latin heritage. Although contemporaneous with these developments, Edward Hopper's "American scene" paintings are interpreted as utterly independent from and unaffected by European precedents. According to Barr in his 1948 survey, paintings such as *House by the Railroad* (page 212), the Museum's first acquisition, were "generated by a deep love . . . for the look of everyday America . . . repudiating the radical innovations of 'modern art' in favor of more traditional and popularly acceptable styles." Including Hopper in his 1948 show *Contemporary Painters*, James Thrall Soby described the artist as a "self-made painter" free from the prejudices of European training which set him apart from the international arena. This insistence upon an untainted American essence, like contemporaneous interpretations of German and French art, betrays the predisposition in the postwar years to see artistic developments as manifestations of national character.

— *Sarah Ganz*

Early Figurative Sculpture

Auguste Rodin

St. John the Baptist Preaching. 1878–80
Illustrated on page 200

Albert Elsen, *Rodin,* **1963,** pages 9, 10, 11

The memorable sentences of the poet, Rainer Maria
Rilke, who served for a time as Rodin's secretary and
remained one of his most loyal friends and admirers,
stand apart with lithic durability from the glutinous
sentimentality and inflated chauvinism that charac-
terize much of the literature on the sculptor and his
art. In Rilke's penetrating essay, written in 1913, one
finds many statements unsurpassed in the depth and
lucidity of their insight. He saw Rodin as the seeker
after "the grace of the great things," although "his
art was not built upon a great idea, but . . . upon a
craft," in which "the fundamental element was the
surface . . . which was the subject matter of his art."
"He was a worker whose only desire was to penetrate
with all his forces into the humble and difficult sig-
nificance of his tools. Therein lay a certain renunci-
ation of Life, but in just this renunciation lay his tri-
umph, for Life entered into his work.". . . And final-
ly, "With his own development Rodin has given an
impetus to all the arts in this confused age."

By the excellence of his own art, Rodin was able to
persuade a previously apathetic society what sculp-
ture could and should be. When he found it necessary
to rethink sculpture down to "the hollow and the
mound," he forced artists, critics and the public to
take stock of their own definitions and beliefs about
art. Since Rodin, this inventory and self-searching
has continued and now seems limitless. When we
search for the origins of modern sculpture, it is to
Rodin's art that we must inevitably go. Every sculp-
tor who came to maturity before 1914 was affected by
him and had to take a stand for or against his sculp-
ture. His was an art that could not be ignored. . . .

Rodin was the Moses of modern sculpture, leading
it out of the wilderness of the nineteenth-century
Salons and academic studios. Like the biblical Moses,
he lived only long enough to look on the Promised
Land. Not his death, however, but his steadfast
adherence to naturalism and certain of its traditions

prevented Rodin from entering into the new terri-
tories that were being surveyed and colonized by
younger sculptors of the twentieth century.

Auguste Rodin

Monument to Balzac. 1898
Illustrated on page 199

Albert Elsen, *Rodin,* **1963,** pages 89, 93, 101

In 1891, when Rodin received from the Société des
Gens de Lettres the commission for a sculpture of
Balzac to be placed in front of the Palais Royal, he
had little idea how prophetic his remark to his
patrons would be: "I should like to do something out
of the ordinary."[1] . . .

The artist himself regarded this as his most im-
portant and daring work, "the sum of my whole life,
result of a whole lifetime of effort, the mainspring of
my esthetic theory. From the day of its conception, I
was a changed man."[2] Yet, in 1898, although sup-
ported by many friendly writers and critics against
what seemed the entire public, a predominantly hos-
tile press, and his patrons themselves, Rodin on at
least one occasion confided that perhaps he should
have dropped the project three years earlier. In
another instance, his correspondence reveals that he
considered the adverse reception of the sculpture a
bitter defeat. At other times, he consoled himself
that the *Balzac* could be appreciated only by connois-
seurs. The ambivalence of the artist's own reaction is
all the more fascinating because, even though he
generally seems to have regarded this as his master-
piece, he never attempted to carry his ideas in the
Balzac further in other large-scale works. . . .

In the firm belief that the geographical area in
which a man was born would reveal similar ethnic
types, and that physical environment could influence
character, Rodin beginning in 1891 made lengthy
trips into Balzac's home territory around Tours. He
made actual clay sketches of Tourangeaux [natives of
Tours] whose resemblance to the dead man struck
him. Balzac's old tailor was commissioned to make a
suit of clothes to the measurement that he had kept

throughout the years. In Paris, Rodin encountered a factory worker who seemed to possess the author's features, which he then transposed into wax and clay studies. Over forty studies in wax, clay, plaster and bronze have survived, but they have so far resisted complete dating or the establishment of a firm chronology.[3] These studies, however, indicate the triple nature of Rodin's problem. First was the task of recreating the head—the likeness that would mirror the spirit. Second, the body had to be built and the amount of stress to accord it be decided. Third, should the figure be clothed, and if so, how?

At the outset, the artist indicated that obtaining a resemblance was not his major problem: "I think of his intense labor, of the difficulty of his life, of his incessant battles and of his great courage. I would express all that."[4] Statements such as this suggest that Rodin may have identified himself with Balzac, so that the projected portrait was in some sense a double one. As the enormity of his objective unfolded in his imagination, Rodin's studies increased, but so did his inactivity, due to demands upon his health and creative powers. Deadlines were continually protracted. His despair deepened as it alternated with moments of enthusiasm.[5]. . .

The side views of the *Balzac* enforce its sexuality. Rodin has transformed the embattled writer into a godlike visionary who belongs on a pedestal aloof from the crowd. His head has become a fountainhead of creative power, and by a kind of Freudian upward displacement it continues the sexual emphasis of the earlier headless nude study. What more fitting tribute to Balzac's potency as a creator from the sculptor most obsessed with the life force!

Aristide Maillol

The Mediterranean. 1902–05
Illustrated on page 201

Andrew Carnduff Ritchie, *Sculpture of the Twentieth Century,* **1952,** page 19

Rodin's forms have a volcanic materiality made all the more substantial when they come closest to bursting their corporeal bonds and exploding into surrounding space. Maillol's, by a process of abstraction, become dematerialized, however massive by symbolic implication they are intended to appear. "Form," he said, "pleases me and I create it; but, for me, it is only the means of expressing the idea. It is ideas that I seek. I pursue form in order to attain that which is without form. I try to say what is impalpable, intangible.". . . His overriding idea, I presume,

from his lifelong preoccupation with the female nude was the womanness of woman, the earth-mother of the peasant, folk memory. In his *Mediterranean,* one of his earliest sculptures but perhaps his most typical, the majesty of Maillol's idea can be appreciated and, at the same time, by comparing this figure with its prototype, Michelangelo's *Night,* one can see how much he has sacrificed of formal and spatial variety and intensity. Perhaps this idealization and therefore abstraction of form in Maillol explains why his sculpture early gained wide popular approval. For one person who looked at his work as sculpture, thousands saw in it a type which inevitably came to be known as the Maillol woman.

Nevertheless, it must be admitted that to the forward-looking generation of sculptors immediately following Rodin, Maillol appeared as a healthy revolutionary come to deliver them from what they considered to be the excessive literary gesturings of the older master. His influence has been felt directly or at a distance by many artists, however much they may differ in personality and in their other sources of stylistic inspiration.

Elie Nadelman

Man in the Open Air. c. 1915
Illustrated on page 203

Lincoln Kirstein, *The Sculpture of Elie Nadelman,* **1948,** pages 8, 9

Some time in 1905, after two months of introspection, [Nadelman] made his decision to devote himself entirely to the root problems of sculpture, which had not been faced seriously for years. He wished to find out, since no one could tell him, of what plastic form was composed: how volume could be described, filled and balanced. This devotion was not towards self-expression, but to researches comparable to an investigation of the nature of physical matter. By analytical drawings of the human nude and head, and sculpture projected from these analyses, he sought the construction underlying form and volume. This was an intellectual rather than an emotional problem undertaken as a moral as much as a manual discipline. Hence he retired from café and salon; later retirement became an increasing compulsion. . . .

His early analytical experiments are the key to Nadelman's entire *oeuvre,* which seems planned from the start as an organic unit, having less development or progression than sequential exhaustion of a number of ways of seeing, of stylistic expression,

all of which were apparent in essence at his beginning. Commencing by the demarcation of big forms in the nude, he outlined them arbitrarily, or "abstractly" although his contours were always based on concrete observation. The outlines were suites of curves expressing a general direction of gesture of the limbs. After the gross shapes were blocked out, he made further decomposition towards analysis; descriptive arcs were bisected and trisected, reciprocals encompassed the interior masses; finally there was an enveloping unification.

Amedeo Modigliani

Head. 1915?
Illustrated on page 204

Alan G. Wilkinson, *"Primitivism" in 20th Century Art,* **1984,** pages 417, 418, 419

Both as a painter and a sculptor, Modigliani was essentially a portraitist. The subject of twenty-three of his twenty-five surviving carvings is the human head. It is in these sculptures and numerous related drawings, rather than in his paintings, that we find Modigliani's subtle assimilation of African tribal art. . . . [T]here can be no doubt that African art was one of the major influences in the formation of the distinctive, highly personal style of Modigliani's elongated stone heads. . . .

The sculpture of Modigliani and that of his mentor [Constantin] Brancusi do not share the close stylistic affinities that often occur in the work of artists living and working in close proximity: . . . Brancusi's early stone carvings certainly influenced Modigliani, but more important was the "moral" example of the Rumanian, a sculptor who retained his individuality and remained fiercely independent of current movements of the avant-garde in Paris. Modigliani, in his dedication to working exclusively in stone, single-mindedly followed Brancusi's dictum "Direct carving is the true path toward sculpture,"[1] whereas Brancusi himself, by 1913–14, was sculpting in various materials—stone, wood, plaster, and had a number of his works cast in bronze. But it must be remembered that when the two artists met in 1909, almost all Brancusi's sculptures of the previous two years were carved in stone or marble. Modigliani, like Brancusi, . . . turned to direct carving and tribal sources as a way of escaping the overpowering influence of [Auguste] Rodin. [Jacques] Lipchitz has recorded of his friend, "Modigliani, like some others at the time, was very taken with the notion that sculpture was sick, that it had become very sick with

Rodin and his influence. There was too much modeling in clay, too much 'mud.' The only way to save sculpture was to begin carving again, directly in stone. We had many very heated discussions about this . . . but Modigliani could not be budged."[2] In 1909 Modigliani could not have found a sculptor more dedicated to direct carving than Brancusi. In addition, Brancusi's interest in tribal art undoubtedly offered Modigliani an alternative to the Greco-Roman Renaissance tradition. . . .

Modigliani's stone heads made a considerable impact on a number of artists who visited his studio. Years later, Lipchitz recalled his visit in 1912 to the studio and made the important observation that the stone heads were intended to be seen together, and as a group produced a unique effect: "I see him as if it were today, stooping over those heads, explaining to me that he had conceived all of them as an ensemble. It seems to me that these heads were exhibited later the same year in the Salon d'Automne, arranged in step-wise fashion, like tubes of an organ, to produce the special music he wanted."[3]

Jacques Lipchitz

Man with a Guitar. 1915
Illustrated on page 205

Henry R. Hope, *The Sculpture of Jacques Lipchitz,* **1954,** pages 10, 11

In the grim atmosphere of war-time Paris, Lipchitz went to work with a devotion and frugality that is reflected in the austerity of the new style. . . . The first new sculpture was a thin statuette in clay, a human figure with all details eliminated, organic shapes transformed to geometric, and volume reduced to a thin shaft. Soon this abstract image appeared in wood—flat boards, cut out and fitted together like prefabricated toys. . . .

Then his vision enriched these thin forms, by transferring them to stone, where they at once acquired weight, solidity and a clean, geometric rhythm. He preferred to hire a stone cutter for all but the finishing touches, but with his meager resources this was difficult. In 1916 a contract with Léonce Rosenberg, providing extra payment for labor and material, gave him what he needed. Thus liberated, he created a series of tall, thin shafts of great beauty. One of these, the *Man with a Guitar*, made a sensation when first exhibited because of the hole cut through the center. . . .

At this time his friendship with Juan Gris had brought Lipchitz into the inner circle of cubism. Like

Gris, and some of the poets, he delved into occult science, looking—in vain—for a deeper meaning in cubism. He also read in metaphysics and philosophy and had many talks with Gris, whose searching intellect always added zest to their conversations. Quite possibly these widening intellectual interests were beginning to divert Lipchitz from his intense preoccupation with cubism and to prepare the way for new subject matter in his sculpture—although the change did not become visible in his work for several years.

The interchange of ideas and images with others in the circle gave some of his work the collective quality of the movement. Occasionally his gouaches and polychromed reliefs, done mostly in 1918, resembled the work of the painters ("that's the closest you ever came to Picasso," Gris once remarked to his infuriated friend).

Pablo Picasso
She-Goat. 1950
Illustrated on page 202

Kirk Varnedoe, *Picasso: Masterworks from The Museum of Modern Art,* **1997,** page 128

This formidably vital *She-Goat* . . . belongs to a new burst of sculptural production at the start of the 1950s, and has a more heartily rude comic presence. It and related assemblage sculptures of the day have an improvisatory playfulness that may connect to Picasso's engagement with the two new children, Paloma and Claude, he fathered at the time with his mistress, Françoise Gilot. Picasso always had a great knack for spotting potential images, animal or otherwise, in pieces of scrap, pebbles, and so on. . . . Thus, when he established a new studio in the small potter's village of Vallauris in 1948, he kept a constant eye on the yard next door, where the town's broken ceramics, scrap metal, and other detritus accumulated, looking for accidental fragments that might spark some new idea. In this case, we know from Gilot that Picasso first conceived the idea of making a goat in sculpture, then set out to find the appropriate elements, which he then held together with plaster. The face and spine were fashioned from a large palm frond the artist had retrieved from the beach years before, the bony rib cage originated in an old wicker wastebasket, the horns were vine stalks, the legs were tree branches (with knots serving for joints in the hindquarters), and metal scraps were inserted into the haunches to make them appear properly bony. Picasso took particular care with, and delight in, the sexual markers and underbelly. He broke and reshaped milk pitchers to make the pendulous teats, then inserted a partially bent can top to make a prominent vulva, and between it and the tail set a protruding pipe to denote the anus. Goats were companions to the gamboling gods and nymphs in many of Picasso's postwar imaginings of arcadia, and he first cast this one in bronze so that it could be a constant presence in his garden—where it occasionally served as a hitching post for the actual goat he took on as a pet a few years later. Even in bronze, though, the separate pieces betray their makeshift origins, and add to the coarsely vivid character of this appealing animal.

Figurative Painting Between the Wars

Alfred H. Barr, Jr., *Modern German Painting and Sculpture,* **1931,** pages 7, 12, 13

To appreciate German art it is necessary to realize that much of it is very different from either French or American art. Most German artists are romantic, they seem to be less interested in form and style as ends in themselves and more in feeling, in emotional values and even in moral, religious, social and philosophical considerations. German art is as a rule not pure art. . . .

Max Beckmann emerged from the vigorous impressionism of the first Berlin Secession, passed through the war period with a violent, contorted manner suggestive of German primitives, into his present style which for strength, vitality and breadth of feeling is unequalled in Germany. Whether the genuine greatness of his personality will be realized

in his paintings so that he will take his place among the half dozen foremost modern artists is a question which the next few years should answer.

Since the War expressionism has been followed by various reactions even in the work of leaders in the movement. . . . Beckmann's work has become happier in spirit and more disciplined in form. But there are also at least three distinguishable movements on the part of younger artists in the repudiation of expressionism. One of these . . . has taken the form of abstract composition of more or less geometrical shapes. Another and very wide-spread movement concerns itself with emphatic and frequently exact realistic painting of the objective world. It has been called *die Neue Sachlichkeit*—the New Objectivity. . . .

The phrase "New Objectivity" was invented by Dr. G. F. Hartlaub, Director of the Mannheim Kunsthalle, to designate artists who were turning both from expressionism and from abstract design to concentrate upon the objective, material world. . . . In Germany, three men who are chosen to represent the New Objectivity . . . have each of them experienced the discipline of abstract composition and the license of expressionism. George Grosz's most important work is in drawing and watercolor by which he has made himself a scourge to all that is comfortable and vulgar in contemporary Germany. Otto Dix, less brilliant than Grosz, but stronger, paints with a strident at times almost bizarre realism. . . . In the work of these men may be found resemblances to 15th century painters such as [Carlo] Crivelli or [Pietro] Perugino, to choose a pair of opposites, or, in the north to the greatest of German painters, [Albrecht] Dürer, [Hans] Holbein, or [Matthias] Grünewald. . . . The New Objectivity is no longer new and like expressionism is taking its place in the past. The future of German painting is difficult to discern. No movement at present is dominant in Germany any more than it is in Paris or America.

Max Beckmann

Self-Portrait with a Cigarette. 1923
Illustrated on page 207

Peter Selz, *Max Beckmann,* **1964,** page 39

The new realism, a bitter and often dry attitude toward reality, was to dominate much of German literature and art between the wars. [G. F.] Hartlaub saw in it an attitude of resignation and cynicism on the one hand and enthusiasm for immediate reality on the other. . . . While Beckmann certainly engaged in social criticism, he did so less exclusively than

[George] Grosz and [Otto] Dix. Beckmann's unique construction of space and personal symbolism transports his paintings . . . far beyond Verist reportage and social comment. . . .

In the splendid *Self-Portrait with a Cigarette* . . . he paints himself as a robust, solid figure with hard contours. Within the narrow surrounding space he cuts out a niche for himself. He poses somewhat haughtily with cigarette in hand, simultaneously ready to take a stand as the witness of his time and to explore his own self. "For the visible world in combination with our inner selves provides the realm where we may seek infinitely for the individuality of our own souls," he was to say years later in his "Letters to a Woman Painter."[1] He would observe and ruthlessly explore the world around him.

Otto Dix

Dr. Mayer-Hermann. 1926
Illustrated on page 206

Robert Storr, *Modern Art despite Modernism,* **2000,** page 59

The portrait *Dr. Mayer-Hermann* provides a four-square image of a portly physician in which each detail of his medical equipment is described with the same emotionally detached precision used for the features of his impassive face. The painting is manifestly the creation of an artist with a camera eye, but the hand that records what the eye sees has been to school with Albrecht Altdorfer, Lucas Cranach, Albrecht Dürer, Hans Baldung Grien, and Wolf Huber. The clinical calm of this portrait differs strikingly from the chaotic ferocity of much of the rest of Dix's work; his ghastly depictions of the trenches, his lurid scenes of poverty, sex crimes, and cabaret life, and his angry caricatures of the war wounded begging on the streets of Berlin show Dix's fury at its bluest flame.

Images of the latter kind suggest another reason why "realism" seemed a necessity for artists wishing to document or react to what they had seen during the war. While it is true that some merely sought security in the old artistic ways and others hoped to rebuild what had been destroyed by patching fragments of modernism together with bits of salvaged tradition, those who wanted to depict a damaged world had to address a basic formal problem: for those damages to be visible some semblance of a pictorial whole needed to exist. A tear in the flesh of an already dismembered image was simply a graphic detail. A gash in a recognizably rendered face, on the

other hand, registered the violence done. In short, bullets and bayonets had "abstracted" the body in ways that grotesquely mimicked Cubist dismantling of the figure; any confusion between the two threatened to become an intolerable, aesthetic parody of actual suffering.

Max Beckmann
Departure. 1932–33
Illustrated on pages 208–09

Peter Selz, *Max Beckmann*, **1964,** pages 55, 56, 58

Beckmann began his great triptych, *Departure*, in May 1932 while he was still in Frankfurt, took the half-finished panels to Berlin with him, and finished the triptych there on December 31, 1933.[1] Although completed during the first year of the Nazi rule of terror, *Departure* is far more universal than the "symbolic portrayal of the artist's departure from his homeland and the reasons for it," in which he "symbolized the cruelty of the Nazi torturer on the left-hand side and the madness and despair of the era on the right. . . . To avoid trouble with the Nazis, Beckmann hid the picture in an attic and affixed the cryptic label *Scenes from Shakespeare's Tempest*."[2] Such explanations are of little help in deciphering the triptych. Not only was *Departure* completed in 1933, long before Beckmann left his homeland in 1937, but its concept is a great deal broader. He himself pointed out that it "bears no tendentious meaning." And surely his reference to the *Tempest* was no whim or mere ruse: He has, in fact, re-created the world of Caliban and Prospero. . . .

Lilly von Schnitzler, Beckmann's friend and patron, remembers explanatory remarks he made in February 1937 in Berlin about the triptych: "On the right wing you can see yourself trying to find your way in the darkness, lighting the hall and staircase with a miserable lamp, dragging along tied to you as part of yourself, the corpse of your memories, of your wrongs and failures, the murder everyone commits at some time of his life—you can never free yourself of your past, you have to carry the corpse while Life plays the drum."[3] . . . A newspaper lies next to the bound woman's globe on which the word *Zeit* is legible. This surely indicates that the triptych alludes to its time. Although beginning his famous speech in London in 1938 by asserting that he had never been politically active in any way, Beckmann was deeply troubled about the events of his time and *Departure* reflects—among other things—on the cruelty of the time. . . .

The darkness, the crowded space, the general oppressiveness and horror of the side panels is in utter contrast to the bright, open, colorful luminosity of the center panel. . . . Here, in the broad midday light, floating in their barge on the luminous blue sea are figures whose scale is larger, as their pace is slower. On the left, standing erect and holding a large fish between outstretched arms, is the large masked personage, "Gliding wrapt in a brown mantle, hooded/I do not know whether a man or a woman."[4] . . .

In the center of the boat the woman . . . holds a child. Her frontal stance and detached look endow her with the appearance of universality. Beckmann, who, like many of his great contemporaries— [James] Joyce, [T. S.] Eliot, [Thomas] Mann, [Pablo] Picasso come to mind—often quotes from the past, has given the woman here a classical appearance— including the almond-shaped eyes and the Phrygian cap—of fifth-century Greece. And if the woman recalls classical antiquity, the fisher-king reminds us of the culture of the Middle Ages. With his three-pointed crown and angular profile he evokes the image of the saints and kings on the portals of Reims and Bamberg and in the choir of Naumburg.

The infant, who may represent the hope embodied in youth, is in the very center of the whole three-panel composition. Next to the mother and child is the largely hidden male figure who has been interpreted variously, as a Joseph accompanying the central Madonna and Child;[5] as Charon steering the boat to an unknown port;[6] or possibly a veiled self-portrait.[7] The fisher-king, pulling in a full net and gazing across the sea into the distant space, lifts his right hand in a magnificent gesture that rejects the despair of the side panels and at the same time points ahead into an unknown future.

Amedeo Modigliani
Reclining Nude. c. 1919
Illustrated on page 210

James Thrall Soby, *Modigliani*, **1951,** pages 13, 14, 15

Modigliani's most ambitious paintings are his nudes—those images of women lying naked, aggressive and pleased, the tension of frank moment in their faces and animal pride. They are in fact the nudest of nudes, the absolute contradiction of [Odilon] Redon's dictum: "The painter who paints a nude woman, leaving in our mind the idea that she is going to dress herself immediately, is not an intellectual." One feels that Modigliani's models have flung off their clothes, eager for the artist's admira-

tion and utterly unrestrained. These are (let us be candid) erotic nudes for the most part, though dignified by conviction of style. If we compare them with [Edouard] Manet's *Olympia*, so scandalous in its time, we see that the last vestiges of allegorical disguise have been abandoned; a Baudelairian atmosphere of sin has been replaced by blunt stress on precisely the physical realities that earlier art had usually moderated or concealed. Modigliani's women are not the grown-up cherubs of which the eighteenth century was fond. They are adult, sinuous, carnal and real, the final stage in the sequence leading from Giorgione's *Concert Champêtre* to Manet's *Déjeuner sur l'Herbe* and on to [Toulouse] Lautrec and his contemporaries. Yet whereas a certain picturesqueness of evil attaches to Lautrec's works, and indeed to those of many modern artists from [Félicien] Rops to [Jules] Pascin, Modigliani's sensuality is clear and delighted, like that of Ingres but less afraid. His nudes are an emphatic answer to his Futurist countrymen who, infatuated with the machine, considered the subject outworn and urged its suppression for a period of ten years.

Pierre Bonnard

Nude in Bathroom. 1932
Illustrated on page 210

Sarah Whitfield, in *Bonnard,* **1998,** pages 23, 24

The way in which Bonnard is never tempted by a precise physical description that might distract from the unity of the whole can . . . be seen as tying in with his respect for the rules of classical art. The faces of the nudes, particularly those of the later years, are erased or blurred, even made invisible, their features scumbled over with a thick residue, rather like the accumulation of mineral deposits that encrust the surface of old marble. . . . And it seems to be broadly true that, although the features of Marthe [Bonnard's wife] are recognisable in many of the domestic scenes in which she figures, they are more often than not effaced or concealed when she is portrayed as a nude. The unity of the composition is further reinforced by what Bonnard called the "aesthetic of movement and gesture."[1] The nude acts as a support, a pole on which the composition rests, and Bonnard is extremely careful not to let her line or form conflict with the simple geometry of the interior. As he said, "there has to be a stop mechanism, something to lean on."[2] . . .

Take *The Bathroom* of 1932. The setting is the bathroom at Le Bosquet, a setting that is by now extremely

familiar. The nude is familiar too, but neutralised into a smooth sculptural form. She is seen against a sheet of yellow-gold striped through with purples and red, a passage of glowing heat which is picked up in the soft brightness of the pink pubis. Between those two warm areas is the cool marble white of the nude's right breast reflecting off the scalding whiteness of the stool. The passage between the bath and the nude is a closely plotted course through the abstract patterns made by the heavily grouted bathroom tiles, the horizontal slats of the blind, and the grid created by the lozenge pattern of the linoleum floor. . . . The eye is encouraged to pass over the painting's surface from left to right, as though following the light as it moves across the porcelain coolness of the bath and the damp blue tiles to the warmth of the nude's skin and the burnished coat of the dog. The measured pace of the colour here, and the way each mark is knitted into the structure of the composition, give the painting its weighty stillness. The clock, its hands pointing at five in the afternoon, quietly signals an arrest of time.

Balthus

The Street. 1933
Illustrated on page 211

James Thrall Soby (mid-1960s?) in *Studies in Modern Art 5,* **1995,** pages 213, 214, 215

The picture, called *The Street,* was the first large-scale work of Balthus' career and is an imaginative transcription of a scene on the short rue Bourbon-le-Château in Paris' VI arrondissement. Balthus had painted the picture in 1933 and it had been shown in his first one-man exhibition at Pierre Loeb's Paris gallery the following year. I had seen *The Street* in that show and had never been able to get it out of my mind. A little more than two years later I was again in Loeb's gallery and, to my astonishment, the painting had not yet been sold. I bought it at once, with a vast sigh of relief, having brooded about it almost constantly since 1934.

The fact that *The Street* was almost 6¼ by 8 feet in size may have discouraged some possible purchasers. But the chief difficulty . . . was that the painting's left section included a passage which even the French, usually calm about such matters, found hard to take. The passage shows a young girl being seized by the crotch by a strange . . . young man who has come up behind her, his face taut with easily decipherable excitement. Since the French had been frightened off by this passage, I began to worry

about getting the picture through U.S. Customs. But Hartford was then a Port of Entry and I had brought so many modern paintings through Customs there that the officers regarded me as eccentric rather than libidinous, and they let the Balthus through without any fuss of any kind. Indeed, one of these men told me, bless his heart, that this was the first picture I'd sent from Europe which he really liked! . . .

As the years went by I worried more and more about whether our Museum [The Museum of Modern Art] would be able to exhibit *The Street* when it was finally turned over to that institution at my death. . . . In 1956, Balthus was having a one-man show in Paris[1] and he wrote to ask me whether I'd lend *The Street*. I replied that I would, of course. I added, not as a condition but as a plea, that I was concerned about the picture ever being shown to a large audience in its then-current state. I told Balthus in all frankness that several restorers had offered to "improve" the lurid passage but that I wouldn't let anyone touch the canvas except Balthus himself. I thought this hint would mean the end of a friendship very dear to me. But to my astonishment Balthus replied that he would like to repaint the offending passage. "When I was young I wanted to shock," he wrote. "Now it bores me."[2]

I heard nothing more from Balthus for months after *The Street* had arrived in Paris for his exhibition, and I assumed he'd had a change of heart about making any changes in the composition. But late in the summer of the same year . . . I stopped off to spend a few days with Balthus . . . I grew steadily more nervous about what condition *The Street* would be in and thought in my gloomier hours that Balthus had probably painted it out entirely. He must have sensed how apprehensive I was, since he dragged the big picture into the living room at once. The Mongolian boy's hand had been moved very slightly to a less committed position on the young girl's body, though his eyes were tense with the same fever. I think *The Street* is safe now anywhere from Puritanical rage; I've always thought it one of the very great pictures produced by a member of Balthus' generation.

Edward Hopper

House by the Railroad. 1925
New York Movie. 1939
Gas. 1940
Illustrated on pages 212, 213

Charles Burchfield, in *Edward Hopper*, **1933**, page 16

Hopper's viewpoint is essentially classic; he presents his subjects without sentiment, or propaganda, or theatrics. He is the pure painter, interested in his material for its own sake, and in the exploitation of his idea of form, color, and space division. In spite of his restraint, however, he achieves such a complete verity that you can read into his interpretations of houses and conceptions of New York life any human implications you wish; and in his landscapes there is an old primeval Earth feeling that bespeaks a strong emotion felt, even if held in abeyance. Mr. Duncan Phillips once called attention to Hopper's power of achieving intensity without distortion—and there is in truth a strong emotional, almost dramatic quality about his work that is not always present in the classic outlook. Some have read an ironic bias in some of his paintings; but I believe this is caused by the coincidence of his coming to the fore at a time when, in our literature, the American small towns and cities were being lampooned so viciously; so that almost any straightforward and honest presentation of the American scene was thought of necessity to be satirical. But Hopper does not insist upon what the beholder shall feel. It is this unbiased and dispassionate outlook, with its complete freedom from sentimental interest or contemporary foible, that will give his work the chance of being remembered beyond our time.

Edward Hopper is an American—nowhere but in America could such an art have come into being. But its underlying classical nature prevents its being merely local or national in its appeal. It is my conviction, anyhow, that the bridge to international appreciation is the national bias, providing, of course, it is subconscious. An artist to gain a world audience must belong to his own peculiar time and place; the self-conscious internationalists, no less than the self-conscious nationalist, generally achieve nothing but sterility. But more than being American, Hopper is—just Hopper, thoroughly and completely himself. His art seems to have had few antecedents and, like most truly individual expressions, will probably have no descendants. Search as you will, you will find in his mature art no flounderings, or deviations, no experimenting in this or that method of working.

Such bold individualism in American art of the present or, at least, of the immediate past, is almost unique, and is perhaps one explanation of Hopper's rise to fame. In him we have regained that sturdy American independence which Thomas Eakins gave us, but which for a time was lost.

Hopper
House by the Railroad
New York Movie
Gas

James Thrall Soby, *Contemporary Painters,* **1948,** pages 36, 37, 39

What is almost always conveyed, what holds our attention in the best of Hopper's works, is the exceptionally clear and devout communication between the painter and his subjects. His language of seeming understatement has a backlash to it. It is not eloquent, but it is memorable, and his art has some of the dramatic force of evidence blurted in a courtroom, in an atmosphere of long circumlocution. He must be deeply stirred or he does not attempt to record his reaction. He works slowly, with infinite care, and sometimes goes through extended periods of inactivity between paintings. And perhaps the struggle his technique costs him accounts for the penetrating quality of his painting. For if the surfaces of his pictures are usually bland and unspectacular, their under-structure is exceptionally firm and sensitive. One has only to look at his recent handling of stone masonry to realize how sure his control of pigment can be. He gives New York's granite something of marble's inner illumination, and cuts its joinings with a sculptor's sense of form. . . .

If Hopper describes light with rare skill, he also records the density of air like the most delicate of barometers. A subtle gradation of atmospheric values is common to many of his finest works. In *Gas*, for example, the air seems to thin out as the eye moves from the bright area of the service station toward the thick woods across the road, light and the breeze waning together. The extremes of his atmospheric control are to be found in his depiction of absolute calm and the medium wind, and it is typical of his restraint that he should reject [Winslow] Homer's northeasters as too plainly dramatic. But he can bring the summer air to a dead halt—a far more difficult task than might be supposed—and he handles the wind with knowledgeable stagecraft. . . .

When the artist paints rooms rather than facades, a comparable lull in activity is usually evoked, and we may take his words on one of John Sloan's New York interiors as an indication that a romantic mood is consciously sought. Sloan's picture, Hopper declared, "renders remarkably the quality of a brooding and silent interior in this vast city of ours." Hopper's depiction of interiors is, however, more piercing in emotion than Sloan's and less often concerned with local color's cheerful familiarity. . . .

Hopper is not a man for whom drawing or color is an unrelenting necessity. He works only when accumulated or sudden experience has inspired him with something to say. But his strength lies in the fact that he is so inartistic in the European sense of the term: no formalism, no seeking for graciousness, no painterly references; but self-invented realism, warm, convinced, romantic in overtone through its very bluntness of statement. If his expression cannot be compared in scope or power to that of leading Europeans, it is emphatically his own and American. Who abroad does what he does? Who there or here does it so well?

Early Figurative Sculpture

Auguste Rodin | FRENCH, 1840–1917
MONUMENT TO BALZAC. 1898
BRONZE (cast 1954), 9' 3" x 48¼" x 41" (282 x 122.5 x 104.2 CM)
PRESENTED IN MEMORY OF CURT VALENTIN BY HIS FRIENDS

Auguste Rodin
ST. JOHN THE BAPTIST
PREACHING. 1878–80
BRONZE, 6' 6¼" (200.1 CM) HIGH,
AT BASE 37 x 22½" (94 x 52.7 CM)
(IRREGULAR)
MRS. SIMON GUGGENHEIM FUND

Aristide Maillol | FRENCH, 1861–1944
THE MEDITERRANEAN. 1902–05
BRONZE (cast c. 1951–53), 41 x 45 x 29¼" (104.1 x
114.3 x 75.6 CM), INCLUDING BASE
GIFT OF STEPHEN C. CLARK

Gaston Lachaise | AMERICAN, BORN
FRANCE. 1882–1935
FLOATING FIGURE. 1927
BRONZE (cast 1935), 51⅜" x 8' x 22" (131.4 x
243.9 x 55.9 CM)
GIVEN ANONYMOUSLY IN MEMORY OF THE ARTIST

Pablo Picasso | SPANISH, 1881–1973
SHE-GOAT. 1950
BRONZE (cast 1952), AFTER AN ASSEMBLAGE OF PALM LEAF, CERAMIC
FLOWER POTS, WICKER BASKET, METAL ELEMENTS, AND PLASTER,
46⅜ x 56⅜ x 28⅛" (117.7 x 143.1 x 71.4 CM), INCLUDING BASE
MRS. SIMON GUGGENHEIM FUND

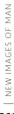

Elie Nadelman | AMERICAN, BORN POLAND. 1882–1946
MAN IN THE OPEN AIR. c. 1915
BRONZE, 54½" (138.4 CM) HIGH, AT BASE 1⅝ x 11¾ x 21½" (4 x 29.9 x 54.6 CM).
GIFT OF WILLIAM S. PALEY (BY EXCHANGE)

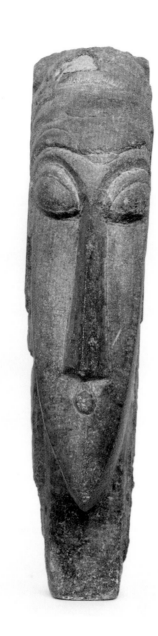

Amedeo Modigliani | ITALIAN, 1884–1920
HEAD. 1915?
LIMESTONE, 22¼ x 5 x 14⅞" (56.5 x 12.7 x 37.4 CM)
GIFT OF ABBY ALDRICH ROCKEFELLER IN MEMORY OF
MRS. CORNELIUS J. SULLIVAN

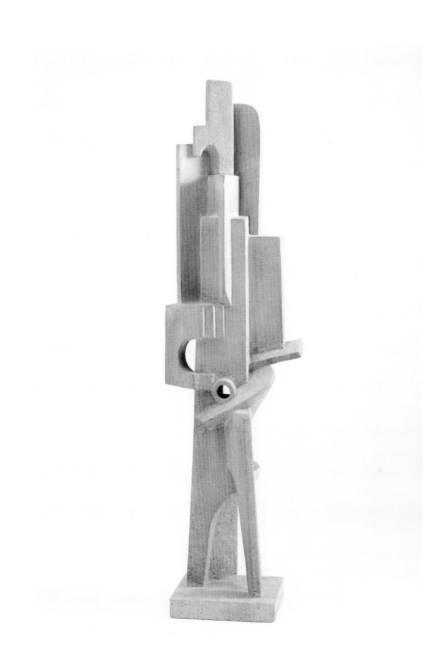

Jacques Lipchitz | AMERICAN, BORN
LITHUANIA. 1891–1973
MAN WITH A GUITAR. 1915
LIMESTONE, 38¼ x 10½ x 7¼" (97.2 x 26.7 x 19.5 CM)
MRS. SIMON GUGGENHEIM FUND (BY EXCHANGE)

205

Figurative Painting Between the Wars

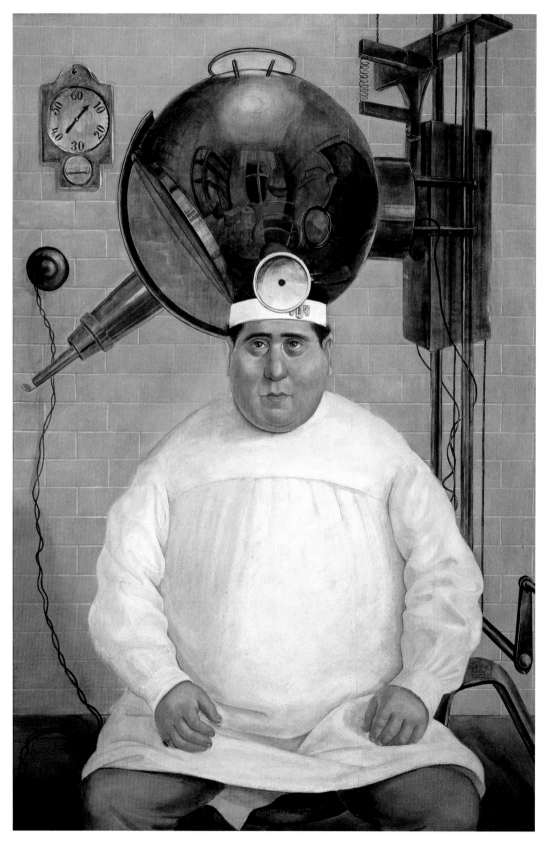

Otto Dix | GERMAN, 1891–1969
DR. MAYER-HERMANN. 1926
OIL AND TEMPERA ON WOOD, 58¼ x 39" (149.2 x 99.1 CM)
GIFT OF PHILIP JOHNSON

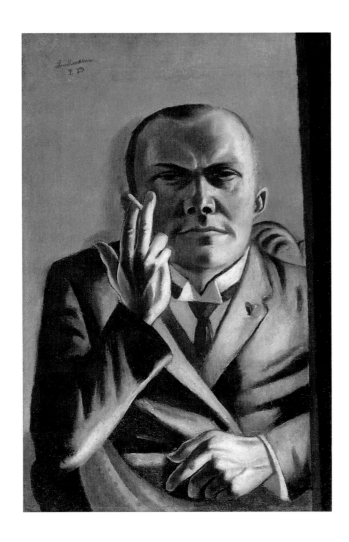

Max Beckmann | GERMAN, 1884–1950
SELF-PORTRAIT WITH A CIGARETTE. 1923
OIL ON CANVAS, 23¾ x 15⅞" (60.2 x 40.3 CM)
GIFT OF DR. AND MRS. F. H. HIRSCHLAND

George Grosz | AMERICAN, 1893–1959
THE POET MAX HERRMANN-NEISSE. 1927
OIL ON CANVAS, 23⅜ x 29⅛" (59.4 x 74 CM)
PURCHASE

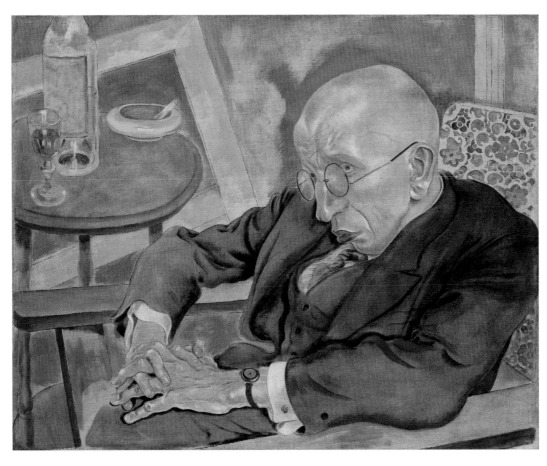

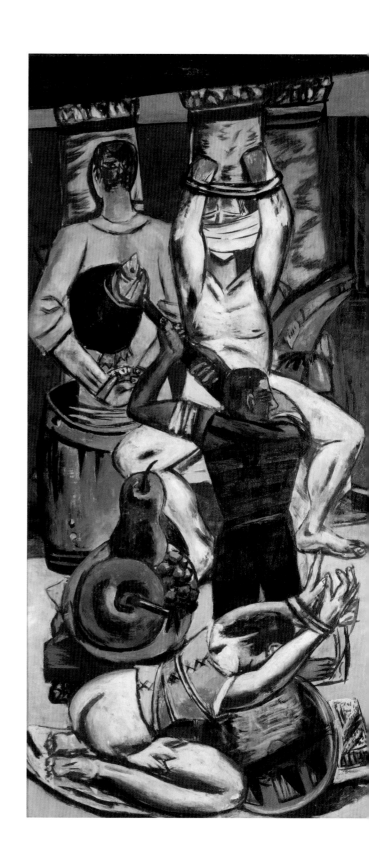

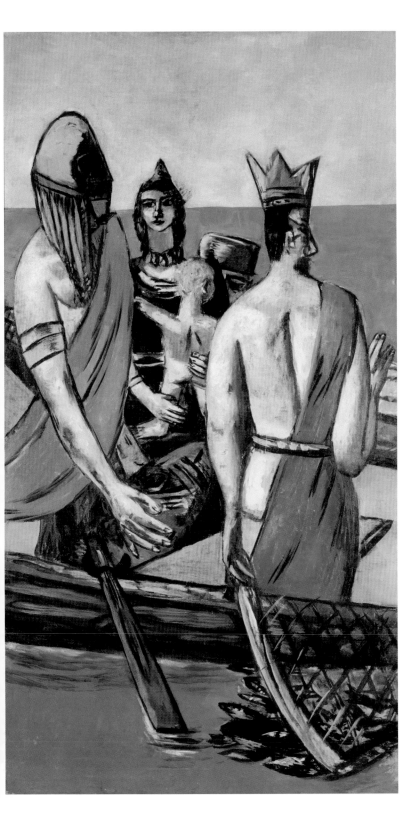
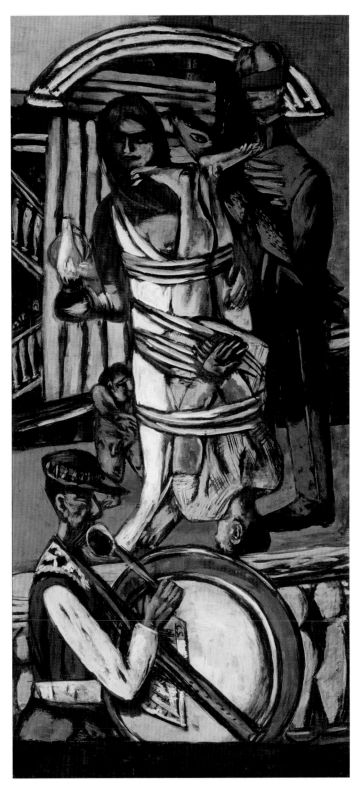

Max Beckmann | GERMAN, 1884–1950
DEPARTURE. 1932–33
OIL ON CANVAS, TRIPTYCH, CENTER PANEL, 7'⅛" x 45⅜" (215.3 x
115.2 CM); SIDE PANELS EACH 7' ¼" x 39¼" (215.3 x 99.7 CM)
GIVEN ANONYMOUSLY (BY EXCHANGE)

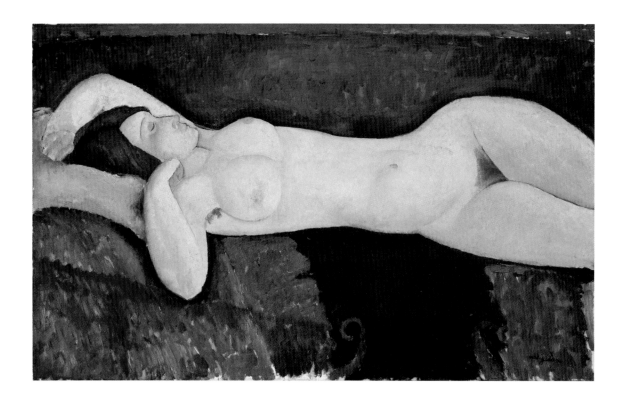

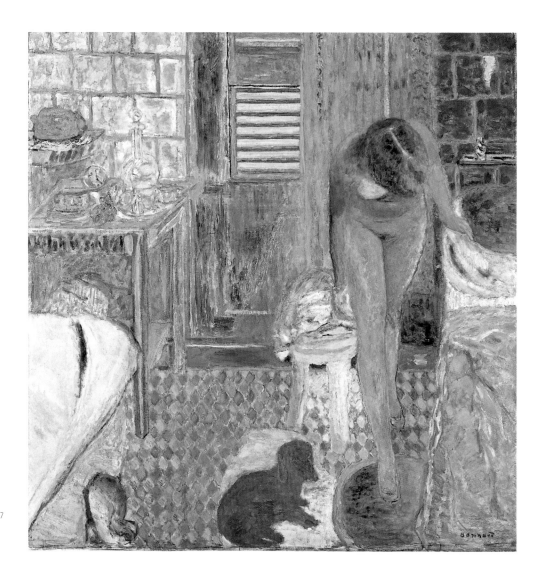

Amedeo Modigliani | ITALIAN,
1884–1920
RECLINING NUDE [LE GRAND NU]. c. 1919
OIL ON CANVAS, 28½ x 45⅞" (72.4 x 116.5 CM)
MRS. SIMON GUGGENHEIM FUND

Pierre Bonnard | FRENCH, 1867–1947
NUDE IN BATHROOM. 1932
OIL ON CANVAS, 47⅜ x 46½" (121 x 118.1 CM)
FLORENE MAY SCHOENBORN BEQUEST

Balthus (Baltusz Klossowksi de Rola) | FRENCH, 1908–2001
THE STREET. 1933
OIL ON CANVAS, 6' 4¼" x 7' 10½" (195 x 240 CM)
JAMES THRALL SOBY BEQUEST

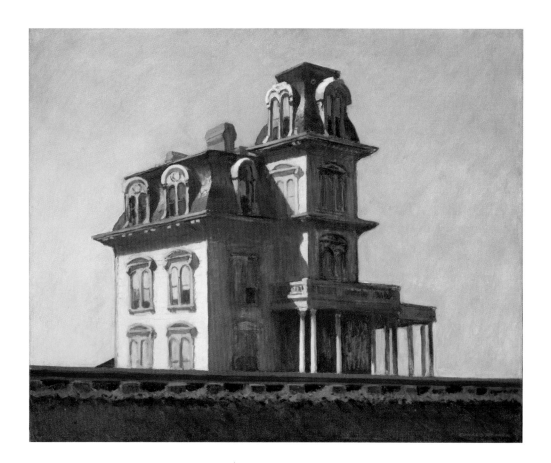

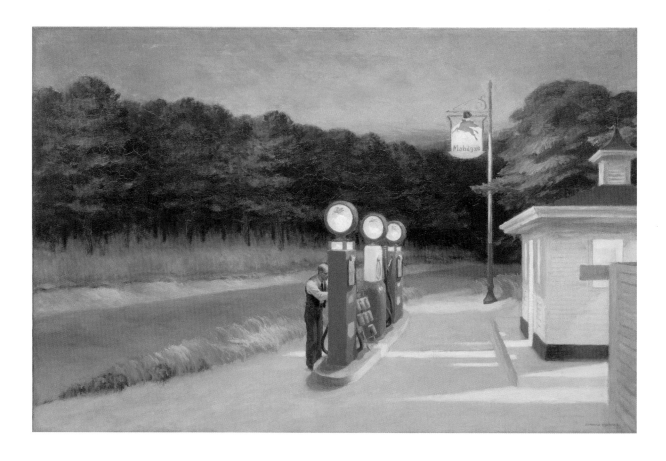

Edward Hopper | AMERICAN, 1882–1967
HOUSE BY THE RAILROAD, 1925
OIL ON CANVAS, 24 x 29" (61 x 73.7 CM)
GIVEN ANONYMOUSLY

Edward Hopper
GAS, 1940
OIL ON CANVAS, 26¼ x 40¼" (66.7 x 102.2 CM)
MRS. SIMON GUGGENHEIM FUND

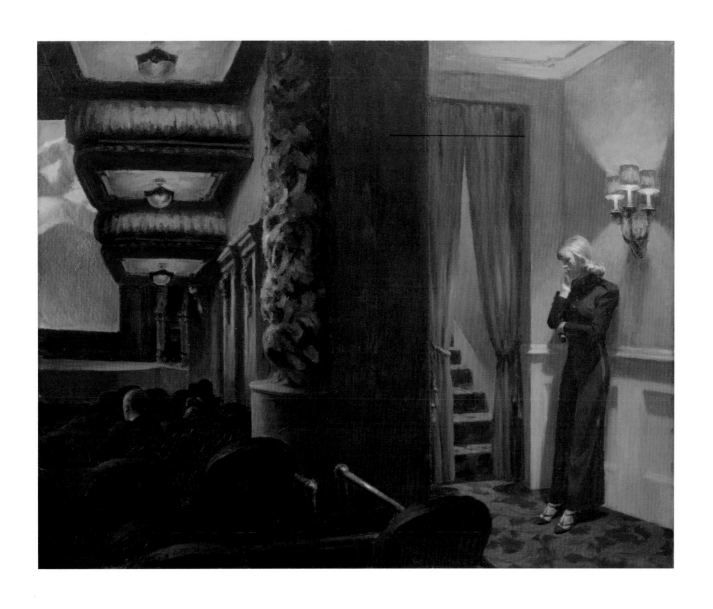

Edward Hopper
NEW YORK MOVIE. 1939
OIL ON CANVAS, 32¼ x 40⅛" (81.9 x 101.9 CM)
GIVEN ANONYMOUSLY

The New American Painting

In 1958, at the request of eight European institutions, The Museum of Modern Art organized a traveling exhibition titled *The New American Painting*. While Abstract Expressionism had enjoyed institutional support since the late 1940s, it was the first time in the Museum's history that so comprehensive a survey of American postwar painting was undertaken. It was also the first attempt by the Museum to introduce a European audience to American abstract art on a major scale. Included in the exhibition were works by Adolph Gottlieb, Philip Guston, Willem de Kooning, Robert Motherwell, Barnett Newman, Jackson Pollock, Mark Rothko, and many others.

From its early beginnings, the Museum had organized a number of group shows of American artists, including *Americans 1942*, *American Realists and Magic Realists* (1943), *Fourteen Americans* (1946), and *15 Americans* (1952). The inclusion of works by Pollock, Rothko, Clyfford Still, and Bradley Walker Tomlin in the 1952 exhibition marked a dramatic turning point, for their abstract gestural paintings created new challenges to the public's understanding and appreciation of modern art. While the exhibition was installed along strict Museum classifications of style, the catalogue included statements by the artists themselves, who acted as interpreters of their work in an attempt to speak directly to their audience. Still's comments in the catalogue, included in the anthology that follows, focused on his attempt to reconcile the art of the past with that of the present while Rothko stressed the artist's need to seek clarity in order to be understood.

In the early 1960s the Museum presented an exhibition titled *Americans 1963* that showed the work of fifteen artists and was equally divided between painting and sculpture. As in previous shows of American art, it brought together strongly contrasting personalities and points of view and, following the lead of the 1952 exhibition, the catalogue texts consisted of artists' statements. Later Abstract Expressionist and Pop artists introduced at that time included Lee Bontecou, Robert Indiana, Richard Lindner, Marisol, Claus Oldenberg, and Ad Reinhardt, among others. Reinhardt's enigmatic comments about his work were later addressed in the 1965 catalogue for the exhibition *The Responsive Eye*, in which William Seitz acknowledged that Reinhardt enjoyed obfuscating the meanings of his paintings. *The Responsive Eye* focused on the illusionistic investigations of the Abstract Expressionists, with plate sections titled "The Color Image," "Invisible Painting," "Optical Paintings," and "Black and White," for example, offering a framework from which to view the art of the early 1960s.

After debuting a number of American abstract artists in group shows, several were given solo exhibitions at the Museum. In 1961 a comprehensive overview of paintings, watercolors, and murals by Rothko was organized by Peter Selz. In his text in the catalogue, Selz makes the eloquent observation that Rothko's "silent paintings with their enormous, beautiful, opaque surfaces are mirrors, reflecting what the viewer brings with him." A year later Seitz, in a retrospective exhibition of the work of Arshile Gorky, presented the artist as one whose personal anguish governed his every expression. William Rubin's 1968 catalogue *Dada, Surrealism, and Their Heritage* contextualized Gorky's work, arguing for its Surrealist tendencies, specifically the artist's interest in automatism.

Other artists who had solo exhibitions in the 1960s and 1970s included Robert Motherwell (1965), Pollock (1967), de Kooning (1969), Rothko (1970), Barnett Newman (1971), and Adolph Gottlieb (1974). While the Museum had included Reinhardt in exhibitions since 1963, it was not until 1991 that he was given a retrospective organized by Rubin and Yve-Alain Bois. In the latter's text in the catalogue, the artist is approached from the point of view of postmodernism rather than biography.

The 1971 exhibition of the work of Newman challenged the more generally accepted sensibilities of Abstract Expressionism. Thomas Hess, who organized the exhibition, believed the viewer needed to take into consideration Newman's religious interests, especially Kabbalah and Jewish mysticism. Hess also expressed a very different kind of art criticism. While Selz and Seitz wrote about the emotional quality of their subjects, Rothko and Gorky, respectively, and Rubin imparted a more traditional art-historical approach, Hess demonstrated a change in art criticism of the time that focused more directly on the artist as subject.

Perhaps the artist most closely associated with Abstract Expressionism is Pollock. In 1968 William Rubin, in his book *Dada, Surrealism, and Their Heritage*, had suggested that Pollock's technique of drippings onto canvas was a proclamation of automatism. More recent Museum publications on Pollock include a 1998 catalogue for a retrospective organized by Kirk Varnedoe with Pepe Karmel. Karmel's essay posits that Pollock inserted figures into his paintings of 1947–50 to avoid the monotony of an otherwise abstract web. In the same catalogue, James Coddington examines Pollock's working process from a conservator's perspective, mentioning that the artist introduced a new tool for his poured paintings of 1951—the turkey baster!

The work of a younger generation of artists, led by Ellsworth Kelly, Cy Twombly, Jasper Johns, and Robert Rauschenberg, soon eclipsed the large gestural canvases of Helen Frankenthaler and Morris Louis. Kelly, after a trip to Marseille, where he saw Le Corbusier's Habitation, sought a conceptual order in his geometric abstractions informed by architecture. Indeed, in his 1973 exhibition catalogue on the artist, critic E. C. Goossen stated that Kelly gave up figure painting to pursue his interest in architecture. Goossen emphasized Kelly's association of the flat facade with the flatness of the canvas, his sketches of walls articulated by chimneys and shadows.

Twombly, too, distilled what he had seen in the mid-1950s into a visual language uniquely his own. The application of swaths of paint prevalent in the 1940s and 1950s has been replaced by the fluid process of drawing and painting. Reductive and sparse, Twombly's intense expressive application was addressed by Kirk Varnedoe in the 1990 exhibition catalogue *High & Low*. Varnedoe posits that while Twombly's method might appear unlearned, it is precisely the duality of the painterly act of marking in juxtaposition to Twombly's subsequent obliteration of markings that the work enjoys.

In the mid- to late 1950s, Johns and Rauschenberg broke with the conventions of the Abstract Expressionists. Although both were interested in "found" objects, Johns attempted to work through these images to gain greater abstraction while Rauschenberg used found objects to create "combines" that he considered both painting and sculpture. In his essay in the catalogue for the 1996 exhibition *Jasper Johns: A Retrospective*, Varnedoe established Johns's conceptual tendencies within an analytical framework, presenting the reader with a varied approach to the artist. The formal art-historical evaluations in recent years illustrate a dramatic change in the interpretation of American art of the 1940s to the 1960s. The rigid formal practices of the past have been replaced by a more flexible tangent and tone.

— *Angela Lange*

Gorky and de Kooning

Arshile Gorky
Agony. 1947
Illustrated on page 235

William Seitz, *Arshile Gorky,* **1962,** page 40

The succession of catastrophes that led to Gorky's suicide on July 21, 1948 began with the destruction of his paintings and his studio by fire in January, 1946 and his operation for cancer in February. During that year he underwent crushing blows to his physique, his personal life and his art. The tragic and beautiful canvas in The Museum of Modern Art is an outcome of these pressures. Compared with preparatory drawings, the anguished theme is aesthetically transformed; but the color scheme alone—cold yellow, smoldering and feverish red, black patches in a curdled umber broth—justifies Gorky's title.

Unlike some other pictures of the period, *Agony* was not systematically developed from one master drawing, but was preceded by several bold studies spasmodically drawn with a soft black pencil. Each one, like the final painting, concentrates on the same structure—a fearful hybrid resembling a dentist's chair, an animated machine, a primitive feathered fetish or a human figure hanging on the rack, its rib cage hollow and its groin adorned with petals. The less shocking form it takes in the painting is studied in a few small wash drawings as an altered detail, and connected with an oval spot at the far left. *Agony* is not a landscape, but a furnished interior closed from behind by a partition; the floor line crosses the picture, and horizontal and vertical lines are echoed throughout. Silhouetted against the brightest cloud of red, at right center, a concave-sided plane is hung from a hook incised as sharply as a knife cut, and counterbalanced by a black weight. From the right a droll homunculus, his two huge vertebrae exposed, bows toward the center. It is of interest to note that a smaller version of the painting, done before the revision of the main motif and in a different color scheme, resembles a landscape. It is delicately painted in deft washes on a bare ground, and drawn with an almost lyrical lightness.

Gorky
Agony

William Rubin, *Dada, Surrealism, and Their Heritage,* **1968,** pages 171, 173, 174

Arshile Gorky was the last important artist to be associated with Surrealism. [André] Breton became interested in him in 1943, and two years later devoted the concluding section of the new edition of his *Le Surréalisme et la peinture* to Gorky.[1] By then he was considered a full-fledged member of the movement. Though Gorky explored the possibilities of automatism and wrung from biomorphism a particular pathos, he was more deeply committed by affinity and by training than even [Joan] Miró to the mainstream of European painting, as represented by [Pablo] Picasso and [Henri] Matisse. The Surrealists, by and large, disdained the medium, as their various techniques for bypassing it suggest. Gorky delighted in oil painting and nursed from its possibilities a range of effects that place him second to none as a manipulator of the brush.

The extraordinary painterly sensibility of Gorky's best work was achieved through a long apprenticeship. Years of paraphrasing [Paul] Cézanne, Picasso, and Matisse, and then in the later thirties and early forties, Miró and Matta, allowed Gorky to select and retain from their styles what was viable for him. But even as he passed into his maturity in the winter of 1942/1943 he was still anxious to learn, and still unwilling to narrow himself to a single tradition, as his assimilations at the time from [Vasily] Kandinsky's works of 1910–1914 testify. By the following year his modesty and openness to the art of other painters, whom he selected with infallible instinct, emerged in pictures that communicated Gorky's personal poetry with an overwhelming orchestral sumptuousness. . . .

During the winter of 1944/1945, Gorky's interest in spontaneity carried him beyond the "Improvisations" of Kandinsky to the technique of automatism. [Some] pictures . . . show him nearer to Surrealism than he had yet been, or was ever to be afterward, and mark precisely the time of his greatest personal

closeness to Breton and to Matta. The rapid drawing, the loose brushwork that encouraged the spilling and dripping of the liquid paint, departed from Matta's automatism of 1938–1942 and went beyond it. It was only natural that Breton should have encouraged Gorky in this excursion. Julien Levy, Gorky's dealer at the time, speaks of this as "liberation." For Gorky, "automatism was a redemption." Surrealism, he continues, helped Gorky "both to bring himself to the surface and dig himself deep in his work," so that "his most secret doodling could be very central."[2]

Willem de Kooning
Painting. 1948
Illustrated on page 235

John Russell, *The Meanings of Modern Art,* **1981,** pages 308, 309

De Kooning is one of the great draftsmen of this century, with a variety of attack and a range of subject matter which are almost beyond comparison. He can do anything that he wants with line; and the line in question can be as thin as a silk thread or as broad as the nose of an orangutan. And when he crossed over from drawing to painting at the end of the 1940s he used zinc white and a housepainter's black enamel to make forms which were completely flat, like the forms in late Cubism. They were not so much painted as *laid on*; and they related to the signs which had been devised by [Jean] Arp and [Joan] Miró to echo the human body without actually naming it. "Even abstract shapes must have a likeness," de Kooning once said. And in pictures like his *Painting,* 1948, every shape has its likeness: its familiar companion, which stays within hailing distance but does not come forward to be identified.

As [Thomas] Hess has remarked, the black-and-white paintings are "packed to bursting with shapes metamorphosed from drawings of women which have been cut apart, transposed, intermixed until they were abstract, but always with a 'likeness' and a memory of their source and its emotive charge."

Willem de Kooning
Woman, I. 1950–52
Illustrated on page 234

Thomas B. Hess, *Willem de Kooning,* **1968,** page 74

In February 1951, de Kooning was invited by The Museum of Modern Art to write a paper for a symposium titled *What Abstract Art Means to Me . . .*

and it has since been frequently quoted and misquoted. But while considered a spokesman for the new American abstract art, de Kooning was engaged in a very different enterprise. Almost as soon as *Excavation* left his studio in 1950, he tacked a seventy-inch-high canvas to his painting wall and began to paint *Woman, I*; it was not finished until two years later, having been abandoned after about eighteen months' work . . .

Most of those who knew de Kooning's work and had followed his heroic struggles with *Woman, I* felt it was a triumph. Many younger artists, already in reaction to the rigorously intellectual climate of Abstract Expressionism, considered it a permission to revive figure painting. But the public was scandalized by de Kooning's hilarious, lacerated goddesses. And the more doctrinaire defenders of abstract art were equally severe.

de Kooning
Woman, I

John Russell, *The Meanings of Modern Art,* **1981,** pages 310, 311

In *Woman I,* de Kooning gave painting its head with what looks to be a maximum of spontaneity. But in point of fact the picture cost him 18 months' hard work and was then put aside, only to be rescued at the suggestion of the art historian Meyer Schapiro and brought to a triumphal conclusion. The image was "painted out literally hundreds of times," Thomas B. Hess tells us; but it stood for a concept of imperious womanhood that would give the painter no rest until it had been set down in canvas.

In this painting, as in certain others of its date, what Ezra Pound had called a *style* came out of America. Action is what . . . *Woman I* [is] all about, and Action Painting (a phrase first used by Harold Rosenberg in 1952) is as good a generic name as any for the "shower of wonders" which was produced in New York in the late 1940s. It is not an all-inclusive name—how could it be?—but it fits much of the work for much of the time. Both words count. "Action" stands for the particular physical involvement which characterizes the work; and it also stands for a determination to get up and go, rather than to settle for nostalgic imitation. "Painting" stands for the belief that there was still a great future for the act of putting paint on canvas. The way to realize that future was, first, to assimilate the past; second, to open out the act of painting in such a way that it became, in itself and by itself, one of the most capacious forms of human expression.

Abstract Expressionist Field Painting

Jackson Pollock

Gothic. 1944
Number I, 1948. 1948
Echo (Number 25, 1951). 1951
Illustrated on pages 237–39

Jackson Pollock (1944 and 1947), in *The Bulletin of The Museum of Modern Art,* **1956–57,** page 33

I accept the fact that the important painting of the last hundred years was done in France. American painters have generally missed the point of modern painting from beginning to end. (The only American master who interests me is [Albert Pinkham] Ryder.) Thus the fact that good European moderns are now here is very important, for they bring with them an understanding of the problems of modern painting. I am particularly impressed with their concept of the source of art being the Unconscious. This idea interests me more than these specific painters do, for the two artists I admire most, [Pablo] Picasso and [Joan] Miró, are still abroad. . . .

The idea of an isolated American painting, so popular in this country during the thirties, seems absurd to me just as the idea of creating a purely American mathematics or physics would seem absurd. . . . And in another sense, the problem doesn't exist at all; or, if it did, would solve itself: An American is an American and his painting would naturally be qualified by that fact, whether he wills it or not. But the basic problems of contemporary painting are independent of any country.

My painting does not come from the easel. I hardly ever stretch my canvas before painting. I prefer to tack the unstretched canvas to the hard wall or floor. I need the resistance of a hard surface. On the floor I am more at ease. I feel nearer, more a part of the painting, since this way I can walk around it, work from the four sides and literally be *in* the painting. This is akin to the method of the Indian sand painters of the West.

I continue to get further away from the usual painter's tools such as easel, palette, brushes, etc. I prefer sticks, trowels, knives and dripping fluid paint or a heavy impasto with sand, broken glass and other foreign matter added.

When I am *in* my painting, I'm not aware of what I'm doing. It is only after a sort of "get acquainted" period that I see what I have been about. I have no fears about making changes, destroying the image, etc., because the painting has a life of its own. I try to let it come through. It is only when I lose contact with the painting that the result is a mess. Otherwise there is pure harmony, an easy give and take, and the painting comes out well.

Pollock

Gothic
Number 1, 1948
Echo

William Rubin, *Dada, Surrealism, and Their Heritage,* **1968,** pages 177, 178

Pollock's development offers a paradigm of the relationship of Surrealism to American art of the forties. The myth-oriented iconography of his work of the early forties like that of [Mark] Rothko, [Adolph] Gottlieb, and others, paralleled that of the late phase of Surrealist *peinture-poésie* and his form-language was influenced by [Joan] Miró and [André] Masson (though his Cubist substructure and bravura execution reflected a more profound commitment to [Pablo] Picasso than to anyone else). But what Pollock really took from Surrealism was an idea—automatism—rather than a manner.[1] . . . His desire to liberate himself from the restrictions of traditional facture and the mannerisms they entailed had led him to drip liquid paint and to draw with a stick rather than a brush. Spilling and dripping as such was hardly a novel idea, but Pollock was the first to use it consistently in order to facilitate extended spontaneous drawing.

Pollock used automatism as a means of getting the picture started, and, like the Surrealists, believed that this method would give freer rein to the unconscious. The increasing velocity of his execution from 1943 onward let to an atomization of the picture surface that permitted him to invest it with a continuous rhythm, his characteristic "pneuma." By the winter of 1946/1947 the scale and richness of this rhythm had necessitated the adoption of the drip technique in a consistent manner; the totemic presences of Pollock's earlier work disappeared under the ensuing labyrinthine web. This "classic" style of Pollock constituted a kind of apotheosis of automatism, and of

the constructive possibilities of chance and accident. His painting not only went beyond the wildest speculations of Surrealism in the extent of its automatism, but in its move toward pure abstraction, was alien to the Surrealist conception of picture-making. Nevertheless, as Pollock relaxed his drip style in the black-and-white paintings of 1951, fragments of anatomies—some monstrous and deformed, others more literal—surfaced again, as if the fearful presences in his work of the early forties had remained as informing spirits beneath the fabric of the "all-over" pictures.

Pollock
Gothic
Number 1, 1948
Echo

Pepe Karmel, *Jackson Pollock,* **1998,** pages 129, 131, 132

Rather than describing the abstract webs of Pollock's 1947–50 work as veiling the painted figures, it might be more accurate to say that the figures are inserted to give form and rhythm to an abstract web that might otherwise tend toward monotony and homogeneity. . . . What was distinctive in Pollock's allover drip paintings was neither their technique nor their appearance of allover abstraction, both of which could be found in the work of contemporaries like Hans Hofmann, Mark Tobey, Janet Sobel, and Knud Merrild.[1] It was, rather, the rhythmic energy that animated Pollock's work at every level, from the individual line to the overall composition. And this energy seems in large part to have resulted from the interaction between Pollock's figurative imagery and his allover, all-absorbing web. . . .

At the risk of oversimplification, we might say that he [Pollock] has two ways of creating a horizontal image. One is to create a vertical composition—a figure—and to turn it sideways. The other is to do just what [Thomas Hart] Benton says: to arrange a series of figures or figure groups into "distinct rhythmical sets which are joined on their fringes." There are numerous examples of Pollock composing in just this way. . . .

Coming to artistic maturity in the early 1940s, Pollock was drawn to an art of the sign rather than an art of primordial sensation. His early work derives with almost painful obviousness from [Pablo] Picasso and [Joan] Miró, but, astonishingly, within a few years he had discovered a way to go beyond his masters. Pollock's achievement, in his pictures of 1947–50, was to transform graphic flatness into optical flatness—to

show that by piling layer upon layer, sign upon sign, you could generate a pictorial sensation equivalent to that of the primordial visual field. The impact of this discovery is evident in Pollock's paintings.

Pollock
Echo

James Coddington, in *Jackson Pollock: New Approaches,* **1999,** pages 110, 111

The black pour paintings of 1951 have been identified as a departure from Pollock's prior work, and this is certainly true in regard to his materials and methods. Aside from the reduced palette, Pollock made some fundamental changes in technique. He introduced a new tool, the turkey baster.[1] He also moved back toward more-consistent direct contact with the canvas, applying some of his initial marks with a brush. *Echo: Number 25, 1951* demonstrates many of his basic techniques in these works: he did indeed brush some passages on, but the bulk of the paint he either poured or more likely worked with the baster, which he used almost like a big fountain pen. For a large, dramatic discharge, he could squeeze the bulb; or he could hold the paint in the device's tube and draw extended lines.

According to Lee Krasner [Pollock's wife], Pollock would start the black pours with a sizing of Rivit glue.[2] It should be clear by now that he was very sensitive to the implications of preparing a canvas or board, in terms both of underlying color and of the way the next layer of paint would be absorbed; choosing whether or not to use a size would have given him a way to control the bleeding of the paint into the canvas. In *Number 22, 1951,* for example, the paint in places bleeds quite readily, blending with the fabric in much the same way it blends with the ground in works on paper from 1948. In *Echo,* on the other hand, although there is variation in the quality of the line from center to edge (hard and glossy in the center, soft toward the edge, as the nap of the fabric reasserts itself), there is nothing that could be called a bleeding of the paint into the canvas. This might suggest a sizing with Rivit glue—yet there is no such coating in *Echo.*[3] Technical analysis suggests that in this case Pollock may have used a more sophisticated technique to control the bleed, and that was the mixing of two different paints, an oil and an alkyd enamel.

Clyfford Still

Painting 1944–N. 1944
Illustrated on page 236

Clyfford Still, in *15 Americans*, **1952,** pages 21, 22

That pigment on canvas has a way of initiating conventional reactions for most people needs no reminder. Behind these reactions is a body of history matured into dogma, authority, tradition. The totalitarian hegemony of this tradition I despise, its presumptions I reject. Its security is an illusion, banal, and without courage. Its substance is but dust and filing cabinets. The homage paid to it is a celebration of death. We all bear the burden of this tradition on our backs but I cannot hold it a privilege to be a pallbearer of my spirit in its name.

From the most ancient times the artist had been expected to perpetuate the values of his contemporaries. The record is mainly one of frustration, sadism, superstition, and the will to power. What greatness of life crept into the story came from sources not yet fully understood, and the temples of art which burden the landscape of nearly every city are a tribute to the attempt to seize this elusive quality and stamp it out.

The anxious men find comfort in the confusion of those artists who would walk beside them. The values involved, however, permit no peace, and mutual resentment is deep when it is discovered that salvation cannot be bought.

We are now committed to an unqualified act, not illustrating outworn myths or contemporary alibis. One must accept total responsibility for what he executes. And the measure of his greatness will be in the depth of his insight and his courage in realizing his own vision.

Demands for communication are both presumptuous and irrelevant. The observer usually will see what his fears and hopes and learning teach him to see. But if he can escape these demands that hold up a mirror to himself, then perhaps some of the implications of the work may be felt. But whatever is seen or felt it should be remembered that for me these paintings had to be something else. It is the price one has to pay for clarity when one's means are honored only as an instrument of seduction or assault.

Still

Painting 1944–N

Lucy Lippard, in *Three Generations of Twentieth-Century Art*, **1972,** page 126

Although Clyfford Still was one of the major innovators among the Abstract Expressionists, often known as the "New York School," he did not settle in New York until 1950; however, from about 1945 on, he was already widely influential among his fellow artists there, through exhibitions and brief sojourns. He developed his basic style in the latter half of the 'forties on the West Coast, where he taught at the California School of Fine Arts in San Francisco. More programmatically than any other of the Abstract Expressionists, Still consciously sought to expunge from his painting any traces of modern European movements—especially Cubism—and, by freeing himself from all such influences, to evolve a completely new art appropriate to the New World. . . .

Painting is a particularly powerful example of Still's early mature style. It presents a variegated surface that negates illusionistic space and concentrates attention on itself. The wide expanse of tarry black impasto is enlivened with knife marks and cut across by a jagged red line that rushes horizontally across the upper part of the canvas, to be intersected by two irregular, pointed, vertical shapes descending from above, before it plunges downward to the bottom edge at the right. The elements of this composition, the way in which it fills the entire surface without reference to a surrounding frame or central scaffolding, and the unusually large size for a painting of this period, are all indicative of Still's originality and his masterly command of a new kind of abstraction, free from any decipherable symbols or references to nature. Although many critics have read into Still's works a vision of the broad, romantic Western landscape, he himself has rejected such allusions, believing that the impact of his work could only be diminished by such associations on the part of the viewer.

Mark Rothko

Number 10. 1950
Illustrated on page 240

Mark Rothko, in *15 Americans*, **1952,** page 18

The progression of a painter's work, as it travels in time from point to point, will be toward clarity: toward the elimination of all obstacles between the painter and the idea, and between the idea and the observer. As examples of such obstacles, I give (among others) memory, history or geometry, which are swamps of generalization from which one might pull out parodies of ideas (which are ghosts) but never an idea in itself. To achieve this clarity is, inevitably, to be understood.

A picture lives by companionship, expanding and quickening in the eyes of the sensitive observer. It dies by the same token. It is therefore a risky act to

send it out into the world. How often it must be impaired by the eyes of the unfeeling and the cruelty of the impotent who would extend their affliction universally!

Rothko
Number 10

Peter Selz, *Mark Rothko,* **1961,** pages 9, 10

Rothko paints large surfaces which prompt us to contemplate. The actuality of the painted surface makes even the symbolic configurations of his earlier work unnecessary. His rectangular configurations have been compared with the work of the followers of neo-plasticism, but unlike them, Rothko does not paint about optical phenomena or space and color relationships. His work has also at times been classed erroneously with action painting, yet he does not inform us about the violence and passion of his gesture.

Holding tenaciously to humanist values, he paints pictures which are in fact related to man's scale and his measure. But whereas in Renaissance painting man was the measure of space, in Rothko's painting space, i.e. the picture, is the measure of man.

This is perhaps the essential nature of the viewer's response to Rothko's work: he contemplates these large surfaces, but his vision is not obstructed by the *means* of painting; he does not get involved in the by-ways of an intriguing surface; these pictures do not remind us of peeling walls or torn canvas. The artist has abandoned the illusions of three-dimensional recession; there is not even the space between various overlaid brushstrokes. The surface texture is as neutral as possible. Seen close up and in penumbra, as these paintings are meant to be seen, they absorb, they envelop the viewer. We no longer look *at* a painting as we did in the nineteenth century; we are meant to enter it, to sink into its atmosphere of mist and light or to draw it around us like a coat—or a skin.

These silent paintings with their enormous, beautiful, opaque surfaces are mirrors, reflecting what the viewer brings with him. . . .

It is important for an understanding of the art of this painter, whose work seems to have little precedent in the history of painting, that the visual arts formed no part of his early background. He recounts that art simply did not exist around him in his youth, that he was not aware of museums or art galleries until he was in his twenties. Since childhood, however, he had been preoccupied with cultural and social values. When Rothko finally encountered the world of painting, his mind was fully formed—much as [Vasily] Kand-

insky's had been at the time of his arrival in Munich some thirty years earlier, before he became the great pioneer of early twentieth-century painting.

Rothko's task now was to make of painting something as powerful and as poignant as poetry and music had seemed to him, to make his painting an instrument of similar force. Even today, he says, he is concerned with his art not esthetically, but as a humanist and a moralist. . . .

Rothko has never abandoned his search for means of expressing human emotion, although he no longer employs the symbol of the figure to enact his drama. He has found his own more conclusive way of dealing with human qualities and concerns.

Mark Rothko
Horizontals, White over Darks. 1961
Illustrated on page 241

Lucy Lippard, in *Three Generation of Twentieth-Century Art,* **1972,** page 128

As Elaine de Kooning once noted, Mark Rothko's paintings are "vertical though retaining their horizontal souls."[1] For the *Horizontals, White over Darks,* he chose the atypical horizontal format—one that he had probably begun to explore in 1958–1959 for a large dining room in a Park Avenue building.[2] Here the usual compression is absent, the principal forms are narrower, and the soft-edged, expansive rectangles float freely.

The chief experience offered by Rothko's work from the late 'forties until his death in 1970 is that of color-light, which creates an absorbent, enveloping space of its own. Rectangular forms hold the pictures near the surface of the canvas, so that the spectator has the sense of an encounter rather than of simply being drawn into an amorphous cloud of color.

Although Rothko has been classified with the Abstract Expressionists, he did not share all the attitudes associated with members of that movement. Completely uninhibited self-expression appealed to him not at all: "There are some artists who want to tell all, but I feel it is more shrewd to tell little."[3]

Barnett Newman
Onement, III. 1949
Illustrated on page 242

Thomas B. Hess. *Barnett Newman,* **1971,** pages 53, 55, 56, 57, 64

The dark-red painting with an orange stripe painted

down its middle, which was to provide a starting point for almost all Newman's later work, was titled *Onement*, a word which suggests wholeness, harmony, but also, as Newman himself pointed out, refers to At-onement, Atonement, the events of Yom Kippur which is a day of remembrance of the dead, but for the Kabbalists, also was the ideal moment for meditation on the Messianic secret, on rebirth, new life—a word, Creation. . . .

By reducing composition to the equivalent of zero, Newman also raised color to its highest power. When, much later, Newman was recognized by critics and collectors, color was the element they praised: they noted how he had liberated it, how it moved freely across the surface of his pictures, raised to new intensities by the lack of digression in textural and graphic details. Yet Newman always insisted that his true originality, his basic contribution, was in creating a new kind of drawing. The color sensations, he felt, were more or less a by-product. But surely, when he was studying *Onement I* during the months of 1948, he must have noted and been delighted by how his relatively simple concordance of red-orange and red-brown—the high and the low notes on the cadmium scale—vibrated with light.

Finally, *Onement I* represented an elegant solution to his problem of subject matter. He was to be the celebrant of the act of Creation, of life and renewal—the poet of Genesis; but he was a poet whose words are visual forms, just as the words of the Torah have their own life as visual forms, as letters which were not joined into words until Adam's sin, when, according to Rabbi Eliyahu, "God arranged the letters before Him into words describing death and other earthly things." *Onement I* is a complex symbol, in the purest sense, of Genesis itself. . . .

"Onement" thus is another way of saying "Genetic Moment" or "Adam and Eve" and the title celebrates a heroic vision of man and of man's creative powers.

It is possible that I am pushing the Kabbalist interpretation too far. Certainly Newman never spoke about such a basis for his art—and he loved to talk about his paintings and sculptures. Furthermore, he was violently opposed to "mysticism"—by which he meant attempts to organize such ineffable states into rules and systems of art or religion—but he stood up for the individual "mystic," a poet such as [William] Blake, "a man with a unique vision.". . .

Onement I . . . is . . . an interrupted work. Newman started it with a certain image, probably based on a 1947 drawing, more or less clearly in mind. He began the process: painted in the background, put a tape down the center, tested a smearing stroke over the tape. The next move would have been to add texture to the background—to start turning the object into a painting, but Newman stopped.

Barnett Newman

Abraham. 1949
Illustrated on page 243

Thomas B. Hess, *Barnett Newman,* **1971,** pages 59, 60

Secret symmetry makes its initial appearance in one of Newman's masterpieces of 1949, *Abraham.* It is a black on black painting, nearly seven feet high and three feet wide. A shiny black stripe seems to divide a comparatively mat black field off-center to the left. It suggests a "felt" situation—an intuition by the artist that such a placement would be "right" in his general format. And this is how *Abraham* has generally been "read."

The real action in *Abraham,* however, is an accurate bisection of the image accomplished by the right-hand edge of the stripe which cuts straight down the center of the painting.[1] . . . Furthermore, there is a kind of thematic substructure: the width of the stripe is one-third of the width of the right section of the field and half the width of the left-hand part; in other words it is a sixth. . . .

The energy of instant division—the gesture of "Let there be . . ."— is heightened, and Newman further emphasizes this quality in *Abraham* by increasing the scale to a more-than-human proportion. By widening the zip until it almost becomes a section of the ground, both its edges become independently important—thus further disguising the secret symmetrical action of the right edge.

Why black? There are, as there always have been, historical precedents. [Aleksandr] Rodchenko's *Black on Black* (see page 130) was sometimes shown in the rehanging of the collection of The Museum of Modern Art . . . Indeed, Newman was surprised when a friend, in the middle of the 1960s, told him about the existence of the Rodchenko; he had never even heard about it. (When, finally, he did take a look at it, he decided that it was really "brown.") The New York artists were disillusioned with ideologies and especially with those which would insert revolutionary politics into painting through some public dialectic, as practiced by the Russian avant-garde. The left-oriented art of the 1930s was regarded as a naïve escapade, and socialist and communist governments were proving to be just as oppressive, inhuman and contemptuous of artists' values as the capitalist establishment. The New York artists interiorized their radical politics; if they had a movement it was an underground.

Barnett Newman

The Wild. 1950
Illustrated on page 244

Thomas B. Hess, *Barnett Newman,* **1971,** pages 72, 73

The Wild . . . is a radical picture, an extreme. Newman arrived at it through a series of intuitions, a testing of scale, and with scale, emotion—for he often insisted that size was the product of feeling. He moved in a way that with hindsight may appear hesitant, although how an artist working at the leading edge of modern art can be considered hesitant is difficult to understand. The point is, I believe, he did not want to discard any part of his art just because that would be an easy way to develop it. He wanted to keep everything with him, like a mountain climber who, on a dash to the summit, may have to lighten his pack by throwing away supplies; he does so reluctantly, as a last resort, and like the mountain climber, Newman marked his discards carefully so that he could get back to them if possible. Thus moving toward *The Wild*, he tries to give his paint [a] hard flat, even surface . . . but finds that in a narrow format the image becomes reduced to the look of a facet. He tries his divisions, but they impede attainment of the very thin and the very tall. He uses the sensuous impastos . . . pushing them up, flattening them. Then, finally, he combines the dimensions of the zip from the *Vir Heroicus Sublimis* with the physical, textured paint of *Onement I.*

For all six of [his] narrow pictures, Newman carpentered his usual meticulous stretchers, with quarter-rounds (curves inside) nailed on the outside edge of each stretcher to hold the canvas away from the wood frame. For *The Wild*, he needed all his ingenuity as a cabinet-maker. It was one of Newman's ways of telling the world that this picture was no stepchild but had received that same thoughtful, disciplined effort as all his other pictures. It was also Newman's way to tell the world secretly—because without cutting off the canvas, who but another expert carpenter would ever know?

There was more than mere attention to the protocol of craft in this decision because adding the quarter-rounds doubled the thickness of the picture, and it assumed an object quality—the critic Lawrence Alloway later would call *The Wild* the first shaped canvas. Newman had been talking about making a sculpture, and *The Wild* is a shaft as much as a plane. It has a strong three-dimensional quality, and as Barbara Reise has pointed out in her perceptive, enthusiastic essay on Newman, . . . "It is not a surprising jump to an urge to work in freestanding

sculpture; and *Here I*, made in wood and plaster . . . seems an inevitable concretion of Newman's concern with the physicality of the vertical."[1]

Newman, however, seldom jumped. The sculpture had been in his mind for more than a year, probably since a visit to Akron in August 1949. He had gone to meet Annalee's family [his in-laws] and to explore Ohio, where he discovered the Indian-mound country. He wrote some notes about it in an unpublished monologue titled "Prologue for a New Esthetic": "Standing before the Miamisburg mound, or walking amidst the Fort Ancient and Newark earthworks—surrounded by these simple walls made of mud—I was confounded by the absoluteness of the sensation, their self-evident simplicity. . . ."

Later, in a conversation, he described the experience as that of "a sense of place, a holy place. Looking at the site you feel, Here I am, *here* . . . and out beyond there [beyond the limits of the site] there is chaos, nature, rivers, landscapes . . . but here you get a sense of your own presence. . . . I became involved with the idea of making the viewer present: the idea that 'Man Is Present.'"

Ad Reinhardt

Number 107. 1950
Abstract Painting. 1963
Illustrated on pages 246, 247

Ad Reinhardt, in *Americans 1963,* **1963,** page 80

A square (neutral, shapeless) canvas, five feet wide, five feet high, as high as a man, as wide as a man's outstretched arms (not large, not small, sizeless), trisected (no composition), one horizontal form negating one vertical form (formless, no top, no bottom, directionless), three (more or less) dark (lightless) non-contrasting (colorless) colors, brushwork brushed out to remove brushwork, a mat, flat, free-hand painted surface (glossless, textureless, non-linear, no hard edge, no soft edge) which does not reflect its surroundings—a pure abstract, non-objective, timeless, spaceless, changeless, relationless, disinterested painting—an object that is self-conscious (no unconsciousness) ideal, transcendent, aware of no thing but Art (absolutely no anti-art). *1961*

The painting leaves the studio as a purist, abstract, non-objective object of art, returns as a record of everyday (surrealist, expressionist) experience ("chance" spots, defacements, hand-markings, accident—"happenings," scratches), and is repainted, restored into a new painting painted in the same old way (negating

the negation of art), again and again, over and over again, until it is just "right" again. *1960*

A clearly defined object, independent and separate from all other objects and circumstances, in which we cannot see whatever we choose or make of it anything we want, whose meaning is not detachable or translatable, where nothing can be added and nothing can be taken away. A free, unmanipulated and unmanipulatable, useless, unmarketable, irreducible, unphotographable, unreproducible, inexplicable icon. A non-entertainment, not for art-commerce or mass-art-publics, non-expressionist, not for oneself. *1955*

Reinhardt
Number 107
Abstract Painting

William Seitz, *The Responsive Eye,* **1965,** pages 16, 17

A disinterested, hurried, or inattentive gallery visitor can easily dismiss these "invisible" works as entirely homogeneous, so slight are the differences in tone and color that distinguish their elements and mark the individuality of each artist. "Quietistic" painting, of which Ad Reinhardt was a pioneer, raises a question posed by Leo Steinberg in a commentary on a series of blue pictures by Paul Brach: "How close to all-one can multiplicity come?"

It is wrong, perhaps, to show close-valued painting in crowded exhibitions, for their viability lies at the threshold of invisibility. Each work should be seen in isolation, for a meditative state of mind, proper lighting, and passage of time are absolutely essential to a meaningful response. The eyes must accommodate to the painting as they do to a dimly lit room after having been in sunlight or, conversely, as they accommodate to the transition from darkness to bright light. The eyes and the mind must be prepared gradually to approach the acuity of perception and feeling that was possible in the quiet of the studio, and must slowly follow the experiences of depth or encompassment, appearance or disappearance, unity or multiplicity for which the painter provided the conditions.

It is easy to associate these large paintings with religious and mystical states. The contemplation of nothingness, which they invite while retaining their identity, quickly goes beyond purely visual sensation.

Reinhardt
Number 107
Abstract Painting

Yve-Alain Bois, *Ad Reinhardt,* **1991,** pages 25, 26

Reinhardt's first attempt at . . . formal structure (the near-monotone) was infecund, perhaps because it was too early and still unnecessary (the all-over had not been fully explored yet). As a result, it was too assertive to produce the effect of almostness: the white on white was feeble precisely because it was too violently white on white. The issue of the non-color reappears, in the early fifties, in connection with the all-over brushstrokes (see *Number 107* of 1950). Here, Reinhardt immediately perceived the problem: . . . if the issue was to abolish contrast (without arriving at the plain monochrome, object-hood, and the like), then the suppression of colors as a means of dispensing with color-contrast was only a brilliant trick (for textural effects could always be perceived as the sublimation of such contrast). To approach it indirectly, by way of value deflation, was much more promising. Paradoxically, to thematize this abolition of contrast through an attenuation of values, one had to *show* this attenuation and thus reintroduce something abandoned long ago, that is, drawing. Drawing had to be reinstated (and geometry was the surest way to accomplish that), but it had to be simultaneously destroyed. The only means not yet explored for this particular purpose was color.

Two options were available to Reinhardt for undermining drawing through color, for rendering the line evanescent while retaining it: . . . either the high pitch, or the low key. The canvases from late 1950 through 1951 (but some as late as 1953) belong to both categories.

Abstract Expressionism: Image and Gesture

Bradley Walker Tomlin
Number 20. 1949
Illustrated on page 248

Helen M. Franc, *An Invitation to See,* **1992,** page 137

Tomlin's monumental, seven-foot-high canvas is filled with a bold calligraphy in which each character stands out clear and distinct. The light-toned bars and ribbons of angular, curving, and hooked signs, punctuated by small black and white squares and circles, seem like hieroglyphs that lack only the appropriate Rosetta Stone for their deciphering. They are deployed against a background of shifting rectangles, derived ultimately from the structural grid of such Cubist paintings as Picasso's *"Ma Jolie"* (see page 113). The sober color of Tomlin's *Number 20* of 1949, relieved only by a small red accent toward the top center, is also reminiscent of monochromatic Cubist paintings of 1911–1912.

The freely invented forms of his calligraphy, on the other hand, come out of a different tradition. They owe something to Surrealist automatism, one of the major formative influences on the avant-garde artists of the New York School, with whom Tomlin became associated in the late forties. His *Number 20*, however, cannot strictly be classified as "Abstract Expressionist," for besides its geometric underpinning, the signs, too, show a disciplined control rather than free spontaneity, and they are arranged in a formal design of austere, though decorative, elegance.

Franz Kline
Chief. 1950
Illustrated on page 250

MoMA Highlights, **1999,** page 205

True to an alternate name for Abstract Expressionism, "action painting," Kline's pictures often suggest broad, confident, quickly executed gestures reflecting the artist's spontaneous impulses. Yet Kline seldom worked that way. In the late 1940s, chancing to project some of his many drawings on the wall, he found that their lines, when magnified, gained abstraction and sweeping force. This discovery inspired all of his subsequent painting; in fact many canvases reproduce a drawing on a much larger scale, fusing the improvised and the deliberate, the miniature and the monumental.

"Chief" was the name of a locomotive Kline remembered from his childhood, when he had loved the railway. Many viewers see machinery in Kline's images, and there are lines in *Chief* that imply speed and power as they rush off the edge of the canvas, swelling tautly as they go. But Kline claimed to paint "not what I see but the feelings aroused in me by that looking," and *Chief* is abstract, an uneven framework of horizontals and verticals broken by loops and curves. The cipherlike quality of Kline's configurations, and his use of black and white, have provoked comparisons with Japanese calligraphy, but Kline did not see himself as painting black signs on a white ground; "I paint the white as well as the black," he said, "and the white is just as important."

David Smith
Australia. 1951
Illustrated on page 251

David Smith, statement at a symposium at The Museum of Modern Art, **1952**

My first steel sculpture was made in the summer of 1933, with borrowed equipment. The same year I started to accumulate equipment and moved into the Terminal Iron Works on the Brooklyn waterfront. My work of 1934, '35, '36 was often referred to as line sculpture, but to me it was as complete a statement about form and color as I could make. The majority of work in my first show at the East River Gallery in 1937 was painted. I do not recognize the limits where painting ends and sculpture begins.

Since the turn of the century painters have led the aesthetic front both in number and concept. Outside of [Constantin] Brancusi, the greatest sculptures were mostly made by painters.

Sculpture is more immediate for visionary action. . . . Natural constants such as gravity, space and hard objects are the physicals of the sculpture process; consequently they flow more freely into the act of vision than the illusion of constants used in

painting alone. The fact that these constants or premises need no translation should make sculpture the medium of greatest vision. This I mention as a theoretic potential but the conviction and meditation on a concept that the resistance of material presents are elements which are unique to this art form. A sculpture is a thing, an object. A painting is an illusion—there is the absolute difference of one dimension.

My position for vision in my works aims to be in it, but not of it, and not as an identified physical participant with its subject. I only wish to comment on the travel. It is an adventure viewed. I do not enter its order as lover, brother or associate. I seem to view it as from the traveling height of a plane two miles up, or from my mountain workshop viewing a cloud-like procession. When [I am] in my shop I see the clouds. When I am in the clouds I am there to look at my work. From there importances become pattern—depth, bulk are not so evident.

Adolph Gottlieb
Blast, I. 1957
Illustrated on page 252

Alfred H. Barr, Jr., *What is Modern Painting?* **1956, page 44**

Gottlieb's *Blast, I* is easy to describe: the background is pure white; the disc is deep luminous red; the irregular, blurred form below is sooty black. The contrasts are violent, form against form, color against color. But the painter insists: "The idea that a painting is merely an arrangement of lines, colors and forms is boring." *Blast!* Does the red disc suggest apocalyptic doom glowing over the world's charred ruins? Is this a succinct 1958 version of *Guernica?* Don't jump to conclusions—the disc may be the rising sun. Besides, in other similar paintings by Gottlieb the disc is a gentle green. *Blast, I* is ambiguous. Its "meaning" depends in part on you—and that accounts for some of its fascination. "When we are solemnly advised . . . to be humanists or to go back to nature, who listens seriously to this whistling in the dark?" Not Gottlieb, for, essentially, he turns his back upon neither humanity nor nature.

Robert Motherwell
Elegy to the Spanish Republic, 54. 1957–61
Illustrated on page 249

Robert Motherwell, in *The Museum of Modern Art Bulletin;* **1951, pages 12, 13**

The emergence of abstract art is one sign that there are still men able to assert feeling in the world. Men who know how to respect and follow their inner feelings, no matter how irrational or absurd they may first appear. From their perspective, it is the social world that tends to appear irrational and absurd. It is sometimes forgotten how much wit there is in certain works of abstract art. . . .

I think that abstract art is uniquely modern—not in the sense that word is sometimes used, to mean that our art has "progressed" over the art of the past; though abstract art may indeed represent an emergent level of evolution—but in the sense that abstract art represents the particular acceptances and rejections of men living under the conditions of modern times. If I were asked to generalize about this condition as it has been manifest in poets, painters, and composers during the last century and a half, I should say that it is a fundamentally romantic response to modern life—rebellious, individualistic, unconventional, sensitive, irritable. . . .

One of the most striking aspects of abstract art's appearance is her nakedness, an art stripped bare. How many rejections on the part of her artists! Whole worlds—the world of objects, the world of power and propaganda, the world of anecdotes, the world of fetishes and ancestor worship. One might almost legitimately receive the impression that abstract artists don't like anything but the act of painting . . .

One might truthfully say that abstract art is stripped bare of other things in order to intensify it, its rhythms, spatial intervals, and color structure. Abstraction is a process of emphasis, and emphasis vivifies life . . .

I love painting the way one loves the body of woman, that if painting must have an intellectual and social background, it is only to enhance and make more rich an essentially warm, simple, radiant act, for which everyone has a need.

Hans Hofmann
Memoria in Aeternum. 1962
Illustrated on page 253

John Russell, *The Meanings of Modern Art,* **1981, pages 300, 302**

Hofmann approached the problems of painting with an immediate physicality which was very attractive to his audiences in New York. The group known as the American Abstract Artists inclined toward a geometrical abstraction in which every straight line was trued and faired and the color was applied with a fastidious thinness; the results often looked, if not

starched, then freshly laundered. Hofmann introduced an element of bodily involvement in which painting became "an affair of prodding and pushing, scoring and marking, rather than of simply inscribing and covering." Those words come from Clement Greenberg's essay of 1961 on Hofmann; and Greenberg is doubtless correct in citing [Chaim] Soutine—above all, Soutine's Céret landscapes—as the source of this element in Hofmann's teaching. In the landscapes which Soutine painted in Céret, in southern France, there is foreshadowed one of the chief characteristics of the First New York School: an intense nervous energy which communicated itself to the movement of the brush. Soutine painted what looks to us like a world in convulsion; but the convulsion in

question was in his own fingers' ends, and in the rapid and purposeful to and fro of the brush. As much as in anything painted by Jackson Pollock, the canvas becomes what Harold Rosenberg in 1952 called "an arena in which to act, rather than a space in which to reproduce, redesign, analyze or 'express' an object, actual or imagined." Insofar as any one man could set up the conditions for a new American painting, that man was Hans Hofmann. He was the complete cosmopolitan; but whereas the cosmopolitan has often more knowledge than drive, Hofmann had in the highest possible degree the German's will to win. And he kept at it with the kind of big, square-built ambition that made it possible for him to peak toward the end of his long life, rather than 30 years earlier.

After Abstract Expressionism —

Helen Frankenthaler
Jacob's Ladder. 1957
Illustrated on page 254

Anne M. Wagner, in *Jackson Pollock: New Approaches*, **1999**, pages 192, 193, 194

In Frankenthaler's hands painting moves farther toward its redefinition as a practice that is both arbitrary and intended as well as both figurative and abstract, produced of moves and gestures whose effects are decisive as their motives are hard to specify. This is a way to proceeding, moreover, that almost didactically disturbs the already improbable and uneasy peace that [Jackson] Pollock sometimes forged between mark and image, drawing and color, figure and ground, and so on; Frankenthaler disrupted that peace almost every chance she got. This is what [Kenneth] Noland and [Morris] Louis were unable to grasp: what Pollock would sometimes integrate and keep in balance when"at home" in his canvas, Frankenthaler insists on prizing apart.

Look at what happens in two very different paintings, *Europa* and *Jacob's Ladder* (both 1957). Both are floor-made pictures, both aggressive in their approach to the conventions and traditions of figuration and landscape—what is attacked and ironized in *Europa* hovers somewhere between comedy and transcendence in *Jacob's Ladder*—but both works have moments where Frankenthaler makes her mark, leaves a trace. And she again does so as a kind of signature that will not quite be integrated or made

part of some whole. . . . Individual marks in *Jacob's Ladder* are less assertive but still figurative, though elusively: when I look at the pours that float in the pale upper third of the picture, I think inevitably of someone making angels in the snow. And these marks are likewise more spatial than those in *Europa*; along with stains and splashes there are four quick circles (they are more mundane than magical) that again seem to delimit sites or moments in the picture's expanse. They also interrupt it. I see such incidents, in their separateness, as having more to do with mark and place than with field or image. Think of these canvases laid horizontal, and their maker pacing and tracing on them as if they were another country, one in which she was prepared to dwell.

Morris Louis
Russet. 1958
Illustrated on page 255

John Elderfield, *Morris Louis*, **1986**, pages 32, 33, 48

Louis was able to combine [Jackson] Pollock's layering and [Helen] Frankenthaler's side-by-side color juxtapositions by pouring waves of thinned-down, transparent paint of different hues down the surface of the canvas "so as to mute their separate intensities into so many neutral and ambiguous shades of a single low-keyed color"[1]—in effect, by working, like Pollock, from repetitively superimposed colors, but, like Frankenthaler, with areas not lines of color laid

down side-by-side, overlapped, and then veiled over. The result is pictures wherein automatically generated drawing created a holistic image, as in Pollock, but with a heightened, richly nuanced color made possible by virtue of Frankenthaler's example. Different, however, from either Pollock or Frankenthaler, is Louis's conception of painting as the creation of flooded homogeneous fields of color, identified with the surface and developed across the surface without any underpinning in the form of a tonal armature. The openness of his work is not the ultimately Cubist openness of Pollock or Frankenthaler, where imaginary space is articulated, reticulated even, by a pattern of lights and darks; rather, it is the spreading, surface openness of an ultimately Impressionist conception of painting as an unconstricted, aerated, colored field. . . .

There are plenty of modern precedents for the adaptation of a watercolor technique to oil painting . . . [I]t is relevant to know that Louis was interested in [Paul] Cézanne's watercolors . . . He was even more interested in [Henri] Matisse, who also consistently used thin paint in order to exclude anything that might detract from the sheer visibility of color. And it is tempting to see Louis as part of the distinctly American watercolor tradition that includes artists like Georgia O'Keefe and John Marin, whose work he could have seen at The Phillips Collection, as well as in relation to [Paul] Klee, whose work certainly affected [Kenneth] Noland's when Louis and Noland first met. It is also worth mentioning at this point that Louis's technique bears comparison with a form of painting conceptually opposite to the intimacy of watercolor, namely, fresco painting. The physical bonding of color to a white surface through tinting has long been a method of accentuating its purity, and also of achieving the difficult coherence of a large-size muralist art. . . . The soak-stain technique that Louis adapted from Frankenthaler combines these opposite traditions: the first, intimate, tending naturally to lyricism, highly dependent on the artist's individual touch, and having the candor and immediacy of a sketch; the second, public, tending to the epic and the monumental, involving suppression of the artist's touch, and having the distanced aloofness of architectural decoration. One way of distinguishing Louis's 1954 Veils and those he began in 1958 is to say that he shifted from the first toward the second of these traditions. . . .

The triadic bronze Veils were among the first that Louis completed in 1958. It would seem that the earlier of these were the pictures with a simpler and duller surface and a less regularly formed veil shape and the later, the pictures with more complex drawing and color contrasts, a more lively, asserted surface, and a more firmly contoured veil shape. Certainly, the more authoritative pictures are those with the latter attributes. Those where the top of the veil shape is not trued to the horizontal, but dips and then peaks as it meets the two vertical "lines" within it, suffer because the functional relationship, thus illustrated, between the internal drawing and the external shape of the veil image tends to give it the appearance of a loosely flapping construction (something like a canvas windbreak) standing in front of the picture surface. Those where the sides of the image are not roughly symmetrical suggest that it is slipping from its mooring, even that the two sides advance and recede in opposite directions. Louis later found that the source of expressive power in the Veils lay in their outside edges. However, he was not able to tap that power until he established the Veil image itself as a flat, heraldic bilaterally symmetrical unit, firmly rested on the base of the picture and floated just free on the other three sides.

Proto-Pop Art

Robert Rauschenberg
Untitled (Ashville Citizen). c. 1952
Illustrated on page 256

Robert Rauschenberg, in *Sixteen Americans*, **1959,** page 58

Any incentive to paint is as good as any other. There is no poor subject.

Painting is always strongest when in spite of composition, color, etc. it appears as a fact, or an inevitability, as opposed to a souvenir or arrangement.

Painting relates to both art and life. Neither can be made. (I try to act in that gap between the two.)

A pair of socks is no less suitable to make a painting with than wood, nails, turpentine, oil and fabric.

A canvas is never empty.

Robert Rauschenberg

First Landing Jump. 1961
Illustrated on page 257

Leslie Jones, in *Pop Art,* **1998,** page 82

Robert Rauschenberg . . . collected mundane objects from everyday life and affixed them to a wood or canvas support. Part painting and part sculpture, part art and part life, Rauschenberg's Combines, begun in the mid-1950s, included everything from the extremely personal, like worn shirts and slept-on pillows, to tires and lumber scavenged from the streets and construction sites of New York City. "I felt very rich being able to pick up Con Edison lumber from the street for combines and stretchers, taking advantage of whatever the day would lay out for me to use in my work."[1] Rauschenberg's preference for the banal as opposed to the sublime of Abstract Expressionism led to his early classification as a neo-Dadaist; later, in the early 1960s commentators were quick to name him, with Johns, a prophet of Pop.

Rauschenberg's openness to chance encounters with the urban environment relates his endeavors to those of the Surrealists and resulted in nonhierarchical allover compositions, described as evidence of his "vernacular glance."[2] In *First Landing Jump,* . . . Rauschenberg's glance seems to be momentarily fixed on the road. Predominant elements include a tire, black-and-white striped street barrier, white-enamel light reflector from the street, and a rusted license plate mounted on composition board covered with black tarpaulin, a white drop cloth, and a paint-stained khaki shirt. The work is lit by a small blue lightbulb inserted in a tin can. According to one reviewer: "The tires in Rauschenberg's shantied cenotaphs have rolled straight off Whitman's open road to come to a great big rubbery stop against [Leo] Castelli's wall. In fact there is a tarry ozone of U.S. traffic here altogether, with its Bogart roadblocks and crushed oilcans like the cuffs of bums' trousers."[3]

Literally stalled not only by the barrier that has punctured and impaled the tire to the floor, but also by the electric cord that ties the Combine to its power source, Rauschenberg's view of highway culture is distinctly curbed in contrast to the expansive interpretations of . . . later Pop artists . . . Rather than accelerating along the open road, capturing glimpses of bold-colored logos and streamlined gas stations, Rauschenberg confined his explorations to the junkyard of journeys past. The colors of *First Landing Jump* are sober and faded, its objects rusted and battered, and its canvas scarred with suture stitches—traces of their pre-artistic histories. . . .

Visual contemplation (as opposed to immediacy) is characteristic of the collage aesthetic, which juxtaposes multiple and often diverse elements that solicit the viewer to "read" its associative potential. Often compared to works by Pablo Picasso and Kurt Schwitters, Rauschenberg's Combines further expanded the collage vocabulary and literally broke through the boundaries of the two-dimensional picture plane to engage floor and space as sculpture does or, as suggested by the artist, to create an environment.

Jasper Johns

Green Target. 1955
White Numbers. 1957
Map. 1961
Illustrated on pages 258–60

Kirk Varnedoe, *Jasper Johns: A Retrospective,* **1996,** pages 15, 16, 18, 31

Through every mode and in all mediums, . . . Johns's art has consistently conveyed a sense of virtuosity, sometimes called erotic in its appeal.[1]

That quality has had little to do with suave figuration in an academic sense, nor with any facile choreography of the medium. In fact it most characteristically involves a willful impersonality in lines and marks,[2] a lack of conventional bravura that speaks instead of other gifts and ambitions. Johns has dealt with the world almost exclusively by treating found images, and as models for drawing he has given pride of place to plans, maps, stencils, and other devices (such as linear tracing) that reduce the world's variety to an apparently objective, flattened form. Representing without describing, these schemas combine a maximum of transformation with a seeming absence of subjective stylization.[3] They are functional, concrete modes of encoding ideas, and they offer, as Johns's early targets also did most succinctly, nonabstract forms of abstraction. Johns has not wanted to be either an abstract or an illusionist artist, but as a constant literalist he has at times been both, and has often purposefully walked the line. Declared admirer of both John F. Peto and Barnett Newman, he has favored in his own work abstractions that can be read as depictions (*Green Target,* 1955) and depictions schematized to the point of abstraction (the masking-tape rectangles, Cubist nails and wood grain, and cartoon facial features of the past decade or so).

Though Johns has often adopted an intentionally staid, [René] Magritte-like manner of depiction, his more declarative "handwriting" in all mediums has been independent of the normal techniques of picto-

rial rendering. Since the slow compilations of encaustic strokes in his first paintings, he has cultivated a combination of programmed disciplines (such as filling in stripes or backgrounds or puzzle segments) and unexpected intensities (underscaled or outsized units of touch applied with exhaustive density or seemingly untoward breadth) that wields a dislocated expressive power over the work's nominal subjects. Even at the most basic level of making marks and applying medium to surface, he has wrought his "signature" manner from techniques that work against any familiar code of self-expression. Indeed his most "expressionist" gestural brushstrokes, seen in works of the late 1950s and early 1960s, seem by willful contrariness self-consciously generic and often openly repetitive, and there has been an equal muzzling of the usual indices of spontaneously released energy, whether lyric or angry, in his repertoire of dry, wet, and viscous material effects—scraping, smearing, pressing, melting, puddling, etc. Yet, by personal alchemy, he has orchestrated this vocabulary into a compelling and influential sense of craft. Typically blending, in illogical or uncanny proportion, elements of crisply controlled exactitude, obsessiveness, and partial liberation of a material's inherent physicality, this craft often seems repressed and ironic in its refusals; but it remains unmistakably alive, emotively and psychically as well as tactilely and optically. . . .

Johns has wanted his subjects, like his schematic models for drawing, to come ready made. He has also long favored those that have arrived involuntarily, through chance encounters or uncontrolled circumstances—fleeting glances, unexpected gifts from friends, suggestions made by others, or even, in the case of the first *Flag*, 1954–55, a dream. This is clearly not, however, a belated case of the Surrealist courtship of chance and the unconscious mind, which meant so much to the generation of American artists immediately preceding Johns's. What came to him from his initial dreams and serendipities were not primal icons beyond civilization's reach, or exotic eccentricities, but everday images shaped by convention and culture. The prime gift, the dream of painting the American flag, was prime precisely because it provided the most conventional of conventions, a wholly public symbol.

It was in acting on that dream that Johns found his way, and decided that through such seemingly self-evident subjects his art could deal in fundamental issues of seeing. More precisely, he was concerned with relations of thought and sight—"the idea of knowing an image rather than just seeing it out of the corner of your eye." To work in that area he needed subjects that had acquired an "invisibility"[4]

by virtue of being too well-known to be truly seen, or conversely by being so often seen that they were not truly thought about. He famously referred to his first choices—the flag, target, and numbers— as "things the mind already knows,"[5] and also (because the mind, knowing them too well, ignores them) as things that were "seen and not looked at, not examined."[6]. . .

The early subjects were chosen as "depersonalized, factual, exterior elements"[7] in part to answer his felt need for emotional disengagement. We know from several accounts that in 1954, Johns decided to reinvent himself; destroying everything he could of his work to that point, and taking what he saw as more adult responsibility for what he was doing, he drastically ratcheted up his level of artistic ambition.[8] A central component of this drive involved an imperious self-repression, a willed emotive shutdown. . . . In Johns's choice of subjects as in every stroke of his brush, this stance hammered a spike into the heart of the existentialist call for decisive engagement and self-expression that had been associated with a sense of epiphany and catharsis in the dominant art movement of his youth, Abstract Expressionism. The singular, compressed power of his early paintings, the sense of life one gains from them, seems to have been fueled by an intense, self-conscious will channeled through a draconian self-policing. . . .

Prime among Johns's refusals has been a refusal of meaning—or, more precisely, an insistence on distancing himself from the enterprise of interpreting what he has achieved. In his ideal of an artist's action, the energies invested in the making of a work should leave none remaining for its analysis or explication. Aside from the commentary or critique implied in the next work he or she makes, the creator then leaves the meaning of a given creation to emerge from its uses or abuses at the hands of its viewers. If there is one key point of congruity between Johns's interest in the language of painting and his broader interest in linguistics, it is this antiessentialist notion—often associated with Ludwig Wittgenstein—that the meaning of something derives from the way in which it is used.

Johns

Green Target
White Numbers
Map

Kirk Varnedoe, *Jasper Johns: A Retrospective*, **1996**, pages 98, 99

Johns . . . is often regarded as the "father of Pop," but

231

as the artist himself has said, "If you make chewing gum and everybody ends up using it as glue, whoever made it is given the responsibility of making glue."[1] It would be obtuse to deny that he and [Robert] Rauschenberg instigated Pop; where [Marcel] Duchamp had put found things on a pedestal, [Frank] Stella remarked, these two took the incidental and the day-to-day world into their art with a striking immediacy and made it functional, finding new relationships between things and forcing unexpected congruities. . . .

Johns seems at first to have sought in American public life a set of symbols that would be timelessly neutral and unvarying. But he did so precisely in a period when political and especially consumer life in this country sped up: the flag got more stars, labels and logos were redesigned, long-steady brand names died or were remade. This sense of accelerated inconstancy, which seems to have figured in his decision to shift away from making a private iconography of "common things" by extracting items of public commerce,[2] is in part what occasioned the deep vein of nostalgia in Pop art—the bitterly shrill keening for waning commonplaces like soup cans with fifty-year-old label designs, Coca-Cola bottles in an age of canned Coke, and crude little pulp advertisement in the full-color heyday of Madison Avenue. . . .

Johns's fatherhood to Pop is typically paired with his parenting of Minimalism, dividing those artists who were marked by the image of *Flag* from those who were taken with the way that image was treated. The former saw it as all subject, the latter as all object; for them, pushing the image forward to take up the canvas's entire surface seemed to obliterate normal representation. As Robert Morris wrote in 1969, "Johns took painting further toward a state of non-depiction than anyone else. The Flags were not so much depictions as copies. . . . Johns took the background out of painting and isolated the thing. The background became the wall. What was previously neutral became actual, while what was previously an image became a thing."[3]

Cy Twombly
The Italians. 1961
Illustrated on page 261

Kirk Varnedoe, *High & Low*, **1990,** pages 96, 97

Twombly's . . . images vary from airy tumbleweeds of tracery to monumental rhetoric, and often achieve the kind of enveloping intimacy that has marked a particular strain of modern larger-than-easel painting, from [Claude] Monet's *Water Lilies* decorations to [Jackson] Pollock's large dripped canvases. And the drawing, alternately innocent and expressive, follows a deceptively "untutored" course between the pitfalls of the merely brittle or the merely fluid, in lines that loop, pause, and run on, at paces that are by turns ambling, ruminative, and impulsive, through skeins, knots, and thicket-like clusters. The surfaces and the emotional impact of Twombly's paintings are enriched, too, by a duality: they seem to show both the basic urge to scribble and, simultaneously, the compulsion to deface. He often appears engaged in constant self-vandalism, as if he were editing while he wrote, making marks with one hand and covering them or emending them with the other. Impulse and erasure, or confession and repression, lock together in a work like *The Italians*, as every area of the canvas seems subject to revision, separate cancellation, and reintegration. Yet the end results, while rife with scattershot diversity and moments of frenzy and frustration, often have an ardent lyricism. From a purposefully limited palette and set of formal strategies, Twombly has coaxed an astonishingly broad range of aesthetic reference and emotion, from a dark-alley impassioned urgency to the ethereal, decorative feel of cloud-spotted skies by [Giovanni Battista] Tiepolo.

Geometric Abstraction —————

Ellsworth Kelly
Colors for a Large Wall. 1951
Illustrated on page 262

E. C. Goossen, *Ellsworth Kelly*, **1973,** page 45

Kelly had given up painting the human figure and had put his plant and nature drawing into a separate category, and so he began again to pursue his fascination with architecture. His association of the flat facade with the flatness of the canvas, his sketches of walls articulated by chimneys and shadows, and his subtle use of architectural fenestration to devise acceptable rhythms and spacing lie behind much of

his abstract work between 1950 and 1953. . . .

It is not surprising then to learn that Kelly took a trip to Marseilles just to see Le Corbusier's apartment house, Habitation, while it was still under construction. He had already studied the architect's Swiss Pavilion at the Cité Universitaire in Paris . . . Unquestionably Corbu's punctured fenestration and his regular but articulated panels on the end walls had an influence on Kelly. Habitation, which he managed to climb around, offered something more—a use of color in modern building Kelly had not seen before. The walls between the balconies were painted bright pastel shades. Corbu was obviously using color to connect his new building form with local tradition. But for Kelly it was something of a shock. He felt that in some way Corbu's scheme diminished his own painting.

Despite Kelly's debts to Le Corbusier and perhaps owing to his continued shyness and modesty, he never made an effort to meet the master architect. But his friend [Alain] Naudé, who had a slight connection with Corbu, showed him slides of Kelly's paintings along with his own and returned with a message that the master had said: "Young people have it so easy these days." Evidently Le Corbusier was thinking of his own early difficulties and what his legacy had cost him. Le Corbusier also observed: "This kind of painting needs the new architecture to go with it.". . .

This picture [*Colors for a Large Wall*] is one of the largest Kelly made in France. The organization, aside from its square panels joined in a grid, is totally arbitrary; the juxtaposition of colors was a matter only of taste. It began, as was Kelly's custom at this time, with the creation of a collage. Using the exact number of leftover squares of colored paper from which the collages for the series of Spectrum Colors Arranged by Chance had been composed, he made the study for *Colors for a Large Wall* and that for *Sanary*. The hues of the colored papers, bought in art stores, were precisely matched in oil paints, and the final, full-sized panels arranged in strict adherence to the paper model.

Alejandro Otero
Colorhythm, I. 1955
Illustrated on page 263

Aracy Amaral, in *Latin American Artists of the Twentieth Century,* **1993,** page 93

The young artist Alejandro Otero had left [Caracas] for Paris on a grant in 1945, in a specific quest to make his pictorial language up-to-date and more universal, paying special attention to the work of [Paul] Cézanne and [Pablo] Picasso. In the French capital he produced a series of still lifes called Coffeepots from 1946 to 1949; in the latter year the Coffeepots were shown in Caracas at the Museo de Bellas Artes and at the Taller Libre de Arte. The tentative abstraction of these paintings sparked a widespread public debate in conservative Venezuelan art circles. In 1950 Otero and a group of Venezuelan artists and writers in Paris, having been branded "dissidents" by [French critic Gaston] Diehl, published five issues of a periodical, *Revista los disidentes,* which attacked the cultural and artistic conservatism of their native country.

The true Constructivist revolution, however, began in Venezuela in the 1950s when the young, restive artists began to return from their trips abroad. A catalyst of that revolution was the design by the architect Carlos Raúl Villanueva for the Ciudad Universitaria in Caracas. This project proposed and implemented integration among the arts, and created a unique atmosphere on the South American continent by placing works by recognized masters of contemporary art—such as Fernand Léger, Alexander Calder, Henri Laurens, Victor Vasarely, Antoine Pevsner, Jean (Hans) Arp, and [Wifredo] Lam—beside those of local artists Otero [and others].

During the 1950s the triad of Venezuelan kinetic Constructivists—[Alejandro] Otero, Soto, and Carlos Cruz-Diez—developed distinctive abstract vocabularies and began to achieve public recognition for their pictorial investigations. For instance, in 1952 Otero was included in the *Primera muestra internacional de arte abstracto* at the Galería Cuatro Muros in Caracas. . . . In 1958 Otero showed his Colorritmos in the annual salon at the Museo de Bellas Artes in Caracas and won the National Prize for painting. . . .

Constructivist kineticism may have become an accepted and acclaimed style in Venezuela because it seemed to fulfill the desire for contemporaneity in art far beyond that offered by more established modernist movements.[1] The vertical black bars and colored forms of Otero's Colorritmos may be seen as successors to [Piet] Mondrian's Neo-Plastic grids; they differed in effecting totally dynamic surfaces. As described by critic José Balza, Otero's lines established "an open directional rhythm as regarded both the sides and the extremities of the panels. The colors play between the lines creating dimensional and spatial counterpoint, whose departure is the vibration of the parallels and the colors."[2]

Gorky and de Kooning

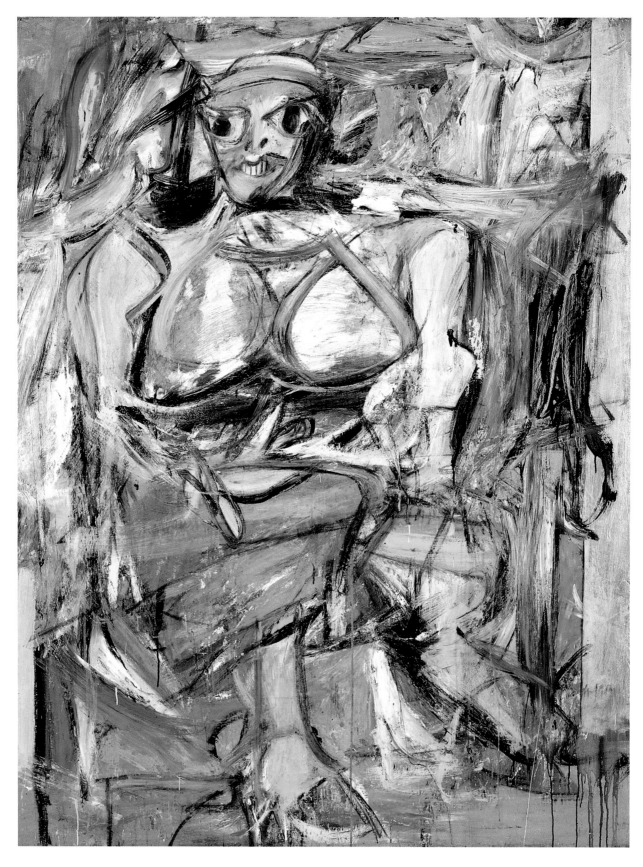

Willem de Kooning | AMERICAN, BORN THE NETHERLANDS. 1904–1997
WOMAN, I. 1950–52
OIL ON CANVAS, 6' 3⅞" x 58" (192.7 x 147.3 CM)
PURCHASE

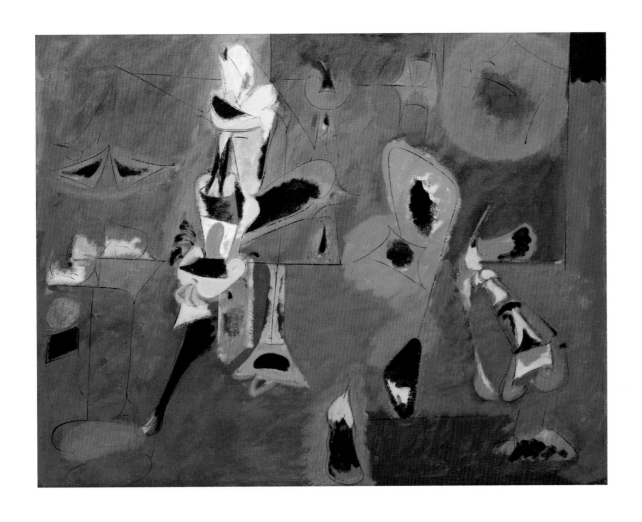

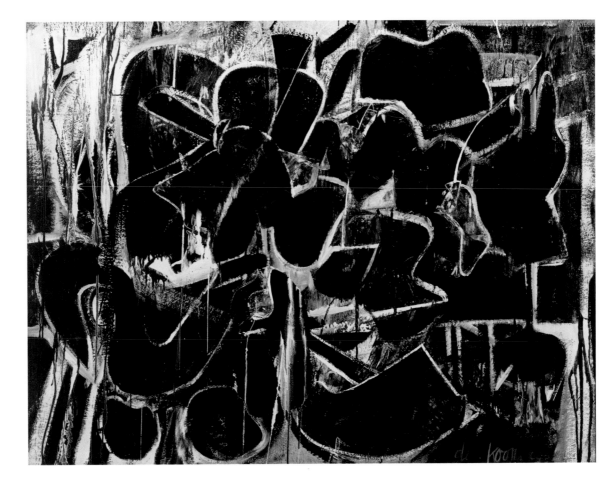

**Arshile (Vosdanig
Manoog Adoian)
Gorky** | AMERICAN,
BORN ARMENIA. 1904–1948
AGONY. 1947
OIL ON CANVAS, 40 x 50½"
(101.6 x 128.3 CM)
A. CONGER GOODYEAR FUND

Willem de Kooning
PAINTING. 1948
ENAMEL AND OIL ON CANVAS,
42⅞ x 56⅛" (108.3 x 142.5 CM).
PURCHASE

Abstract Expressionist Field Painting

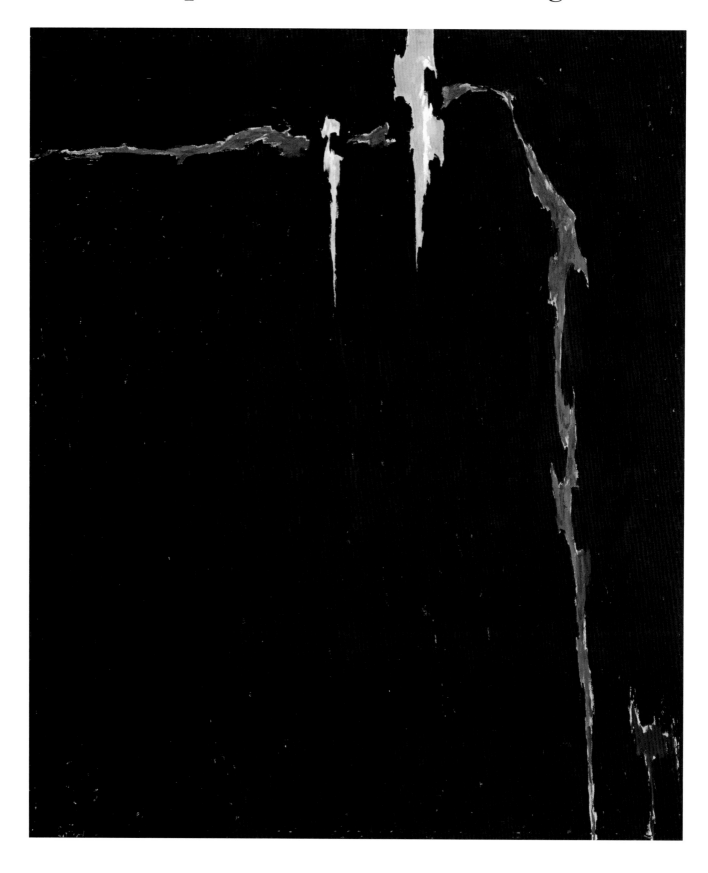

Clyfford Still | AMERICAN, 1904–1980
PAINTING 1944–N. 1944
OIL ON UNPRIMED CANVAS, 8' 8¼" x 7' 3¼" (264.5 x 221.4 CM)
THE SIDNEY AND HARRIET JANIS COLLECTION

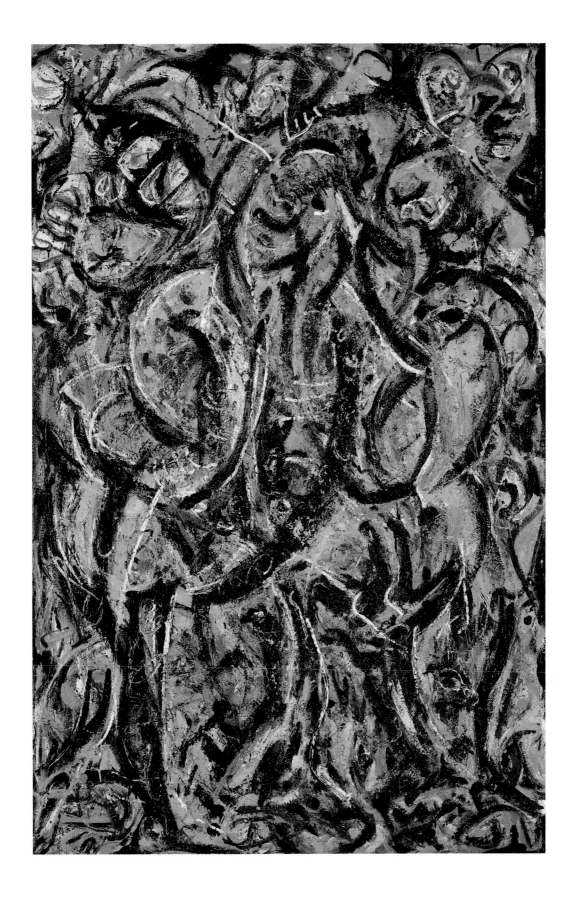

Jackson Pollock | AMERICAN, 1912–1956
GOTHIC. 1944
OIL ON CANVAS, 7' ⅛" x 56" (215.5 x 142.1 CM)
BEQUEST OF LEE KRASNER

237

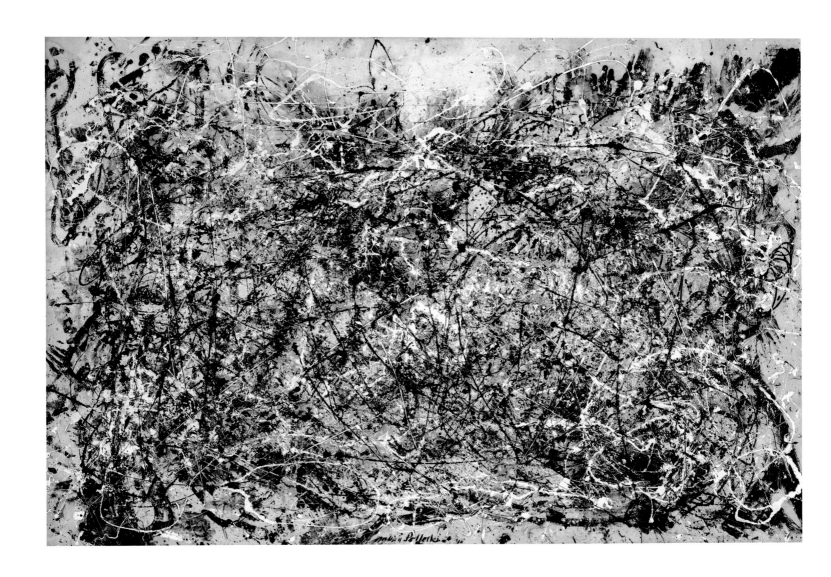

Jackson Pollock | AMERICAN, 1912–1956
NUMBER 1, 1948. 1948
OIL AND ENAMEL ON UNPRIMED CANVAS, 68" x 8' 8"
(172.7 x 264.2 CM)
PURCHASE

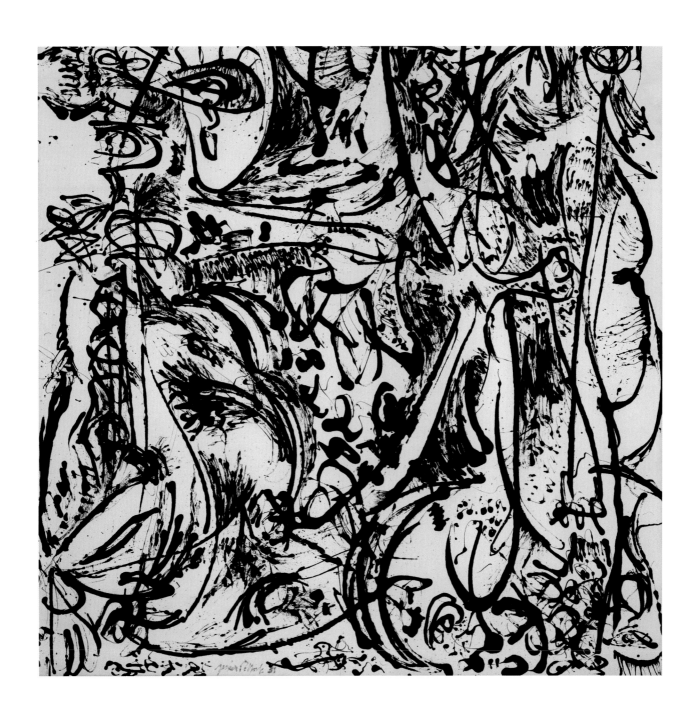

Jackson Pollock
ECHO (NUMBER 25, 1951). 1951
ENAMEL ON UNPRIMED CANVAS, 7' 7⅞" x 7' 2" (233.4 x 218.4 CM)
ACQUIRED THROUGH THE LILLIE P. BLISS BEQUEST AND MR. AND
MRS. DAVID ROCKEFELLER FUND

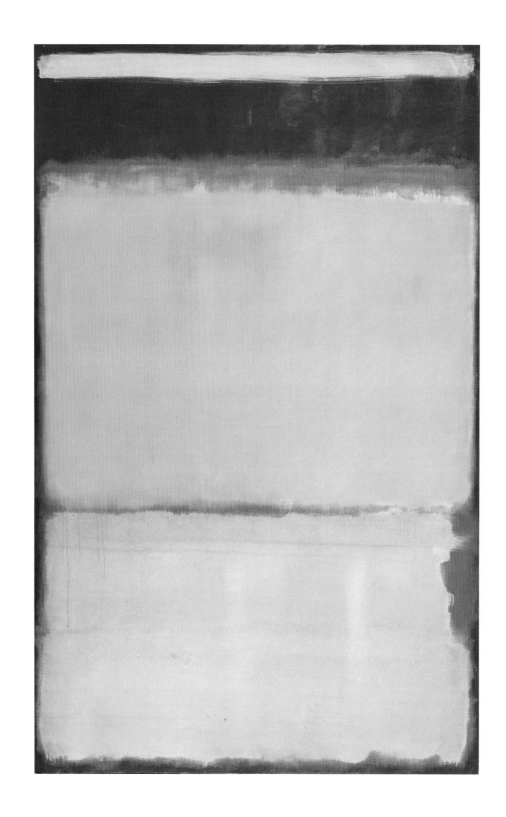

Mark Rothko | AMERICAN, BORN LATVIA. 1903–1970
NUMBER 10. 1950
OIL ON CANVAS, 7' 6⅜" x 57⅛" (229.6 x 145.1 CM)
GIFT OF PHILIP JOHNSON

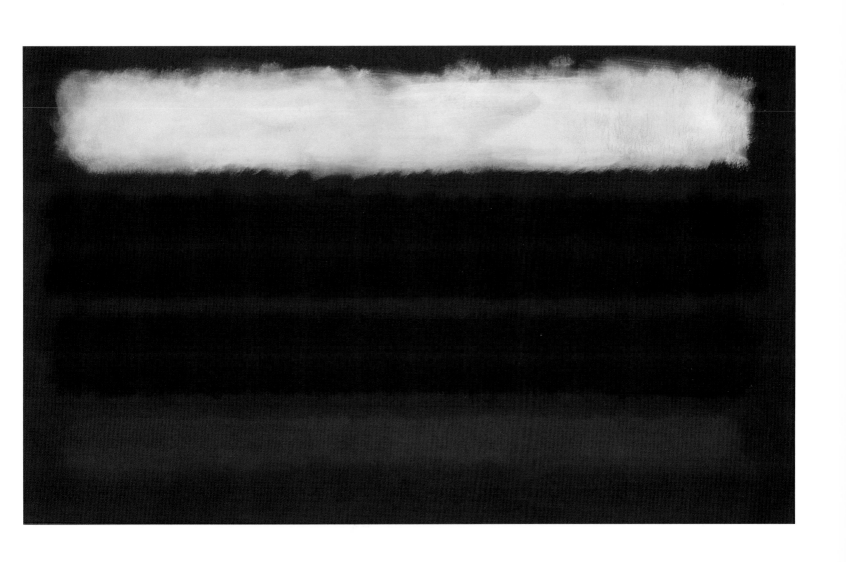

Mark Rothko
HORIZONTALS, WHITE OVER DARKS. 1961
OIL ON CANVAS, 56½" x 7' 9¼" (143.3 x 237 CM)
THE SIDNEY AND HARRIET JANIS COLLECTION

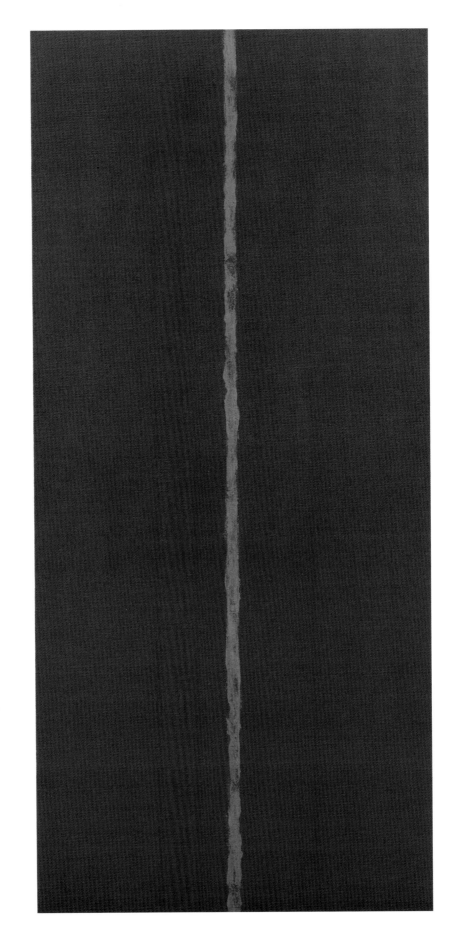

Barnett Newman | AMERICAN, 1905–1970
ONEMENT, III. 1949
OIL ON CANVAS, 71⅞ x 33½" (182.5 x 84.9 CM)
GIFT OF MR. AND MRS. JOSEPH SLIFKA

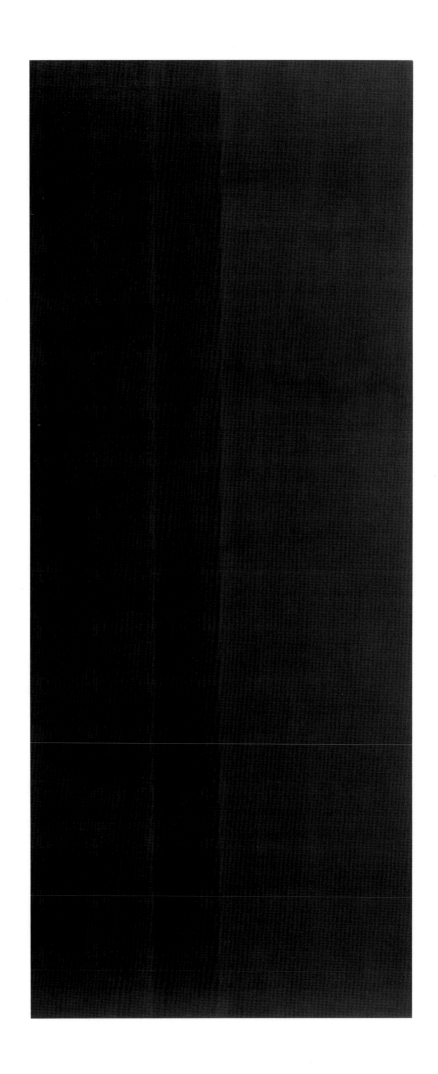

Barnett Newman
ABRAHAM. 1949
OIL ON CANVAS, 6' 10¾" x 34½" (210.2 x 87.7 CM)
PHILIP JOHNSON FUND

Barnett Newman | AMERICAN,
1905–1970
THE WILD. 1950
OIL ON CANVAS, 7' 11⅞" x 1⅝" (243 x 4.1 CM)
GIFT OF THE KULICKE FAMILY

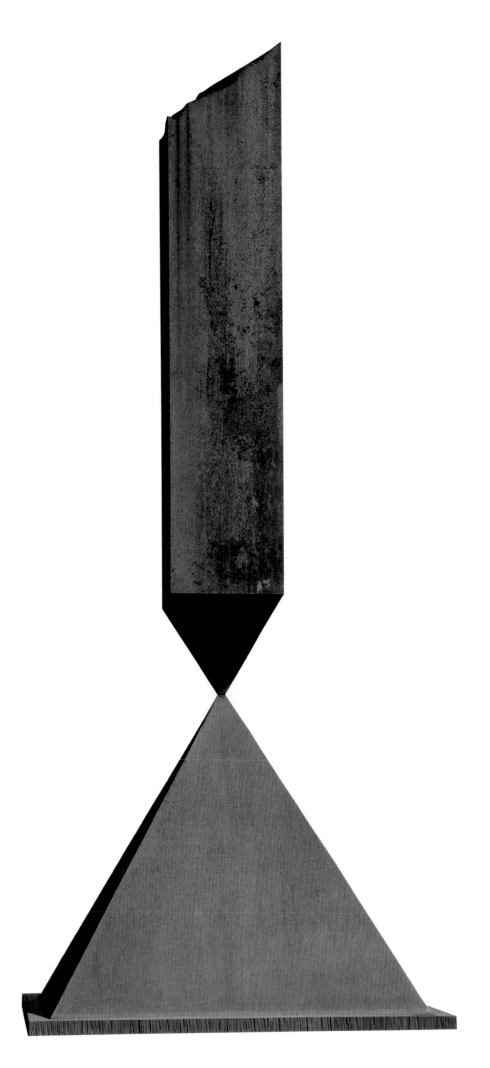

Barnett Newman
BROKEN OBELISK. 1963–69
COR-TEN STEEL, IN TWO PARTS,
OVERALL 25' 5" x 10' 6" x 10' 6"
(774.5 x 320 x 320 CM)
GIVEN ANONYMOUSLY

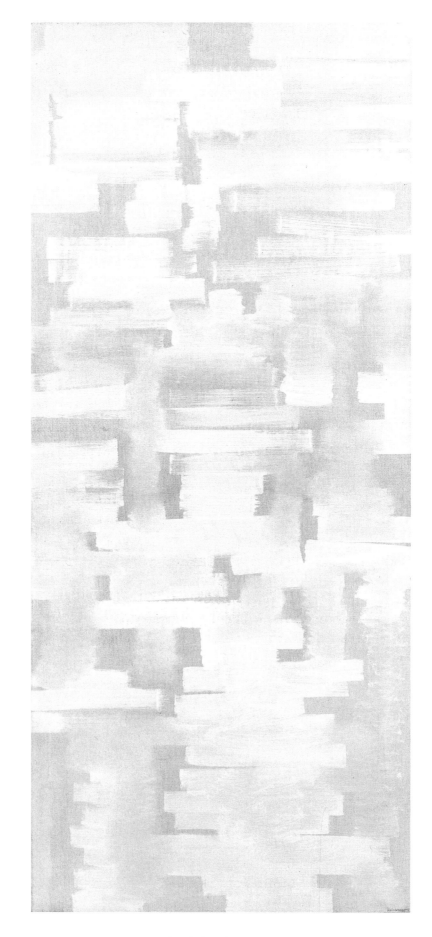

Ad Reinhardt | AMERICAN, 1913–1967
NUMBER 107. 1950
OIL ON CANVAS, 6' 8" x 36" (203.2 x 91.4 CM)
GIVEN ANONYMOUSLY

Ad Reinhardt
ABSTRACT PAINTING. 1963
OIL ON CANVAS, 60 x 60" (152.4 x 152.4 CM)
GIFT OF MRS. MORTON J. HORNICK

Abstract Expressionism: Image and Gesture

Bradley Walker Tomlin | AMERICAN, 1899–1953
NUMBER 20. 1949
OIL ON CANVAS, 7' 2" x 6' 8¼" (218.5 x 203.9 CM)
GIFT OF PHILIP JOHNSON

THE NEW AMERICAN PAINTING

Robert Motherwell | AMERICAN, 1915–1991
ELEGY TO THE SPANISH REPUBLIC, 54. 1957–61
OIL ON CANVAS, 70" x 7' 6¼" (178 x 229 CM)
GIVEN ANONYMOUSLY

Franz Kline | AMERICAN, 1910–1962
CHIEF. 1950
OIL ON CANVAS, 58⅜" x 6' 1½" (148.3 x 186.7 CM)
GIFT OF MR. AND MRS. DAVID M. SOLINGER

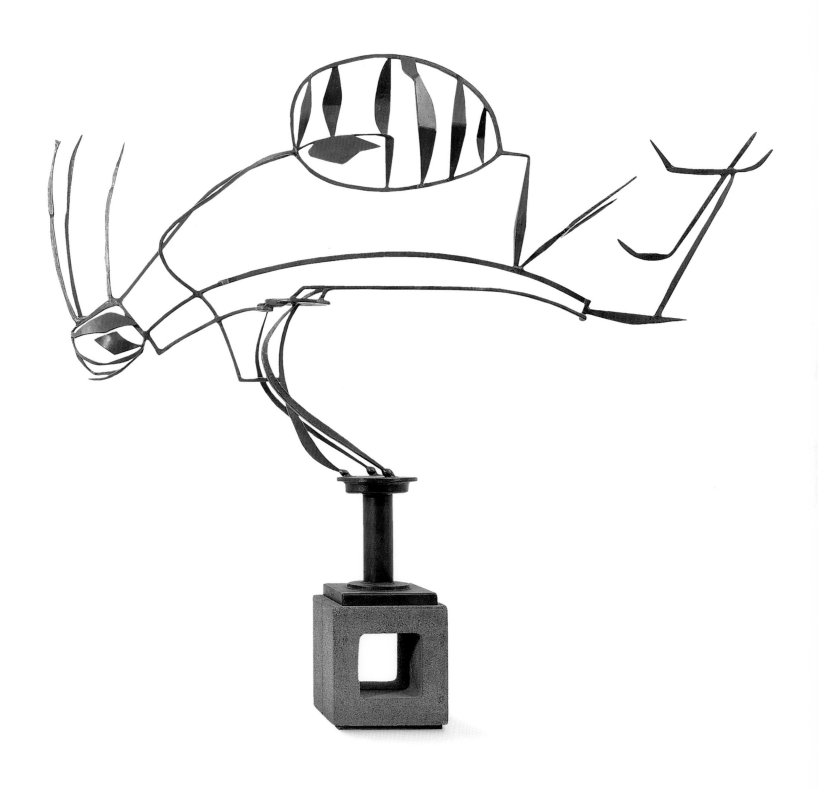

David Smith | AMERICAN, 1906–1965
AUSTRALIA. 1951
PAINTED STEEL, 6' 7½" x 8' 11⅞" x 16⅛" (202 x 274 x 41 CM);
AT BASE, 14 x 14" (35.6 x 35.6 CM)
GIFT OF WILLIAM RUBIN

Adolph Gottlieb | AMERICAN, 1903–1974
BLAST, I. 1957
OIL ON CANVAS, 7' 6" x 45½" (228.7 x 114.4 CM)
PHILIP JOHNSON FUND

Hans Hofmann | AMERICAN, BORN GERMANY. 1880–1966
MEMORIA IN AETERNUM. 1962
OIL ON CANVAS, 7' x 6' ½" (213.3 x 183.2 CM)
GIFT OF THE ARTIST

253

After Abstract Expressionism

| THE NEW AMERICAN PAINTING

254

Helen Frankenthaler | AMERICAN, BORN 1928
JACOB'S LADDER. 1957
OIL ON UNPRIMED CANVAS, 9' 5⅛" x 69⅞" (287.9 x 177.5 CM)
GIFT OF HYMAN N. GLICKSTEIN

Morris Louis | AMERICAN, 1912–1962
RUSSET. 1958
SYNTHETIC POLYMER PAINT ON UNPRIMED CANVAS, 7' 8¼" x 14' 5⅛"
(235.6 x 441.1 CM)
GIVEN ANONYMOUSLY

Proto-Pop Art

Robert Rauschenberg | AMERICAN, BORN 1925
UNTITLED (ASHEVILLE CITIZEN). c. 1952
OIL AND NEWSPAPER ON TWO CANVASES, 6' 2" x 28½" (188 x 72.4 CM)
PURCHASE

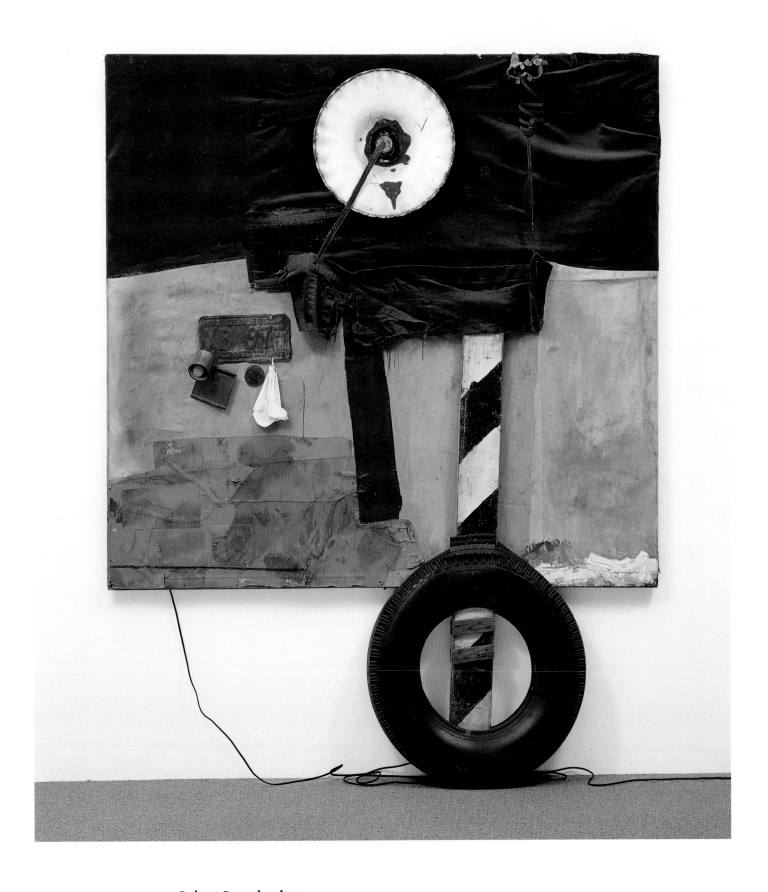

Robert Rauschenberg
FIRST LANDING JUMP. 1961
COMBINE PAINTING: CLOTH, METAL, LEATHER, ELECTRIC FIXTURE, CABLE, AND OIL PAINT ON COMPOSITION BOARD;
OVERALL, INCLUDING AUTOMOBILE TIRE AND WOODEN PLANK ON FLOOR, 7' 5⅛" x 6' x 8⅞" (226.3 x 182.8 x 22.5 CM)
GIFT OF PHILIP JOHNSON

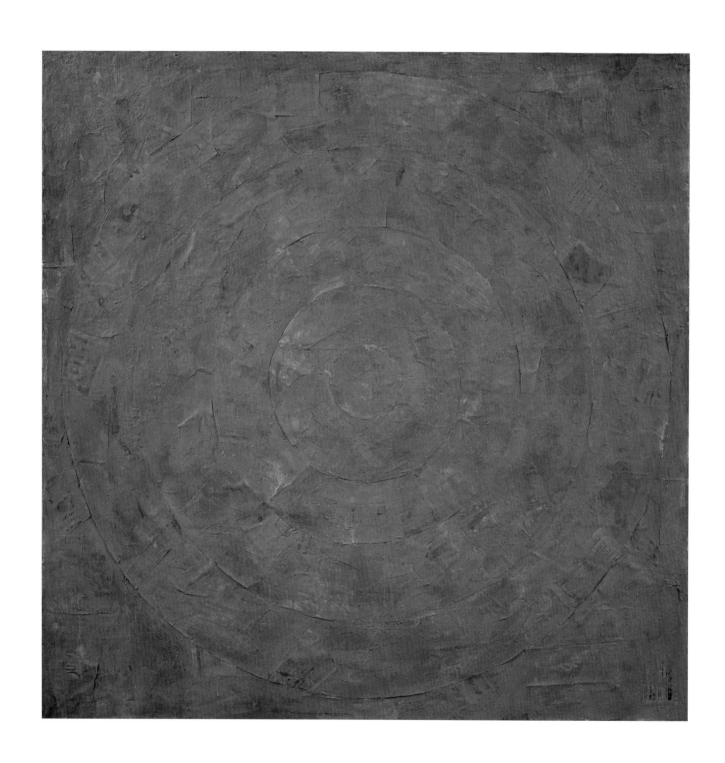

Jasper Johns | AMERICAN, BORN 1930
GREEN TARGET. 1955
ENCAUSTIC ON NEWSPAPER AND CLOTH OVER CANVAS,
60 x 60" (152.4 x 152.4 CM)
RICHARD S. ZEISLER FUND

Jasper Johns
WHITE NUMBERS. 1957
ENCAUSTIC ON CANVAS, 34 x 28⅛" (86.5 x 71.3 CM)
ELIZABETH BLISS PARKINSON FUND

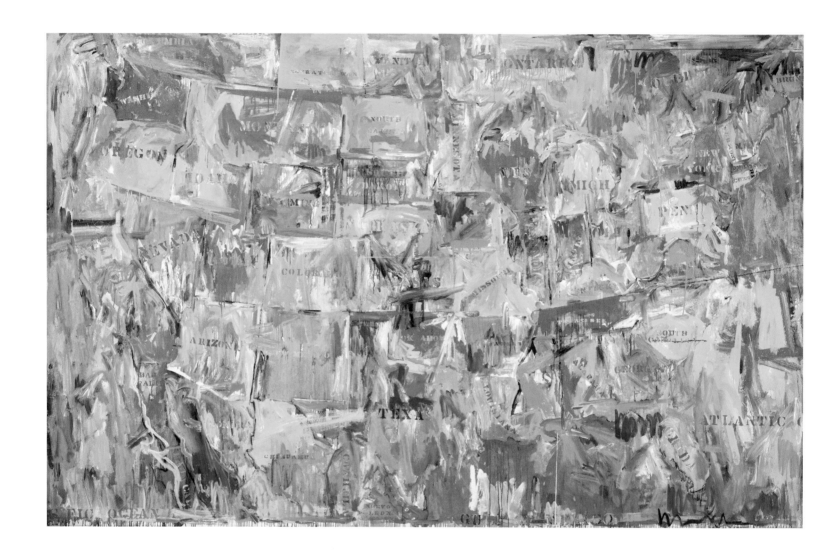

Jasper Johns | AMERICAN, BORN 1930
MAP, 1961
OIL ON CANVAS, 6' 6" x 10' 3¹/₄" (198.2 x 314.7 CM)
GIFT OF MR. AND MRS. ROBERT C. SCULL

Cy Twombly | AMERICAN, BORN 1928
THE ITALIANS. 1961
OIL, PENCIL, AND CRAYON ON CANVAS, 6' 6¼" x 8' 6¼"
(199.5 x 259.6 CM)
BLANCHETTE ROCKEFELLER FUND

Geometric Abstraction

Ellsworth Kelly | AMERICAN, BORN 1923
COLORS FOR A LARGE WALL. 1951
OIL ON CANVAS, MOUNTED ON SIXTY-FOUR WOOD PANELS;
OVERALL, 7' 10¼" x 7' 10½" (239.3 x 239.9 CM)
GIFT OF THE ARTIST

Alejandro Otero | VENEZUELAN, 1921–1990
COLORHYTHM, 1 [COLORITMO 1]. 1955
ENAMEL ON PLYWOOD, 6' 6¼" x 19" (200.1 x 48.2 CM)
INTER-AMERICAN FUND

The Art of the Real

The first exhibition at The Museum of Modern Art to recognize Pop and Minimalism was the last exhibition organized by Dorothy Miller in 1967 entitled *The 1960s*. Athough Pop art was already widely popular by 1962, Miller, in keeping with her and Alfred H. Barr, Jr.'s emphasis on seeking plurality in contemporary art, resisted identifying new movements in her survey of contemporary art, *Americans 1963*. Coming on the heels of a symposium on Pop art organized by Peter Selz at the Museum the year before, the 1963 exhibition was generally acknowledged as an endorsement of Pop, despite the curators' stated intentions and the fact that only four out of fifteen artists were Pop artists.

In 1968, with Pop and Minimal art admitted into the canon of modern art, E. C. Goossen organized *The Art of the Real*. Goosen's exhibition argued for a literalist art purged of "metaphor, or symbolism, or any kind of metaphysics," which he defined as a specifically American tendency discernible not only in Minimalism, but also in its precursors from Georgia O'Keefe to Morris Louis. Circulated widely abroad, *The Art of the Real*, despite its hotly debated premise, set the stage for Minimalism's international reception.

In 1969 critic Barbara Rose organized a retrospective of Claes Oldenburg's work. Citing the artist's emphasis on the physical as opposed to the metaphysical in his imagining of everyday objects, Rose firmly places Oldenburg's "low, vulgar, representational art of formal significance" in the context of 1960s American art. This formal significance is to be found in what she perceives as the artist's stylistic charade. Masquerading as a seemingly naïve, specifically American realism based on commercial art, Oldenburg's style turns out to be of great complexity, drawing from both the classic and romantic traditions of Western art, only to mock them all and formulate a new contemporary sensibility akin to the Baroque.

William Rubin's formalist approach to Frank Stella's work in his exhibition and catalogue of 1970 mirrors the artist's own theoretical inclinations. The first abstract painter of the so-called cool generation to be given a retrospective at the Museum, Stella developed one of the few genuinely new paths for the continued development of major non-figurative art. This new path is manifested in Stella's conception of painting as "non-relational," in which the use of biaxial symmetry and regular patterning in the organization of the picture surface deny any possibility of a spatial, directional, or relational reading. The precedent for this non-relational painting can be found in Abstract Expressionism. According to Rubin, it is in resistance to artists such as Barnett Newman and Jackson Pollock that Stella found the power of his art.

In 1978 the Museum staged an exhibition of the work of one of the foremost theoreticians of the period, Sol LeWitt. In emphasizing the potential for growth and transformation underlying LeWitt's work, critic Lucy Lippard reveals how the artist subverts the contained and static stance of Minimal art. His emphasis on the idea as the main content of his art, the multiplicity of its material formulation, and the hermeticism of its physical experience, in her view, firmly establishes him as the premier practitioner of Conceptualism.

The Museum's Richard Serra exhibition of 1986 was the only one of that decade to focus on the art of the sixties. Serra belonged to the generation of artists called Post-Minimalists. Although his work, in its emphasis on process, consciously departed from the Minimalist concern

with the finite object, critic Rosalind Krauss argues that his formulation of an "abstract subject" nonetheless relates to the Minimalist project in that both made an art "of the subject turned inside out." In Krauss's theory Serra's sculpture is modeled after the "abstract conditions of the body" and its shifting, always relative, spatial-temporal experience of the world.

Two years after Andy Warhol's death in 1987, Kynaston McShine organized a retrospective that marked the first full-scale critical examination of the artist's oeuvre and the first exhibition devoted to a Pop artist at the Museum in twenty years. Considering the overwhelming power of Warhol's celebrity, McShine set out to pull the curtain of fame. Emphasizing Warhol's dissatisfaction with his social background and physical appearance, his fascination with tabloid beauty, wealth, and stardom, and his early aspiration to fame as a transformative power, McShine reveals the "complex and private set of concerns" that informed Warhol's innovations from the outset.

The Warhol exhibition signaled the active reassessment of the art of the sixties, culminating in the 1998 *Pop Art* exhibition organized by Anne Umland for the High Museum in Atlanta. This was the first exhibition to examine the Museum's "ongoing affair" with Pop in all its specificity and complexity and offers exemplary in-depth analyses of Pop work in the Museum's collection.

In *High & Low*, an exhibition organized in 1990, Kirk Varnedoe and art critic Adam Gopnik traced the evolving relationship between modern art and popular culture from Cubism on. In conscious opposition to the theoretical discourse on the subject, the exhibition sought to look at the particulars of this exchange, and Gopnik's discussion of Roy Lichtenstein's paintings does just that: identify the comics sources and the individual illustrators behind the imagery, describe Lichtenstein's stylization of found motifs into Pop icons, and analyze how his reformulation of the comics language revitalized a dying genre.

With a Robert Ryman retrospective in 1993 and a Tony Smith retrospective in 1998, Robert Storr organized two exhibitions dedicated to artists who operated outside the realm of Minimalism, but whose related formal language affected their initial reception in the context of the critical debate surrounding it. Storr alternatively suggests a reading of the work of both artists against Minimalism and in keeping with their respective idiosyncrasies. Ryman's enterprise is described as a self-proclaimed Realism grounded in the autonomy of the painted picture and in the immediacy of its material reality. Smith's specificity emerges out of his generational adherence to Abstract Expressionism and its concept of art as a heroic individual enterprise. Where Minimalism deploys objective matter-of-fact-ness, Smith's sculpture appears "imbued with life force."

Another important concern to emerge in exhibitions over the past decade is the embrace of Minimalist principles by contemporary artists of the 1990s. Lynn Zelevansky argues in the exhibition catalogue for *Sense and Sensibility: Women Artists and Minimalism in the Nineties* that Minimalism, with its reliance on concepts such as repetition, the grid, modularity, and objecthood, "offered the first really versatile new set of formal strategies since Cubism, one that could tolerate the imposition of many different meanings." Such contemporary reformulation of sixties principles also stood at the center of Varnedoe's two exhibitions *Pop and After* and *Minimal and After*, conceived for the last cycle of MoMA 2000, *Open Ends*. Here Pop- and Minimalist-inflected art of the 1980s and 1990s was juxtaposed with that from the 1960s. The most recent project to address the legacy of sixties art, it also set the tone for future investigations.

— *Claudia Schmuckli*

Pop Art

Andy Warhol

Before and After. 1961
Illustrated on page 278

Kynaston McShine, *Andy Warhol: A Retrospective,*
1989, pages 14, 15, 16

Warhol's first major appearance as an artist came in 1961. He exhibited five paintings as a backdrop to mannequins sporting the latest fashions in a display window at Bonwit Teller. The imagery of all five works, whether drawn from the comic strips or from the advertisements printed in the newspaper, reflects his desires and deficiencies, for all traffic in vernacular metaphors of metamorphosis and self-transcendence. Of the three works from the comics, two show characters who change dramatically: Superman, who emerges from his secret identity of Clark Kent, and Popeye, who is made a new man by spinach . . . Even The Little King, from a comic strip more limited to the sight gag, is nonethelesss representative: the victory of the little guy. . . .

The images in the other two works in the Bonwit's window, *Advertisement* and *Before and After*, draw on newspaper material that is starkly nonfictional. The subject of both works is physical self-improvement. Promoting devices and products promising improved posture and silhouette, fuller hair, broader shoulders, and bigger arms, these ads touch the core of Warhol's physical insecurities. They also provide the impulse for much of his painting over the next several years.

The newspaper ads that most interested Warhol were graphically crude and terribly direct—aimed at the lowest common denominator, and delivered with maximum force and economy . . . As he worked on the paintings, he avoided "improving" these images, or any vestige of his personal handwriting. The rather un-sexy advertisements for such household items as pots and pans, kitchen appliances, hardware, and a television set, on the one hand, and self-improvement ads for nose jobs, trusses, and wigs, on the other, gradually give way to those for simple food and drink: Coca-Cola and Pepsi, and such products as Del Monte peach halves and Campbell's soup.

The newspaper suggested other avenues, which Warhol pursued simultaneously. It is of course a major medium for advertising, a means of proffering objects of desire in a way that Warhol, a veteran of print ad campaigns, understood as creating, as much as satisfying, the needs of the consumer. But more than this, the tabloids were seen as a source of sensational news and gossip, a vehicle for fame. Following the lives of glamorous celebrities provided the artist, hungering for recognition and starved for beauty, with a nourishment as essential as food.[1] . . .

The graphic immediacy of the tabloid format, with bold headlines and photos, appealed to Warhol's developed sense of style. . . . Warhol had been experimenting with mechanical means of reproduction (such as rubber stamps and silkscreens prepared from drawings) to produce works based on printed "currency," like the S & H Green Stamps, Airmail Stamps, and Dollar Bill paintings. Now he went further toward removing the traditional sense of the artist's "touch" by utilizing silkscreens prepared by a photo-mechanical process. This was the beginning of a new phase in the manipulation of his images taken from the mass media, images of disasters, celebrities, and products.

Roy Lichtenstein

Girl with Ball. 1961
Drowning Girl. 1963
Illustrated on pages 280, 281

Adam Gopnik, *High & Low,* **1990,** pages 199, 200

Almost without exception, Lichtenstein's comics paintings from the early 1960s (as Lichtenstein, of course, could not have known; all of the romance and war comics were unsigned) were adapted from the work of a small handful of ambitious comic-book artists. The styles of these artists were distinct enough that, thirty years later, their work can still be picked out immediately by the Berensons and Offners of the comics. Lichtenstein's romance images are adapted almost entirely from the works of Tony Abruzzo, John Romita, and Bernard Sachs; his war images almost entirely from the work of Russ Heath—and Irv Novick. High art on the way down

267

to the bottom met, without quite knowing it, low art struggling to find its way back up.

Lichtenstein recast his found images in complicated ways.[1] Ironically, he had to aggressively alter and recompose them to bring them closer to a platonic ideal of simple comic-book style—he had to work hard to make them look more like comics. The effects that make Lichtenstein into Lichtenstein involved not the aestheticizing of a consistent style through mechanical displacements, but the careful, artificial construction of what appears to be a generic, whole, "true-folk" cultural style from a real world of comics that was by then far more "fallen" and fragmented. His early pictures work by making the comic images more like the comics than the comics were themselves.

Lichtenstein was often taken with the Abruzzo-like close-ups of girls caught, lips parted, in states of clichéd emotion: tension, anxiety, misery. But he consistently simplified and isolated these images, translating what was essentially an illustration style into a comic-book style. . . .

Sometimes, Lichtenstein can seem like the perfect Abruzzite. Intuitively recognizing that the girls' faces had a kind of strange intensity that the other elements in the comics lacked, Lichtenstein would pull them out of context, until today the Abruzzo girls have become immortalized, through Lichtenstein, as pop clichés. In *Drowning Girl*, he changes a hero's name from what was, for his purposes, the wrong cliché—the peculiar "Mal"—the right cliché, the nifty "Brad." But the girl's face and the swirling, Beardsley-like, high-contrast liquid patterning of the background are lifted from the original almost entirely intact. . . .

Throughout these transpositions, Lichtenstein emphasizes his constant imposition upon his cartoon figures of Benday dots which, surprising as it may seem to those of us who have learned to see romance comics through Lichtenstein, are hardly visible in the original.

Jim Dine

Five Feet of Colorful Tools. 1962
Illustrated on page 282

Lucy Lippard, in *Three Generations of Twentieth-Century Art,* **1972,** page 150

Jim Dine shares with Jasper Johns a debt to both Marcel Duchamp and the Abstract Expressionists. There has in fact been a certain interplay between the two younger artists, although Johns matured considerably earlier. In Dine's *Five Feet of Colorful Tools,* there are cross references not only to other of his works with palettes and spectrums but also to

Johns's paintings that label (or mislabel) colors, as well as to Duchamp's Readymades, especially the snow shovel called *In Advance of the Broken Arm,* 1915. The *Five Feet* is also reminiscent of Duchamp's last painting, *Tu m',* 1918, which is dominated by the shadows of a bicycle wheel, hat rack, and corkscrew, and includes real safety pins to close a painted opening. Dine has made his tools—saws, hammers, pliers, screwdrivers, cramps, braces, and nuts—both realities and illusions, three-dimensional and "painted." Despite all this, plus the visual pun made by combining colors and shadows with actual objects, the configuration of this work has less to do with Dada than with Abstract Expressionism—especially those paintings by Clyfford Still in which jagged, irregular forms anchored at the edge cut into the field of the pictures.

The *Five Feet of Colorful Tools* was shown in the "New Realists" exhibition in 1962, which was installed in the Sidney Janis Gallery and a Fifty-seventh Street store one block away. The first group show in New York to juxtapose American Pop art and its European counterparts (including many works that had been seen the previous year in The Museum of Modern Art's exhibition "The Art of Assemblage"), it marked the end of Pop's underground phase and the beginning of its public triumph.

Claes Oldenburg

Floor Cake. 1962
Illustrated on page 283

Barbara Rose, *Claes Oldenburg,* **1969,** pages 145, 146, 152, 153

According to Oldenburg, his softening of objects should not be seen as the effect of atmospheric blurring on forms, but as "in *fact* a softening"—in other words, a literal translation of painterly values into their sculptural equivalents. Such a transmutation of originally pictorial effects into sculpture recalls the age of the Baroque, when painterly sculpture in the round was produced for the first time since antiquity. To this tradition, which stresses the tactile value of surface and the properties of the materials represented, belong the great Baroque sculptors—[Gianlorenzo] Bernini towering above them—as well as the late-nineteenth-century revival of painterly sculpture by such artists as [Edgar] Degas, [Auguste] Rodin, and Medardo Rosso. Oldenburg's soft sculptures are notable as being the first significant reassertion of this tradition in the 1960s. . . .

Although there are no fingerprints on Oldenburg's sculpture to remind one of his personal touch, his is

both an extremely personal and an extremely tactile art. The later Store objects, in particular, ask to be handled. Details are executed with meticulous care; variation is cultivated; each tiny plaster pancake and cupcake, each chocolate bar and sundae, is unique. What counts is the subtle contour, the small detail played against the large, simple form of the whole. Moreover, Oldenburg's aim is to enhance this tactility and intensify the urge to touch . . . This invitation to pick up or handle an object is also a function of the type of objects that Oldenburg chooses to make. The food, articles of clothing, and furniture are normally articles of personal contact, of the kind we would normally tend to pick up, handle, or consume. . . . By choosing as his subjects such everyday objects, rather than making paintings or sculpture immediately identifiable as "art," Oldenburg forces the viewer to react to them in terms of his normal expectations instead of with the specialized, detached attitude generally associated exclusively with aesthetic encounters in the artificial isolation of a museum or gallery. The artist's intention is to short-circuit perception by forcing a direct, intimate, and personal contact with the work. . . .

The first series of soft sculptures, the objects made for the Green Gallery exhibition of The Store, were meant to appear crude and vulgar. Splashed with quick coats of dripping paint, they sink comfortably into the floor and thereby solve the problem of a base, which has plagued twentieth-century sculpture. Pat Oldenburg [the artist's wife] has described how the seams on these first puffed and shirred pieces, such as the *Floor-Burger*, *Floor-Cone*, or the *Floor-Cake*, were allowed to be casual; whereas later, when working in a more refined, smooth vinyl version of the soft sculpture, Oldenburg would demand the utmost precision. . . .

Because Oldenburg demands the freedom to allow his imagination to meander through the history of art, his own art becomes a metaphor for the democratization of art history as well. "Imagination," he insists, "does not obey any proprieties, as of scale or time, or any proprieties whatsoever." In other words, the two chief standards of academic art are lacking: there is no decorum and no canon.

Ed Ruscha
OOF. 1962–63
Illustrated on page 277

Anne Umland, *Pop Art,* **1998,** page 92

Oof! Like a punch line without a joke, or an effect

searching for a cause, the bright yellow letters that spell out the word "oof" are centered and isolated within the boundaries of Ruscha's canvas. They lack even a punctuating exclamation mark. Belonging to that class of words known as interjections, "oof," despite its deadpan presentation, is onomatopoeic, it imitates a sound from the audible world. An "oof" is often prompted by an action like a punch in the stomach or sinking down, exhausted, into a chair. Involving an abrupt, sometimes violent, expulsion of breath, it is typically human. Like other words that appear in Ruscha's paintings of this period . . . it often functions as an interruption, just as, visually speaking, it interrupts the deep blue of the painting's ground.

In its written form, "oof" has definite pop-culture associations, in particular those of comic-strip or cartoon language. Unlike the short phrases or words included in [Roy] Lichtenstein's comic-book paintings, however, it has no graphic sound bubble or any sort of explanatory surround. As a result, it imbues Ruscha's spare, abstract painting with an uncanny, anthropomorphic presence. At the same time, it emphasizes the gap that exists between the noise of human speech and the silence of the written (or painted) word. Emblazoned across the flat opaque surface of Ruscha's canvas, "oof" appears in a state of suspended animation. Noise is presented visually, muted, and severed from literal sound just as the word is severed from clues to its meaning.

Frustrating all but the most rudimentary attempts at reading, *OOF* insists that it is there to be looked at, forcing us to distinguish, as the critic Peter Schjeldahl has noted, between the word as sign and the word as sight. Appearance, sound, and spelling— the "non-discursive aspects of language"[1]—are highlighted and brought, literally, to the foreground. To look at *OOF*, is, first of all, to acknowledge its abstract simplicity, its hard-edged geometric forms, restricted palette, and uninflected ground. At the same time, its two yellow "O"s appear to ogle or gaze at us, doubling as glow-in-the-dark, cartoonlike "eyes." The plain, sans-serif style of *OOF*'s letters contributes to the work's cartoonlike punch and graphic effect.

Tom Wesselmann
Still Life #30. 1963
Illustrated on page 282

Leslie Jones, in *Pop Art,* **1998,** page 122

Following his 1961 exhibition of Great American Nudes, Wesselmann initiated his second major series

based on a traditional theme—the still life. Like the nudes, the still life featured in *Still Life #30* is set in a contemporary domestic interior; from the bedroom to the kitchen (and eventually the bathroom), Wesselmann's paintings of the early to mid-1960s depict the private spaces of "typical" middle-class homes in postwar America. Displayed within a meticulously clean, orderly, and color-coordinated kitchen, a cornucopia of mass-produced food items spills onto the blue-and-white checkered tablecloth.... The contents of *Still Life #30* represent an inventory of mass-produced appliances and food that in the postwar years signified American economic prosperity, while the distant vista of New York City seen through the window locates the home in the suburbs.

The incorporation of three-dimensional objects combined with pasted and painted images presents the viewer with three different layers, literally and figuratively, of representation. For Wesselmann, the hand-painted and machine-made elements "traded off" against one another, heightening the visual tension of the painting surface. By juxtaposing "real" objects, photomechanically reproduced products, and other conventionally painted accoutrements, Wesselmann may also have intended to suggest the disparity between the idealized image of American domesticity portrayed in the media and actual domestic life. Upon close examination, even the three-dimensional elements included in *Still Life #30* are "fake": the 7UP bottles and roses are plastic replicas, the Picasso is a reproduction, and the refrigerator door, a mere facade.

As homemakers, it was, of course, women who were implicated in the maintenance of the American domestic ideal. In addition to the pink color scheme, Wesselmann calls attention to the notion of the kitchen as a "feminine" space by painting two perfectly round oranges which, in his other paintings, are often matched with female breasts. These same two oranges, however, combine with the skyscraper that appears above them to suggest male genitals, insinuating a "masculine" presence within this private, feminine realm.[1]

In this and other paintings in the Still Life series, Wesselmann decorates his domestic interiors with reproductions by great modern painters. Juxtaposed with 7UP, the [Pablo] Picasso may be perceived as just one more brand name product to be consumed by American society. Or, hung as it is within a middle-class home, it may attest to the democratization of high art brought about by mechanical reproduction. In either case, Picasso has been subsumed by mass culture. Another high-art reference in *Still Life #30* are the yellow, red, and blue panels characteristic of Mondrian's explorations into pure abstraction which, in Wesselmann's painting, function purely as interior design. In the context of the kitchen, Picasso and [Piet] Mondrian become decorator items; in the context of the museum, Wesselmann's kitchen becomes art. The interplay between high and low in *Still Life #30* raises questions concerning both the nature of art and idealized notions of domesticity.

Abstract and Minimalist Painting

Frank Stella
The Marriage of Reason and Squalor, II. 1959
Illustrated on page 284

William Rubin, *Frank Stella,* **1970,** pages 20, 21, 25, 26, 32

Stella began the Black paintings late in 1958.... The sketches of the Black pictures, made on drawing paper and yellow pads (graph paper only came later), set out the schemas of their emblematic patterns in a very summary manner.[1] Stella then painted the stripes freehand on the canvas. Sometimes he did not know how many bands the picture would contain....

Stella's absolute bilateral symmetry would produce a sense of *imbalance,* precisely because his configurations are not designed to be read across the picture. Stella's paintings—and those of certain of his contemporaries—force us to look in a different way; the apprehension of their balance demands an instantaneous visual grasp of their oneness.

In order to assure his absolute symmetry, Stella was compelled to force out of the picture the implications of illusionist space that were still present to varying degrees in geometrical painting.... His monochromy, his avoidance of modeling, his "negative pat-

tern," and use of deep stretchers helped accomplish this. But as Clement Greenberg has observed, *absolute* flatness is possible only on an empty canvas.[2] A single line drawn on its surface is sufficient to compel some kind of spatial reading. Hence Stella had to confront the fact that though he had mightily pared down the suggestion of space, he could never totally abolish it. His solution was the "regulated pattern" which "forces illusionistic space out of the painting at a constant rate." In the end, it is the "constant rate" that is the key to the spatial equilibrium and thus to the symmetry. We might therefore recast Stella's statement by saying that "such inevitable vestiges of spatial suggestion as remain are kept at even depths by the regular pattern, hence maintaining the possibility of absolute symmetry.". . .

The immediate predecessor of Stella's "non-relational" image is to be found not in the geometrical tradition but in the all-over style of [Jackson] Pollock and the related configurations of [Mark] Rothko and [Barnett] Newman. The synoptic, holistic character of Pollock's poured pictures depended on suppressing traditional hierarchies of size in favor of an approximate all-over evenness in the pictorial fabric. The similar all-over distribution of color, which averaged out into a tonal whole, and the more or less even densities of pigment dosage, assured a web which would be biaxially symmetrical and frontal and situated in a space that—however it might be read[3]—would suggest an approximately even depth throughout. Rothko's characteristic configurations also combined frontality, lateral symmetry, and an elusive but approximately even depth, while in Newman the image was frontal, but the symmetry was usually vertical rather than lateral. . . . Newman's minimizing of "visual incident," his rectilinear format, and his less painterly facture anticipated the manner of Stella, while the all-overness of Pollock foreshadowed Stella's synoptic, biaxially symmetrical configurations. . . .

Stella's Black pictures divide roughly into two groups: those painted during 1958 and through the fall of 1959, and those dating from the winter of 1959/60. In the earlier group, the black bands are all rectilinear and parallel to the framing edge. . . . *The Marriage of Reason and Squalor* . . . is symmetrical only on its vertical axis, its binary form constituting, in effect, a mirror-image pairing of the configuration. In none of these paintings is the symmetry exact, however, since they were all painted freehand from sketches that were less fully elaborated than were the graph-paper studies for later works.

This is, of course, the way Stella wanted it. Not only did he wish to avoid the mechanical appearance of the truing and fairing of geometrical art, but he wished frankly to reveal the tracking of the brush with whatever awkwardness that might entail. Such an approach constituted for him more than an affirmation of anti-elegance; it revealed an insistence upon the importance of the *conception* of the picture as opposed to the refinements of its *execution*.

Agnes Martin
Red Bird. 1964
Illustrated on page 286

Amelia Arenas, *Abstraction, Pure and Impure,* **1995,** n.p.

A Zen silence pervades [Martin's] work. Her gentle rhythms are the visual equivalent of a chant, monotonous and constant, lulling the eye into introspection. As Martin says, "the work is all about perfection as we are aware of it in our minds," but "the paintings are very far from being perfect." Looking at them closely, one can follow the delicate variations of the lines that edge the grey bands; one can imagine the pencil sliding tentatively over the field, wavering slightly as it responds to the weave of the canvas.

Some critics have proposed a link between these nuanced paintings and the vast wheat fields of the farm in Vancouver where Martin lived as a child, but she insists that her work is not *about* nature. However, it is hardly about "pure form." If anything, it is an effort to release the tight intellectual grip that form has held on painting. A near contemporary of the Abstract Expressionists, Martin felt at odds with the individualism of her generation. The leanness of her compositions and her self-effacing technique made her seem more akin to some of her younger contemporaries, the Minimalists. But Martin does not seek an exacting scrutiny of sensory phenomena. Her monastic studio method is a way to prevent the interference of the ego with the voice of the spirit, in order to reveal the tacit continuum of life.

Robert Ryman
Twin. 1966
Illustrated on page 287

Robert Storr, *Robert Ryman,* **1993,** pages 24, 25, 26

Starting in 1965 Ryman . . . pursue[d] avenues parallel to those travelled by the minimalists, whose hallmarks are routinized handwork, modular formats and programmatic production. The "Winsor" paintings [of which *Twin* is on] . . . were executed on sized but

unprinted linen with the same brand of cool white Winsor & Newton oil pigment that lends its name to the group. . . . The "Winsors," properly speaking, were done with a two-inch brush that could cover about six to ten inches before running out. Dragged over the dry tooth of the fabric, the opaque white paste leaves a crackling or clotted edge, horizontal bristle tracks, and at the point where it overlaps with the next stroke there is often a thick crest. In . . . *Twin*, Ryman . . . employed a specially made twelve-inch-wide brush and thinner, smoother paint, so that the grain would be finer, and the white could be pulled all the way from one side to the other without reloading. The painterly field that results is extraordinarily active. Tripping on the lateral striations in the paint as it would in much magnified fashion off the louvers of a white venetian blind, light vibrates at an intense pitch. Where the paint is thickest, it creates reflective hot-spots and small contrasting shadows; where strokes merge in a upright seam an irregular counter-rhythm to the horizontal segments catches the eye so that the whole painting becomes a sliding grid of still white ribbons laid end to end.

Inevitably, the "Winsors" summon to mind Frank Stella's "Black Paintings" of 1959 (see page 284). . . . When, in 1965, Ryman adopted a method similar to the one employed in the "Black Paintings," his choice of a different paint and application substantially altered the results. These differences in technical approach define their basic aesthetic differences as well. Stella is a theoretically inclined formalist; Ryman is a lyric pragmatist. . . . For Ryman, the art of painting is a search for particulars and distinctions; accordingly, composition is an experiment in the behavior of the medium and its sensory effects. . . . Stella tries to make things happen to painting; Ryman paints in order to see things happen. . . . In the "Winsors" Ryman sets his course, monitors the distribution of pigment and discovers in the brush tracks the structure of concentration and the fascination of random incident. All the works in the series have the same design; each depends for its identity on minor shifts in painterly emphasis. . . .

Small paintings with the wide, waxing lozenges and large ones . . . are clearly informed by Ryman's study of [Mark] Rothko. Yet, rather than evoke a diffuse and remote "sublime," the white lozenges in Ryman's paintings mate hypnotic luminosity and tactile immediacy. Standing in front of them, the viewer is at once drawn toward and held in place by the surface of these paintings. Their radiance releases the spirit, but the spirit remembers its body and takes satisfaction in the tangible proportions the body registers.

Minimalist Sculpture

Tony Smith

Free Ride. 1962
Illustrated on page 291

Robert Storr, *Tony Smith*, **1998**, pages 11, 25, 27

Tony Smith's lifelong quest was to seize upon the defining framework of . . . "wholeness" and represent it in concrete terms. Rather than admit a categorical separation of natural and artificial forms, he sought a generative connection between them. By itself textbook geometry seemed lifeless to him; in time, so, too, did most varieties of geometric stylization in modern art. Mathematics, nevertheless, remained the key to unlocking the mysteries of dynamic form, models for which Smith found in the formation of crystals and in the growth of elemental organic matter. . . . Smith shunned overt figuration but his regular and apparently inert solids followed this credo in their implicit anthropomorphism, while his irregular shapes seemed to be internally oriented by some vital impulse. . . .

Free Ride is the partial contour of a cube six feet eight inches on each side. Sculpturally speaking, the piece defines space graphically while physically occupying it and is thus simultaneously emblematic and dynamic. In Joan Pachner's words: "Smith created a work dependent not on a traditional bilateral symmetry, but on a more organic kind of rotation or balance arranged around an imaginary center point."[1] . . .

The model for *Free Ride* had been patched together from Alka-Seltzer boxes, in accordance not only with his habits—at other times milk cartons had been his basic building block—but also with his pedagogical technique, of which he was perhaps the greatest direct beneficiary. . . .

The affinities between Smith's work and that of

the "minimalists"—all of whom eschewed the term—are not to be denied. Like theirs, Smith's sculptural language was geometric and structurally "fundamentalist," his facture impersonal and largely indirect, and—as [Michael] Fried had accurately observed but incorrectly analyzed—his attention to an object's situation was essential to the impact of the piece. Viewed from the perspective of Abstract Expressionism's emphasis on improvisation as a means of psychological transcription, as distinct from preordained compositional constructs, Smith would, superficially, seem to have common cause with [Donald] Judd, [Carl] Andre, [Robert] Morris, [Sol] LeWitt, and their cohort.

The reality was that Smith retained all the basic attitudes of his contemporaries despite the fact that he was breaking new ground in a circumstantial alliance with his juniors. Methodical certainly, Smith was never consistently programmatic. "Morris and Judd and all those guys really thought about what they were doing. I never thought about anything that I did. I just did it," he told one interviewer.[2] To another, he said: "I use angles that are derived from different solids. When they go together, they do not follow any internal system. I assemble them, you might say, in capricious ways rather than systematic ways. You have to take each plane as it comes and find out in what way it will join the other planes."[3] Intuition combined with trial and error was his *modus operandi*, backed up, of course, by lifelong familiarity with the basic mathematical variables that comprised his conceptual and material medium. Undeniably, Smith made use of systems, but their role was to engender unanticipated choices rather than any foreseeable outcome. To [E. C.] Goossen he said it most simply, "I don't make sculpture, I speculate in form."[4]

Walter de Maria
Cage II. 1965
Illustrated on page 290

MoMA Highlights, 1999, page 286

Cage II may seem easy to grasp: a space sealed by bars—a cage. But it would be a thin person indeed who could fit in this narrow room, and in any case, how would anyone get in? There are no doors, no hinges. The metal, too, a pristine stainless steel, is richer than brute prison iron. *Cage II* is surely a paradox: a cage made elegant and abstract.

The paradox only multiplies, for *Cage II* is also a kind of portrait. It remakes a piece from 1961, in wood, but otherwise [is] the same except for the title: *Statue of John Cage.* The John Cage whose name gave de Maria a pun was, of course, the well-known composer and theorizer of modern music. But an aesthetic tradition is also cited here, for Cage had close links to an art-making approach associated with Marcel Duchamp (a long-standing friend of Cage's)—an approach favoring conceptual thought, and, also, a love of puns and wordplay.

The foursquare geometry of *Cage II*, meanwhile, and the purity of the work's medium, point in another direction—toward the Minimal art of the 1960s, an art of system and order. Yet in the work's enigmatic combination of openness and rigor there remains a tribute to the paradoxical artist and musician who inspired it.

Sol LeWitt
Serial Project, I. 1966
Illustrated on page 293

Lucy Lippard, *Sol LeWitt,* **1978,** pages 23, 25, 26

Integral to the systems that generate LeWitt's art is the "idea," which, he has implied, can be considered synonymous with intuition.[1] He is far more concerned with what things are and how they come about than with how they look. His art is an objective *activity*, related to play in the most profound sense of fundamental creative discovery. The elusive "idea" that delivers his work from academic stagnation is transformation—the catalytic agent that makes it *art* even when the artist plays down its visual powers. . . .

LeWitt's work is rich in contradictory material, which operates at times as a mental and at times as a visual construct. He confronts concepts of order and disorder, open and closed, inside and outside, two- and three-dimensionality, finity, and infinity, static (modular) and kinetic (serial). For all the overt simplicity of his serial systems, the content of his work is often hermetic. On one level, the concepts themselves may be perfectly accessible, but the viewer needs an overview to understand not only the mechanism of the system, but also the philosophy by which the art was made *from* that system. It has also been part of what artist Terry Atkinson has called LeWitt's "quiet strategy"[2] to actually hide things, most of which are subsequently revealed by the operations of the same systems that have hidden them. This lends a progressive dimension even to modular works, and further transforms the serial works. . . .

In 1966–67, this idea was subjected to the more complex systems of LeWitt's later work with *Serial*

Project No. 1 (ABCD), four nine-part pieces on a gridded base that explored the known and unknown within a finite, self-exhausting framework. Here sensuous or perceptual order was firmly neglected in favor of conceptual order, reflecting LeWitt's notion of a "nonvisual" art that could be made (and appreciated) by a blind person. The project as a whole must be read sequentially and conceptually; in some parts the closed elements are contained by open ones so both are visible, but in other parts, the open elements are contained by the closed or the closed by the closed, leaving the viewer to believe what s/he cannot see. . . .

The hermetic notion also points up the Conceptual aspect of LeWitt's art because it forces the viewer to think, sometimes to guess, and to decide whether what is inferred is in fact true. *Serial Project No. 1* was, therefore, a highly significant development in the Minimal movement in that it indicated LeWitt's dissatisfaction with the "specific object," or the mute Gestalt. The goal of Minimalism (or in fact of most 1960s art, far more than that of the 1970s) was to find a new way of making art, a new vocabulary and even new forms—something "neither geometric nor organic," as Don Judd put it.[3] While Minimal art succeeded in logically extending the Cubist-Constructivist tradition by divesting it of the expressive touch and compositional subjectivity hitherto associated with art and by making clear that even the most obvious forms, executed by assistants or in a factory, could contain or transmit complex esthetic content,[4] form, or the physical vehicle, still presented a major problem in advance. Being stuck with geometry was not entirely satisfying to the more visually oriented of these artists.

LeWitt, however, saw no need to invent new forms and is still not interested in originality.[5] He was content with the "relatively uninteresting, standard and officially recognized" forms of the square and the cube because "released from the necessity of being significant in themselves, they can be better used as grammatical devices from which the work may proceed." By synthesizing the Cubist-Constructivist tradition with the intelligent perversity of the best of the Surrealist tradition, LeWitt could incorporate both order and disorder, and thereby set up a far more complex *modus operandi* than that offered by the basic Minimalist doctrines, with their sources in Josef Albers, Ad Reinhardt and Jasper Johns.

Carl Andre
144 Lead Square. 1969
Illustrated on page 292

Robert Storr, *On the Edge,* 1997, page 20

From the rigid male figures of earliest Greek antiquity to the elegantly simplified heads, birds, and pillars fashioned by Constantin Brancusi in the first half of this century, sculpture, when detached from architecture, has generally stood upright in our midst. It is, in a wisecrack usually ascribed to the abstract artist and wit Ad Reinhardt, "the thing you bump into when you back up to look at a painting."

Thanks in large part to the work of Carl Andre, this generalization no longer holds true. Instead, a sculpture may now be something you walk across, like a carpet; step onto, like a patio platform; or wander through, like purposely scattered stones in a garden. Even if it should still crowd the gallery-goer or claim large segments of his or her territory, it does so as something not apart from but a part of his or her immediate reality.

Despite their obvious differences over the position and, correspondingly, the relative importance of painting and sculpture, Andre has always worked in tacit agreement with Reinhardt regarding the resolute nonreferentiality of modern abstract art. Just as Reinhardt's gridded pictures represent nothing, offering instead a unique experience of an externally bounded and internally ordered visual field, Andre's variously squared-off or irregularly scattered sculptures occupy and articulate physical space in a similarly austere but even more matter-of-fact way. . . .

The essence of Andre's innovation was to establish a strong sculptural presence without recourse to traditional monumentality. Instead of building up, as artists of the past as well as he himself had once done, Andre built out. Instead of confronting the public with static monoliths, he created markers and zones around and through which people would move, thereby becoming active protagonists in the work rather than passive viewers of it.

Although Andre may be credited as one of the first artists of his generation to explore the possibilities of the random distribution of objects in space . . . the vast majority of his sculptures have been based on the sequential and often plainly symmetrical deployment of a given set of standardized components. These elementary but imposing compositions frequently recall the similarly emblematic configurations found in [Frank] Stella's black, aluminum, and copper "stripe" canvases of 1959–61, signaling the extent to which Minimalism depended upon precedents in painting even though its sculptural manifestations seemed to dominate the tendency as a whole.

Post (and non) -Minimalism

Lee Bontecou
Untitled. 1961
Illustrated on page 294

MoMA Highlights, **1999,** page 254

Painting or sculpture? Organic or industrial? Invitation or threat? A rectangle of canvas, like a painting, but one that pushes its faceted, equivocally machine-like mouth out from the wall, this untitled work lives on ambiguity. What many have seen in Bontecou's works of this kind, with their built-up rims and hollow voids, are the nacelles or casings of jet engines, and she, too, acknowledged their influences: "Airplanes at one time, jets mainly." Interest in the streamlined products of modernity may link Bontecou to Pop art, a movement developing at the time, but her work's dark and restricted palette gives it a sobriety distant from much of Pop, and she describes the world more obliquely. Also, instead of replicating an engine's metallic surfaces, she stitches panels of canvas over a steel skeleton. If this is a machine, it is a soft one—which, again, leads many to think of the body, and its charged interiors and openings.

Mystery is one quality Bontecou is interested in, and also "fear, hope, ugliness, beauty." As for those inky cavities, a consistent theme, she remarks, "I like space that never stops. Black is like that. Holes and boxes mean secrets and shelter."

Eva Hesse
Vinculum, II. 1969
Illustrated on page 297

Lynn Zelevansky, *Sense and Sensibility,* **1994,**
pages 8, 9, 10

Eva Hesse's use of repetition with abstract forms that are either erotic or have uncomfortable, even repugnant, associations with the human body, may have emphasized the absurd nature of repetitive activity, but the connection to Minimalism is nonetheless there. . . .

Post-Minimalism enabled women as a group to have an impact on the art world for the first time; this occurred in terms of both the critical dialogue and the marketplace. Eva Hesse was among the first

to offer an alternative to orthodox Minimalism. Her mature career spanned only five years,[1] but during that time she created emphatically handmade work that, in its bold exploration of disquieting psychological realms, prefigured certain concerns of the Women's Movement as they would be manifested in the art world. Its preoccupation with the body, and its embrace of absurdity and freedom, opened up new avenues of expression that would speak especially pointedly to artists of the following two and a half decades.[2] . . .

Hesse's work resonates in many directions, and it is clear that part of what she had to overcome in order to make her best pieces was the fear of manifesting "feminine" traits in her art. . . .

It is evident in Hesse's works, from *An Ear in the Pond* of 1965 to *Addendum* of 1967, with their breast-like forms; from *Ingeminate* of 1965 to *Untitled or Not Yet* of 1966, which reference male genitalia, or *Accession II* of 1969, which contends with all possible associations with the word "box," from the vaginal to the Minimalist, that, in overcoming her fear of being uncool or untalented, she also found the courage to confront and accept her sexual identity. Clearly, she did so with the vengeance of those who must have truth at all costs: "I could take risks . . . my attitude toward art is most open. It is totally unconservative—just freedom and the willingness to work. I really walk on the edge."[3]

Robert Morris
Untitled. 1969
Illustrated on page 296

MoMA Highlights, **1999,** page 287

Although Morris helped to define the principles of Minimal art, writing important articles on the subject, he was also an innovator in tempering the often severe appearance of Minimalism with a new plasticity—a literal softness. In works like this one, he subjected sheets of thick industrial felt to basic formal procedures (a series of parallel cuts, say, followed by hanging, piling, or even dropping in a tangle), then accepted whatever shape they took as the work of art. In this way he left the overall configuration of the work (a configuration he imagined as temporary)

to the medium itself. "Random piling, loose stacking, hanging, give passing form to material," Morris wrote. "Chance is accepted and indeterminacy is implied. . . . Disengagement with preconceived enduring forms and orders for things is a positive assertion."

This work emphasizes the process of its making and the qualities of its material. But even if Morris was trying to avoid making form a "prescribed end," as a compositional scheme, the work has both formal elegance and psychological suggestiveness: the order and symmetry of the cut cloth is belied by the graceful sag at the top. In fact, a work produced by rigorous aesthetic theory ends up evoking the human figure. "Felt has anatomical associations," Morris has said, "it relates to the body—it's skinlike."

Richard Serra
One Ton Prop (House of Cards). 1969
Illustrated on page 296

Rosalind Krauss, *Richard Serra/Sculpture*, **1986,** pages 20, 21, 22, 23, 24

In 1968, in addition to the actions to *cast, roll,* and *tear,* Serra had used lead to enact another transitive relationship: to prop. One sheet of lead, tightly rolled to form a pole, was inclined against another, still-flat sheet, hoisted on the plane of a wall, the dense inert weight of the one propping up the leaden expanse of the other. Insofar as *Prop* depended upon the wall plane as a ground, it was of course open to much the same criticism from its maker as *Casting* and *Tearing.* . . . But where it differed from the others was in the process informing this work: it was not something applied to the materials of the object, imprinting itself upon them, an external force coming from outside them to leave its trace so to speak. In *Prop* the process was a function of the relationship between the two elements of the piece, working against each other in a continuous labor of elevation. It was in this constantly renewed tension, active within the object at each moment, necessary to the very prolongation of its existence, that Serra located a special aspect of his vocation as a sculptor.

The Prop Pieces of 1969—*One Ton Prop (House of Cards), 5:30, 2-2-1*—provided the basis for Serra's criticism, voiced in 1970, of his earlier work. For these sculptures are resolutely vertical, their internal dynamic securing their independence of any external ground, be it floor or wall. And the extremely simple principle of their verticality rests in the heaviness of lead and its earnest response to the downward pull of gravity; for in that pull there operates the resistance that is the principle of the prop—stability achieved through the conflict and balance of forces. In *One Ton Prop (House of Cards)* four lead slabs (each weighing 500 pounds) maintain their mutual erectness through the reciprocity of their leaning sides, propping each other up by weighing each other down. . . .

In the Prop Pieces, Serra discovered what might be called an erotics of process. And this erotics of process can be thought of as a new site within which to locate the problematics of sculpture. . . .

One Ton Prop, in breaking with the closed, preformed geometries of [Donald] Judd's boxes or Tony Smith's prisms, does not merely put in place the paradox of an unstable geometric form. It forces a certain analogy between that form and the human body, which, like the Prop, "continues."

In some sense, of course, all sculpture configures the human body; that is, it operates as a model—of wildly divergent kinds—of the human subject: as an image of ideal repose or of the purposiveness of action; of the centeredness of reason or the abandon to feeling. Further, it does this no matter how reduced it might be in the manner of its actual likeness to the human body. A generation of Early Modernist sculptors demonstrated sculpture's capacity to model the human subject from the simplest forms and from the most ordinary ones: from the shape of an egg to the presentation of a teacup. The issue, then, is not that the Props create for their viewer the experience of the human subject; rather, the question must be what kind of subject they insist on modeling. . . .

The way *One Ton Prop* creates a geometric form that is all outside, nothing but exterior, so that one's sense of the "inner being" of this form is utterly demystified, is part of this problematic of public versus private. Steve Reich, comparing this phase of Serra's work with what he was then doing musically, said: "The analogy I saw with Serra's sculpture, his propped lead sheets and pole pieces (that were, among other things, demonstrations of physical facts about the nature of lead), was that his works and mine are both more about materials and process than they are about psychology."[1] But by making the very constitution of this "outside" a question of an always precarious, restabilizing balance, a matter of propping, a function of an equilibrium that has constantly to be resecuring itself from within the pressures of time, *One Ton Prop* reformulates the inside/outside issue, for the "outside" itself is now understood as organized within the temporal: "of waves," we had read, "of tides . . . of time . . . to continue."

Pop Art

Ed Ruscha | AMERICAN, BORN 1937
OOF. 1962, reworked 1963
OIL ON CANVAS, 71½ x 67" (181.5 x 170.2 CM)
GIFT OF AGNES GUND, THE LOUIS AND BESSIE ADLER
FOUNDATION, INC., ROBERT AND MERYL MELTZER, JERRY I.
SPEYER, ANNA MARIE AND ROBERT F. SHAPIRO, EMILY AND
JERRY SPIEGEL, AND ANONYMOUS DONOR, AND PURCHASE

Andy Warhol | AMERICAN, 1928–1987
BEFORE AND AFTER. 1961
SYNTHETIC POLYMER PAINT ON CANVAS, 54 x 69⅞" (137.2 x 177.5 CM)
GIFT OF DAVID GEFFEN

Andy Warhol
S&H GREEN STAMPS. 1962
SILKSCREEN INK ON CANVAS, 71¼ x 53¾" (182.2 x 136.6 CM)
GIFT OF PHILIP JOHNSON

Roy Lichtenstein | AMERICAN, 1923–1997
GIRL WITH BALL. 1961
OIL AND SYNTHETIC POLYMER PAINT ON CANVAS, 60¼ x 36¼"
(153 x 91.9 CM)
GIFT OF PHILIP JOHNSON

Roy Lichtenstein
DROWNING GIRL. 1963
OIL AND SYNTHETIC POLYMER PAINT ON CANVAS, 67⅝ x 66¾" (171.6 x 169.5 CM)
PHILIP JOHNSON FUND AND GIFT OF MRS. BAGLEY WRIGHT

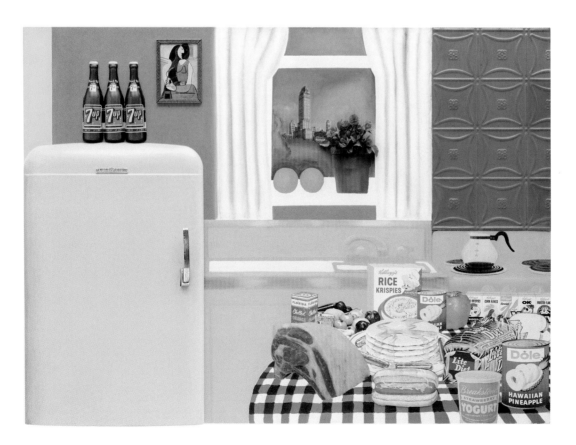

Jim Dine | AMERICAN, BORN 1935
FIVE FEET OF COLORFUL TOOLS. 1962
OIL ON UNPRIMED CANVAS SURMOUNTED BY
A BOARD ON WHICH THIRTY-TWO PAINTED
TOOLS HANG FROM HOOKS; OVERALL, 55⅝ x
60¾ x 4⅜" (141.2 x 152.9 x 11 CM)
THE SIDNEY AND HARRIET JANIS COLLECTION

Tom Wesselmann | AMERICAN,
BORN 1931
STILL LIFE #30. 1963
ASSEMBLAGE: OIL, ENAMEL, AND SYNTHETIC
POLYMER PAINT ON COMPOSITION BOARD
WITH COLLAGE OF PRINTED ADVERTISEMENTS,
PLASTIC ARTIFICIAL FLOWERS, REFRIGERATOR
DOOR, PLASTIC REPLICAS OF "7-UP" BOTTLES,
GLAZED AND FRAMED COLOR REPRODUCTION,
AND STAMPED METAL, 48½ x 66 x 4"
(122 x 167.5 x 10 CM)
GIFT OF PHILIP JOHNSON

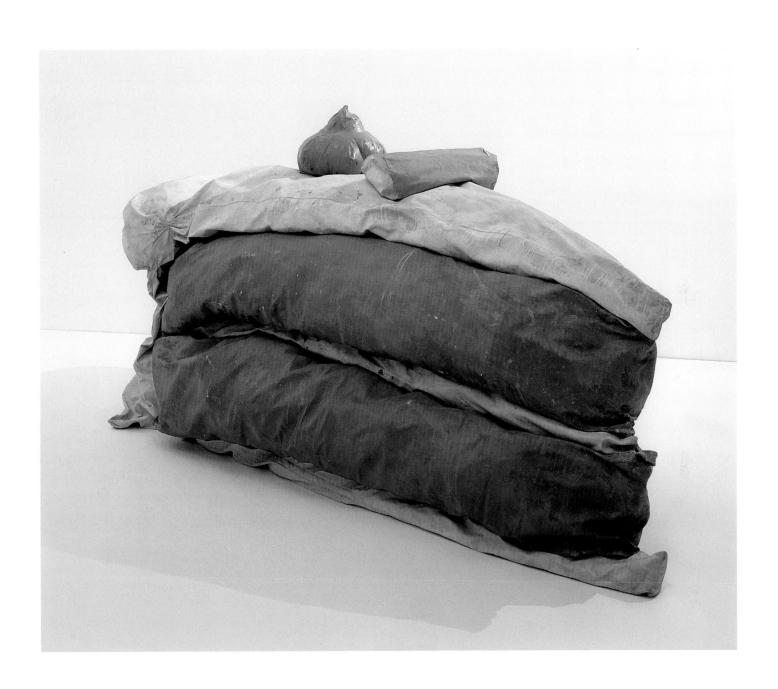

Claes Oldenburg | AMERICAN, BORN SWEDEN 1929
FLOOR CAKE (GIANT PIECE OF CAKE). 1962
SYNTHETIC POLYMER PAINT AND LATEX ON CANVAS FILLED WITH
FOAM RUBBER AND CARDBOARD BOXES, 58⅛" x 9' 6¼" x 58⅛"
(148.2 x 290.2 x 148.2 CM)
GIFT OF PHILIP JOHNSON

Abstract and Minimalist Painting

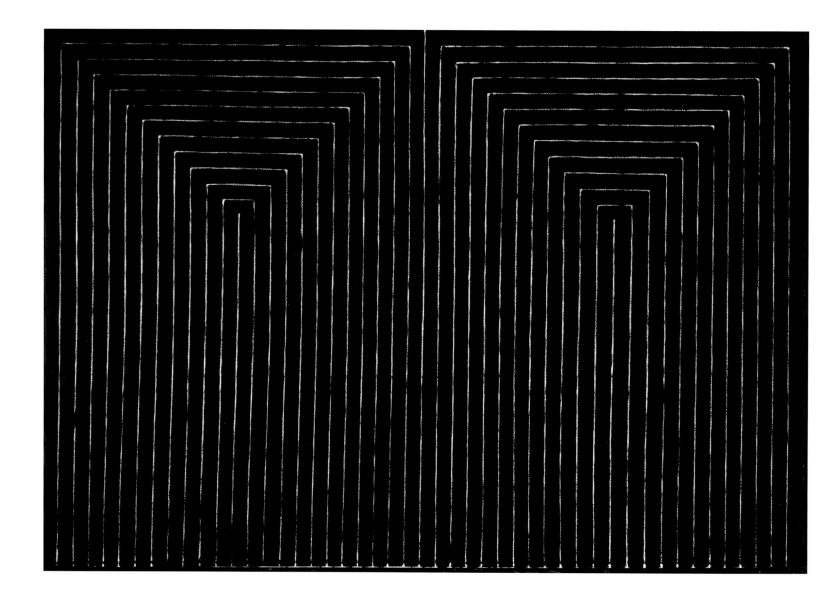

Frank Stella | AMERICAN, BORN 1936
THE MARRIAGE OF REASON AND SQUALOR, II. 1959
ENAMEL ON CANVAS, 7' 6¾" x 11' ¾" (230.5 x 337.2 CM)
LARRY ALDRICH FOUNDATION FUND

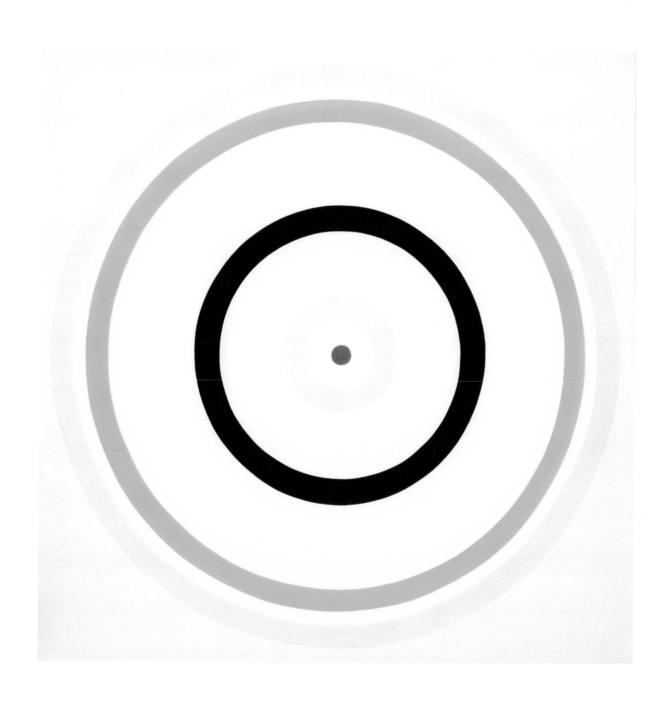

Kenneth Noland | AMERICAN, BORN 1924
TURNSOLE. 1961
SYNTHETIC POLYMER ON PAINT ON UNPRIMED CANVAS,
7' 10⅛" x 7' 10⅛" (239 x 239 CM)
BLANCHETTE ROCKEFELLER FUND

285

Agnes Martin | AMERICAN, BORN CANADA 1912
RED BIRD. 1964
SYNTHETIC POLYMER PAINT AND COLORED PENCIL ON CANVAS,
71⅛ x 71⅛" (180.5 x 180.5 CM)
GIFT OF PHILIP JOHNSON

Robert Ryman | AMERICAN, BORN 1930
TWIN. 1966
OIL ON COTTON, 6' 3¼" x 6' 3⅞" (192.4 x 192.6 CM)
CHARLES AND ANITA BLATT FUND AND PURCHASE

Minimalist Sculpture

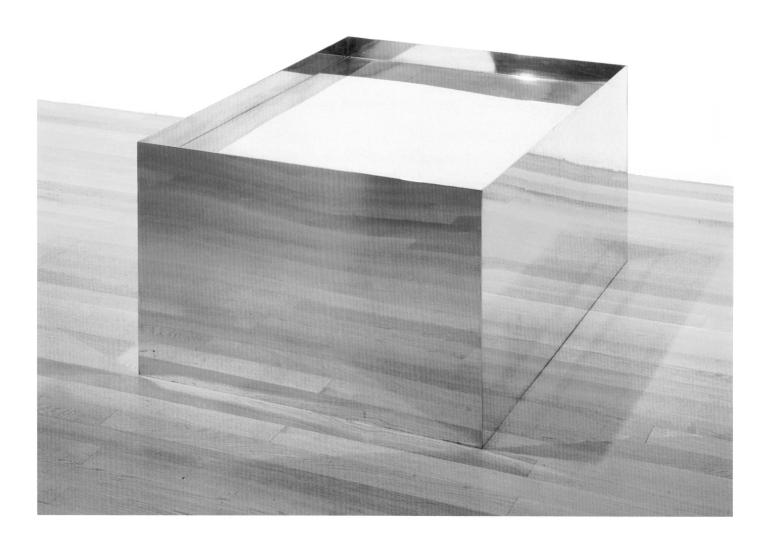

Donald Judd | AMERICAN, 1928–1994
UNTITLED. 1968
BRASS, 22 x 48⅛ x 36" (55.9 x 122.6 x 91.4 CM)
GIFT OF PHILIP JOHNSON

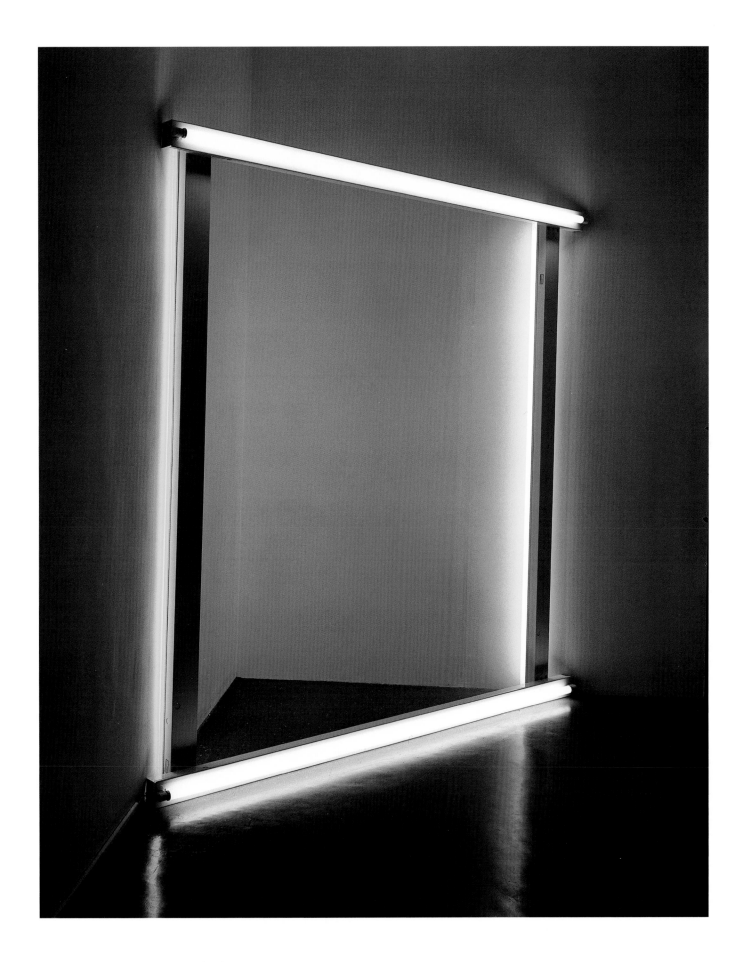

Dan Flavin | AMERICAN, 1933–1996
UNTITLED (TO THE "INNOVATOR" OF WHEELING PEACHBLOW). 1968
FLUORESCENT LIGHTS AND METAL FIXTURES, 8' ½" x 8' ¼" x 5¼" (245 x 244.3 x 14.5 CM)
HELENA RUBINSTEIN FUND

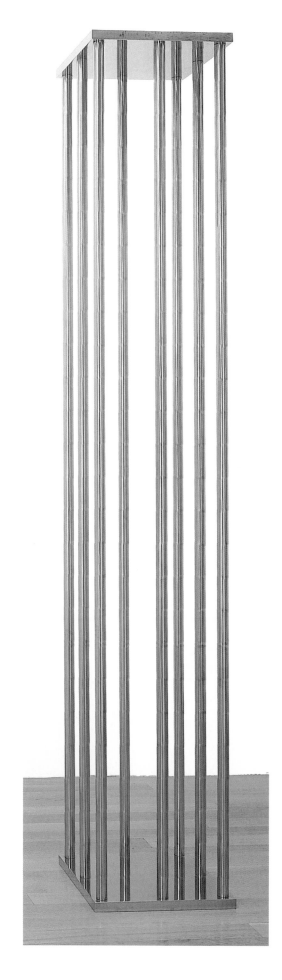

Walter de Maria | AMERICAN, BORN 1935
CAGE II. 1965
STAINLESS STEEL, 7' 1½" x 14¼" x 14¼"
(216.5 x 36.2 x 36.2 CM)

GIFT OF AGNES GUND AND LILY AUCHINCLOSS

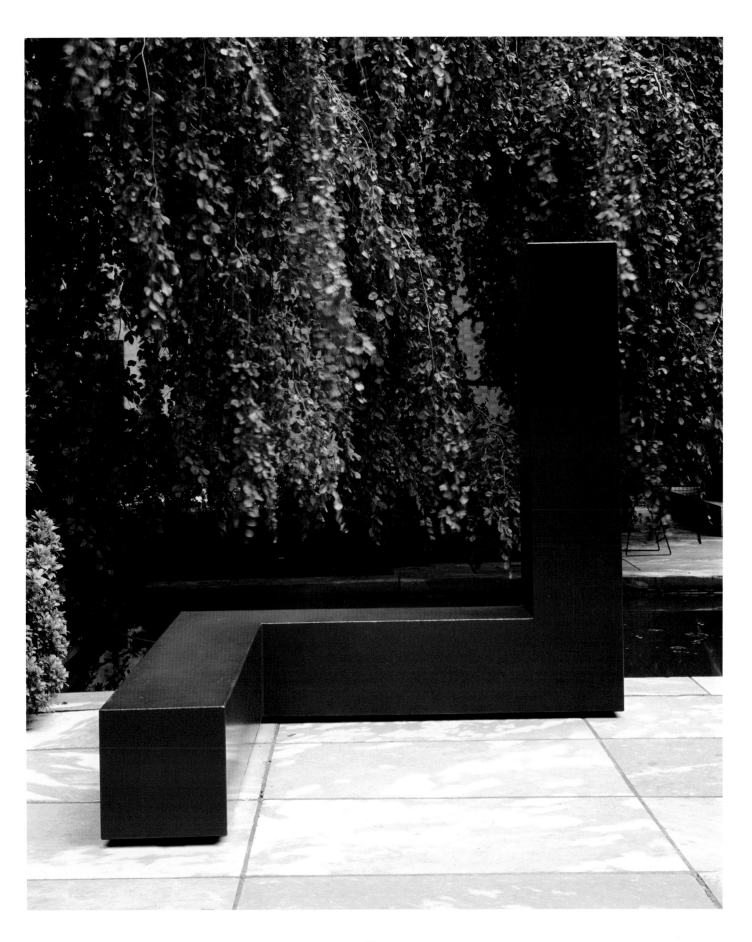

Tony Smith | AMERICAN, 1912–1980
FREE RIDE. 1962
PAINTED STEEL (refabricated 1982), 6' 8" x 6' 8" x 6' 8"
(203.2 x 203.2 x 203.2 CM)
GIFT OF AGNES GUND AND PURCHASE

Carl Andre | AMERICAN, BORN 1935
144 LEAD SQUARE. 1969
144 LEAD PLATES, EACH APPROXIMATELY ⅜ x 12 x 12"
(.9 x 30.5 x 30.5 CM); OVERALL, ⅜" x 12' ⅞" x 12' 1½"
(.9 x 367.8 x 369.2 CM)
ADVISORY COMMITTEE FUND

Sol LeWitt | AMERICAN, BORN 1928
SERIAL PROJECT, I (ABCD). 1966
BAKED ENAMEL ON ALUMINUM, 97 UNITS,
OVERALL, 20" x 13' 7" x 13' 7"(50.8 x 398.9 x 398.9 CM)
GIFT OF AGNES GUND AND PURCHASE (BY EXCHANGE)

Post (and non) -Minimalism

Lee Bontecou | AMERICAN, BORN 1931
UNTITLED. 1961
RELIEF CONSTRUCTION OF WELDED STEEL, WIRE, AND
CANVAS, 6' 8¼" x 7' 5" x 34 ½" (203.6 x 226 x 88 CM)
KAY SAGE TANGUY FUND

Richard Tuttle | AMERICAN, BORN 1941
CLOTH OCTAGONAL, 2. 1967
DYED AND SEWN CANVAS, IRREGULAR,
57⅛ x 53¾" (145.2 x 136.5 CM).
MRS. ARMAND P. BARTOS FUND

295

Robert Morris | AMERICAN, BORN 1931
UNTITLED. 1969
DRAPED 1" (2.5 CM) THICK, GRAY-GREEN FELT,
15' ¾" x 6' ½" x 1" (459.2 x 184.1 x 2.5 CM)
THE GILMAN FOUNDATION FUND

Richard Serra | AMERICAN, BORN 1939
ONE TON PROP (HOUSE OF CARDS). 1969
LEAD ANTIMONY, FOUR PLATES, EACH 48 x 48 x 1"
(122 x 122 x 2.5 CM)
GIFT OF THE GRINSTEIN FAMILY

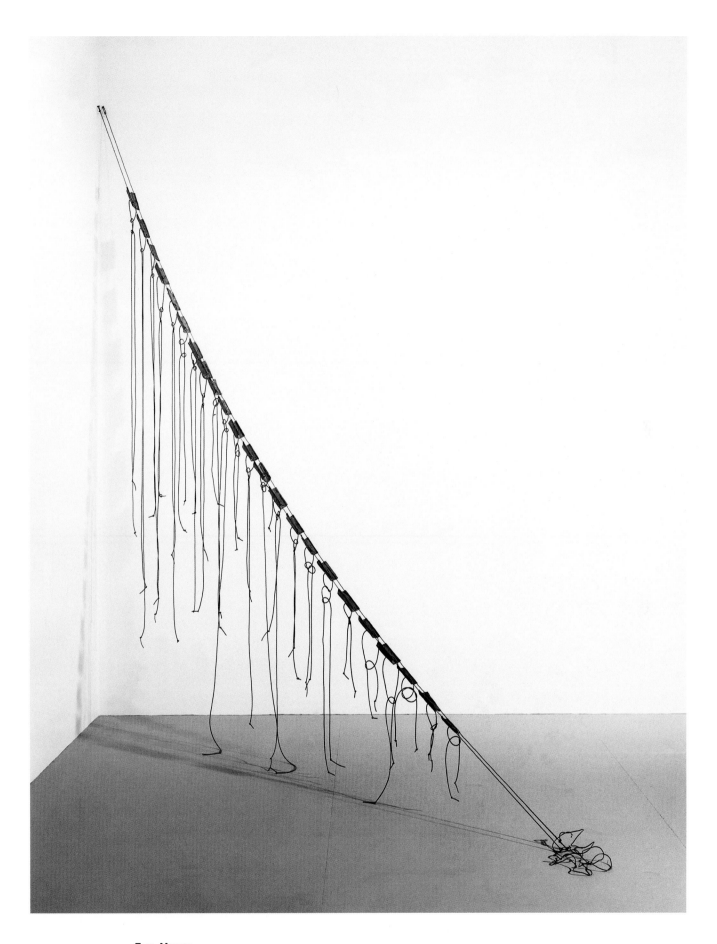

Eva Hesse | AMERICAN, BORN GERMANY. 1936–1970
VINCULUM, II. 1969
TWENTY-THREE RUBBERIZED WIRE-MESH PLAQUES STAPLED TO SHIELDED WIRE, 19' 5" x 3" (591.7 x 7.6 CM), WITH TWENTY-THREE HANGING EXTRUDED
RUBBER WIRES, KNOTTED, RANGING IN SIZE FROM 7" (17.9 CM) TO 62" (157.6 CM). SIZE INSTALLED, 9' 9" x 2½" x 9' 7½" (297.2 x 5.8 x 293.5 CM)
THE GILMAN FOUNDATION FUND

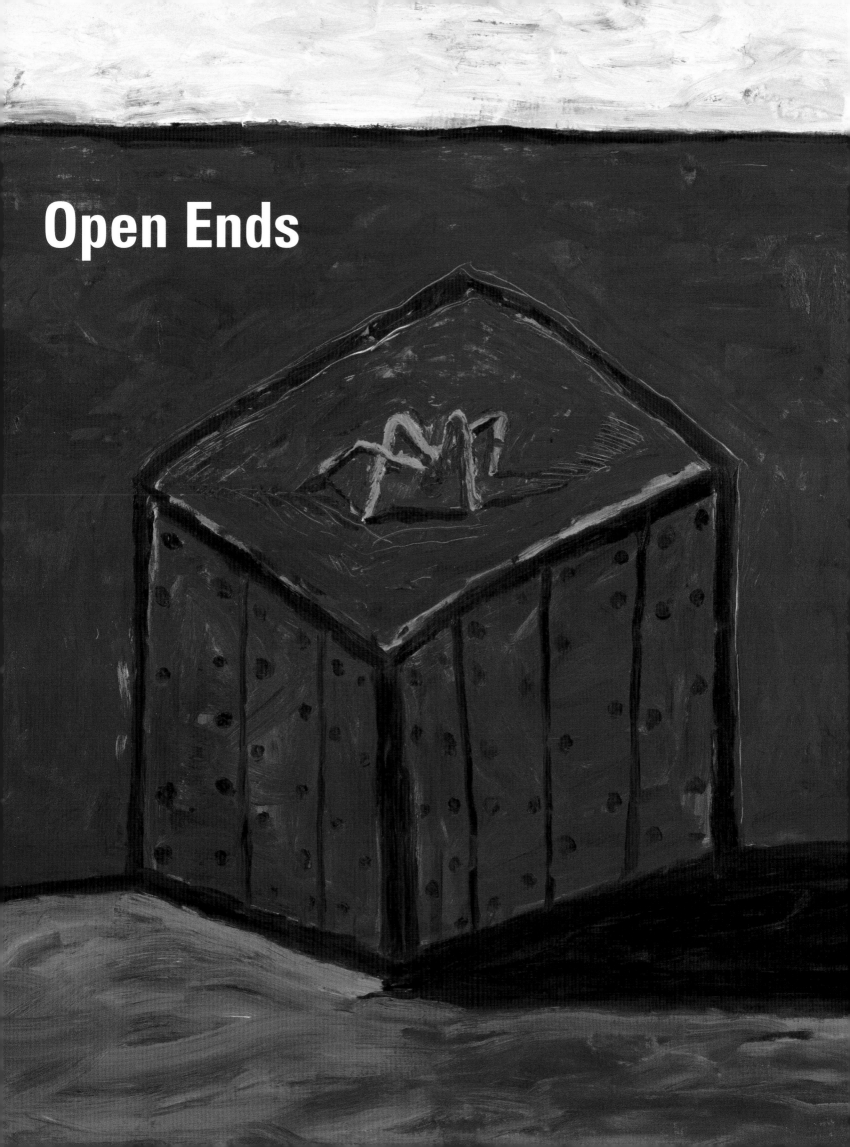

Open Ends

This final section of the catalogue differs from the preceding ones in that, rather than presenting a cursory review of the art of the 1970s and 1980s, it focuses on the work of two major artists represented in the collection of The Museum of Modern Art: Philip Guston and Gerhard Richter. Their painterly practices proved to be most influential for the art of the following decades.

Philip Guston was first included in an exhibition at The Museum of Modern Art in 1951 in a survey of abstract painting and sculpture in America organized by Andrew Carnduff Ritchie. *Red Painting* of 1950, which Guston bequeathed to the Museum upon his death in 1980, was his first allover abstract painting. With it he took his place alongside Jackson Pollock, Franz Kline, and Willem de Kooning as a vanguard innovator, and celebrated as the most poetic painter among the gestural Abstract Expressionists. In 1956 Dorothy Miller chose him to be one of twelve Americans in the second of her surveys of contemporary American art. Two years later he was included in the traveling exhibition *The New American Painting* devoted to Abstract Expressionism. Then, in 1966, during a major exhibition of his work of the 1950s and 1960s at the Jewish Museum, Guston gave up abstract painting and, to his contemporaries' consternation, took up figuration.

In retrospect, what seemed like a sudden reorientation emerges in Robert Storr's lucid analysis in the 1992 exhibition catalogue *Philip Guston in the Collection of The Museum of Modern Art* as a logical conclusion of his artistic development through the 1950s and 1960s. Originally a maker of images, Guston found that abstraction was a hard-won achievement, and in the 1950s he struggled during most of the next decade with "the tendency of pure form to acquire the impure attributes of the image." But even if figuration was latently present as narrative interaction among the elements of painting since 1957, the deeper cause for change was ideological. Guston's move toward storytelling and caricature was prompted by the contradictory social and aesthetic climates of the late 1960s. Turning to his own painterly past, he rephrased the symbol-laden imagery from his paintings of the 1930 and 1940s in a caricature style derived from comics while at the same time applying the broadly brushed manner he had developed in his abstract work. In the last ten years of his life, he created a body of work whose existential weight and "burlesque pathos" speaks of unsparing inquisition of the self and the world which is experienced through the realm of mundane objects. His paintings of marauding hooded figures, studded shoes, lightbulbs, ladders, and bricks accumulated in heaps or suspended from the skies shocked and offended his erstwhile supporters but, as Storr argues, in the past two decades have come to be viewed as his most important legacy.

The Museum of Modern Art's collection of works by Guston reflects this significant shift in evaluation. The four abstract works from 1950 through 1962, and the eight paintings from the late sixties to late seventies, not only demonstrate the artist's blend of contradictions and consistencies, but emphasizes that Guston, in Storr's words, "saved the best for last."

If Guston's aesthetic position confounded his contemporaries, so does the multifaceted nature of Gerhard Richter's ongoing output challenge his public today. Seemingly all-encompassing in

its subject matter drawn from the leveling pool of photography, and endlessly fluctuating between abstract and realist styles, classical genres, coloristic schemes, and painterly techniques, Richter's work embodies the dialectical stance at the heart of his enterprise. Filled with the same philosophical doubt about the possibilities of painting in the postmodern era that led many of his peers to declare painting dead, Richter relentlessly probed and still probes its potential in his open-ended daily practice.

That this practice would implicate photography as the medium that relieved painting from its originally primary function of recording reality and would make the problematic reality of photographs part of his philosophical enterprise only underscores the fundamental nature of his concerns. This is especially true for the cycle of fifteen paintings that comprise *October 18, 1977*, which the Museum acquired in 1995. In its unparalleled scale akin to history painting and its resonant political topics, it represents Richter's most ambitious meditation on truth and ideology and their shaping in and of history.

In *Modern Art despite Modernism*, a 2000 exhibition and book about twentieth-century art that defies the teleological modernist canon, Storr himself linked the consequences of Richter's achievement to that of Guston's and thus unintentionally offered the argument for their juxtaposition here today. Both are connected in their devotion to the medium in which they worked and in their effort to extend its relevance in aesthetic as well as political terms. Storr casts Guston's obstinate pursuit of a singular mode of expression in open opposition to an aesthetic status quo as the "stand-and-fight variant" of what he calls Richter's "elusiveness." Thus, according to Storr, together they "bracket postmodern painting and forge the link between it and its modernist and antimodernist sources, one hot, one cool, one struggling to harness his contradictory impulses to a single purpose, the other methodically setting forth his contradictions canvas by canvas."

In choosing to represent the 1970s and 1980s primarily with the work of these two artists, this exhibition highlights two individual and idiosyncratic positions of unparallel relevance for the artistic practice in the decades that followed. Storr's claim in *Modern Art despite Modernism* that, "at least in the United States, 1980s art would have turned out very differently without his [Guston's] presence," the same certainly rings true for Richter and Germany and the 1990. By giving prominence to Guston and Richter, Storr singled out two artists who subverted and continue to subvert the modernist canon in whose formation this institution has played a crucial part, and thus from within has paved the way for a more pluralistic consideration of the art of the late twentieth century.

— *Claudia Schmuckli*

Guston

Philip Guston
City Limits. 1969
Illustrated on page 307

Robert Storr, *Philip Guston in the Collection of The Museum of Modern Art,* **1992,** page 19

In *City Limits*, 1969, a three-man crew of slapstick thugs cruises a vacant metropolis in an old jalopy. It is unclear who they are, but plainly they are up to no good. Their iconographic antecedents can, of course, be found in Guston's anti-[Ku Klux] Klan murals of the 1930s. As bad as things were in 1969, however, the Klan was not the widespread domestic menace it has since become. Rather than invoking an actual and specific evil, the hooded men Guston called "those little bastards" were symbolic embodiments of a general know-nothing violence, as were the clenched fists that appeared out of nowhere . . . along with the flying bricks that fill the air and the half-buried legs that litter the foreground. Even so, a simple desire to make protest pictures hardly squares with the cartoon manner Guston seems to have adopted suddenly. The change was, in fact, gradual and deeply rooted. It had taken the artist two years of working on small, single-image panels to identify his protagonists, their attributes, and their settings; and nearly all of these works hark back to images found in his paintings of the 1930s and 1940s. The type of caricature in which he rephrased them, meanwhile, dated to the artist's childhood imitations of comic strips such as Krazy Kat and Barney Google as well as to satirical portraits of fellow artists done during the 1950s and 1960s.

Nevertheless, the basic armature of Guston's abstract paintings remained intact behind the objects and activities depicted in this revived graphic style. Applied solely and directly to the once insubstantial structures, that broad treatment lent his objects an ambiguous and uncanny bulk. . . .

Using this vernacular manual of style, what Guston wanted to do, he said in 1970, was to tell stories. The principal story told in paintings such as *City Limits* is that of an America run afoul of its liberal promise. It is a tale of blundering meanness and self-betrayal. Identifying himself with Klansmen, as he does in several pictures showing a sheet-covered artist at his easel, Guston insisted on depicting the fascination cruelty holds even for the civilized. At a time of crisis, when many decried the actions of nefarious "outside agitators" or consoled themselves with thoughts of their own good intentions, Guston was reminding his fellow citizens that we remain our own worst enemies. Setting scenes and cuing his ill-starred cast in a more broadly brushed version of his abstract gestural manner, Guston, like a film director, reinvented what [critic] Harold Rosenberg had once called Action Painting as a paradoxically comic and horrible "Action!" painting that was antically cartoon-like rather than anxiously refined, yet for all that possessed of a strange baroque grandeur.

Philip Guston
Head. 1977
Illustrated on page 308

Robert Storr, *Philip Guston in the Collection of The Museum of Modern Art,* **1992,** page 20

While recondite images filled the artist's mind and social discord prompted his angry response, domestic reality also inspired some of Guston's best, most mysterious, and most troubling pictures of the 1970s. For many of these his wife Musa was quite literally his muse. It is her parted hair that appears on the horizon in many canvases, like drawn theater curtains bracketing a brow whose thought one cannot read. It is her raised eyes that are visible above the flood in other pictures; and at least once her tears are its source. Simultaneously mythic and painfully intimate, these paintings are scenes from a difficult but enduring marriage.

Head, 1977, is the starkest among them. Made shortly after Musa suffered a series of small strokes, it is a painting of a wound. Only the simple contours of a shaven head frame the drawnback flaps and interlaced sutures of this surgical window on the brain. Yet the contrast between the ugliness of the stitched aperture and the delicacy of the profile

makes an indelible impression of the fragility of the life at stake and the crudeness of medical necessity. Other paintings describe Guston's marital ambivalence and guilt, the result of his single-minded concentration of his art. Inspired by near loss, *Head*, in contrast, is a modern ex-voto and testament to his abiding love.

Philip Guston
Box and Shadow. 1978
Illustrated on page 309

Robert Storr, *Philip Guston in the Collection of The Museum of Modern Art,* **1992,** page 20

Almost a decade after *City Limits* (see page 307) Guston painted *Box and Shadow*, 1978, the symmetrical stillness of which seems the antithesis of the clamorously eventful [Ku Klux] Klan pictures. Divided into essentially monochromatic bars and bands, its background is expansive and nearly abstract, as if the artist had rendered Mark Rothko's or Barnett Newman's "sublime" in warm red mud. The lush oleaginous brushwork of Guston's late paintings is most evident here, especially in the monochrome areas where the artist was able to cut loose, confident that the uniform color would contain within its pictorial boundaries the tumult stirred by his hand. Closely examined, these areas show the full repertoire of his strokes; slathered zig-zags, suave sweeps, and dragged sticky pastes. Storyteller that he was, Guston understood that the best tales are those that resonate in the senses as well as in the mind, and so he rehearsed his gesture and extended its range like an actor practicing his lines in various vocal registers and at different volumes—from a dry whisper to a resounding laugh or a booming speech.

At the center foreground of *Box and Shadow* a spider is poised atop a nail-studded crate that casts a long evening shadow across a scorched wasteland. The location and contents of the box are unknown, as are the reasons for the spider being there. The choice and arrangement of symbols, recalling the hermetic still lifes of [Giorgio] de Chirico, are enigmas—impenetrable but therefore inexhaustible points of focus for speculation.

Philip Guston
Tomb. 1978
Illustrated on page 310

Robert Storr, *Philip Guston in the Collection of The Museum of Modern Art,* **1992,** pages 20, 23

In contrast to the sparseness of *Box and Shadow* (see page 309), another work of the same year, *Tomb*, is a symbol dump—or, rather, a cairn or headstone. Piled on the shelves or steps of the black monolith that blocks the sky-blue horizon are an assortment of objects: a misshapen ball, an idle brush plunged into a paint can, a still-smoking cigarette, and tiers of luckless horseshoes that list and droop like rough iron analogs to the sleek soft watches in Salvador Dali's *The Persistence of Memory* of 1931 (see page 173). There all of Guston's objects sit as if the painter had just abandoned them; and there they stay on their pedestal, an epitaph composed of things instead of words. The dead weight of this accumulation is no accident. Typical of those items that surrounded him in the studio, each is a memento mori of the artist, and their ensemble constitutes a *vanitas*, a still-life reminder of the fatal inconsequentiality of human endeavor. Yet, never did Guston paint more vigorously than when contemplating his own mortality, and of the many works he devoted to the subject in his last years, none has greater force or mystery than *Tomb*. Loading his brush with liver grays, charred-bone blacks, and arterial reds, the artist delineated these congested iconic forms with a painterly draftsmanship of commensurate density. "Stapling" hatches onto worked tonal facets, binding edge against edge with pigment welds and figure to ground with pigment rivets until nothing moved, Guston labored in his studio like Vulcan forging a memorial from his own anvil.

Philip Guston
Moon. 1979
Illustrated on page 311

Robert Storr, *Philip Guston in the Collection of The Museum of Modern Art,* **1992,** pages 23, 27

In 1979 Guston suffered a near-fatal heart attack. Death had made itself known to him directly. . . . Neither whimper nor bang ended Guston's world but, instead, a general clatter punctuated by leaden thuds. Objects are responsible for most of the noise. Canvas stretchers, chair backs, coffee cups, bottle, cigarettes, and other studio junk are symbols of the

artist, and the bent nails that rim the stretchers or stud other objects are the self-mocking stigmata of his vocation for aesthetic martyrdom. Garbage-pail tops held up like shields, hairy paws, stamping feet, and ominously clustered heads represent an intrusion into studio chaos of agents of the social chaos prevalent outside.

Scattered one by one over a bleak landscape or regrouped into ill-assorted clusters, all these random parts are emblematic of the disintegrating wholes to which they formerly belonged. Many of these objects represent verbs of motion, which their static positions qualify, like adverbs of inertia. . . .

In Guston's final works life seems like a bad dream about weight, and feeling its full onus seems akin to finding oneself transported to a planet whose gravity is a hundred times that on earth. Representing the burden of a past that only increased as he struggled ahead, the artist's mysterious accumulations were his resources and his nemesis.

Richter

Gerhard Richter

October 18, 1977 cycle. 1988
Illustrated on pages 312–23

Robert Storr, *Gerhard Richter: Forty Years of Painting,* **2002,** pages 74, 75, 76, 77

The date from which this cycle of fifteen paintings takes its title marked the mysterious end of a prolonged struggle between a small group of student radicals turned armed revolutionaries, and the police, courts, political establishment, and large parts of the population of the German Federal Republic. . . . Of the many who participated in such tactics, the Red Army Faction (RAF) became the most notorious. Its principal members were a rebellious street hustler with a streak of bandit-like bravado named Andreas Baader and a morally severe radical journalist and former pacifist, Ulrike Meinhof. Added to this mismatched pair . . . were another antiwar organizer and sometime publisher Gudrun Ensslin, . . . a sociologist of the counter-culture and filmmaker, Holger Meins, and two others who shared their fate, Jan Carl Raspe and Irmgard Möller. In varying degrees and capacities, all were involved in a two-year string of robberies, shooting, escapes, and bombings, which ended in 1972 with their arrest and imprisonment and eventual trial. . . .

Inside Stammheim [prison], among the methods of protest followed by the prisoners were hunger strikes, the longest of which physically and emotionally exhausted Meinhof and claimed the life of Holger Meins. On May 9, 1976, Meinhof was found hanged in her cell; the official and probably accurate verdict was suicide but circumstances bred widespread suspicion that she had been murdered. On the night of October 18, 1977, the last and most desperate attempt to free the prisoners in exchange for hostages on a plane hijacked by terrorists and flown to Mogadishu, Somalia, ended in a raid that killed all but one of the hijackers, and released the passengers. The following morning, Baader was found dead in his cell with a bullet wound in his head; Raspe was found dying, also of a bullet wound; Ensslin was found dead in her cell hanging from a grate; and Möller, the only one of the core group to survive, was found with stab wounds in her chest. Once again, the official verdict was suicide, but the situation was even more fraught with suspicion and more mysterious than at the time of Meinhof's death. The question of whether the three who died took their own lives as a last act of revolutionary defiance or out of despair, or whether they were executed by agents of the state has never been settled, although some combination of the first two explanations is the most probable answer. . . .

October 18, 1977 of 1988 consists of fifteen paintings depicting people or scenes from the Baader-Meinhof story. With one exception—*Youth Portrait*, based on a studio photograph of Ulrike Meinhof taken shortly before she abandoned her career as a political essayist and public spokesperson for the Left and went underground—all are based on video footage, press images, and evidentiary pictures from the police archives . . . *Arrest 1* and *Arrest 2* show Meins surrendering to an armored car whose gun is trained on him while he strips to prove that he is unarmed. *Confrontation 1, Confrontation 2,* and *Confrontation 3* follow Ensslin as she passes in front of the camera on her way to or from her cell. *Hanged* centers on Ensslin's corpse as it was discovered on the morning of October 18. *Cell* reveals the book-lined corner of Baader's quarters in Stammheim; and

Record Player zeros in on the phonograph that was supposedly the hiding place for a smuggled gun with which police claimed Baader shot himself. *Man Shot Down 1* and *Man Shot Down 2* are two versions of the same forensic image of Baader dead on the floor of his cell. The three versions of *Dead* are likewise based on a single photograph of the hanged Meinhof, cut down and laid out, with the ligature still around her neck. The final and largest canvas, *Funeral*, depicts a procession of three coffins containing the remains of Baader, Ensslin, and Raspe as they moved through the crowd of thousands of sympathizers—interspersed with and surrounded by a thousand armed police officers—on their way to a common grave in a cemetery on the outskirts of Stuttgart. . . .

The painterly alterations—of size, proportion, tonal nuance, properties of pigment, manner of application, manner of revision or un-painting—of the photographic source call into doubt the pretense that such documentary sources can be trusted to testify to the truth of the situations or events they ostensibly register faithfully and without visual distortion or bias. At the same time, the alterations edit out nonessential details and add pictorial accents to those that remain, leaving us with inflections that tap into uncertainties about overly familiar ready-made images and the intense, contradictory feelings that may be absent from the original but are deeply rooted in the media-saturated consciousness of the viewer who recalls seeing the pictures before, yet is suddenly confronted with the ambiguity and instability of the information they contain, and, by extension, with the gaps in the stories they purport to tell. . . .

Richter's aim was more complex than hagiography and by far harder to achieve. First, he sought to make a series of modern paintings that would do the work of traditional history painting in a period when photography, film, and television had taken over as the chroniclers and preservers of public memory, and to do it in a way that instilled the critical doubts about the memories we harbor and those that are handed down to us by professionals in the media, government, and academy. Second, he wanted to give a human face to the victims of ideology who, for ideology's sake, created victims of their own, and to free the suffering they experienced and caused from reductive explanations of their motives and actions, and from political generalizations and rigid antagonisms that triggered the events in the first place. Richter's third purpose in painting *October 18, 1977* was to mourn.

Identifying with the idealism but not the ideals of the RAF, Richter painted a lament for the mesmerizing, unrealistic, and potentially ruinous visions to which critical reason gives rise. "The deaths of the terrorist, and the related events both before and after, stand for a horror that distressed me and has haunted me as unfinished business ever since, despite all my efforts to suppress it." Richter wrote in preparation for a press conference held when the cycle was first exhibited.[1] "It is impossible for me to interpret the pictures. That is: in the first place they are too emotional; they are, if possible, an expression of a speechless emotion. They are the almost forlorn attempt to give shape to feelings of compassion, grief and horror (as if the pictorial repetition of the events were a way of understanding those events, being able to live with them)."[2] This reckoning runs directly counter to the assumption of many postmodern critics that painting had once and for all forfeited its claims to speaking to the public on public matters but, even more, had given up on doing so in ways that could bring about genuine catharsis, which is the culminating effect of tragedy. By word and deed Richter insists that this cathartic function, though not a symbolic resolution to social and political dilemmas, remains within painting's scope. He wrote: "Art has always been basically about agony, desperation and helplessness. . . . We often neglect this side of things by concentrating on the formal, aesthetic side in isolation. Then we no longer see content in form. . . . The fact is that content does not have a form (like a dress that you can change): it *is* form (which cannot be changed). Agony, desperation and helplessness cannot be represented except aesthetically, because their source is the wounding of beauty (Perfection)."[3]

Gonzalez-Torres

Felix Gonzalez-Torres
"Untitled." 1991
Illustrated on page 324

Anne Umland, *Projects 34,* **1992,** n. p.

In 1991, Ross [the artists lover], whom Gonzalez-Torres has referred to in the past as his only audience, his public of one, died of AIDS. His illness and, ultimately, his early and tragic death permeate the panorama of Gonzalez-Torres's art. . . .

Like those of many other artists of his generation, Gonzalez-Torres's concerns extend beyond the self-contained boundaries of the art object to encompass the circumstances that surround it. At issue here is not only the artist's choice of the image (his bed) and medium (photography) but also the decision of where and how to display the picture (on billboards, scattered across New York City, repeated twenty-four times over, enlarged to superhuman scale). . . .

Absence shadows Gonzalez-Torres's work in every way. Rumpled bed sheets and dented pillows are presented both as evidence of and as a sign for two absent human bodies. Ghostly contours are all that is left of beings who are no longer there. . . . The image hugs its supports rather than taking up space. To remove the picture is to destroy it. Awareness of this fact heightens our consciousness of the physical fragility that inhabits the work as a whole.

Also absent are human touch, which is banished by the use of photography, and color, which is eliminated by the use of black-and-white film. In addition, there is no original. No "unique" art object is presented, and the "whole" of this work can never be seen all at one time. In each instance, what is visible is defined by the invisible. Presence, whether of bodies in bed or of art in a gallery, becomes only a mirror of things unseen.

Cai

Cai Guo-Qiang
Borrowing Your Enemy's Arrows. 1998
Illustrated on page 2 (frontispiece)

Fereshteh Daftari, in *Modern Contemporary,* **2000,** pages 513, 515

In the last two decades, the escalating interconnections throughout the world have made "globalization" a master concept and a key term. An expanding market economy and thickening net of communication have touched, and often altered, an exceptionally broad range of cultures, traditions, and practices. . . .

Contemporary artists often cross cultural boundaries, and have been implicated in and attentive to . . . changes and debates. Their traffic within the networks of globalization is multidirectional. Western artists, . . . by immersing themselves in the cultures of the past, have reaffirmed a familiar linkage between modern art's dominant centers and formerly peripheral cultures. But other artists, of non-Western origin, have also created more complex and unprecedented hybrids in their physical and in their spiritual "residences." Transition has been the order of the day, shuttling between a variety of global terms and an equal mix of local identities. . . .

Cai Guo-Qiang is a telling example [of this transition]. [He was] born in Quanzhou, in the Fujian province of China . . . *Borrowing Your Enemy's Arrows* [is] a sculpture that embodies a metaphor for cross-cultural exchange. The work is built on the skeleton of an old fishing boat, excavated near the port where the artist began his personal journey. Bristling with 3,000 arrows designed by the artist, and fabricated in his native city, the ship flies the flag of contemporary China, but refers to the nation's deeper history. Historical texts recount how General Zhuge Liang, lacking ammunition in the face of a heavily armed enemy, was ordered to procure 100,000 arrows in ten days. The legend recounts that, on a foggy night, the general sent a boat loaded with bales of straw across the river, toward his foes. When the enemy had fired

volley after volley of arrows at this decoy, the general pulled it back, full of a captured store of fresh ammunition. One subject of the sculpture, then, is how culture may appropriate and transform foreign intrusions into a defensive strategy. . . .

Hybridization is no absolute novelty, but until now only Western artists . . . have received attention, at the expense of Third World artists grappling with the mainstream. The brand new spotlight currently focused on the many individual "creole" languages of various artists may represent nothing more than a trendy thirst for exoticism. Globalization . . . raises a host of unresolved questions, and a globalized field of art poses similar conundrums. Are the borrowings from and minglings of references from marginalized cultures only a savvy strategy of "niche marketing," bound eventually to exhaust the freshness of their appeal, or are they the signal of a growing wave of art that will render obsolete many of the frontiers, boundaries, and self-enclosed traditions that have been so determining? Is this a phenomenon of greater tolerance of expanded diversity, or only the cloak for an increasing homogenization? . . . Fluency in the language of Western art has been the requisite for access to the global sphere of exhibitions, museums, galleries, and journals. It may be fair, then, to wonder whether, in the process of featuring and enabling difference, the new art world is ultimately weakening the authority of any zone of resistance, such as those artists who choose not to speak in the current vernacular of the marketplace.

Guston

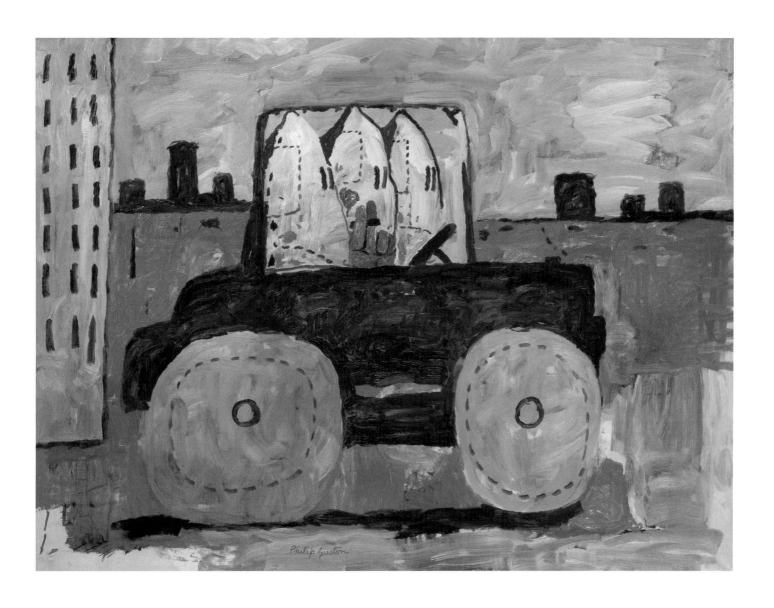

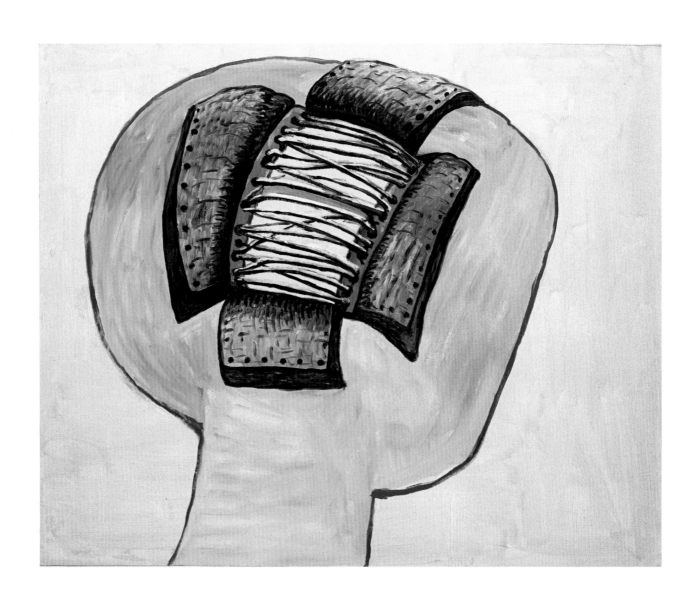

Philip Guston | AMERICAN, BORN CANADA. 1913–1980
HEAD. 1977
OIL ON CANVAS, 69⅞" x 7' 1" (176.8 x 215.7 CM)
MUSA GUSTON BEQUEST

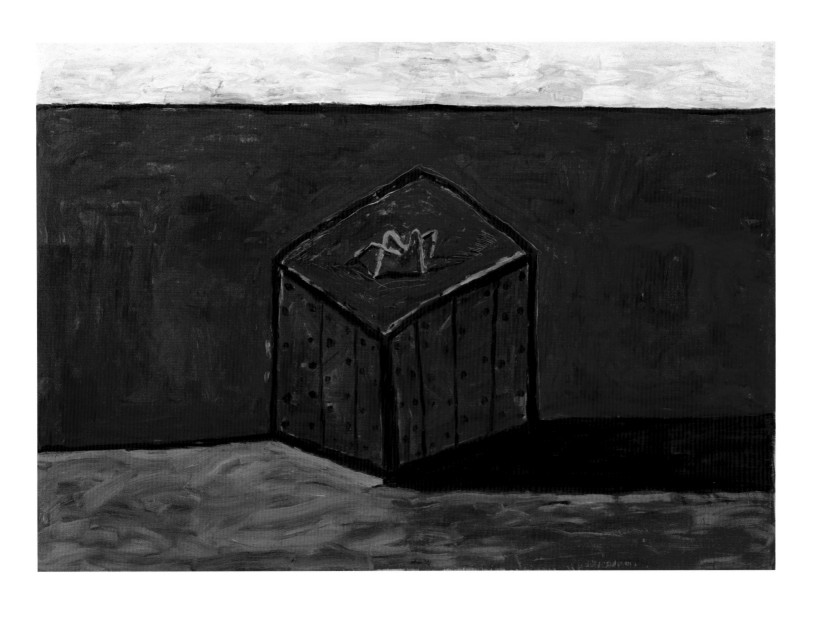

Philip Guston
BOX AND SHADOW. 1978
OIL ON CANVAS, 69⅛" x 8' 2⅝" (175.6 x 250.5 CM)
GIFT OF MUSA GUSTON

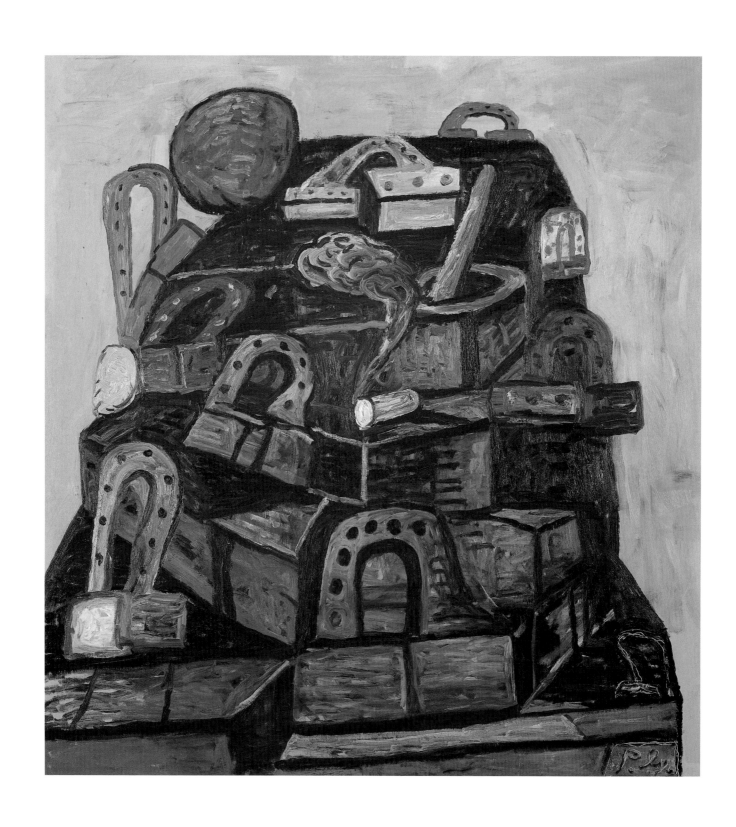

Philip Guston | AMERICAN, BORN CANADA. 1913–1980
TOMB. 1978
OIL ON CANVAS, 6' 6⅛" x 6' 1¼" (198.4 x 187.6 CM)
ACQUIRED THROUGH THE A. CONGER GOODYEAR AND ELIZABETH BLISS
PARKINSON FUNDS AND GIFT OF THE ARTIST

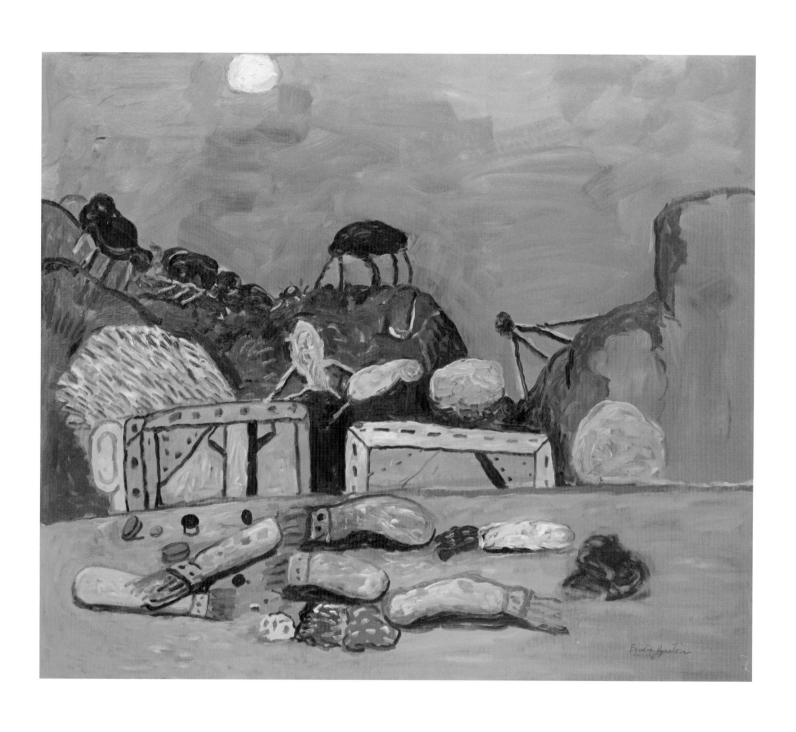

Philip Guston
MOON, 1979
OIL ON CANVAS, 69" x 6' 8⅛" (175.3 x 203.5 CM)
GIFT OF PHILIP JOHNSON

Richter

YOUTH PORTRAIT [JUGENDBILDNIS]. 1988
OIL ON CANVAS, 28½" x 24½" (72.4 x 62 CM)

Gerhard Richter | GERMAN, BORN 1932
OCTOBER 18, 1977 [18 OKTOBER 1977]. 1988
FIFTEEN PAINTINGS, OIL ON CANVAS, INSTALLATION VARIABLE (see pages 312–23).
THE SIDNEY AND HARRIET JANIS COLLECTION, GIFT OF PHILIP JOHNSON, AND ACQUIRED
THROUGH THE LILLIE P. BLISS BEQUEST (ALL BY EXCHANGE), ENID A. HAUPT FUND, NINA
AND GORDON BUNSHAFT BEQUEST FUND, AND GIFT OF EMILY RAUH PULITZER

Gerhard Richter
ARREST 1 [FESTNAHME 1]. 1988
OIL ON CANVAS, 36½ x 49¾" (92 x 126.5 CM)

Gerhard Richter
ARREST 2 [FESTNAHME 2].
1988
OIL ON CANVAS, 36½ x 49¾"
(92 x 126.5 CM)

Gerhard Richter
CONFRONTATION 1 [GEGENUBERSTELLUNG 1]. 1988
OIL ON CANVAS, 44 x 40¼" (112 x 101.6 CM)

Gerhard Richter
CONFRONTATION 2 [GEGENUBERSTELLUNG 2]. 1988
OIL ON CANVAS, 44 x 40¼" (112 x 102 CM)

Gerhard Richter
CONFRONTATION 3 [GEGENÜBERSTELLUNG 3]. 1988
OIL ON CANVAS, 44 x 40¼" (112 x 102 CM)

Gerhard Richter
HANGED [ERHÄNGTE]. 1988
OIL ON CANVAS, 6' 7" x 55" (201 x 140 CM)

Gerhard Richter
CELL [ZELLE]. 1988
OIL ON CANVAS, 6'7" x 55" (201 x 140 CM)

Gerhard Richter
RECORD PLAYER [PLATTENSPIELER]. 1988
OIL ON CANVAS, 24⅜ x 32¾" (62 x 83 CM)

Gerhard Richter
MAN SHOT DOWN 1 [ERSCHOSSENER 1]. 1988
OIL ON CANVAS, 39½ x 55¼" (100.5 x 140.5 CM)

Gerhard Richter
MAN SHOT DOWN 2 [ERSCHOSSENER 2]. 1988
OIL ON CANVAS, 39½ x 55¼" (100.5 x 140.5 CM)

Gerhard Richter
DEAD [TOTE]. 1988
OIL ON CANVAS, 24½ x 28¾ " (62 x 73 CM)

Gerhard Richter
DEAD [TOTE]. 1988
OIL ON CANVAS, 24½ x 24½" (62 x 62 CM)

Gerhard Richter
DEAD [TOTE]. 1988
OIL ON CANVAS, 13¾ x 15½" (35 x 40 CM)

Gerhard Richter
FUNERAL [BEERDIGUNG]. 1988
OIL ON CANVAS, 6' 6¾" x 10' 6" (200 x 320 CM)

Gonzalez-Torres

Felix Gonzalez-Torres | AMERICAN, BORN CUBA. 1957–1996
"UNTITLED." 1991
PRINTED BILLBOARD, DIMENSIONS VARIABLE: MUSEUM INSTALLATION
10' 5" x 22' 8" (317.5 x 690.9 CM)
GIFT OF WERNER AND ELAINE DANNHEISSER

Notes to the Texts

Modern Starts

Cézanne. *Pines and Rocks,*
PP. 26–27
1. Paul Cézanne, *Letters,* ed. John Rewald, 4th ed. (New York: Hacker Art Books, 1976), p. 303, to Emile Bernard, May 26, 1904.
2. Paul Klee, *Diaries,* ed. Felix Klee (Berkeley: University of California Press, 1964), p. 237. Alfred H. Barr, Jr., *Matisse: His Art and His Public* (New York: Museum of Modern Art, 1951), p. 87. Daniel Henry Kahnweiler, *My Galleries and My Painters,* trans. Helen Weaver (New York: Viking Press, 1971), p. 55.
3. Robert Delaunay, *Du cubisme à l'art abstrait,* ed. Pierre Francastel (Paris: S.E.V.P.E.N., 1957), p. 58.
4. [Amédée] Ozenfant, *Foundations of Modern Art,* trans. John Rodker (New York: Dover Publications, 1952), p. 68.
5. Marcel Jean, *The History of Surrealist Painting,* trans. Simon Taylor (New York: Grove Press, 1960), p. 12.
6. Hans Hofmann, "The Search for the Real in the Visual Arts," in Sam Hunter, *Hans Hofmann* (New York: Abrams, 1964), p. 41.
7. Karl Ernst Osthaus, "Cézanne," *Feuer; Monatschrift fur Künst und Künstlerische Kultur* 2 (1920-21): 82.
8. Cézanne, *Letters,* p. 320, to his son, August 3, 1906. *Idée et sensations* was the title of a book published by Edmond and Jules de Goncourt in 1866.

Cézanne. *Le Château Noir,*
PP. 27–28
1. Achille Makaire, *Excursions aux environs d'Aix* (Aix: La Tour-Keyrie, 1894), p. 141.

van Gogh. *The Starry Night; The Olive Trees,* PP. 28–29
1. V. van Gogh to his brother, [Saint-Rémy, June 19, 1889]; Verzamelde Brieven van Vincent van Gogh, Amsterdam, 1952–54, vol. III, no. 595, p. 432.
2. V. van Gogh to his brother, [Saint-Rémy, middle of Sept. 1889]; Verzamelde Brieven, vol. III, no. 607, p. 464.

Gauguin. *The Seed of the Areoi,*
PP. 29–30
1. Most commentators do not attempt to identify the seed in Tehura's hand, although Bengt Danielsson (*Gauguin in the South Seas* [Garden City, N.Y.: Doubleday, 1966, p. 109) declares it to be that of a coconut. The seed's size makes this unlikely, however, and Edward Dodd (*Polynesia's Sacred Isle* [New York: Dodd, Mead, 1976], p. 117) states, correctly I believe, that "she is holding the sprouting seed of the hutu reva, the sacred marae tree" (which is a form of mango).
2. The Aeroi were, in effect, a religious secret society that was founded—at least a century before the Western discovery of Polynesia—on the island of Raiatea, whence it fanned out to the other islands. Although Oro, the deity to whom

it was devoted, was primarily a war god, the activities of the society's itinerant members took the form of religious dancing and music-making. Within that context, they also carried on ritual copulation, independent of marital ties among the members. As a result of the "licentious" character of these activities, the clan was suppressed early on by Christian missionaries. For eighteenth- and nineteenth-century accounts, see Dodd, *Polynesia's Sacred Isle,* pp. 116–27.
3. "Tehura spoke with a kind of religious dread of the sect or secret society of the Areoi, which ruled over the islands during the feudal epoch. Out of the confused discourse of the child I disentangle memories of a terrible and singular institution"; Paul Gauguin, *Noa-Noa,* trans. O. F. Theis (New York: Nicholas L. Brown, 1920), p. 114. In fact, Gauguin's account was lifted virtually verbatim from Moerenhout, *Voyages aux îles du Grand Océan.*
4. According to Danielsson (*Gauguin in the South Seas,* p. 108), there still were a few people alive in Tahiti of Gauguin's time who knew a good deal about its ancient lore. The most learned of these was the seventy-year-old mother of Queen Marau, Arü Taimai, who had married an Englishman named Salmon. She had earlier received both Robert Louis Stevenson and Henry Adams, to whom she recounted much of what she knew. For a variety of reasons, a poor Frenchman such as Gauguin would not have been received by her, and he was probably not even aware of her existence, not to speak of her special knowledge.
5. *Self-Portrait in Front of the "Yellow Christ"* (1889), reproduced in Michel Hoog, *Paul Gauguin: Life and Work* (New York: Rizzoli, 1987), pl. 52.
6. Cited in John Rewald, *Post-Impressionism: From van Gogh to Gauguin* (New York: The Museum of Modern Art, 1956), p. 492.

Ensor. *Masks Confronting Death,*
P. 31
1. "Countries differ in aspect, in climate, in atmosphere, in temperature, and always one senses a secret accord between a man and his surroundings. In the eyes of a painter, the role is very far from the equator. Fast travel multiplies, and soon men will cross whole nations without seeing them. But always it will be necessary for men to build their houses, fish their fishes, cultivate their gardens, plant their cabbages, and for that they must see with all their eyes. And to see is to paint, and to paint is to love—nature and woman and children and the solid earth." Ensor letter reproduced in *Ecrits . . . de 1921 à 1926* (Ostend-Bruges: Editions de "La Flandre littéraire," 1926), p. 3.

Klimt. *Hope, II,* P. 33
1. Makart was the dictator of style

in the Vienna of the 1860s and 1870s. For accounts of his career, see the list of references in Varnedoe, *Vienna 1900,* "Painting & Drawing," p. 149, note 1. Klimt's major ceiling commissions were for the Burgtheater (1886–88) and the Kunsthistorisches Museum (1890–92); see Carl E. Schorske's consideration of these in relation to Klimt's biography in *Fin-de-Siècle Vienna: Politics and Culture* (New York: Knopf, 1980), pp. 209–12.
2. The Siebener and another club, the Hagenbund, were artists' coffee-house clubs in the nineties, each of which became the core of later exhibition societies. The Siebener members were pioneers in the Secession and then in the Wiener Werkstätte. The Hagenbund members later defected from the Secession to form their own, independent organization, including the architect Josef Urban and the graphic artist Heinrich Lefler; their emphasis on folk-style and fairy-tale illustration appears before 1900 and prefigures much of the design that became more dominant in Vienna around 1907–08. On these clubs see the references in Varnedoe, *Vienna 1900,* "Painting & Drawing," p. 149, note 2.
3. Klimt's father died in 1892, a fact that was likely to have affected his outlook. In this context, see Schorske's discussion of the attitudes toward the generation of the "fathers" in "Gustav Klimt: Painting and the crisis of the Liberal Ego," in Schorske, *Fin-de-Siècle Vienna.*
4. The poet Peter Altenberg praised Klimt in these terms: ". . .as a painter of vision you are also a modern philosopher, a totally modern poet! In the act of painting you transform yourself, in an instant, as in a fairy-tale, into the 'most modern of men': something which in the reality of every day you may not be at all!" Quoted in Fritz Novotny and Johannes Dobai, *Gustav Klimt* (New York and Washington, D.C.: Praeger, 1968), p. 64, and in Schorske, *Fin-de-Siècle Vienna,* p. 225. On the accuracy of Altenberg's assessment, see the defense of Klimt as thinker by Yves Kobry, "Klimt derrière le décor," in *Vienne: Fin-de-siècle et modernité,* special issue of *Cahiers du Musée national d'art moderne* (Paris), 14 (1984): 56 ff.
5. See Werner Hofmann's discussion of Klimt's use of figure-ground ambiguity, in relation to contemporary work on decoration in *Gustav Klimt and Vienna at the Turn of the Century,* trans. Inge Goodwin (Greenwich, Conn.: New York Graphic Society, 1971), pp. 34 ff.
6. On the erotic symbolism of these forms, see Hofmann, *Gustav Klimt and Vienna at the Turn of the Century,* pp. 35 ff. Alessandra Comini has discussed this kind of device in relation to Adolf Loos's premise that all art is at base erotic; see her *Gustav Klimt* (New York: Braziller, 1975), p. 6.

Fauvism, PP. 35–36
1. Georges Duthuit. *The Fauvist Painters* (New York: Wittenborn, Schultz, 1950), p. 35.
2. E. Tériade, "Constance du fauvism," *Minotaure* (Paris), October 15, 1936, p. 3; Jack D. Flam, *Matisse on Art* (London: Phaidon, 1973), p. 74.
3. Although it is possible to speak of the Fauve artists as having had certain "Expressionist" ambitions—as evidenced by Matisse's published concern with "expression"—we must await more precise study of the concept and usage of the term before too readily describing Fauvism as an Expressionist movement. A proper distinction certainly should be made between French and German art in this respect: Fauvism is often treated as a parallel movement to the Brücke group. Donald E. Gordon in "Kirchner in Dresden," *The Art Bulletin* (New York), September–December 1966, pp. 335–61, argues convincingly that this concept should be considered.
4. Gaston Diehl's *The Fauves* (New York: Abrams, 1975) valuably illustrates the idea of Fauvism as a broad European form of color painting derived from French sources.
5. The term is Meyer Schapiro's.

Braque. *Landscape at La Ciotat,*
PP. 36–37
1. John Golding, *Cubism: A History and Analysis, 1907–14,* 2nd rev. ed. (London: Faber and Faber, 1968), p. 64. The full quote is, "Hitherto, as a minor Fauve, Braque had not been a painter of any great historical importance."
2. Hilton Kramer, "Those Glorious 'Wild Beasts,'" *New York Times,* Sunday, April 4, 1976.
3. See Douglas Cooper, *G. Braque,* ex. cat. (Edinburgh: Royal Scottish Academy, and London: The Tate Gallery, 1956), pp. 26–27.

Monet. *Water Lilies,* PP. 39–40
1. Claude Roger-Marx, "Les Nymphéas de M. Claude Monet," *Gazette des Beaux-Arts,* series 4, vol. 1 (June 1909): 529.
2. René Gimpel, [Unpublished journal], Paris.
3. The 42-foot composition acquired by The Museum of Modern Art in 1959 is plainly a variant of that opposite the entrance door in the first of the two oval rooms in the Orangerie, and it is also made up of three panels approximately 14 feet in width.
4. Georges Clemenceau, *Claude Monet: The Water Lilies,* trans. George Boaz (Garden City: Doubleday, 1930), pp. 154–55.

Matisse Picasso

Matisse. *Moroccan Garden,* P. 60
1. On Henri Matisse's visits to Morocco see Jack Cowart et al., *Matisse in Morocco: The Paintings and Drawings, 1912–1913,* exh. cat. (Washington, D. C.: National Gallery of Art, 1990).

2. Matisse, in "Matisse Speaks," *Matisse on Art,* ed. Jack D. Flam (London: Phaidon, 1973), p. 132.

3. *Periwinkles/Moroccan Garden* is discussed in depth in *Matisse in Morocco,* cat. 6, p. 70.

4. Matisse, in *Matisse on Art,* p. 55.

Matisse. *View of Notre Dame,*
PP. 60–61

1. Matisse, who had a studio in 1891 at 19 quai Saint-Michel in the gables and without a view, moved to the fifth floor between 1895 and 1908, then went to the fourth floor in 1913.

2. "Notes of a Painter," in Jack Flam, ed., *Matisse on Art* (Berkeley and Los Angeles: University of California Press, 1995), p. 37.

3. Pablo Picasso quoted in Christian Zervos, "Conversations avec Picasso," *Cahiers d'art,* special issue, 1935.

4. Stéphane Mallarme, "The Impressionists and Edouard Manet," *Art Monthly Review,* Sept. 30, 1876, retranslated from the French.

5. To use an expression coined by Pierre Schneider in chapter 13 of his *Matisse* (Paris, 1984).

6. Pablo Picasso, quoted by Hélène Parmelin, *Picasso dit . . .* (Paris, 1966), p. 127.

7. Likewise, in his 1900–1901 paintings entitled *Le Pont Saint-Michel* which face in the opposite direction, Matisse uses for these landscape paintings two formats which are half the size of standard French windows: 64 x 80.6 cm. and 59 x 72 cm.

8. This essential moment in Matissian research will reach an outermost limit in *Porte-fenêtre à Collioure,* painted several months later. See Isabelle Monod-Fontaine with Anne Baldassari and Claude Laugier, *Matisse: Collections du musée national d'art moderne* (Paris, 1989), pp. 41–45, no. 10.

9. The color is evocative of a Matisse painting dated 1902, *Notre Dame, fin d'après-midi,* altogether Cezannian in inspiration, and sharing the same twilight purplish blue atmosphere.

10. As Picasso writes: "Nature is one thing, painting another . . . the image we have of nature we owe to painters. . . . In fact, there are only signs involved in that image." *Arts,* no. 22 (June 29, 1945).

Matisse. *Woman with a Veil,* P. 63

1. *Henriette I,* bronze, 1925; *Henriette II* (the so-called Big head), bronze 1927; *Henriette III,* bronze 1929.

2. Yve-Alain Bois, *Matisse and Picasso: A Gentle Rivalry,* exh. cat. (Fort Worth: Kimbell Art Museum, 1999). On *Woman with a Veil,* see chapter 2, pp. 33–54.

3. Bois, *op. cit.,* quotes Matisse in a letter to his daughter, June 13, 1926: "I have not seen Picasso for years . . . I don't care to see him again . . . He is a bandit waiting in ambush" (Matisse Archives, Paris).

4. To the extent that the pertinent title of the exhibition organized by Elizabeth Cowling and John Golding at the Tate Gallery in 1994, *Picasso: Sculptor-Painter,* also applies to Matisse. On their respective relations to sculpture, see Anne Baldassari, *Matisse Picasso*

(New York: The Museum of Modern Art, 2002), pp. 264–81.

Matisse. *Jeannette, I, II, III, IV, V,*
PP. 63–64

1. See John Elderfield, *Matisse in the Collection of The Museum of Modern Art* (New York: The Museum of Modern Art, 1978), p. 64; William Tucker, *Language of Sculpture* (London: Thames & Hudson, 1974), p. 98; and Pierre Schneider, *Matisse* (New York: Rizzoli, 1984), p. 562.

2. The association between the Rochefort bust and the Jeannette heads is made in Schneider, *Matisse,* p. 562.

3. For the 1916 date for *Jeannette (V),* see Jack Flam, *Matisse: The Man and His Art* (Ithaca, N.Y.: Cornell University Press, 1986), pp. 419–20.

Picasso. *Boy Leading a Horse,*
P. 65

1. The various sketches which came to be summarized in the study for *The Watering Place* extend from the last months of 1905 to early summer 1906. One cannot be sure where *Boy Leading a Horse* fits into this order. Alfred H. Barr, Jr., *Picasso: Fifty Years of His Art* (New York: The Museum of Modern Art, 1946, p. 42) accepted Zervos' dating of 1905 (Zervos, I, 118). I have adopted that of Pierre Daix and Georges Boudaille (*Picasso: The Blue and Rose Periods* [Greenwich, Conn.: New York Graphic Society, 1967], p. 286).

2. *Boy Leading a Horse* had particular affinities with Cézanne's *Bather,* c. 1885; while this picture was probably not in the Salon d'Automne of 1904 and certainly not in that of 1905, it was in [Ambroise] Vollard's possession in 1901 when Picasso exhibited with him, and the artist very probably saw it at the time.

3. Meyer Schapiro, lectures at Columbia University.

4. A. Blunt and P. Pool, *Picasso: The Formative Years* (Greenwich, Conn.: New York Graphic Society, 1962), pp. 26–27.

5. "Rosewater Hellenism" is a term employed in the literary criticism in the late nineteenth century; Meyer Schapiro was the first to apply it to the painting of Puvis.

Picasso. *Harlequin.* PP. 67–68

1. Stein archives, Collection of American Literature, Beinecke Rare Book and Manuscript Library, Yale University. The identification of the Museum's picture with the *Harlequin* mentioned in the letter was made by Alfred Barr in 1950.

2. There are at least ten drawings and watercolors that relate directly to *Harlequin,* though it is possible that most of them postdate the painting. This was Zervos' opinion. Because one of them (Zervos II, part 2, 557) is inscribed to André Level and dated 1916, Zervos presumably also dated numbers 556, 558 and 559 in that year. But Picasso dated his gifts when he inscribed them. Thus, the Level picture could have been executed late in 1915—either before or at the time of the painting of *Harlequin*—and dated a few months

later when Picasso gave it away. In any case it is probable that some of the related drawings and watercolors antedate the oil.

Picasso. *Girl Before a Mirror,*
P. 69

1. Reinhold Hohl, "C. J. Jung on Picasso (and Joyce)," *Source: Notes in the History of Art* (New York), 3, no. 1 (fall 1983): 15–16.

2. For more on these sexual puns, see my "Picasso and the Anatomy of Eroticism," in Theodore Bowie and Cornelia V. Christenson, eds., *Studies in Erotic Art* (New York: Basic Books, 1970); and László Glózer, *Picasso und der Surrealismus* (Cologne: M. DuMont Schauberg, 1974), pp. 56–69.

Cubism and Abstract Art

Cubism, PP. 91–92

1. That Picasso was well aware of Leonardo's definition of painting as *cosa mentale* is indicated by his remark to Françoise Gilot: "Leonardo came nearer the truth by saying that painting is something that takes place in your mind . . ." (cited in Françoise Gilot and Carlton Lake, *Life with Picasso* [New York: McGraw-Hill, 1964], p. 284). Picasso goes on to say that Leonardo's definition is incomplete and, invoking Cézanne, who had characterized his own pictures of the 1860s as *couillard,* adds that a painter has also to paint with [his] balls."

2. Picasso's remark is cited in Daniel-Henry Kahnweiler, *Juan Gris: His Life and Work,* trans. Douglas Cooper (New York: Abrams, 1969), p. 168.

3. Dora Vallier, "Braque, la peinture et nous," *Cahier d'art* 29, no. 1 (October 1954): 16. John Golding (*Cubism: A History and an Analysis, 1907–1914* [1959; London: Faber & Faber, 1968], pp. 84–85) was the first to underscore this distinction.

4. Edward Fry in his probing comparison of Braque's and Picasso's Cubism ("Braque, Cubism and the French Tradition," in *Braque: The Papiers Collés,* ed. Isabelle Monod-Fontaine with E. A. Carmean, Jr. [Washington, D.C.: National Gallery of Art, 1982], pp. 45–51) goes so far as to summarize "the interaction of Braque and Picasso" as "nothing less than the confrontation of the principles of reduction and invention." As comparative terms, I would myself prefer to pair the word "reduction" with "imagination" or "fantasy" rather than "invention," inasmuch as reductiveness, when exercised in the manner of Braque—or Mondrian or Newman—involved considerable invention. Nevertheless, Fry has emphasized here, I think, an essential difference between the two artists. The solution to the "dilemma of post-classical signification," which Fry sees as the real triumph of high Cubism, "lies in the combination of the two modes." Neither "the purely reductive nor the purely inventive approach" alone would have been capable, Fry insists, of producing this Cubist solution.

Braque. *Road near L'Estaque,*
PP. 92–93

1. André Salmon, *La Jeune peinture française* (Paris: Société des Trente, Albert Messein, 1912), p. 28; Henri Matisse, "Testimony Against Gertrude Stein," *transition,* no. 23 (July 1935), supplement, p. 6.

Braque. *Still Life with Tenora,*
PP. 93–94

1. Without knowing the real identity of this enigmatic instrument, I suggested as far back as 1960 (*Cubism and Twentieth-Century Art* [New York; Harry N. Abrams, 1960], p. 94) that the clarinet in a Braque papier collé of 1913 more closely resembled an oboe with a projecting reed.

2. I rapidly surveyed the question of musical references in Cubism, both popular and classical, in my "Picasso and the Typography of Cubism," in *Picasso/An Evaluation: 1900 to the Present* (London: Paul Elek, 1972), p. 57.

Picasso. *Ma Jolie,* PP. 94–95

1. This type of brushwork originated in [Paul] Signac's basket-weave variation on [Georges-Pierre] Seurat's *points.* But unlike Picasso, the Neo-Impressionists had used it in the form of a consistent, molecular screen. Matisse, too, frequently used such neo-impressionist brushwork with varying degrees of consistency until about 1905.

The choice of rectangular strokes that echo the framing edge and almost resemble a kind of brickwork is consistent with the architectural nature of Cubist pictures. The texture of the strokes varies with the solidity of the planes they articulate. Compare, for example, those in the center of "*Ma Jolie*" with those in its upper corners.

2. With the exception of *Guernica* and perhaps a few other pictures, Picasso has never titled his works. Daniel-Henry Kahnweiler (*The Rise of Cubism* [New York: Wittenborn, Schultz, 1949], p. 13) stresses the importance of providing Cubist pictures with descriptive titles so as to "facilitate" the viewer's "assimilation" of the image. This was, in any case, his common practice. Zervos accepted the tradition, cataloguing the picture the Museum has called "*Ma Jolie*" as *Woman with a Guitar* (II, part I, 244). An early inscription on the stretcher—though not in Picasso's handwriting—identifies the picture as *Woman with a Zither.* Picasso told the author he is no longer sure what instrument was intended; he thinks it was a guitar.

3. Braque described the letters as "forms which could not be distorted because, being themselves flat, the letters were not in space, and thus by contrast their presence in the picture made it possible to distinguish between objects situated in space and those that were not." "La Peinture et nous, Propos de l'artiste, recueillis par Dora Vallier," *Cahiers d'art* (Paris), 29, no. I (October 1954), p. 16.

4. Statement by Picasso, 1923, as reprinted in Alfred H. Barr, Jr., Picasso: *Fifty Years of His Art*

(New York: The Museum of Modern Art, 1946), pp. 270–71.
5. The refrain of *Dernière Chanson* begins "O Manon, ma jolie, mon coeur te dit bonjour." Maurice Jardot, *Picasso, Peintures 1900–1955* (Paris: Musée des Arts Décoratifs, 1955), no. 28, identifies it as a well-known song of 1911 composed by Fragson and based upon a motif from a dance by Herman Frink.
6. Letter to Kahnweiler dated June 12, 1912, cited in Jardot, *Picasso*, no. 30. In some paintings of 1912 Picasso went beyond the allusion involved in the inscription "Ma Jolie," writing *j'aime Eva* on the surface.
7. See Robert Rosenblum, "Picasso and the Typography of Cubism," in *Picasso/An Evaluation: 1900 to the Present* (London: Paul Elek, 1972).
8. Picasso told the author that this picture was painted from the imagination and that while it was in no way a portrait, he had Eva "in mind" when he painted it.

Delaunay. *Simultaneous Contrasts*, P. 97
1. *Du Cubisme à l'art abstrait*, edited by Pierre Francastel, with an oeuvre catalog by Guy Habasque (Paris; S.E.V.P.E.N., 1957), p. 129.
2. See John Elderfield, *The "Wild Beasts": Fauvism and Its Affinities* (New York: The Museum of Modern Art, 1976), pp. 35, 40.
3. Habasque, p. 155.
4. For a discussion of Delaunay's color theories in relation to Chevreul's see Gustav Vriesen and Max Imdahl, *Robert Delaunay: Light and Color* (New York: Abrams, 1957), pp. 44–46, 79 ff.

Futurism, PP. 99–100
1. An exception was the Florentine periodical, *La Voce*, founded in 1908, which was an important force in encouraging rebellion against tradition and fostering the discussion of new ideas concerning society and the arts. Certainly the Futurists owed much to its renovating spirit.
2. *Le Temps*, Paris, 14 March 1911 (*Archivi*, p. 473).

Boccioni. *Unique Forms of Continuity in Space*, PP. 100–101
1. Umberto Boccioni, "Technical Manifesto of Futurist Painting," in Charles Harrison and Paul Wood, eds., *Art in Theory, 1900–1990: An Anthology of Changing Ideas* (Oxford: Blackwell, 1992), p. 124.
2. Henri Bergson, *An Introduction to Metaphysics*, trans. T.H. Hume (London: Macmillan, 1913), pp. 1–2.

Brancusi. *Endless Column*, PP. 101–02 (Naumann text)
1. G. P. Adrian, "Constantin Brancusi," *Goya* 16 (January–February 1957): 238.
2. "Propos by Brancusi," in *Brancusi* (New York: Brummer Gallery, 1926), n. p.
3. Siegfried Giedion, *Mechanization Takes Command* (New York: Oxford News, 1948), p. 395.
4. M.M., "Constantin Brancusi: A Summary of Many Conversations," *The Arts* 4, no. 1 (July 1923): 16–17.
5. Date from *Brancusi* (1926), catalogue to the exhibition organized by Brancusi.

Brancusi. *Endless Column*, P. 102 (Soby text)
1. Constantin Brancusi. *La Colonne sans fin [The Endless Column]*. 1937. Gilt steel, 97'6" (30 m) high. Brancusi began producing his "endless columns" in 1918; the Tîrgu Jiu column was commissioned in 1935 to commemorate the fallen heroes of World War I.
2. Quoted in "Constantin Brancusi," *Saturday Review* 38, no. 49 (December 3, 1955), p. 50.

Rodchenko. *Non-Objective Painting: Black on Black*, PP. 105–06
1. *A. M. Rodchenko, Star'i*, ed. V. A. Rodchenko, E. Iu. Dutlova, and Aleksandr Lavrent'ev (Moscow: Sovetskii Khudozhnik, 1982), p. 62.
2. Ibid.
3. See Aleksandr Lavrent'ev, "On Priorities and Patents," in Magdalena Dabrowski, Leah Dickerman, and Peter Galassi, *Aleksandr Rodchenko* (New York: The Museum of Modern Art, 1998).
4. Malevich's presentation of *Black Square* and thirty-eight other non-objective Suprematist paintings in December 1915 in Petrograd was accompanied by a pamphlet, *From Cubism and Futurism to Suprematism. The New Realism in Painting*— an apologia for his newly evolved style and for the philosophy of Suprematism. Here Malevich delineates the fundamental premises of Suprematism. The pamphlet, distributed at the exhibition, was illustrated with two Suprematist paintings, *Black Square* and *Black Circle*. Published in English in Troels Andersen, ed., *K.S. Malevich: Essays on Art 1915–1928*, vol. 1 (Copenhagen: Borgen, 1968), pp. 19–41.

Taeuber-Arp. *Composition of Circles and Overlapping Angles*, P. 108
1. "Reminiscences" (1913), in Robert L. Herbert, ed., *Modern Artists on Art* (Englewood Cliffs, N.J.; Prentice Hall, 1964), p. 32.
2. Taeuber was making work containing figurative imagery throughout the period from 1915 to 1920.
3. Hugo Weber, *Sophie Taeuber-Arp*, ed. by Georg Schmidt (Basel: Holbein Verlag, 1948), p. 121.
4. Ludmila Vachtova, [review], *Neue Zürcher Zeitung* (Zurich), vol. 24, no. 29/30 (Jan. 1977), p. 57.

Torres-García. *Composition*, PP. 108–09
1. Juan Torres-García, *Universalismo constructivo*. 2 vols. (Buenos Aires: Editorial Poseidon, 1944), p. 98.
2. Ibid., p. 79.
3. Ibid., pp. 101, 178.
4. Juan Torres-García, *Estructura* (Montevideo: Biblioteca Alfar, 1935), p. 45.
5. Torres-García, *Universalismo*, p. 99.
6. Juan Fló, *Torres-García en (y desde) Montevideo* (Montevideo: Arca, 1991), pp. 15–17.
7. Stephen Bann, "Introduction: Constructivism and Constructive Art in the Twentieth Century," in Stephen Bann, ed., *The Tradition of Constructivism* (New York: Viking Press, 1974), p. XXV.

8. Naum Gabo and Antoine Pevsner, "Realistic Manifesto" (1920), in Bann, *Tradition of Constructivism*, pp. 3–11.

Murphy. *Wasp and Pear*, PP. 110–11
1. Calvin Tomkins, *Living Well Is the Best Revenge* (New York: The Viking Press, 1971), p. 144.
2. Douglas MacAgy, "Gerald Murphy: 'New Realist' of the Twenties," *Art in America* (New York), vol. 51, no. 2 (April 1963): 54.
3. John C. Palester, Research Associate, Entymology, at the American Museum of Natural History, New York, kindly verified the accuracy of this detail and pointed out the absence of the wasp's rear wings.

Bruce. *Painting*, P. 111
1. See Henri-Pierre Roché, *Collection of the Société Anonyme* (New Haven: Yale University Press, 1950), statement, p. 223.

Fantastic Art, Dada, Surrealism

Duchamp. *The Passage from Virgin to Bride*, P. 143
1. See Marcel Duchamp, "The Creative Act," in Robert Lebel, *Marcel Duchamp* (New York: Grove Press, 1959), p. 77.
2. Elizabeth Sewell, *The Field of Nonsense* (London: Chatto & Windus, 1952).
3. The notion of "short-circuit" is derived from Duchamp's notes for the *Large Glass* and the "blossoming of the bride."
4. For these images, see Lebel, *Marcel Duchamp*, pp. 10–15; Arturo Schwarz, *Complete Works of Marcel Duchamp* (New York: Abrams, 1969), pp. 103–20; and Lawrence D. Steefel, "The Position of *La Mariée mise à nu par ses célibataires même (1915–1923)*" in *Stylistic and Iconographic Development of the Art of Marcel Duchamp* (Ann Arbor: University Microfilms, 1960), pp. 133–50.
5. See Michel Foucault, "7 Propos sur le 7e ange," in Jean-Pierre Brisset, *La Grammaire logique* (Paris: Tchou, 1970), pp. vii–xix, and Brisset's own text.
6. The most compelling frame of reference for *l'état brut* of Duchamp's obsessional matrix is Georges Bataille's *Death and Sensuality: A Study of Eroticism and the Taboo* (New York: Ballantine, 1969), pp. 5–19 and passim.

Duchamp. *Bicycle Wheel*, P. 145
1. Probably the 1925 *Rotary Demisphere (Precision Optics)* (The Museum of Modern Art, Gift of Mrs. William Sisler and Purchase, 1970), a motorized construction on a metal stand. When operated, black eccentric circles painted on the rotating demisphere appear to undulate, producing an illusion of space and depth.

Man Ray. *The Rope Dancer Accompanies Herself with Her Shadows*, PP. 145–46
1. Walter Pach, *Queer Thing, Painting: Forty Years in the World*

of Art (New York: Harper and Brothers, 1938), p. 162.
2. Man Ray, *Self Portrait* (Boston: Little, Brown, 1963), p. 82.
3. Before beginning the painting, Man Ray worked on a collage version of the same subject in which the scraps of paper left over from the operation of cutting out the dancer in her various positions were used as the shadows. Following Duchamp, Man Ray evolved a constructive technique that departed from all previous artistic conventions. From collage he turned to airbrush painting, photography, and the rayograph.
With the aerographs and the rayographs he discovered additional ways of eliminating the personal touch. Using a spraygun and stencils of various shapes, he showed in *Untitled*, 1919, that a Cubist painting could be created using entirely mechanical means, the end product lacking nothing in sensitivity when compared to a carefully handcrafted painting. "It was thrilling," he said, "to paint a picture hardly touching the surface—a purely cerebral act, as it were" (*Self-Portrait*, pp. 72–73).

de Chirico. *The Enigma of a Day*, P. 146
1. "Sur les possibilités irrationnelles de pénétration et d'orientation dans un tableau—Giorgio de Chirico: L'Enigme d'une journée." *Le surréalisme au service de la revolution* (Paris), no. 6 (May 15, 1933): 13–16.

de Chirico. *The Song of Love*, PP. 146–47
1. *L'Art magique* (Paris, 1957), p. 42.

Klee. *Actor's Mask*, P. 148
1. *Klee (1879–1940)*, with an introduction and notes by Andrew Forge (London: Faber and Faber, 1954), vol. 2, p. 12.

Klee. *Castle Garden*, P. 149
1. In early 1911 Klee began an oeuvre catalogue in which he retroactively included works dating back to 1883 and which he would maintain for the rest of his life. It detailed titles, dates, and mediums, as well as prices and sales. While he included several works from his childhood, he omitted his school drawings "because they lack creative self-sufficiency." See *The Diaries of Paul Klee, 1898–1918*, ed. Felix Klee (Berkeley and Los Angeles: University of California Press, 1964), p. 256, no. 895 (1911).
2. Paul Klee, "Ways of Nature Study" (1923), in *The Thinking Eye: The Notebooks of Paul Klee*, ed. Jürg Spiller (New York and London: Wittenborn and Lund-Humphries, 1961), p. 63.

Surrealist Dream Images, PP. 149–50
1. According to [André] Breton, the first appearance in print of the word "surrealism" was as the subtitle ("a surrealist drama") of Apollinaire's *Les Mamelles de Tirésias (The Breasts of Tiresias)*, which had its première on June 24, 1917, under the sponsorship of Pierre-Albert-Birot and his review *Sic*. Actually, as William S. Lieber-

man has pointed out ('Picasso and the Ballet," *Dance Index* [New York], November–December 1946, p. 265), the word had appeared in print a month earlier, in a short text written by Apollinaire for the program of Diaghilev's production of the Satie-Massine-Picasso ballet *Parade*.

2. "Entrée des médiums," reprinted in André Breton, *Les Pas perdus* (Paris, 1924), p. 149.

3. *Manifeste du Surréalisme* (Paris, 1924), p. 42.

4. Though "abstract" is a handy word to distinguish the surrealism of Miró and Masson from the illusionism of Magritte and Dali, the process it normally describes—and the etymology of the word itself—are, in fact, alien to all Surrealist art. For this reason I have placed the word in quotation marks.

Miró. *The Hunter*, PP. 153–54

1. Shown for the first time in a one-man exhibition at the Galerie Pierre, Paris, June 12–27, 1925, as "Le Chasseur," this painting is inscribed on the reverse "Paysage catalan" (no longer visible because of lining) and has often been exhibited and referred to as "Catalan Landscape." At Miró's request the painting is now titled as it was in its initial showing, with the inscribed title following in parentheses.

2. For discussion see Rosalind Krauss and Margit Rowell, *Magnetic Fields* (New York: Solomon R. Guggenheim Foundation, 1972), pp. 77–78.

3. Ibid., p. 77.

4. Gerta Moray, "Miró, Bosch and Fantasy Painting," *The Burlington Magazine* (London), vol. 113, no. 820 (July 1971): 387, proposes paintings by Bosch as the source of this and other motifs in Miró's painting of 1923–25.

5. For example, *The Eye Like a Strange Balloon Mounts toward Infinity*. Masson was a great admirer of Redon and frequently brought his work to Miró's attention.

6. See Krauss and Rowell, p. 77, who single out in particular a collage from Ernst's *Repetitions* (1922) showing a string pulled through the eye parallel to the lower edge of the picture thus suggesting Miró's horizon line.

7. Jacques Dupin interprets the following quotation from a Miró letter to Rafols as referring only to *The Hunter*: "Hard at work and full of enthusiasm. Monstrous animals and angelic animals. *Tree with ears and eyes and a peasant in a Catalan cap*, holding a shotgun and smoking a pipe" (italics mine). In fact, as Miró has told the author, he was referring to two pictures, *The Tilled Field*, which does depict a tree with both an ear and an eye, and *The Hunter*, in which the peasant is presented as described.

Miró. *Hirondelle/Amour*, P. 154

1. The four paintings were commissioned by Mme Marie Cuttoli, a well-known collector and an early patron of many of the major painters of the [twentieth] century. It is largely to her efforts that the French tapestry industry owes its revival after a decline of nearly

two hundred years. Among other artists from whom she has commissioned tapestry cartoons are Matisse, Braque, and Picasso.

2. Among example of Miró's picture-poems of the twenties are: *Photo: Ceci est la couleur de mes rêves*, 1925; *Etoiles et des sexes d'escargot*, 1925; *Un Oiseau poursuit une abeille et la baisse*, 1927; *Musique, Seine, Michel, Bataille et moi*, 1927. In these paintings, as in *Hirondelle/Amour*, the writing serves an essential plastic function within the pictorial structure while at the same time verbally reinforcing the emotional and connotative impact of the image. For an in-depth discussion of Miró's picture-poems see Krauss and Rowell, pp. 11–35, pp. 39–64 passim.

3. Pierre Schneider, "Miró," *Horizon* (New York) 1, no. 4 (March 1959): 72.

Masson. *Battle of Fishes*, PP. 154–55

1. *Manifeste du surréalisme, poisson soluble* (Paris: Editions du Sagittaire, Kra, 1924), pp. 100–102.

2. Masson's sand paintings of the twenties have always been dated 1927 by the artist himself and all who have written on his work. His first use of this technique, however, most have occurred earlier—in late 1926—as is made evident by a letter from Masson to [Daniel Henry] Kahnweiler uncovered in 1975 in the files of the Galerie Louise Leiris by Frances Beatty. In his letter, dated January 8, 1927, Masson tells Kahnweiler that he has just finished twelve sand paintings. The previous misdating was in part the result of the fact that Kahnweiler's Galerie Simon records assigned the date of recently completed work according to the year in which it was received by the gallery.

Placing the sand series earlier than heretofore necessitates a dating change for the group of works that just preceded it, of which *Hunted Castle* was one of the earliest. Masson remembers painting such as *Chevauché*, *Children of the Isles*, and *Horses Attacked by Fish* as preceding the sand series, and, while his memory was faulty about the exact date of the sand paintings, it is most unlikely that he would not accurately remember the sequence which led up to realization of the sand paintings. This new dating explains what had previously seemed the curious barrenness of 1926 as compared with the highly prolific years which preceded and followed. As for the order within the series of sand paintings, we know that *Battle of Fishes* was the first and that the more schematic, such as *Villagers*, tend to have been executed toward the last.

Arp. *Human Concretion*, P. 157

1. Cited in Carola Giedion-Welcker, *Jean Arp* (New York, 1957), p. xxvii.

Calder. *Gibraltar*, PP. 157–58

1. J. J. Sweeney, *Alexander Calder*, 2nd ed. (New York: The Museum of Modern Art, 1951).

Bourgeois. *Sleeping Figure, II*, P. 159

1. Louise Bourgeois, statement in

Belle Krasne, "10 Artists in the Margin," *Design Quarterly* (Minneapolis), no. 30 (1954): 18.

New Images of Man

Rodin. *Monument to Balzac*, PP. 189–90

1. L. Scholl, article in *Echo de Paris*, August 28, 1896.

2. Judith Cladel, *Auguste Rodin* (Brussels: Van Oest, 1908), p. 145 and the entire chapter on the *Monument to Balzac*.

3. Cécile Goldscheider, *Balzac et Rodin* (Paris: Musée Rodin, 1950). Leo Steinberg has stated that on a visit to the Meudon studio in the summer of 1962, he found among the terra cottas in one of the glass cases what he believes to be a small study for the *Balzac*. This study, of which no photographs exist in the albums of the Musée Rodin, does not appear in Goldscheider's writings on the subject.

4. Cladel, *op cit*, p. 131, gives the whole letter.

5. Many writers commented upon Rodin's extreme illness and prolonged fatigue during the year 1894–95.

Modigliani. *Head*, P. 191

1. Sidney Geist, *Brancusi/The Kiss* (New York: Harper and Row, 1978), p. 9.

2. Alfred Werner, *Modigliani the Sculptor* (New York: Golden Griffin, 1962), p. xxiii.

3. Ibid., p. xxiii.

Beckmann. *Self-Portrait with a Cigarette*, P. 193

1. "Letters to a Woman Painter," first published in *College Art Journal* 9, no. 1 (autumn 1949): 39–43.

Beckmann. *Departure*, P. 194

1. According to Beckmann's carefully kept records, the central and right panels were completed in November 1933, and the left panel in December 1933. (Heretofore it was believed that Beckmann worked on *Departure* until 1935.)

2. Bernard S. Myers, *The German Expressionists* (New York, Frederick A. Praeger, 1957), p. 304.

3. Unpublished letter dated June 1, 1955.

4. T. S. Eliot, "The Waste Land," 1922, in *Collected Poems 1909–1935* (New York, Harcourt, Brace & World, 1963).

5. Charles S. Kessler, "Max Beckmann's *Departure*," *Journal of Aesthetics & Art Criticism* 14, no. 2 (December 1955): 215.

6. Günter Busch, *Max Beckmann* (Munich: R. Piper Verlag, 1960), p. 76. But how could Charon convey his passengers into such a bright world?

7. Lothar-Günther Buchheim, *Max Beckmann* (Feldafing: Buchheim Verlag, 1959), p. 159.

Pierre Bonnard. *Nude in Bathroom*, P. 195

1. "Esthétique du mouvement et des signes. Il faut qu'il ait un arrêt, un appui." [Bonnard] Diary entry, December 4, 1935.

2. Ibid.

Balthus. *The Street*, PP. 195–96

1. The exhibition was held at the Galerie Beaux-Arts, Paris, in March 1956. Soby's letter to Balthus of October 28, 1955, indicates that it was Soby who offered the painting for the Paris show: "Pierre [Matisse] tells me that you are having a retrospective exhibition in Paris this winter. If you would like to have *La Rue* in the exhibition, by all means do so" (MoMA Archives: Soby Papers, IV.C.1).

2. Concerned that the French Customs officials would not permit the reentry of *La Rue* into France, Soby asked the conservators Sheldon and Caroline Keck to advise him as to methods of camouflage. They overpainted the offending area with watercolor, so that it could be easily and safely removed by Balthus when the painting reached France. Pierre Matisse acted as intermediary between Soby and the artist, arranging for the painting to be sent from Paris "to Chassy where Balthus plans to operate on the offending parts! T[o] tell you the truth he does not quite know how he is going to do it and it will probably require quite a bit of thought" (letter, Pierre Matisse to Soby, June 21, 1956; MoMA Archives, Soby Papers, I.7.2). On June 20, 1956, Balthus wrote to Soby, "It was a strange feeling, after so many years, to see this picture again which I painted when I was little over twenty. I succeeded only in the last few days to change the objectionable gesture of the boy—a rather difficult affair, the whole picture having been built up mathematically. As I told P.M. [Pierre Matisse] I accepted to reconsider the matter as I do not think—and never thought—that the real interest, if any, was residing *there*. It was rather done in a mood of youthful desire to provoke, at a time one still believed in scandal. Today scandal is just worn out as an old shoe." Soby was thoroughly pleased with the changes made, writing to Balthus on August 20, 1956, "I am everlastingly grateful for your repairs on *La Rue*. I know it must have been a struggle and I greatly appreciate it" (MoMA Archives: Soby Papers, I.7.2).

The New American Painting

Gorky. *Agony*, P. 217

1. *Le Surréalisme et la peinture*, 2nd ed. (New York, 1945), pp. 196–99.

2. Foreword, in William C. Seitz, *Arshile Gorky: Paintings, Drawings, Studies* (New York, 1961), p. 8.

Pollock. *Gothic; Number 1, 1948; Echo*, PP. 219–20
(Rubin text)

1. Pollock's relationship to Surrealist methods has been discussed many times; see interview between Robert Motherwell and Sidney Simon, *Art International* (Zurich) (summer 1967): 21–23, and the author's "Jackson Pollock and the Modern Tradition, VI: An Aspect of Automatism," *Artforum* (Los Angeles) (May 1967): 28–33. Pollock's experimentation with auto-

matic poetry has been specifically noted by Francis V. O'Connor, *Jackson Pollock* (New York, 1967), p. 26.

Pollock. *Gothic; Number 1, 1948; Echo,* P. 220 (Karmel text)
1. For a discussion of the work of Mark Tobey and Janet Sobel in relation to Pollock, see William Rubin, "Jackson Pollock and the Modern Tradition, Part III," *Artforum* (New York) 5, no. 8 (April 1967): 27–30.

Pollock. *Echo,* P. 220
(Coddington text)
1. See Krasner, quoted in B. H. Friedman, "An Interview with Lee Krasner Pollock," in Hans Namuth et al., *Pollock Painting* (New York: Agrinde Publications, 1980), n.p.
2. Ibid. Rivit was manufactured by Behlen's, a company that has since been absorbed into larger corporations. The current company, Mohawk industries, after cursory search, found no record of the glue's formula in the early 1950s, but the evidence points to it being a (poly)vinyl acetate emulsion, a white glue similar to Elmer's.

Rothko. *Horizontals, White over Darks,* P. 222
1. Introduction to exh. cat., *Mark Rothko* (Houston: Contemporary Arts Museum, 1957).
2. The murals for that room were never delivered, because Rothko decided that their somber, almost religious intimations did not suit the setting. Since 1970 they have been installed in the Tate Gallery, London, the gift of the American Federation of Arts.
3. From a lecture given at Pratt Institute, Brooklyn, in 1958 excerpted by Dore Ashton, "Letter from New York," *Cimaise* (Paris), sér. 6 (December 1958): 38–39.

Newman. *Abraham,* P. 223
1. Annalee Newman remembers that he [Newman] made most of his measurements on the canvas by eye, using a ruler or tape measure only to make sure that a tape was fixed plumb. His sense of size and scale was extraordinarily acute, so much so that when once he "spotted a chair out on line, we measured and found that one side was a thirty-second of an inch higher." Some working notes found after his death indicate that Newman calculated the placement of his zips and divisions of the field down to an eighth of an inch.

Newman. *The Wild,* P. 224
1. Barbara Reise, "The Stance of Barnett Newman," *Studio International* (London), 179 (February 1970): 53.

Louis. *Russet,* PP. 228–29
1. Clement Greenberg in *Three New American Painters: Louis, Noland, Olitski*, exh. cat. (Regina, Saskatchewan: Norman Mackenzie Art Gallery, 1963), p. 174.

Rauschenberg. *First Landing Jump,* P. 230
1. Robert Rauschenberg, quoted by Dorothy Gees Seckler, "The Artist Speaks: Robert Rauschenberg," *Art in America* 54, no. 3 (May–June 1966): 76.

2. Brian O'Doherty, "Rauschenberg and the Vernacular Glance," *Art in America* 61, no. 4 (September–October 1973): 84.
3. J[ack]. K[roll]., "Robert Rauschenberg," *Art News* 60 (December 1961): 12.

Johns. *Green Target; White Numbers; Map,* PP. 230–31
1. Characteristic responses to this quality in John's work include [Barbara] Rose's remark "Jasper Johns seems to me in love with his paintings. . . . Only a lover could lavish the kind of care and consideration Johns gives the surfaces of his paintings"; see her "Pop Art at the Guggenheim," *Art International* 5, no. 7 (May 25, 1963): 22.
2. [Barbara] Rose writes, "Johns often displaces elements from one context to another. Depriving color of its conventionally expressive role as well as disregarding the associative possibilities of objects, he displaces a great deal of the expressive burden of his work to technique. . . . His expressiveness arises . . . out of an ability to create analogs of emotional experience in the tempo, regularity and irregularity of stroke, firmness or openness of contour and sensitive bleeding or dripping wash passages." Rose, "The Graphic Work of Jasper Johns: Part II," *Artforum* 9, no. 1 (September 1970): 69–70.
3. In a 1990 interview, Johns discussed his lack of training as a draftsman, his techniques, and his predilection for "found" schemas. He allowed that "perhaps I'm more confident working with images of a schematic nature or images that lend themselves to schematization than with things that have to be established imaginatively." Johns, quoted in Ruth E. Fine and Nan Rosenthal, *The Drawings of Jasper Johns*, exh. cat. (Washington, D.C.: National Gallery of Art, 1990), p. 70.
4. Johns, quoted in Grace Glueck, "No Business like No Business," *New York Times*, January 16, 1966, Section II, p. 26x.
5. Johns, quoted in "His Heart Belongs to Dada," *Time* 73 (May 4, 1959): 58.
6. Johns, quoted in Walter Hopps, "An Interview with Jasper Johns," *Artforum* 3, no. 6 (March 1965): 34.
7. Johns in David Sylvester, "Interview with Jasper Johns," in *Jasper Johns Drawings*, exh. cat. (London: Arts Council of Great Britain, 1974), p. 7.
8. Johns has said, "After the army, I wondered when I was going to stop 'going to be' an artist and start being one. I wondered what was the difference between these two states, and I decided that it was one of responsibility. . . . I could not excuse the quality of what I did with the idea that I was going somewhere or that I was 'going to be something.' What I did would have to represent itself. I would be responsible to it now, in the present tense, and though everything would keep changing, I was as I was and the work was as it was at any moment. This became more important to me than any idea about 'where things were going.'" Johns, quoted in Sylvia L. McKenzie, "Jasper Johns Art Hailed World-

wide," *Charleston (S.C.) News and Courier*, October 10, 1965, p. 13-B.

Johns. *Green Targets; White Numbers; Map,* PP. 231–32
1. Johns, quoted in G. R. Swenson, "What is Pop Art? Part II," *Artnews* 62, no. 10 (February 1964): 66.
2. See Johns interview with David Sylvester published in *Jasper Johns Drawings* (London: Arts Council of Great Britain, 1974), pp. 7–8.
3. Robert Morris, "Notes on Sculpture, Part 4, Beyond Objects," *Artforum* 7, no. 8 (April 1969): 50.

Otero. *Colorythm, I,* P. 233
1. The idea is Roberto Guevara's. See Guevara, "Artes visuales en Venezuela," in Damián Bayón, ed., *Arte Moderno en América Latina* (Madrid: Taurus, 1985), p. 211.
2. José Balza, *Alejandro Otero* (Milan: Olivetti, 1977), p. 66.

The Art of the Real

Warhol. *Before and After,* P. 267
1. Walter Hoops has described his first visit to Warhol's studio in 1961 in Jean Stein with George Plimpton, eds., *Edie: An American Biography* (New York: Alfred A. Knopf, 1982), p. 192: "What really made an impression was that the floor—I may exaggerate a little—was not a foot deep, but certainly covered wall to wall with every sort of pulp movie magazine, fan magazine, and trade sheet, having to do with popular stars from the movies or rock 'n' roll. Warhol wallowed in it. Pulp just littering the place edge to edge."

Lichtenstein. *Girl with Ball; Drowning Girl,* PP. 267–68
1. See John Coplans, "Interview. Roy Lichtenstein" (1970) in Coplans, ed., *Roy Lichtenstein* (New York: Praeger, 1972).

Ruscha. *OOF,* P. 269
1. Dave Hickey, quoted in Michael Dooley, "Ed Words: Ruscha in Print," *Print* 48, no. 5 (September–October 1994): 36.

Wesselmann. *Still Life #30,* PP. 269–70
1. See Cécile Whiting, "Wesselmann and Pop at Home," in Whiting, *A Taste for Pop: Pop Art, Gender, and Consumer Culture* (Cambridge: Cambridge University Press, 1997), pp. 50–99.

Stella. *The Marriage of Reason and Squalor, II,* PP. 270-71
1. Graph-paper drawings of the configurations of some of the Black pictures do exist but, like many such drawings of the early pictures, they were executed some years after the paintings.
2. See, for example, Clement Greenberg, "Modernist Painting," *Art and Literature* (Lausanne) (spring 1965): 198.
3. There are two alternative spatial readings for the classic configuration of Pollock. Since none of the conventional visual cues for what we call illusionistic space are present, we are *required* to see only the very shallow space created by the actual displacement of the overlap-

ping skeins, whose unique anti-sculptural line implies no space in itself (see the author's "Jackson Pollock and the Modern Tradition, II: The All-Over Compositions and the Drip Technique," *Artforum* (Los Angeles) (February 1967): 20–21.

Smith. *Free Ride,* PP. 272-73
1. Joan Pachner, "Tony Smith: Architect, Painter, Sculptor," Ph.D. diss., New York University, Institute of Fine Arts, 1993, p. 226.
2. Phyllis Tuchman, "Tony Smith: A Modern Master," *New Jersey Monthly* 5 (January 1981): 126.
3. Grace Glueck, "Tony Smith, 68, Sculptor of Minimalist Structures," *New York Times*, December 27, 1980, sec. D, p. 26.
4. E. C. Goossen, "Tony Smith, 1912–1980," *Art in America* 69 (April 1981): 11.

LeWitt. *Serial Project, I,* PP. 273-74
1. In taped conversations with the author, 1971–72.
2. Terry Atkinson of Art & Language in *Sol LeWitt*, Haags Gemeentemuseum, 1970. LeWitt had been in touch with Atkinson and Michael Baldwin since the winter of 1965 or so; he admired their use of maps and linguistic philosophy to generate a unique kind of content.
3. Bruce Glaser interview, "Questions to Stella and Judd," broadcast on WBAI, New York, February 1964; subsequently edited by Lucy R. Lippard and published in *Art News* (New York) (September 1966).
4. There were of course precedents in the twentieth century for this attitude, especially [Lázló] Moholy-Nagy's famous Telephone Pictures series. As Lawrence Alloway has put it, "What the Americans did was to standardize the unit," *Artforum* (New York) (April 1975): 42.
5. This disinterest in "originality" became something of a *cause célèbre* in 1973, when the Italian artpaper *Flash Art* published an advertisement accusing LeWitt of copying European artists, an accusation LeWitt answered easily. In the process he noted that "there are many works of artists that superficially resemble the works of other artists" but that the only valid comparison is between the total works of any artist.

Hesse. *Vinculum, II,* P. 275
1. Hesse died of a brain tumor at the age of thirty-four on May 19, 1970. Jewish, born in Hamburg, Germany, in 1936; at two she was separated from her parents for some months, when she was evacuated to Holland. At three the family, reunited, emigrated to the United States. When she was nine her parents divorced and when she was ten, her mother committed suicide. An unhappy marriage ended shortly before the death of her father in 1966.
2. Lucas Samaras is one of a number of artists who shared Hesse's interests.
3. Quoted in Lucy R. Lippard, "Eva Hesse: The Circle," in *From the Center: Feminist Essays on Women's Art* (New York; E. P. Dutton, 1976), p. 161.

Serra. *One Ton Prop (House of Cards),* P. 276
1. Emily Wasserman, "An Interview with Composer Steve Reich," *Artforum* 10 (May 1972): 48.

Open Ends

Richter. *October 17, 1977* cycle, PP. 303-04
1. Gerhard Richter, "Notes for a Press Conference, November/December 1989." In Hans-Ulrich Obrist, ed., *Gerhard Richter: The Daily Practice of Painting. Writings and Interviews, 1962–1993* (Cambridge, Mass.: MIT Press, 1995), p. 173.
2. Ibid., p. 174.
3. Ibid., "Notes for a Press Conference, 1985," p. 102.

329

Selected Bibliography

The publications listed below are those cited in the anthology texts.

Agee 1979
Agee, William C. *Patrick Henry Bruce, American Modernist: A Catalogue Raisonné.* New York: The Museum of Modern Art, 1979.

Amaral 1993
Amaral, Aracy. "Abstract Constructivist Trends in Argentina, Brazil, Venezuela, and Colombia." In *Latin American Artists of the Twentieth Century,* edited by Waldo Rasmussen. New York: The Museum of Modern Art, 1993, pp. 86–99.

Arenas 1995
Arenas, Amelia. *Abstraction, Pure and Impure.* New York: The Museum of Modern Art, 1995.

Baldassari 2002
Cowling, Elizabeth, Anne Baldassari, John Elderfield, John Golding, Isabella Monod-Fontaine, and Kirk Varnedoe. *Matisse Picasso.* New York: The Museum of Modern Art, 2002.

Barr 1929
Barr, Alfred H., Jr. *The Museum of Modern Art: First Loan Exhibition, New York, November 1929: Cézanne, Gauguin, Seurat, van Gogh.* New York: The Museum of Modern Art, 1929.

Barr 1931
Barr, Alfred H., Jr. *Modern German Painting and Sculpture.* New York: The Museum of Modern Art, 1931.

Barr 1941
Barr, Alfred H., Jr. *Paul Klee.* New York: The Museum of Modern Art, 1941.

Barr 1943
Barr, Alfred H., Jr. *What is Modern Painting?* New York: The Museum of Modern Art, 1943.

Barr 1951
Barr, Alfred H., Jr. *Matisse: His Art and His Public.* New York: The Museum of Modern Art, 1951.

Barr 1953
Barr, Alfred H., Jr. Notes on New Acquisitions. Exhibition at The Museum of Modern Art, New York, February 11–March 15, 1953.

Barr 1954
Barr, Alfred H., Jr., ed. *Masters of Modern Art.* New York: The Museum of Modern Art, 1954.

Barr 1956
Barr, Alfred H., Jr., *What Is Modern Painting?* Rev. ed. New York: The Museum of Modern Art, 1956.

Bois 1991
Bois, Yve-Alain. *Ad Reinhardt.* New York: The Museum of Modern Art, 1991.

Burchfield 1933
Burchfield, Charles. In *Edward Hopper: Retrospective Exhibition.* New York: The Museum of Modern Art, 1933.

Calder 1951
Calder, Alexander. "What Abstract Art Means to Me," statement presented at a symposium at The Museum of Modern Art, February 1951, and subsequently published in *The Museum of Modern Art Bulletin* 18, no. 3 (spring 1951): 8–9.

Chagall 1946
Chagall, Marc. "Eleven Europeans in America." In *The Bulletin of the Museum of Modern Art* 13, nos. 4–5 (1946): 32–34, 37.

Coddington 1999
Coddington, James. "No Chaos Damn It." In *Jackson Pollock: New Approaches,* edited by Kirk Varnedoe and Pepe Karmel. New York: The Museum of Modern Art, 1999, pp. 101–15.

Dabrowski 1980
Dabrowski, Magdalena. *The Symbolist Aesthetic.* New York: The Museum of Modern Art, 1980.

Dabrowski 1998
Dabrowski, Magdalena, Leah Dickerman, and Peter Galassi. *Aleksandr Rodchenko.* New York: The Museum of Modern Art, 1998.

Dabrowski 1999
Dabrowski, Magdalena. *French Landscape: The Modern Vision 1880–1920.* New York: The Museum of Modern Art, 1999.

Dabrowski 1999
Dabrowski, Magdalena. "Vasily Kandinsky: The Campbell Commission." In *MoMA: The Magazine of The Museum of Modern Art* 2, no. 9 (November 1999): 2–5.

Daftari 2000
Daftari, Fereshteh. "Home and Away." In *Modern Contemporary: Art at MoMA since 1980,* edited by Kirk Varnedoe, Paola Antonelli, and Joshua Siegel. New York: The Museum of Modern Art, 2000, pp. 513–15.

Duchamp 1946
Duchamp, Marcel. In *The Bulletin of The Museum of Modern Art: Eleven Europeans in America* 13, nos. 4–5 (1946): 19–21, 37.

Duchamp 1975
Duchamp, Marcel. In *Modern Masters: Manet to Matisse* by William S. Liberman. New York: The Museum of Modern Art, 1975. Originally published in *The Collection of the Société Anonyme: The Museum of Modern Art 1920,* by Katherine S. Dreier and Marcel Duchamp. 1950.

Eggum 1979
Elderfield, John, and Arne Eggum. *The Masterworks of Edvard Munch.* New York: The Museum of Modern Art, 1979.

Elderfield 1976
Elderfield, John. *The "Wild Beasts": Fauvism and Its Affinities.* New York: The Museum of Modern Art, 1976.

Elderfield 1976
Elderfield, John. *European Master Paintings from Swiss Collections: Post-Impressionism to World War II.* New York: The Museum of Modern Art, 1976.

Elderfield 1979
Elderfield, John, and Arne Eggum. *The Masterworks of Edvard Munch.* New York: The Museum of Modern Art, 1979.

Elderfield 1986
Elderfield, John. *Morris Louis.* New York: The Museum of Modern Art, 1986.

Elderfield 1996
Elderfield, John. *Henri Matisse: Masterworks from The Museum of Modern Art.* New York: The Museum of Modern Art, 1996.

Elsen 1963
Elsen, Albert. *Rodin.* New York: The Museum of Modern Art, 1963.

Franc 1992
Franc, Helen M. *An Invitation to See: 150 Works from The Museum of Modern Art.* New York: The Museum of Modern Art, 1992.

Ganz 1999
Alexander, M. Darsie, Mary Chan, Starr Figura, Sarah Ganz, and Maria del Carmen González. *Body Language.* New York: The Museum of Modern Art, 1999.

Goossen 1973
Goossen, E. C. *Ellsworth Kelly.* New York: The Museum of Modern Art, 1973.

Gopnik 1990
Varnedoe, Kirk, and Adam Gopnik. *High & Low: Modern Art and Popular Culture.* New York: The Museum of Modern Art, 1990.

Haftmann 1957
Haftmann, Werner. *German Art of the Twentieth Century.* New York: The Museum of Modern Art, 1957.

Hess 1968
Hess, Thomas B. *Willem de Kooning.* New York: The Museum of Modern Art, 1968.

Hess 1971
Hess, Thomas B. *Barnett Newman.* New York: The Museum of Modern Art, 1971.

Holzer 1990
Holzer, Jenny. "Jenny Holzer on Meret Oppenheim's Object: A Cup of Words." In *Contemporary Art in Context,* edited by Christopher Lyon. New York: The Museum of Modern Art, 1990, pp. 55–56.

Hope 1949
Hope, Henry R. *Georges Braque.* New York: The Museum of Modern Art, 1949.

Hope 1954
Hope, Henry R. *The Sculpture of Jacques Lipchitz.* New York: The Museum of Modern Art, 1954.

Jones 1998
Jones, Leslie. In *Pop Art: Selections from The Museum of Modern Art,* by Anne Umland. New York: The Museum of Modern Art, 1998.

Karmel 1998
Karmel, Pepe. "Pollock at Work: The Films and Photographs of Hans Namuth." In *Jackson Pollock* by Kirk Varnedoe with Pepe Karmel. New York: The Museum of Modern Art, 1998, pp. 87–139.

Kelly 1990
Kelly, Ellsworth. *Artist's Choice: Fragmentation and the Single Form.* New York: The Museum of Modern Art, 1990.

Kernan 1999
Kernan, Beatrice. "Expression and the Series: Rodin and Matisse." In *Modernstarts: People, Places, Things,* edited by John Elderfield, Peter Reed, Mary Chan, and Maria del Carmen González. New York: The Museum of Modern Art, 1999, pp. 66–73.

Kirstein 1948
Kirstein, Lincoln. *The Sculpture of Elie Nadelman.* New York: The Museum of Modern Art, 1948.

Kosuth 1990
Kosuth, Joseph. "Joseph Kosuth on Marcel Duchamp: 'Please Do Not Touch the Sculpture.'" In *contemporary Art in Context,* edited by Christopher Lyon. New York: The Museum of Modern Art, 1990, pp. 46–47.

Krauss 1986
Krauss, Rosalind E. *Richard Serra/Sculpture.* New York: The Museum of Modern Art, 1986.

Lanchner 1981
Lanchner, Carolyn. *Sophie Taeuber-Arp.* New York: The Museum of Modern Art, 1981.

Lieberman 1975
Lieberman, William. *Modern Masters: Manet to Matisse.* New York: The Museum of Modern Art, 1975.

Lippard 1972
Three Generations of Twentieth-Century Art: The Sidney and Harriet Janis Collection of The Museum of Modern Art. Foreword by Alfred H. Barr, Jr. Introduction by William Rubin. Text on works by Lucy Lippard. New York: The Museum of Modern Art, 1972.

Lippard 1978
Lippard, Lucy. *Sol LeWitt.* New York: The Museum of Modern Art, 1978.

McShine 1989
McShine, Kynaston. ed. *Andy Warhol: A Retrospective.* New York: The Museum of Modern Art, 1989.

MoMA Highlights 1999
MoMA Highlights: 325 Works from The Museum of Modern Art, New York. New York: The Museum of Modern Art, 1999.

Monod-Fontaine 2002
Cowling, Elizabeth, Anne Baldassari, John Elderfield, John Golding, Isabelle Monod-Fontaine, and Kirk Varnedoe. *Matisse Picasso.* New York: The Museum of Modern Art, 2002.

Morris 1935
Morris, George L. K. "Fernand Léger versus Cubism." In *The Bulletin of the Museum of Modern Art: Fernand Léger Exhibition* 1, no 3 (October 1935): 2–7.

Morris 1951
Morris, George L. K. "What Abstract Art Means to Me," statement presented at a symposium at The Museum of Modern Art, February 1951, and subsequently published in *The Museum of Modern Art Bulletin* 18, no. 3 (spring 1951): 3–4.

Motherwell 1951
Motherwell, Robert. "What Abstract Art Means to Me," statement presented at a symposium at The Museum of Modern Art, February 1951, and subsequently published in *The Museum of Modern Art Bulletin* 18, no. 3 (spring 1951): 12–13.

Naumann 1984
Naumann, Francis M. *The Mary and William Sisler Collection.* New York: The Museum of Modern Art, 1984.

Nelson 1993
Nelson, Florencia Bazzano. "Joaquín Torres-García and the Tradition of Constructive Art." In *Latin American Artists of the Twentieth Century,* edited by Waldo Rasmussen. New York: The Museum of Modern Art, 1993, pp. 72–85.

Pollock 1956–57
Pollock, Jackson. "Statements by Pollock." Written in 1944 and 1947 and published in *The Bulletin of The Museum of Modern Art* 24, no. 2 (1956–57): 33.

Ratcliff 1980
Ratcliff, Carter. "Joseph Cornell: Mechanic of the Ineffable." In *Joseph Cornell,* edited by Kynaston McShine. New York: The Museum of Modern Art, 1980, pp. 43–67.

Rauschenberg 1959
Rauschenberg, Robert. In *Sixteen Americans,* edited by Dorothy C. Miller. New York: The Museum of Modern Art, 1959.

Reff 1977
Reff, Theodore. "Painting and Theory in the Final Decade." In *Cézanne: The Late Work,* edited by William Rubin. New York: The Museum of Modern Art, 1977, pp. 13–53.

Reff 1992
Reff, Theodore. "The Reaction Against Fauvism: The Case of Braque." In *Picasso and Braque: A Symposium,* organized by William Rubin. New York: The Museum of Modern Art, 1992, pp. 17–43.

Reinhardt 1963
Reinhardt, Ad. In *Americans 1963,* edited by Dorothy C. Miller. New York: The Museum of Modern Art, 1963.

Rewald 1978
Rewald, John. *Post-Impressionism: From van Gogh to Gauguin.* New York: The Museum of Modern Art, 1978.

Rich 1942
Rich, Daniel Catton. *Henri Rousseau.* New York: The Museum of Modern Art, 1942.

Rich 1958
Rich, Daniel Catton, ed. *Seurat: Paintings and Drawings.* New York: The Museum of Modern Art, 1958.

Ritchie 1952
Ritchie, Andrew Carnduff. *Sculpture of the Twentieth Century.* New York: The Museum of Modern Art, 1952.

Rose 1969
Rose, Barbara. *Claes Oldenberg.* New York: The Museum of Modern Art, 1969.

Rosenblum 1990
Rosenblum, Robert. "Cubism as Pop Art." In *Modern Art and Popular Culture: Readings in High and Low,* edited by Kirk Varnedoe and Adam Gopnik. New York: The Museum of Modern Art, 1990, pp. 116–32.

Rosenblum 1996
Rosenblum, Robert. "Rapturous Masterpieces: Picasso's Portraits of Marie-Thérèse." In *MoMA: The Magazine of The Museum of Modern Art,* no. 22 (summer 1996): 3–8.

Rothko 1952
Rothko, Mark. In *15 Americans,* edited by Dorothy C. Miller. New York; The Museum of Modern Art, 1952.

Rubin 1957
Rubin, William. *Matta.* New York: The Museum of Modern Art, 1957.

Rubin 1968
Rubin, William. *Dada, Surrealism, and Their Heritage.* New York: The Museum of Modern Art, 1968.

Rubin 1970
Rubin, William. *Frank Stella.* New York: The Museum of Modern Art, 1970.

Rubin 1972
Rubin, William. *Picasso in the Collection of The Museum of Modern Art.* New York: The Museum of Modern Art, 1972.

Rubin 1973
Rubin, William. *Miró in the Collection of The Museum of Modern Art.* New York: The Museum of Modern Art, 1973.

Rubin 1974
Rubin, William. *The Paintings of Gerald Murphy.* New York: The Museum of Modern Art, 1974.

Rubin 1976
Rubin, William, and Carolyn Lanchner. *André Masson.* New York: The Museum of Modern Art, 1976.

Rubin 1976
Rubin, William. "Klee's Cat and Bird." In *MoMA: A Publication for Members of The Museum of Modern Art* (spring 1976), n.p.

Rubin 1977
Rubin, William, ed. *Cézanne: The Late Work.* New York: The Museum of Modern Art, 1977.

Rubin 1989
Rubin, William. *Picasso and Braque: Pioneering Cubism.* New York: The Museum of Modern Art, 1989.

Rubin 1992
Rubin, William, and Matthew Armstrong. *The William S. Paley Collection.* New York: The Museum of Modern Art, 1992.

Russell 1981
Russell, John. *The Meanings of Modern Art.* New York: The Museum of Modern Art, 1981.

Seitz 1960
Seitz, William C. *Claude Monet: Seasons and Moments.* New York: The Museum of Modern Art, 1960.

Seitz 1962
Seitz, William. *Arshile Gorky: Paintings, Drawings, Studies.* New York: The Museum of Modern Art, 1962.

Seitz 1965
Seitz, William. *The Responsive Eye.* New York: The Museum of Modern Art, 1965.

Selz 1961
Selz, Peter. *Mark Rothko.* New York: The Museum of Modern Art, 1961.

Selz 1964
Selz, Peter. *Max Beckmann.* New York: The Museum of Modern Art, 1964.

Selz 1965
Selz, Peter. *Alberto Giacometti.* New York: The Museum of Modern Art, 1965.

Smith 1952
Smith, David. Statement presented at a symposium on "The New Sculpture" at The Museum of Modern Art, New York, Februay 12, 1952.

Soby 1948
Soby, James Thrall. *Contemporary Painters.* New York: The Museum of Modern Art, 1948.

Soby 1951
Soby, James Thrall. *Modigliani: Paintings, Drawings, Sculpture.* New York: The Museum of Modern Art, 1951.

Soby 1955
Soby, James Thrall. *Giorgio de Chirico.* Rev. ed. New York: The Museum of Modern Art, 1955.

Soby 1958
Soby, James Thrall. *Juan Gris.* New York: The Museum of Modern Art, 1958.

Soby 1995
Soby, James Thrall. "The Changing Stream." Personal reminiscences written between 1962 and 1971 and published, in part, in *Studies in Modern Art 5: The Museum of Modern Art at Mid-Century, Continuity and Change.* New York: The Museum of Modern Art, 1995, pp. 183–229.

Steefel 1973
Steefel, Lawrence D., Jr. "Marcel Duchamp and the Machine." In *Marcel Duchamp,* edited by Anne d'Harnoncourt and Kynaston McShine. New York: The Museum of Modern Art, 1973, pp. 69–81.

Still 1952
Still, Clyfford. In *15 Americans,* edited by Dorothy C. Miller. New York: The Museum of Modern Art, 1952.

Storr 1992
Storr, Robert. *Philip Guston in the Collection of The Museum of Modern Art.* New York: The Museum of Modern Art, 1992.

Storr 1993
Storr, Robert. *Robert Ryman.* New York: The Museum of Modern Art, 1993.

Storr 1997
Storr, Robert. *On the Edge: Contemporary Art from the Werner and Elaine Dannheisser Collection.* New York: The Museum of Modern Art, 1997.

Storr 1998
Storr, Robert. *Tony Smith: Architect, Painter, Sculptor.* New York: The Museum of Modern Art, 1998.

Storr 2000
Storr, Robert. *Modern Art despite Modernism.* New York: The Museum of Modern Art, 2000.

Storr 2002
Storr, Robert. *Gerhard Richter: Forty Years of Painting.* New York: The Museum of Modern Art, 2002.

Sweeney 1946
Sweeney, James Johnson. *Marc Chagall.* New York: The Museum of Modern Art, 1946.

Sweeney 1948
Sweeney, James Johnson. *Mondrian.* New York: The Museum of Modern Art, 1948.

Tancock 1973
Tancock, John. "The Influence of

Marcel Duchamp." In *Marcel Duchamp,* edited by Anne d'Harnoncourt and Kynaston McShine. New York: The Museum of Modern Art, 1973, pp. 159–78.

Tannenbaum 1951
Tannenbaum, Libby. *James Ensor.* New York: The Museum of Modern Art, 1951.

Taylor 1961
Taylor, Joshua. *Futurism.* New York: The Museum of Modern Art, 1961.

Temkin 1987
Temkin, Ann. "Klee and the Avant-Garde 1912–1940." In *Paul Klee,* edited by Carolyn Lanchner. New York: The Museum of Modern Art, 1987, pp. 13–37.

Umland 1992
Umland, Anne. *Projects 34: Felix Gonzalez-Torres.* New York: The Museum of Modern Art, 1992.

Umland 1998
Umland, Anne. *Pop Art: Selections from The Museum of Modern Art.* New York: The Museum of Modern Art, 1998.

Varnedoe 1986
Varnedoe, Kirk. *Vienna 1900: Art, Architecture & Design.* New York: The Museum of Modern Art, 1986.

Varnedoe 1990
Varnedoe, Kirk, and Adam Gopnik. *High & Low: Modern Art and Popular Culture.* New York: The Museum of Modern Art, 1990.

Varnedoe 1994
Varnedoe, Kirk. *Masterpieces from the David and Peggy Rockefeller Collection: Manet to Picasso.* New York: The Museum of Modern Art, 1994.

Varnedoe 1995
Varnedoe, Kirk. *Masterworks from the Louise Reinhardt Smith Collection.* New York: The Museum of Modern Art, 1995.

Varnedoe 1996
Varnedoe, Kirk. *Jasper Johns, A Retrospective.* New York: The Museum of Modern Art, 1996.

Varnedoe 1997
Varnedoe, Kirk, and Pepe Karmel. *Picasso: Masterworks from The Museum of Modern Art.* New York: The Museum of Modern Art, 1997.

Wagner 1999
Wagner, Anne M. "Pollock's Nature; Frankenthaler's Culture." In *Jackson Pollock: New Approaches,* edited by Kirk Varnedoe and Pepe Karmel. New York: The Museum of Modern Art, 1999, pp. 181–99.

Whitfield 1998
Whitfield, Sarah. "Fragments of an Identical World." In *Bonnard,* by Sarah Whitfield and John Elderfield. New York: The Museum of Modern Art, 1998, pp. 9–31.

Wilk 1999
Wilk, Deborah, "Nine Guitars." In *Modernstarts,* edited by John Elderfield, Peter Reed, Mary Chan, and Maria del Carmen González. New York: The Museum of Modern Art, 1999, pp. 308–11.

Wilkinson 1984
Wilkinson, Alan G. "Paris and London: Modigliani, Lipchitz, Epstein and Gaudier-Brzeska." In *"Primitivism" in 20th Century Art,* edited by Willliam Rubin. New York: The Museum of Modern Art, 1984, vol. 2, pp. 417–51.

Wye 1982
Wye, Deborah. *Louise Bourgeois.* New York: The Museum of Modern Art, 1982.

Zevelansky 1994
Zevelansky, Lynn. *Sense and Sensibility: Women Artists and Minimalism in the Nineties.* New York: The Museum of Modern Art, 1994.

Chronology

The following chronology serves as a brief introduction to the history of The Museum of Modern Art, its exhibitions and acquisitions history with a primary focus on painting and sculpture. The history module chronicles major developments concerning the institution and its staff. The exhibitions module recognizes selected major painting and sculpture exhibitions, exhibitions from whose catalogues anthology excerpts have been extracted, as well as selected circulating exhibitions organized by The Museum of Modern Art. The acquisitions column contains works exclusive to *Visions of Modern Art: Painting and Sculpture from The Museum of Modern Art*.

The Museum's staff in 1937. Dorothy Miller (third from left), Director Alfred H. Barr, Jr. (second from right), and Beaumont Newhall (far right)

	Museum History	Major Exhibitions of Painting and Sculpture	Acquisitions
1929	• Museum founded by Lillie P. Bliss, Mary J. Sullivan, and Abby Aldrich Rockefeller; opens November 8 in space rented in Heckscher Building, 730 Fifth Avenue • Alfred H. Barr, Jr., appointed first Director • A. Conger Goodyear named first President • Founding of Committee on Gifts and Bequests • The Museum's collection begins with eight prints and a drawing	• *Cézanne, Gauguin, Seurat, van Gogh*, first loan exhibition • *Paintings by Nineteen Living Artists*	
1930	• Founding of Junior Advisory and Membership Committees	• *Weber, Klee, Lehmbruck, Maillol* • *Homer, Ryder, and Eakins* • *Corot and Daumier*. First loan of pictures to an American museum from the Louvre and the National Gallery, Berlin	• Edward Hopper, *House by the Railroad* (1925), first painting to enter Museum's collection
1931		• *Modern German Painting and Sculpture* • *Toulouse-Lautrec, Redon* • *Memorial Exhibition: The Collection of the Late Lillie P. Bliss* • *Henri Matisse* first solo exhibition of a European artist • *Diego Rivera*, first solo exhibition of a Latin-American artist	

Museum History	Major Exhibitions of Painting and Sculpture	Acquisitions
1932 • Move to 11 West 53 Street • Department of Architecture formed under directorship of Philip Johnson • Alfred H. Barr takes one year leave of absence • Holger Cahill, Director of Exhibitions, appointed Acting Director • Thomas Hart Benton gives first artist lecture	• *A Brief Survey of Modern Painting* • *American Folk Art: The Art of the Common Man in American, 1750–1900* • *American Painting and Sculpture 1862–1932* • *Murals by American Painters and Photographers*	• Otto Dix, *Dr. Mayer-Hermann* (1926)
1933 • Formation of Departments of Circulating Exhibitions, headed by Elodie Courter; Publications; and Department of Publicity, headed by Sarah Newhall • Founding of Reference Library with 2,000 books given by A. Conger Goodyear; Beaumont Newhall first librarian • Alfred H. Barr resumes Directorship of Museum	• *Edward Hopper: Retrospective Exhibition* • *American Sources of Modern Art*	
1934 • Dorothy Miller joins staff as Assistant to the Director • Philip Johnson resigns • Lillie P. Bliss Bequest of 116 works forms nucleus of Museum Collection	• *Whistler: Portrait of the Artist's Mother* • *Modern Works of Art: Fifth Anniversary Exhibition*	• Constantin Brancusi, *Bird in Space* (1928) • Paul Cézanne, *The Bather* (c. 1885) and *Pines and Rocks* (1896–99) • Salvador Dali, *The Persistence of Memory* (1931) • Georges Seurat, *Port-en-Bessin, Entrance to the Harbor* (1888)
1935 • Plans announced for new building on West 54th Street. Architects Edward D. Stone and Philip L. Goodwin • Department of Architecture renamed Department of Architecture and Industrial Art • Establishment of Film Library; Iris Barry named first curator • Beaumont Newhall named first curator of photography • Abby Aldrich Rockefeller donates 181 paintings and sculptures specifying that a number be exchanged or sold in order to build the collection	• *Gaston Lachaise: Retrospective* • *African Negro Art* • *Fernand Léger: Drawings and Paintings* • *Vincent van Gogh*	• Kazimir Malevich, *Woman with Water Pails: Dynamic Arrangement* (1912–13), *Suprematist Composition: Airplane Flying* (1914), and *Suprematist Composition: White on White* (1918) • Pablo Picasso, *The Studio* (1927–28)
1936	• *Cubism and Abstract Art* • *New Horizons in American Art* • *Fantastic Art, Dada, Surrealism* • *John Marin Retrospective*	• Giorgio de Chirico, *The Evil Genius of a King* (1914–15) • Joan Miró, *The Hunter (Catalan Landscape)* (1923–24) • René Magritte, *The False Mirror* (1928) • Aleksandr Rodchenko, *Non-Objective Painting: Black on Black* (1918) • Yves Tanguy, *Mama, Papa is Wounded!* (1927)

	Museum History	Major Exhibitions of Painting and Sculpture	Acquisitions
1937	• Announcement of gift by John D. Rockefeller, Jr. of site of Museum's future Sculpture Garden along West 54th Street • John McAndrew appointed Curator of Architecture and Industrial Design (succeeding Philip Johnson)	• *Vincent van Gogh* (second expanded showing) • *The War: Etchings by Otto Dix and a Painting by Gino Severini* • *Paintings by Paul Cézanne*	• Max Ernst, *Two Children Are Threatened by a Nightingale* (1924) • Gaston Lachaise, *Floating Figure* (1927) • André Masson, *Battle of Fishes* (1926) • Joan Miró, *Person Throwing a Stone at a Bird* (1926) • Piet Mondrian, *Composition in White, Black, and Red* (1936)
1938	• Creation of Department of Education • Monroe Wheeler named Director, Department of Membership (formerly Membership Committee) • Introduction of gallery talks on a regular basis	• *Three Centuries of Art in the United States*, Jeu de Paume, Paris	• Pablo Picasso, *Girl Before a Mirror* (1932), first gift of Mrs. Simon Guggenheim
1939	• New building on West 53rd Street opens • Nelson A. Rockefeller named Museum President (succeeding A. Conger Goodyear) • John E. Abbott named Director of the Film Library • Establishment of Department of Publications under Monroe Wheeler • Library opens to the public and becomes the most extensive library on modern art in the U.S.	• *Art in Our Time: Tenth Anniversary Exhibition* • *Picasso: 40 Years of His Art* • *Charles Sheeler*	• Paul Klee, *Around the Fish* (1926) • Amedeo Modigliani, *Head* (1915?)
1940	• Department of Photography established under Beaumont Newhall • Department of Industrial Design separates from Department of Architecture; Eliot Noyes named Director of Department of Industrial Design • Monroe Wheeler appointed Director of Exhibitions (succeeding Holger Cahill) • Abby Aldrich Rockefeller donates 400 works of art and her entire collection of 1600 prints for the Museum's print room • Barr assists Emergency Rescue Committee, founded to aid those seeking asylum in the U.S. Artists helped included Chagall, Dali, Ernst, Léger, and Mondrian	• *Italian Masters* • *Twenty Centuries of Mexican Art* • *Portinari of Brazil* • *George Grosz*	
1941	• Nelson A. Rockefeller resigns as Museum President; John Hay Whitney succeeds briefly. Thereafter Clark would serve as acting President • Inter-American Fund inaugurated. By end of war, Museum had circulated nineteen exhibitions of contemporary painting in South America • Wheeler named Director of newly founded Department of Exhibitions and Publications	• *New Acquisitions: American Painting and Sculpture* • *Ancestral Sources of Modern Painting* • *Indian Art of the U.S.* • *Britain at War* • *Paul Klee* • *Masterpieces of Picasso* • *Joan Miró* • *Salvador Dali*	• Vincent van Gogh, *The Starry Night* (1889) • Edward Hopper, *New York Movie* (1939)

	Museum History	Major Exhibitions of Painting and Sculpture	Acquisitions
1942	• Sculpture Garden opens • Children's Art Carnival established, sponsored by Department of Education • Publication of Barr's *Painting and Sculpture in The Museum of Modern Art*, first of four books giving full account of the collection. Updated versions were published in 1948, 1958, and 1967	• *Americans 1942: 18 Artists from 9 States* • *Henri Rousseau*	• Max Beckmann, *Departure* (1932–33) • Fernand Léger, *Three Women* (1921)
1943	• Barr asked to step down as Director • James Thrall Soby appointed Assistant Director of the Museum, subsequently Director of Department of Painting and Sculpture	• *American Realists and Magic Realists* • *The Latin American Collection of The Museum of Modern Art* • *Alexander Calder*	• Georges Braque, *Road Near L'Estaque* (1908) • Edward Hopper, *Gas* (1940)
1944	• René d'Harnoncourt appointed Director of Department of Manual Industry to parallel the Museum's Department of Industrial Design and Vice-President in Charge of Foreign Affairs	• *Modern Cuban Painters* • *Paintings by Jacob Lawrence* • *Lyonel Feininger* • *Art in Progress: Fifteenth Anniversary Exhibition*	• Matta, *The Vertigo of Eros* (1944)
1945	• First in-depth presentation of approximately fifteen percent of the Painting and Sculpture collection • James Johnson Sweeney named Director of Department of Painting and Sculpture (succeeding James Thrall Soby)	• *Piet Mondrian* • *Georges Rouault* • *Stuart Davis*	• Georges Braque, *Man with a Guitar* (1912) • Marc Chagall, *I and the Village* (1911) • Marcel Duchamp, *The Passage from Virgin to Bride* (1912) • Georgia O'Keeffe, *Lake George Window* (1929) • Pablo Picasso, *Ma Jolie* (1911–12) and *Card Player* (1913–14)
1946	• John Hay Whitney named Chairman of the Board • Nelson A. Rockefeller renamed President (succeeding John Hay Whitney) • Réné d'Harnoncourt named Chairman of the Coordination Committee around which the management of the Museum is centered from 1943 to 1950 • Edgar Kaufmann named Director of Deptartment of Industrial Design (succeeding Eliot Noyes) • Iris Barry named Director of Film Library (suceeding John E. Abbott)	• *Marc Chagall* • *Georgia O'Keeffe* • *Fourteen Americans* • *Florine Stettheimer* • *Henry Moore*	• Theo van Doesburg, *Rhythm of a Russian Dancer* (1918) • Meret Oppenheim, *Object (Le Déjeuner en fourrure)* (1936)
1947	• D'Harnoncourt restores Barr as Director of Museum Collections • Porter McCray appointed Director of Circulating Exhibitions (succeeding Elodie Courter) • Edward Steichen named Director of Department of Photography (succeeding Beaumont Newhall)	• *Ben Shahn*	• Juan Gris, *Guitar and Flowers* (1912) • Roger de La Fresnaye, *The Conquest of the Air* (1913)
1948	• Founding of the Junior Council	• *Pierre Bonnard* • *Elie Nadelman* • *Contemporary Painters* • *Timeless Aspects of Modern Art*	• Umberto Boccioni, *Unique Forms of Continuity in Space* (1913) • Carlo Carrà, *Funeral of the Anarchist Galli* (1911) • Willem de Kooning, *Painting* (1948) • Elie Nadelman, *Man in the Open Air* (c. 1915)

	Museum History	Major Exhibitions of Painting and Sculpture	Acquisitions
1949	• D'Harnoncourt named Museum Director • The Abby Aldrich Rockefeller Study Center for Prints opens to the public • Dissolution of Department of Manual Design; merger of Department of Architecture with Department of Industrial Design, Philip Johnson named Director • Andrew Ritchie appointed Director of Department of Painting and Sculpture (succeeding Stephen C. Clark) • Film Library becomes Department of Film	• *Georges Braque* • *Twentieth-Century Italian Art* • *Oskar Kokoschka* • *Paul Klee*	• Hans (Jean) Arp, *Human Concretion* (1935) • Giacomo Balla, *Swifts: Paths of Movement+Dynamic Sequences* (1913) • Alberto Giacometti, *Woman with Her Throat Cut* (1932) • Pablo Picasso, *Three Musicians* (1921)
1950		• *Picasso: The Sculptor's Studio* • *Charles Demuth* • *Edvard Munch* • *Chaim Soutine*	• Arshile Gorky, *Agony* (1947) • Amedeo Modigliani, *Reclining Nude* (c. 1919) • Piet Mondrian, *Color Planes in Oval* (1913–14) • Pablo Picasso, *Harlequin* (1915) • Jackson Pollock, *Number 1, 1948* (1948)
1951	• Art Lending Service established	• *Abstract Painting and Sculpture in America* • *Amedeo Modigliani* • *James Ensor* • *Henri Matisse: Retrospective* CIRCULATING EXHIBITION: • *U.S. Representation: I Bienal do Museu de Arte Moderna, São Paulo: works by 58 artists*; first time Museum assumes responsibility for organizing U.S. representation at the São Paulo Bienals	• James Ensor, *Masks Confronting Death* (1888) • Jacques Lipchitz, *Man with a Guitar* (1915)
1952	• Establishment of the International Program under the supervision of Porter McCray • Katherine S. Dreier Bequest enters the collection	• *Masterworks acquired through the Mrs. Simon Guggenheim Fund* • *15 Americans* • *Les Fauves* • *De Stijl*	• George Grosz, *The Poet Max Herrmann-Neisse* (1927) • Franz Kline, *Chief* (1950) • Henri Matisse, *Jeannette, I, III–V* (1910–16) • Mark Rothko, *Number 10* (1950) • Bradley Walker Tomlin, *Number 20* (1949)
1953	• Abby Aldrich Rockefeller Sculpture Garden opens, designed by Philip Johnson • Announcement that Museum plans on creating permanent collection galleries • William A. M. Burden named Museum President (succeeding Nelson A. Rockefeller) • William S. Lieberman named first Curator of Prints	• *Katherine S. Dreier Bequest* • *Sculpture of the XXth Century* • *Fernand Léger* CIRCULATING EXHIBITION: • *U.S. Representation: II Bienal do Museu de Arte Moderna, São Paulo: Sculptures by Alexander Calder; paintings and drawings by fifteen artists*	• Constantin Brancusi, *Mlle Pogany* (1913) • Fernand Léger, *Propellers* (1918) • Aristide Maillol, *The Mediterranean* (1902–05) • Piet Mondrian, *Painting, I* (1926) • Willem de Kooning, *Woman, I* (1950–52)

The Museum of Modern Art at 11 West 53 Street, 1932

The Museum of Modern Art International Style building, 1939, designed by Philip L. Goodwin and Edward D. Stone

The Abby Aldrich Rockefeller Sculpture Garden, 1953, designed by Philip Johnson

New Garden Hall and Tower, designed by Cesar Pelli & Associates

MoMA QNS, the Museum's temporary quarters in Long Island City, 2002, designed by Cooper, Robertson & Partners of New York; lobby and roof-scape designed in collaboration with Michael Maltzan Architecture of Los Angeles

Museum affiliate P.S.1 Contemporary Art Center in Long Island City, Queens, New York, as seen from the number 7 subway train with Manhattan skyline in distance, August 2001

Yoshio Taniguchi's model of the new Museum of Modern Art, 54th Street facade, looking west, April 2000

Construction site of new Museum, 53rd Street, March 2003

339

	Museum History	Major Exhibitions of Painting and Sculpture	Acquisitions
1954		• *Twenty-fifth Anniversary Exhibitions* • *Vuillard* • *The Sculpture of Jacques Lipchitz* • *Sculpture of Constantin Brancusi* CIRCULATING EXHIBITION: • *U.S. Representation: XXVII Biennale di Venezia: principally Willem de Kooning; and Ben Shahn*	• Robert Delaunay, *Simultaneous Contrasts: Sun and Moon* (1913) •Vasily Kandinsky, *Panels for Edwin R. Campbell Nos. 1 and 3* (1914) • Francis Picabia, *I See Again in Memory My Dear Udnie* (1914) • Man Ray, *The Rope Dancer Accompanies Herself with Her Shadows* (1916) • Henri Rousseau, *The Dream* (1910)
1955		• *Fifteen Paintings by French Masters of the 19th Century from the Louvre and the Museums of Albi and Lyon* • *Picasso: 12 Masterworks* • *Giorgio de Chirico* • *Yves Tanguy* CIRCULATING EXHIBITIONS: • *U.S. Representation: III Bienal do Museu de Arte Moderna, São Paulo: Pacific Coast Art* • *The Family of Man* (traveled to thirty-nine countries)	• Henri Matisse, *The Moroccans* (1915–16) and *Jeannette, II* (1910) • Auguste Rodin, *St. John the Baptist Preaching* (1878–80) and *Monument to Balzac* (1898)
1956	• Nelson A. Rockefeller named Chairman of the Board (succeeding John Hay Whitney) • Arthur Drexler appointed Director of Department of Architecture and Design (succeeding Philip Johnson)	• *Kandinsky Murals* • *Twelve Americans* • *Toulouse-Lautrec* • *Balthus* • *Jackson Pollock*	• Max Beckmann, *Self-Portrait with a Cigarette* (1923) • Alejandro Otero, *Color Rhythm, I* (1955) • Joaquin Torres-Garcia, *Composition* (1931)
1957	• International Council assumes sponsorship of Museum's exhibition program abroad	• *Picasso 75th Anniversary* • *Matta* • *David Smith* • *Marc Chagall* • *German Art of the Twentieth Century* • *Antonio Gaudi* CIRCULATING EXHIBITIONS: • *U.S. Representation: III International Contemporary Art Exhibition, India: Nine American artists* • *U.S. Representation: IV Bienal do Museu de Arte Moderna, São Paolo: Jackson Pollock and eight additional artists* • *Jackson Pollock, 1912–1956* (based on retrospective exhibition shown as part of U.S. Representation at IV Bienal do Museu de Arte Moderna, São Paolo; traveled to six European countries)	• Paul Cézanne, *Le Château Noir* (1904–06)

	Museum History	Major Exhibitions of Painting and Sculpture	Acquisitions
1958	• David Rockefeller named Chairman of the Board (succeeding Nelson A. Rockefeller) • Mrs. John D. Rockefeller III named President (succeeding William A. M. Burden) • Peter Selz and William C. Seitz named Co-Directors of Department of Painting and Sculpture (succeeding Andrew Ritchie) • Kay Sage Tanguy Bequest; Mrs. David M. Levy Bequest; Bequest of works from Philip L. Goodwin Collection	• *Seurat: Paintings and Drawings* • *Juan Gris* • *Jean Arp: A Retrospective* • *Philip L. Goodwin Collection* CIRCULATING EXHIBITION: • *The New American Painting* (shown in eight European countries)	• Adolph Gottlieb, *Blast, I* (1957) • Jasper Johns, *Green Target* (1955) and *White Numbers* (1957) • Liubov Sergeievna Popova, *Painterly Architectonic* (1917)
1959	• Mrs. John D. Rockefeller III named Chairman of the Board (succeeding David Rockefeller) • Henry Allen Moe named Chairman of the Board (succeeding Mrs. John D. Rockefeller III) • Mrs. Simon Guggenheim Bequest	• *Joan Miró* • *Recent Sculpture USA* • *Sixteen Americans* • *New Images of Man* CIRCULATING EXHIBITION: • *U.S. Representation: Dokumenta II, Kassel: works by 44 artists, plus a retrospective of works by Pollock*	• Burgoyne Diller, *First Theme* (1942) • Claude Monet, *Water Lilies* (c. 1920) • Barnett Newman, *Abraham* (1949) • Pablo Picasso, *She-Goat* (1950) • Frank Stella, *The Marriage of Reason and Squalor, II* (1959)
1960	• Jazz in the Garden summer concerts initiated • International Council assumes full sponsorship of the International Program • Department of Drawings and Prints established with William S. Lieberman named curator • Art in Embassies Committee formed by the International Council to assemble loan collections of American art for residences of U.S. ambassadors abroad	• *Claude Monet: Seasons and Moments* • *New Spanish Painting and Sculpture* • *Fernand Léger in the Museum Collection* CIRCULATING EXHIBITION: • *Art in Embassies*	• Helen Frankenthaler, *Jacob's Ladder* (1957) • Isamu Noguchi, *Bird C (Mu)* (1952–58)
1961	• William A. M. Burden named Chairman of the Board (succeeding Henry Allen Moe) • Waldo Rasmussen named Director of International Council (succeeding Porter McCray)	• *Mark Rothko* • *Paintings and Sculpture from the James Thrall Soby Collection* • *Max Ernst* • *Futurism* • *The Last Works of Matisse: Large Cut Gouaches* • *The Art of Assemblage*	• Robert Motherwell, *Elegy to the Spanish Republic, 54* (1957–61)
1962	• Construction of the new Garden Wing on West 54th Street begins • David Rockefeller named Chairman of the Board (succeeding William A. M. Burden) • John Szarkowski named Director of Department of Photography (succeeding Edward Steichen)	• *Jean Dubuffet* • *Picasso in The Museum of Modern Art* • *Arshile Gorky: 1904–1948* CIRCULATING EXHIBITION: • *Two Decades of American Painting* (traveled to three countries)	• Louise Bourgeois, *Sleeping Figure, II* (1959)
1963	• Museum closes for six months of construction and remodeling, during which 153 paintings are lent to the National Gallery of Art, Washington, D.C., and the Philadelphia Museum of Art	• *The Intimate World of Lyonel Feininger* • *Emil Nolde: 1867–1956* • *Auguste Rodin* • *Americans 1963* • *André Derain in the Museum Collection* • *Hans Hofmann* • *Medardo Rosso*	• Lee Bontecou, Untitled (1961) • Hans Hofmann, *Memoria in Aeternum* (1962) • Jasper Johns, *Map* (1961) • Henri Matisse, *Dance (First Version)* (1909) • Georges Seurat, *The Channel at Gravelines, Evening* (1890)

	Museum History	Major Exhibitions of Painting and Sculpture	Acquisitions
1964	• Major expansion, designed by Philip Johnson	• *Art in a Changing World: 1884–1964* • *Bonnard and His Environment* • *Max Beckmann*	• Henri Matisse, *Goldfish and Palette* (1914) • Gerald Murphy, *Wasp and Pear* (1927) • Pablo Picasso, *Boy Leading a Horse* (1905–06)
1965	• Elizabeth Bliss Parkinson named Museum President (succeeding William A. M. Burden) • Willard van Dyke named Director of Department of Film (succeeding Richard Griffith)	• *The Responsive Eye* • *Alberto Giacometti* • *The Kay Sage Tanguy Bequest* • *Robert Motherwell* • *The School of Paris: Paintings from the Florene May Schoenborn and Samuel A. Marx Collection* • *René Magritte*	
1966	• Lieberman named Director of Department of Drawings and Prints • Alexander Calder gives thirteen sculptures to the Museum	• *Turner: Imagination or Reality* • *Henri Matisse: 64 Paintings* • *The Taste of a Connoisseur: The Paul J. Sachs Collection*	• Alexander Calder, *Gibraltar* (1936) • René Magritte, *The Menaced Assassin* (1926) • Man Ray, *Indestructible Object* (1964)
1967	• Alfred H. Barr retires after thirty-seven years with the Museum. He remains Counselor to the Trustees and serves as a Trustee • Lieberman appointed curator in Department of Painting and Sculpture (concurrent with his appointment as Director of Department of Drawings) • The Sidney and Harriet Janis Collection Bequest enters the collection	• *Latin American Art 1931–1966* • *Jackson Pollock* • *Guernica: Studies and Postscripts* • *The 1960s: Painting and Sculpture from the Museum Collection* • *Lyonel Feininger: The Ruin by the Sea* • *The Sculpture of Picasso*	• Umberto Boccioni, *Dynamism of a Soccer Player* (1913) • Salvador Dali, *Illumined Pleasures* (1929) • Jim Dine, *Five Feet of Colorful Tools* (1962) • Marcel Duchamp, *Bicycle Wheel* (1951) • Paul Klee, *Actor's Mask* (1924) • Piet Mondrian, *Composition with Color Planes, V* (1917) • Mark Rothko, *Horizontals, White over Darks* (1961) • Clyfford Still, *Painting 1944–N* (1944)
1968	• Retirement of René d'Harnoncourt (succeeded by Bates Lowry) • William S. Paley named Museum President (succeeding Elizabeth Bliss Parkinson) • René d'Harnoncourt dies in a car accident • Cineprobe initiated, devoted to screening films by experimental filmmakers	• *The Sidney and Harriet Janis Collection* • *Dada, Surrealism, and Their Heritage* • *The Art of the Real* • *Christo Wraps the Museum* • *Tribute to Marcel Duchamp* • *Robert Rauschenberg: Soundings* • *The Machine as Seen at the End of the Mechanical Age*	• Kenneth Noland, *Turnsole* (1961) • Jackson Pollock, *One (Number 31, 1950)* (1950) • David Smith, *Australia* (1951)
1969	• Bates Lowry resigns • Walter Bareiss, Trustee, serves as interim Director • Formation of Department of Prints and Illustrated Books supervised by William Lieberman • William S. Rubin appointed Chief Curator and William Lieberman Director, Department of Painting and Sculpture • Richard E. Oldenburg named Director, Department of Publications	• *Willem de Kooning* • *New American Painting and Sculpture: The First Generation* • *Claes Oldenburg* • *A Salute to Alexander Calder*	• Carl Andre, *144 Lead Square* (1969) • Giorgio de Chirico, *Gare Montparnasse* (1914) • Dan Flavin, *Untitled (To the "Innovator" of Wheeling Peachblow)* (1968) • Ellsworth Kelly, *Colors for a Large Wall* (1951) • Barnett Newman, *The Wild* (1950) • Jackson Pollock, *Echo* (1951) • Cy Twombly, *The Italians* (1961)

	Museum History	Major Exhibitions of Painting and Sculpture	Acquisitions
1970	• John B. Hightower named Director of the Museum • Art in Embassies Committee dissolved	• *Frank Stella* • *Mark Rothko: 1903–1970* • *Information* • *Archipenko: The Parisian Years* • *Four Americans in Paris: The Collection of Gertrude Stein and Her Family*	• Marcel Duchamp, *Network of Stoppages* (1914) • Agnes Martin, *Red Bird* (1964) • Tom Wesselmann, *Still Life #30* (1963)
1971	• *Projects* series founded, exhibition series presenting works by younger artists • *Summergarden* founded, program of evening concerts in the Sculpture Garden • William Rubin appointed Director of Department of Painting and Sculpture • Department of Drawings created under Directorship of William Lieberman	• *Romare Bearden: The Prevalence of Ritual* • *The Sculpture of Richard Hunt* • *The Artist as Adversary* • *Barnett Newman: 1905–1970* • *Seven by de Kooning*	• Roy Lichtenstein, *Drowning Girl* (1963) • Barnett Newman, *Onement, III* (1949) • Robert Ryman, *Twin* (1966) • Barnett Newman, *Broken Obelisk* (1963–69)
1972	• Richard E. Oldenburg, head of Museum's Publications Department, named Director (succeeding John B. Hightower) • William S. Paley named Chairman of the Board (succeeding David Rockefeller) • Mrs. John Rockefeller III named President (succeeding William S. Paley)	• *Picasso in the Collection of The Museum of Modern Art* • *The Sculpture of Matisse* • *Tchelitchew: Early Works on Paper*, the Museum's one thousandth exhibition • *Kurt Schwitters* • *Dubuffet: Persons and Places*	• Robert Rauschenberg, *First Landing Jump* (1961)
1973	• Painting and Sculpture galleries expanded and reinstalled by William Rubin	• *Pablo Picasso: 1881–1973* • *Agnes Martin : On a Clear Day* • *Jacques Lipchitz: 1891–1973* • *Ellsworth Kelly* • *Miró in the Collection of The Museum of Modern Art* • *Marcel Duchamp*	
1974		• *Adolph Gottlieb: 1903–1974* • *The Painting of Gerald Murphy* • *Contemporary Soviet Artists* • *Eight Contemporary Artists*	• Edvard Munch, *The Storm* (1893) • Pablo Picasso, *Landscape* (1908) • Richard Tuttle, *Cloth Octagonal, 2* (1967)
1975	• Dedication of Painting and Sculpture collection galleries in honor of Alfred H. Barr, Jr. and exhibition galleries in honor of René d'Harnoncourt • Ted Perry appointed Director of Department of Film (succeeding Willard van Dyke) • First video work enters collection as part of Department of Prints and Illustrated Books	• *Lucas Samaras* • *Anthony Caro* • *Modern Masters: Manet to Matisse*	• Georges Braque, *Landscape at La Ciotat* (1907) • Eva Hesse, *Vinculum, II* (1969) • Paul Klee, *Cat and Bird* (1928) • Henri Matisse, *View of Notre Dame* (1914) • Robert Morris, Untitled (1969) • Claes Oldenburg, *Floor Cake (Giant Piece of Cake)* (1962)
1976	• Building program announced to add West Wing on parcel formerly occupied by 21-35 West 53 Street • Riva Castleman appointed Director of Department of Prints and Illustrated Books	• *Cubism and Its Affinities* • *The "Wild Beasts": Fauvism and Its Affinities* • *Joseph Albers: 1888–1976* • *Max Ernst: 1891–1976* • *André Masson* • *The Natural Paradise: American Painting 1800–1950* • *Alexander Calder: 1898–1976* • *Man Ray: 1890–1976*	• Joan Miró, *Hirondelle/Amour* (1933–34)

	Museum History	Major Exhibitions of Painting and Sculpture	Acquisitions
1977	• Cesar Pelli & Associates selected to design West Wing expansion • Department of Film renovates Roy and Niuta Titus Auditorium (opened in 1939)	• *Robert Rauschenberg* • *Impresario: Ambroise Vollard* • *Cézanne: The Late Work*	• Morris Louis, *Russet* (1958) • Ad Reinhardt, *Abstract Painting* (1963)
1978	• Helen Acheson Bequest	• *Sol LeWitt* • *Matisse in the Collection of The Museum of Modern Art*	• Patrick Henry Bruce, *Painting* (1929–30) • Gustav Klimt, *Hope, II* (1907–08) • Sol LeWitt, *Serial Project, I (ABCD)* (1966)
1979	• John Elderfield, Curator in Department of Painting and Sculptor, appointed Director of Department of Drawings (succeeding William S. Lieberman) • James Thrall Soby Bequest • Nelson A. Rockefeller Bequest	• *Jackie Winsor* • *The Masterworks of Edvard Munch* • *Bequest of James Thrall Soby* • *Patrick Henry Bruce: American Modernist* • *1929, Arts of the Twenties*	• Hans Arp, *Enak's Tears (Terrestrial Forms)* (1917) • Balthus, *The Street* (1933) • Georges Braque, *Still Life with Tenora* (1913) • Giorgio de Chirico, *The Song of Love* (1914) • Giorgio de Chirico, *The Enigma of a Day* (1914) • Pablo Picasso, *Girl with a Mandolin (Fanny Tellier)* (1910), and *Guitar* (1913)
1980	• Construction begins on West Wing and Museum Tower • Mary Lea Bandy appointed Director of Department of Film (succeeding Ted Perry) • Bequest of Lee Krasner	• *Pablo Picasso: A Retrospective* • *Joseph Cornell*	• Donald Judd, *Untitled* (1968) • Ad Reinhardt, *Number 107* (1950)
1981	• Death of Alfred H. Barr, Jr. • Following Picasso's wish, *Guernica* (1937), on loan since 1939, is transferred back to Spain for the centenary of his birth • Bequest of Mark Rothko Foundation	• *Sophie Taeuber-Arp*	• Philip Guston, *Tomb* (1978) • Roy Lichtenstein, *Girl with Ball* (1981)
1982		• *Giorgio de Chirico* • *Louise Bourgeois*	• Paul Klee, *Castle Garden* (1931) • Egon Schiele, *Portrait of Gertrude Schiele* (1909)
1983	• Gift of Riklis/McCrory Corporation Collection	• *Mondrian: New York Studio Compositions* • *Joan Miró: 1893–1983*	• Constantin Brancusi, *Endless Column* (1918) • Vassily Kandinsky, *Panels for Edwin R. Campbell No. 2 and 4* (1914) • Henri Matisse, *Woman Beside the Water* (1905) • Laszlo Moholy-Nagy, *Q 1 Suprematistic* (1923) • George L.K. Morris, *Rotary Motion* (1935) • Sophie Taeuber-Arp, *Composition of Circles and Overlapping Angles* (1930) • Ivan Puni, *Suprematist Relief-Sculpture* (1915)

	Museum History	Major Exhibitions of Painting and Sculpture	Acquisitions
1984	• Opening of new West Wing, designed by Cesar Pelli & Associates, and renovated Museum facilities • Edward John Noble Education Center opens	• *An International Survey of Recent Painting and Sculpture* • *Lee Krasner: A Retrospective* • *"Primitivism" in 20th Century Art: Affinity of the Tribal and the Modern*	• Jackson Pollock, *Gothic* (1944) • Tony Smith, *Free Ride* (1962)
1985	• Mrs. John D. Rockefeller III named Chairman of the Board (succeeding William S. Paley) • Donald B. Marron named President (succeeding Mrs. John D. Rockefeller III)	• *Henri Rousseau* • *Kurt Schwitters* • *Contrasts of Form: Geometric Abstract Art 1910–1980* • *Henri de Toulouse-Lautrec*	• Henri Matisse, *Moroccan Garden* (1912) 1986
1986		• *Richard Serra* • *Vienna 1900: Art, Architecture and Design* • *Morris Louis*	• Richard Serra, *One Ton Prop (House of Cards)* (1969) 1987
1987	• David Rockefeller named Chairman of the Board (succeeding Mrs. John D. Rockefeller III)	• *Paul Klee* • *Berlinart 1961–1987* • *Frank Stella: Works from 1970–1987*	
1988	• Kirk Varnedoe named Director of Department of Painting and Sculpture (succeeding William Rubin) • Stuart Wrede appointed Director of Department of Architecture and Design (succeeding Arthur Drexler)	• *Committed to Print* • *Vito Acconci: Public Places* • *Anselm Kiefer*	• Ed Ruscha, *OOF* (1962-63)
1989	• *Artist's Choice* series founded, exhibition series for which artists are invited to select and install works from the collection	• *Andy Warhol: A Retrospective* • *Christopher Wilmarth* • *Helen Frankenthaler: A Paintings Retrospective* • *Picasso and Braque: Pioneering Cubism*	
1990	• William S. Paley Bequest • Mary Sisler Bequest	• *Robert Moskowitz* • *Francis Bacon* • *Matisse in Morocco: The Paintings and Drawings, 1912-1913* • *High & Low: Popular Art and Modern Culture* CIRCULATING EXHIBITION: • *Picasso Exchange Exhibition* (shown at two venues in Soviet Union)	• Joseph Cornell, *Untitled (Dieppe)* (c. 1958) • Paul Gaugin, *The Seed of the Areoi* (1892) • Henri Matisse, *Odalisque with a Tambourine* (1926), *Woman with a Veil* (1927), and *Landscape at Collioure* (1905)
1991	• Agnes Gund named President of the Museum (succeeding Donald B. Marron) • Peter Galassi appointed Director of Department of Photography (succeeding John Szarkowski)	• *Liubov Popova* • *Ad Reinhardt* • *Dislocation*	• Philip Guston, *City Limits* (1969), and *Box and Shadow* (1978)
1992	• Terence Riley appointed Director of Department of Architecture and Design (succeeding Stuart Wrede) • Bequest of Musa Guston • UBS PaineWebber gifts	• *The William S. Paley Collection* • *Philip Guston in the Collection of The Museum of Modern Art* • *Henri Matisse: A Retrospective* CIRCULATING EXHIBITIONS: • *MoMA, New York from Cézanne to Pollock*, Bonn, Germany • *Masterworks from the Museum of Modern Art*, Tokyo, Japan	• Philip Guston, *Head* (1977)

345

	Museum History	Major Exhibitions of Painting and Sculpture	Acquisitions
1993	• Agnes Gund named Chairman of the Board (succeeding David Rockefeller) • David Rockefeller named Chairman Emeritus • John Elderfield named Chief Curator at Large • Margit Rowell appointed Chief Curator of Department of Drawings (succeeding John Elderfield)	• *Max Ernst: Dada and the Dawn of Surrealism* • *John Heartfield: Photomontages* • *Latin American Artists of the Twentieth Century* • *Robert Ryman* • *Joan Miró*	• Walter de Maria, *Cage II* (1965)
1994	• Department of Film renamed Department of Film and Video	• *Masterpieces from the David and Peggy Rockefeller Collection: From Manet to Picasso* • *Sense and Sensibility: Women Artists and Minimalism in the Nineties* • *Cy Twombly: A Retrospective*	
1995	• Glenn D. Lowry appointed Director of the Museum (succeeding Richard E. Oldenburg) • Ronald S. Lauder named Chairman of the Board (succeeding Agnes Gund) • Agnes Gund resumes position of President • Louise Reinhardt Smith Bequest	• *Kandinsky: Compositions* • *Bruce Nauman* • *Masterworks from the Louise Reinhardt Smith Collection* • *Selections from the Bequest of Nina and Gordon Bunshaft* • *Piet Mondrian: 1872–1944*	• Alberto Giacometti, *Hands Holding the Void (Invisible Object)* (1934) • Henri Matisse, *Still Life with Aubergines* (1911) • Pablo Picasso, *Bather* (1908–09) • Gerhard Richter, *October 18, 1977* (1988) • Andy Warhol, *Before and After* (1961)
1996	• Acquisition of Dorset Hotel at 30 West 54 Street and two adjacent townhouses at 39 and 41 West 53 Street for future expansion • The Museum's Celeste Bartos Film Preservation Center dedicated in Hamlin, Pennsylvania • Museum launches Website: (www.moma.org) • Deborah Wye appointed Chief Curator of Department of Prints and Illustrated Books (succeeding Riva Castleman) • Donation of the Werner and Elaine Dannheisser Collection • Florene May Schoenborn Bequest	• *Brancusi: Selected Masterworks from the Musée de l'Art Moderne, Paris and from The Museum of Modern Art, New York* • *Deformations: Aspects of the Modern Grotesque* • *Picasso and Portraiture: Representation and Transformation* • *Jasper Johns: A Retrospective* • *Simple Gifts: A Selection of Gifts to the Collection from Lily Auchincloss* CIRCULATING EXHIBITIONS: • *The William S. Paley Collection*, Tokyo, Japan • *Henri Matisse: Masterworks from The Museum of Modern Art*, Atlanta	• Pierre Bonnard, *Nude in Bathroom* (1932) • Felix Gonzalez-Torres, "Untitled" (1991)
1997	• Yoshio Taniguchi wins competition to design new Museum of Modern Art	• *Willem de Kooning: The Late Paintings, the 1980s* • *Masterworks from the Florene May Schoenborn Bequest* • *The Photomontages of Hannah Höch* • *Objects of Desire: The Modern Still Life* • *On the Edge: Contemporary Art from the Werner and Elaine Dannheisser Collection* CIRCULATING EXHIBITION: • *Picasso: Masterworks from The Museum of Modern Art*, Atlanta and Ottawa, Canada	• Stuart Davis, *Odol* (1924)
1998	• Mrs. John Hay Whitney Bequest	• *Fernand Léger* • *Chuck Close* • *Pierre Bonnard* • *Aleksandr Rodchenko* • *Tony Smith: Architect, Painter, Sculptor* • *Love Forever: Yayoi Kusama, 1958–1968* • *Jackson Pollock* CIRCULATING EXHIBITION: *Pop Art: Selections from The Museum of Modern Art*, Atlanta	• Philip Guston, *Moon* (1979) • Vincent van Gogh, *The Olive Trees* (1889) • Andy Warhol, *S&H Green Stamps* (1962)

	Museum History	Major Exhibitions of Painting and Sculpture	Acquisitions
1999	• MoMA and P.S.1 Contemporary Art Center sign a letter of intent to merge • Purchase of Swingline Staple Factory in Long Island City, Queens as storage facility	• *The Museum as Muse: Artists Reflect* • *Ellsworth Kelly: Sculpture for a Large Wall and other Recent Acquisitions* • *ModernStarts: People, Places, Things*, first of three cycles of exhibitions representing all of the Museum's curatorial departments, to mark *MoMA 2000*	• Cai Guo-Qiang, *Borrowing Your Enemy's Arrows* (1998) • Robert Rauschenberg, *Untitled (Asheville Citizen)* (c. 1952)
2000	• Gary Garrels appointed Chief Curator of Department of Drawings (succeeding Margit Rowell)	• *Making Choices*, second of three cycles of exhibitions representing all of the Museum's curatorial departments, to mark *MoMA 2000* • *Open Ends*, third of three cycles of exhibitions representing all of the Museum's curatorial departments, to mark *MoMA 2000*	
2001	• Kirk Varnedoe, Chief Curator of Department of Painting and Sculpture, resigns • Department of Film renamed Department of Film and Media	• *Van Gogh's Postman: The Portraits of Joseph Roulin* • *Alberto Giacometti* CIRCULATING EXHIBITION: • *Masterworks from The Museum of Modern Art, New York (1900–1955)*, Tokyo, Japan	
2002	• The Museum opens MoMA QNS, its temporary new home in Long Island City, designed by Cooper, Robertson & Partners; lobby and roofscape designed in collaboration with Michael Maltzan Architecture • Robert B. Menschel, Vice Chairman of the Board, named President (succeeding Agnes Gund) • Agnes Gund named President Emerita	• *Gerhard Richter: Forty Years of Painting* • *Tempo* • *To Be Looked At: Painting and Sculpture from the Permanent Collection*	
2003	• Kynaston McShine appointed Chief Curator at Large • John Elderfield appointed Chief Curator of Department of Painting and Sculpture	• *Matisse Picasso* • *Max Beckmann* CIRCULATING EXHIBITION: • *Visions of Modern Art: Painting and Sculpture from The Museum of Modern Art, New York*, Houston, Texas	
2004	November, 2004: 75th Anniversary of The Museum of Modern Art; newly expanded Museum to reopen in this anniversary year.		

Index

This index references the texts to the illustrations and the illustrations. Numbers in *italics* refer to the plates.

Photograph Credits

David Allison, 78 bottom, 239; Digital image © The Museum of Modern Art, 334, 339 top four photos; © Elizabeth Felicella, 339 MoMA QNS, MoMA construction site; Tom Griesel, 76, 78 top left and right, 119, 152 bottom, 160 bottom, 168 top, 184, 237, 277, 278, 279; © 2002 John Harris, 339 P.S.1; Kate Keller, 43, 44 top, 46, 48 top, 49, 50 bottom, 51 top, 54, 72, 74, 75, 77, 79, 80, 83, 84, 85, 86, 112 top, 113, 114, 115, 116, 117, 118, 120, 122, 123, 124, 125, 126, 127, 128, 130, 132 top, 134, 136 top, 139 top, 160 top, 163, 164, 168 bottom, 170, 171 bottom, 173 top, 174, 178, 179, 183, 185, 199, 201, 202, 207 bottom, 210, 212, 235 bottom, 238, 246, 247, 251, 252, 256, 258, 259, 261, 280, 281, 282 top, 283, 284, 290, 292, 293; Paige Knight, 41, 42, 50 top, 51 bottom, 52, 81, 82, 121, 131, 133, 135, 139 bottom, 162 left, 165, 166, 167, 169 top, 175 bottom, 176 top, 180, 181, 182, 200, 205, 206, 211, 213, 241, 242, 244, 248, 249, 253, 254, 255, 257, 260, 263, 282 bottom, 285, 286, 287, 295, 307, 308, 309; Erik Landsberg, 49, 173 bottom, 234; George Meguerditchian, Courtesy Centre Georges Pompidou, © The Museum of Modern Art, 208, 209; Mali Olatunji, 47, 87, 112 bottom, 129 bottom, 136 top, 139 top, 161, 162 right, 171 top, 177, 178, 199, 202, 204, 207 top, 212 bottom, 240, 243, 246, 247, 291, 292, 296 top, 310; © 2002 Jock Pottle/Esto, 339 Taniguchi model; Malcolm Varon, 136 bottom; Graydon Wood, Philadephia Museum of Art; Courtesy The Museum of Modern Art, 245; John Wronn, 44 bottom, 45, 48 bottom, 71, 73, 129 top, 137, 138, 169, 172, 175, 176, 203, 235 top, 236, 250, 251, 256, 262, 288, 290, 293, 294, 296 bottom, 311, 312–23.

The following credits appear at the request of the artist or the artist's representatives and/or the owners of the work:

Arp: © 2003 Artists Rights Society (ARS), New York / VG Bild-Kunst, Bonn; Balla: © 2003 Artists Rights Society (ARS), New York / SIAE, Rome; Balthus: © 2003 Artists Rights Society (ARS), New York / ADAGP, Paris; Beckmann: © 2003 Artists Rights Society (ARS), New York / VG Bild-Kunst, Bonn; Bonnard: © 2003 Artsts Rights Society (ARS), New York / ADAGP, Paris; Bontecou: © Lee Bontecou / courtesy Knoedler & Company, New York; Bourgeois: © 2003 Louise Bourgeois; Brancusi: © 2003 Artists Rights Society (ARS), New York/ ADAGP, Paris; Braque: © 2003 Artists Rights Society (ARS), New York / ADAGP, Paris; Cai Guo-Qiang: © 2003 Cai Guo-Qiang; Calder: © 2003 Estate of Alexander Calder / Artists Rights Society (ARS), New York; Chagall: © 2003 Artists Rights Society (ARS), New York / ADAGP, Paris; Chirico, de: © 2003 Artists Rights Society (ARS), New York / SIAE, Rome; Dali: © 2003 Salvador Dalí, Gala-Salvador Dalí Foundation / Artists Rights Society (ARS), New York; De Maria: © 2003 Walter de Maria; Derain: © 2003 Artists Rights Society (ARS), New York / ADAGP, Paris; Dine: © 2003 Jim Dine / Artists Rights Society (ARS), New York; Dix: © 2003 Artists Rights Society (ARS), New York / VG Bild-Kunst, Bonn; Duchamp: © 2003 Artists Rights Society (ARS), New York / ADAGP, Paris, Estate of Marcel Duchamp; Ensor: © 2003 Artists Rights Society (ARS), New York / SABAM Brussels; Ernst: © 2003 Artists Rights Society (ARS), New York / ADAGP, Paris; Flavin: © 2003 Estate of Dan Flavin / Artists Rights Society (ARS), New York; Giacometti: © 2003 Artists Rights Society (ARS), New York / ADAGP, Paris; Gonzalez-Torres: As installed for Bilioteca Luis Angel Arrango, Bogota, Colombia, *Felix Gonzalez-Torres*, November 3, 1999–January 30, 2000; in six locations throughout Bogota. © 2003 The Felix Gonzalez-Torres Foundation, courtesy of Andrea Rosen Gallery, New York; Gorky: © 2003 The Estate of Arshile Gorky / Artists Rights Society (ARS), New York; Gris: © 2003 Artists Rights Society (ARS), New York / ADAGP, Paris; Grosz: © 2003 Artists Rights Society (ARS), New York / VG Bild-Kunst, Bonn; Guston: © 2003 The Estate of Philip Guston, courtesy of McKee Gallery, New York; Hesse: © 2003 The Estate of Eva Hesse, courtesy Galerie Hauser & Wirth, Zurich; Hofmann: © 2003 Estate of Hans Hofmann / Artists Rights Society; Johns: © 2003 Jasper Johns / Licensed by VAGA; Kandinsky: © 2003 Artists Rights Society (ARS), New York / ADAGP, Paris; Kelly: © 2003 Ellsworth Kelly; Klee: © 2003 Artists Rights Society (ARS), New York / VG Bild-Kunst, Bonn; Kline: © 2003 The Franz Kline Estate / Artists Rights Society (ARS), New York; De Kooning: © 2003 The Willem de Kooning Foundation / Artists Rights Society (ARS), New York; Leger: © 2003 Artists Rights Society (ARS), New York / ADAGP, Paris; LeWitt: © 2003 Sol LeWitt / Artists Rights Society (ARS), New York; Lichtenstein: © 2003 Estate of Roy Lichtenstein; Magritte: © 2003 C. Herscovici, Brussels / Artists Rights Society (ARS), New York; Maillol: © 2003 Artists Rights Society (ARS), New York; ADAGP, Paris; Man Ray: © 2003 Man Ray Trust / Artists Rights Society (ARS), New York / ADAGP, Paris; Martin: © 2003 Agnes Martin; Masson: © Artists Rights Society (ARS), New York / ADAGP, Paris; Matisse: © 2003 Succession H. Matisse / Artists Rights Society (ARS), New York; Matta: © Artists Rights Society (ARS), New York / ADAGP, Paris; Miró: © 2003 Successió Miró / Artists Rights Society (ARS), New York / ADAGP, Paris; Moholy-Nagy: © 2003 Artists Rights Society (ARS), New York / VG Bild-Kunst, Bonn; Mondrian: © 2003 Mondrian/Holtzman Trust, c/o Beeldrecht / Artists Rights Society (ARS), New York; Monet: © Artists Rights Society (ARS), New York / ADAGP, Paris; Morris: © 2003 Robert Morris / Artists Rights Society (ARS), New York; Munch: © 2003 The Munch Museum / The Munch-Ellingsen Group / Artists Rights Society (ARS), New York; Newman: © 2003 Barnett Newman Foundation / Artists Rights Society (ARS), New York; O'Keeffe: © 2003 The Georgia O'Keeffe Foundation / Artists Rights Society (ARS), New York; Oppenheim: © 2003 Artists Rights Society (ARS), New York / Pro Litteris, Zurich; Picabia: © 2003 Artists Rights Society (ARS), New York / ADAGP, Paris; Picasso: © 2003 Estate of Pablo Picasso / Artists Rights Society (ARS), New York; Pollock: © 2003 Pollock-Krasner Foundation / Artists Rights Society (ARS), New York; Puni: © 2003 Artists Rights Society (ARS), New York / ADAGP, Paris; Reinhardt: © 2003 Estate of Ad Reinhardt / Artists Rights Society (ARS), New York; Richter: © 2003 Gerhard Richter; Rothko: © 2003 Kate Rothko Prizel & Christopher Rothko / Artists Rights Society (ARS), New York; Ruscha: © 2003 Ed Ruscha; Ryman: © 2003 Robert Ryman; Serra: © 2003 Richard Serra / Artists Rights Society (ARS), New York; Smith: © 2003 Estate of Tony Smith / Artists Rights Society (ARS), New York; Stella: © 2003 Frank Stella / Artists Rights Society (ARS), New York; Taeuber-Arp: © 2003 Artists Rights Society (ARS), New York / VG Bild-Kunst, Bonn; Tanguy: © 2003 Estate of Yves Tanguy / Artists Rights Society (ARS), New York; Torres-Garcia: © 2003 Artists Rights Society (ARS), New York / VEDAP, Madrid; Tuttle: © 2003 Richard Tuttle; Twombly: © 2003 Cy Twombly; Warhol: © 2003 Andy Warhol Foundation for the Visual Arts / Artists Rights Society (ARS), New York.

351